EDIE HAND TESTIMONIALS AND ENDORSEMENTS

I have known Edie for thirty years now, and I consider it a true honor and pleasure to call her my friend and colleague. She is a uniquely talented woman of incredible integrity and creativity who brings an enormous passion to everything she does, motivated by her deep desire to help the world and those around her. I look forward to continuing to work together for many years to come.

ADAM TAYLOR
President/CEO, APM Music
www.apmmusic.com

Every quarter, our firm, Northwestern Mutual of Alabama, hosts a sales meeting. Edie was a keynote speaker at our June 2018 meeting. Her message was inspiring, sincere, had a touch of humor, and was loaded with great advice on being a person of grit...an example of survival during life's trials. She also presented at one of our breakout sessions on the ABC's of Relationship Selling. This session was particularly helpful to our newer advisors. I highly endorse her as a professional speaker and know she will go above and beyond to deliver a powerful and impactful message to your group.

COLLEEN EIKMEIER
Chief Growth Officer, Northwestern
Mutual of Alabama

Edie Hand is a consummate professional with a heart of gold. Her life experience as a caregiver and her inspirational journey through hardship and loss has uplifted thousands who have heard her speak, read her books, seen her on camera, and interacted with her directly. It has been my honor to work with Edie for the past few years in various venues such as *Prescription for Healthy Lifestyles* on Rural TV, and she has enriched my life invaluably.

DANIEL C. POTTS, M.D., FAAN
Attending Neurologist at US
Department of Veterans Affairs

Edie Hand has been a valued member of Nashville Women in Film & Television for over five years. She always shows a commitment to improving the film community and supporting our members. Her storytelling abilities, highlighted in the *Women of True Grit* series in our monthly *Reel Lumiere* magazine, help to inspire women from all walks of life. Edie's network of professionals has also played a part in the success of our annual Southern Women in Film and Television Summit, bringing nationally recognized participants to this event. This book will inspire you and give you hope.

LYNDA EVJEN
President, Nashville Women in
Film & Television

This is a long-overdue recommendation for a most incredible woman. I had the pleasure of first working with Edie as a writer while I worked at Promenade Pictures. We became fast friends, and later she contacted me to help her produce a new idea she had for *A Country Music Christmas with Edie Hand and Friends*. A woman of integrity with great passion for everything she does, Edie is a strong woman of faith, and I learned so much from her and about myself while working together. She taught me that no matter what card we are dealt in life, there is always a higher purpose. GOD works all things for the good. Edie always works from a place of love and compassion for others. On our show, we worked closely with the Children's Miracle Network in Nashville. The love that she brings to those children and their families is invaluable. Aside from her passion projects, she is a talented writer who has touched so many with her successful books and wonderful stories of encouragement. The talent gene is strong in her family bloodline—as a relative of Elvis Presley's, the apple doesn't fall far from the tree. Edie has pursued her dreams in entertainment with conviction and endless talents. I only wish the best for Edie always and hope you too can one day have the pleasure of working with her.

KAREN WALDRON
Executive Producer, Owner, and
Creative Director
Ampersand Entertainment Inc.

I had the honor of meeting Edie at the Alliance for Women in Media (AWM) Gracie Awards while serving as a judge for the awards show. As an honored member of the Alliance for Women in Media, Edie is one of the founders of the Gracie Awards, which recognizes excellence in media and entertainment. She is an avid champion of women in the industry, and she also served as a local AWM affiliate president in Alabama.

Most recently, Edie sat on the documentary panel during the Southern Women in Film & TV summit and shared her filmmaking process with attendees that included my AWM affiliate in Southern California. Her passion and creativity are reflected in her good works, and it was a wonderful opportunity to gain insight into her role as a documentary producer.

I am always amazed by Edie's many talents. She's a successful business-woman, speaker, media personality, filmmaker, author, mom, and cousin to the legendary Elvis Presley. As a four-time cancer survivor, she inspires all with her *True Grit* book series, sharing pearls of wisdom that uplift the spirit—helping individuals and small businesses overcome their hurdles and thrive.

Always thinking of others, this amazing woman continues to pay it forward with her philanthropy work supporting organizations like St. Jude Children's Research Hospital. A beautiful legacy of uplift, Edie is a friend, a colleague, and a woman of true grit!

KIM SPENCE DICKEY
Executive Board of Directors
Alliance for Women in Media, SoCal
im@storybookproducer.com
WomeninMediaSocal.org

I know Edie's story, and if anyone has ever shown true grit, she has! And she's done it with grace, gratitude, and a beautiful loving spirit. I look forward to her *Women of True Grit* stories. I have no doubt they will be inspiring and transforming.

DAVE ALAN JOHNSON
Writer/Producer/Director

Edie Hand and I have been friends for many years. Since I met Edie at Graceland with her Aunt Nash, I've known she was destined to be a great writer. She has been inspired by her desire to share her experiences and the experiences of other women in their quest for equality and the fulfillment of their aspirations. This is a must-read book!

GIGI BALLESTER
Memphis, Tennessee
Special Correspondent/RCA
Senior Analyst/Flight Manager-TWA

Edie Hand is by far one of the strongest women I have ever met. She is so strong and full of dreams, and she has so much energy. She not only endured the tragedies of losing her brothers but also survived several bouts of cancer. Her book *Women of True Grit* tells the unique and courageous life stories of many women who faced life with courage and, yes, true grit. Enjoy reading this uplifting collection of inspiring stories.

KERRI WOODS BREEDING
Entrepreneur

This book is for every person who is wondering how to find the grit to *not* quit. *Women of True Grit* is a rallying cry, a healing balm, and a warm embrace to anyone in the middle of a difficult season of pain. Whether the battle is on the home front, the health front, or the work front, her message—"Pearls on. Swords up!"—is the game-changing message that every woman needs to hear today!

KAROLYN HART
Founder, InspireHUB Inc.

Edie Hand's support of women knows no bounds. She truly puts in the work to uplift all voices and better the communities that she touches. This *Women of True Grit* book demonstrates powerful sisterhood by telling about the hardships of these various women from various walks of life, and how they have defined success for themselves. It is thought-provoking, heartbreaking, and beautiful.

TIFFANI ADAMS
HandNHand Entertainment Intern

Meeting Edie Hand or reading from this book is like meeting an unforgettable life-force brimming with a bounty of true grit. Teeming with women who, like Edie, are breaking boundaries and have faced life's adversities and forged their own way, this spellbinding book holds the reader's attention throughout. Edie's stories, like magnets, embody persistence, dedication and, yes, true grit. For readers searching for a book to make an impact and to inspire, look no further. This is it!

JOY WILLOW
Founder, Shoals Writers Guild

Through the stories and life lessons of successful women who have been challenged and have overcome, Edie Hand gives us hope, inspiration, and determination. Her *Women of True Grit* series offers us nuggets of wisdom mixed with some joy, sadness, and humor, to give us the motivation to keep pushing forward. Edie's down-to-earth storytelling style makes her work an absolute pleasure to read. We all need some encouragement in our lives, and Edie delivers it straight from her heart to yours.

KEVIN MATOSSIAN
Producer, SilverCrest Entertainment,
Los Angeles

The interviews in Edie Hand's *Women of True Grit* give us insight into the lives of many women who dared to make a difference. I trust one will be inspired during these challenging times…this book is worth the read.

KATHY NELSON
(R) Music Department Disney A&R
Kathy Nelson Company

Edie Hand's *Women of True Grit* publications are filled with life stories of women who have journeyed through good and bad times and experienced phenomenal success. These stories are moving examples of what persistence and faith can do to propel individuals to reach their full potential.

DEVIN STEPHENSON, PH.D.
President/CEO Northwest
Florida State College

Edie is a gifted author and uniquely talented. So much energy and focus on helping others. She has a real gift for telling stories that connect with audiences in impactful and compelling ways. She has an earnest desire to help people all over the world and is a resolute supporter of women in business which is reflected in *Women of True Grit*. She truly is a gift to all that know her, set on this earth for a divine purpose.

PASTOR RAY GENE WILSON
West Coast Life Church, Murrieta, CA

EDIE HAND'S

WOMEN

OF TRUE GRIT™

EDIE HAND'S

WOMEN

OF TRUE GRIT™

PASSION • PERSEVERANCE • POSITIVE PROJECTION

EDIE HAND

FRANKLIN GREEN
PUBLISHING

.

Women of True Grit
Passion • Perseverance • Positive Projection

© 2023 Edie Hand

Published by Franklin Green Publishing

Cover & Interior Design: Bill Kersey, KerseyGraphics
Cover photographer: Josh Fogel, www.joshfogel.com
Editor: Mary Sanford

ISBN: 978-1936487-47-9

DEDICATION

My grandmother Alice Hood Hacker, my mother, Ripple Sue Blackburn, my grandmother Floy Thorn Blackburn, my aunt Clyneice Ledbetter, my aunt Jackie Coleman, my aunt Lela Myrick Dawson, my aunt Minnie Mae Hood Presley, Nash Presley Pritchett, Margie Hand, Barbara Cashion, Gladys Shepard, Earline McClanahan, Phyllis Diller, Dr. Judy Kuriansky, Lucille Luongo, Terre Thomas, Peggy Mitchell, Linda Sandy Cox Coons, and Colleen Ruszkowski. These are women who helped me along the different seasons in life to find true grit and grace to push through fears and seize the courage through some of my extraordinary opportunities.

They taught me about the purity of one's word, and like the metaphor of the pearl, out of irritations comes beauty—therefore, our strength builds through life lessons. You can find yourself again with mentors, through mistakes—enjoying new magical moments.

Thank you all for loving me, encouraging my imagination, and seeing my gifts from God. Some helped me through bad choices, some gave me pearls of hope through laughter, some helped me slay my demons, some shared their resources, and some were just there to guide this country girl to maneuver through the city traffic and never give up on big dreams at any season of life.

Thanks for being the pearls around my heart as Earth and Heavenly Angels . . . forever.

Edie Hand

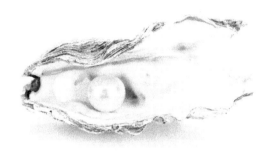

A piece of grit inside an oyster shell transforms over time into
a beautiful Pearl, and so it is for women of true grit, who
persevere through life's irritations and navigate through
hard things to turn them into beautiful situations.

GRIT:
GREAT RESILIENCE IS TRANSFORMATIVE

CONTENTS

ACKNOWLEDGMENTS

I am so blessed with vast friends with unlimited talents. My precious son, Linc Hand, is my heart and my biggest voice of support. His talented wife, Victoria Renee, is like a daughter and a voice for my *Women of True Grit* brand. Thank you both for your love and for believing in me.

I'd like to thank the following for their talents:

First, I would like to recognize the memory of Joel Anderson of Anderson Merchandisers in Florence, Alabama. Joel gave me a hand up through his family, Books A Million stores, and Walmart distribution companies and became a friend. I was a north Alabama college girl who enjoyed the Anderson Bookstore in those days and was just getting started in the advertising/book business. He was a mentor who showed me kindness that gave me the confidence to push through new territory. His counsel was priceless. I know firsthand that there are Angels among us.

To Josh Fogel and Bill Love, thank you for your exceptional photography talents.

To Paula Smith, Debra Stanford, and Jasmin of Hollywood, California, a big thanks for keeping me camera-ready wherever I go!

To Mark Dubis, for his outstanding technical support on my websites, organizational skills, and valued friendship.

To Karolyn Hart, your tireless support for *Women of True Grit,* the design of The Grit Hub/Pearl Coaches development, and being a prayer warrior with me are dear to my heart.

To Kevin Matossian for being an amazing producer and believing in the WOTG brand.

To Steve McBeth and Dave Alan Johnson, thank you for being my connections to tell better stories.

To Shirley and Dan Mullally for helping me with all my many *Women of True Grit* projects and for introducing me in to the FedEx family. Glad we

share the joy of helping kids with cancer in Memphis for St. Jude Children's Research Hospital.

A special thank you to Dr. Patrick Daugherty for always supporting my projects and being a long-time friend.

To Autumn King for seeing the vision and sharing her talents in the development of my *Women of True Grit* stories. To Tiffani Adams, my intern from the University of North Alabama, in whom I see a lot of me regarding her work ethic and resilience. To Camille Womack for sharing her editing talents as a graduate of Samford University and her Birmingham Ad Club Federation connection. To all three of these young women: I am grateful for your assistance with editing, writing, and associate producing tasks for the *Women of True Grit* stories and vignette films with me and for me.

To writers and directors like Don Keith, Norton Dill, Brian Covert, and my recent works with Jared Johnson of ABC Sinclair Broadcasting of Birmingham, Alabama, a genuine thank you for your support and hard work toward my passions of works along the ride.

Big thank you to Eric Land and Wayne Reid for helping me bring *Women of True Grit* to life on network television. A special thank you to the Alabama Public Television team for airing the *Women of True Grit* documentaries. To Nashville Women in Film and Television for inviting me to share my *Women of True Grit* stories in your national *Reel Lumiere* digital magazine. Donna Caldwell and Lynda Evjen, you are both filled with resilience to help your sisterhood in Nashville, Tennessee, and beyond.

To Dr. Devin and Judy Stephenson for supporting my *Women of True Grit* mission and lecture tours to junior colleges of the South.

To 8-Track entertainment of Muscle Shoals, Alabama, for believing in my writings; and here's to our music documentaries for Alabama history and beyond! It is a blessing to know Jeff Goodwin and Noah Gordon.

Additional thanks to friends for their continual hands up: Mary Jo Gunter, Mary Ellen Capps, Janet Noll, Jeffy Beavers, Ellen Graham, Nancy Logan, Kim Spence Dickey, K. C., Judy Hester Bodie, Barbara Mansell, Judy Nelon, Judy Martino, Patricia Hacker Tesseneer, Tonya Holly, Sharon Tinsley, Colleen Eikmeier, Kelley Hand Buras, Darlene Real Higginbotham, Darcy Bonfils Reid, Dr. Judy Kuriansky, Jean Williams, Karen Waldron, Judy Sargent, Peggy Mitchell, Judith Murray, Lennis Ledbetter Sewel, Linda Sandy Coons, Marsha

Kinsaul, Colleen Ruszkowski, Jackie Peters, Connie Wolfe, Anne Sward Hansen, Bobbie Knight, Linda Sewell, Dr. Rochelle Brunson, Dr. Marlene Reed, Becky Daugherty, Lauren Miller, GiGi Ballester, Terre Thomas, Shea Vaughn, Wanda McKoy, Judy Nelon, and my Shades Mountain Baptist Women's Sunday School Class for thirty-plus years. My Graceland family and friends. I know not everyone is so blessed in their friendships, and I could not have done it without your acts and words of encouragement throughout these years. If I missed saying your name, know that I value all of my relationships, and if our paths crossed, know that I was and am grateful. They just do not make old friends.

Bennie Jacks, thank you for introducing me into our world of NASA and beyond blessed for our journey through breast cancer and surviving. It does not hurt that you love Elvis so much also!

To Patsy Riley, the best First Lady of Alabama ever. You are such a joy in my life. To Roxie Kelley, I appreciate all the road warrior trips and life lessons we have shared over our adult lifetime.

A special thanks to Dr. Bob and Susan Flowers and their family. I am honored to be one of your son Jonathan's godmothers.

Thanks to my Burnout, Red Bay, and Florence, Alabama, friends who are so dear to my heart. The childhood horseback rides I cherish a lot in my mind with my young brothers I grew up with in that Burnt plum out community—they planted deep seeds of kindness in my heart. Rest in peace David, Terry, and Phillip, with Mom and Dad.

To my grandnieces Kyleigh and Kadence and grandnephew Beau: you make me laugh and light up my life (your EITTLE forever). Thanks to my sister, Kim, for sharing your girls Kristi and Kayla and for showing up for my filming projects ready to work and learning how to turn hard things into beautiful situations.

Special thanks to all the *Women of True Grit* in this book who shared their stories on different levels. Your voices will make a difference in this world, and I am happy I am the one who gets to tell each of your stories!

Pearls on. Swords up!

FOREWORD

BOBBI J. WELLS

AMERICAN AIRLINES
VICE PRESIDENT—SAFETY, ENVIRONMENTAL
& REGULATORY COMPLIANCE

*E*xamples are important to all of us. However, for women striving to battle their way into the boardroom, find opportunities where they are challenged and valued, and negotiate male-dominated fields, examples are essential. In fact, seeing someone who looks like them in a position of power and success is one of the most powerful and influential demonstrations for women everywhere.

Further, understanding the struggles of fellow women as they advanced helps to right-size personal challenges as they're happening. *Women of True Grit* does both. Through story after story of struggle and triumph, women and men can find a reflection of their experiences and aspirations, which will encourage them to push on. Because each of these amazing women personally relate the elements of their journey, we get the exclusive opportunity to imagine their difficulties and discover techniques we can apply in our lives.

There is something particularly compelling about being inspired by real women who battled and flourished despite the odds. Edie Hand's thoughtful and engaging approach brings out the best in these stories, while ensuring that what is special in each woman is particularly noted. Women should be unapologetically who they are, with the skills and perspective that is distinctively theirs. These stories will influence your approach and broaden your toolkit. Don't miss them!

PHENOMENAL WOMAN

A POEM BY MAYA ANGELOU

Pretty women wonder where my secret lies.
I'm not cute or built to suit a fashion model's size
But when I start to tell them,
They think I'm telling lies.
I say,
It's in the reach of my arms
The span of my hips,
The curl of my lips.
I'm a woman
Phenomenally
Phenomenal woman,
That's me.
I walk into a room
Just as cool as you please,
And to a man,
The fellows stand or
Fall down on their knees.
Then they swarm around me,
A hive of honey bees.
I say,
It's the fire in my eyes,
And the flash of my teeth,
The swing in my waist,
And the joy in my feet.
I'm a woman
Phenomenally

Phenomenal woman,
That's me.
Men themselves have wondered
What they see in me.
They try so much
But they can't touch
My inner mystery
When I try to show them
They say they can't see.
I say,
It's in the arch of my back,
The sun of my smile,
The ride of my breasts,
The grace of my style.
I'm a woman
Phenomenally
Phenomenal woman,

That's me.
Now you understand
Just why my head's not bowed.
I don't shout or jump about
Or have to talk real loud.
When you see me passing
It ought to make you proud.
I say,
It's in the click of my heals,
The bend of my hair,
the palm of my hand,
The need of my care,
'Cause I'm a woman
Phenomenally
Phenomenal woman,
That's me.

INTRODUCTION

EDIE HAND

DAUGHTER, SISTER, MOTHER, ACTRESS,
WRITER, AND ENTREPRENEUR

*When one door of happiness closes, another opens. But
often we look so long at the closed door that we do
not see the one that has been opened for us.*
—HELEN KELLER

My precious grandma, Alice Hood Hacker, was my mom's mom. I always called her Grandma Alice. On her nightstand, she kept her Sunday pearls draped over her Bible. I had no idea why anyone would keep their good pearls over their Bible out in the open. When I asked Grandma Alice about them, she said to me, "Edith, the word of the Bible is pure. I was taught that if I directed my pearls over the Bible that it would serve as a reminder that everything we needed was in that book. And that The Word was pure." She and her sister, Minnie Mae, Elvis Presley's grandmother, kept up the tradition of the pearls throughout their lives. And I am carrying on their legacy to this day.

Grandma Alice and my mother gave me my first strand of pearls along with the book *The Velveteen Rabbit*. They told me, "If you believe in something long enough, it can become real. Even if your pearls are faux, they can be real to you." Their words and gifts encouraged my imagination. The story of the pearls, and a tea party now and then, created a strong connection between my Grandma Alice and me.

She always told me that I had the power to do hard things if I only had the will and the courage to push through my fears. She taught me about the rides in life, and that sometimes I would be on a road with mudholes and steep curves. But if I stayed focused, I could get around them and make it to the next road. As a child, I had no idea how much I would need these tools, nor did I know just how rocky my road would be.

We were not wealthy, but we lived comfortably growing up in the community of Burnout, Alabama. I was the oldest of the five Blackburn kids. I had three younger brothers and, much later, a sister. It seemed to me that my dad was working all the time. He was just trying to put food on the table and find success in one of his many businesses. My mother was often ill. We called it "bad nerves" back in those days. Today, I know it was severe migraine headaches and depression, a condition not well understood at the time. And as a little girl, I could hardly understand. Grandma Alice would comfort me. She told me, "Edith, your mother loves you but sometimes you have to walk away to get the full picture." She had the love of a mother and the commonsense wisdom to understand her daughter's struggles and encourage her granddaughter.

My mother came from a big working family of twelve. She told me it was the responsibility of the older siblings to care for the younger ones. Not only that, but my mother and her siblings had serious chores like picking cotton and milking cows before school. So I just did what I was told. Mom was sweet in those younger years. After we got off the school bus, Mom would have a glass of milk, hot sweet potatoes, and chocolate doodad cookies waiting for my three brothers and me. She was fun until her illness changed her. The boys and I were left to be creative with our time after homework. I grew up already being old. I don't remember much time at all just being a little girl.

My father was a mechanical engineer at the Tennessee Valley Authority (TVA). He would oversee the hauling of tile across the country on several trucks that he owned while managing a country grocery store that he also owned. He had no college degree, but he worked hard to provide for us. We had the first brick house in Burnout. It had a garage and a laundry room on 40 acres of spacious land. We had horses, and riding became our favorite pastime.

My brothers—David, Terry, and Phillip Blackburn—and I would ride the horses across the pasture and play Roy Rogers, Dale Evans, Gene Autry, or whatever cowboy or cowgirl heroes we were emulating at the time. However, we usually ended up atop an ancient Indian burial mound in the pasture. We would be close enough to hear Mom call us to dinner but far enough away we could dream out loud.

As kids, my brothers and I would lie in the tall grass on the Indian mound. I would tell my brothers that one day I would be a famous writer and a movie star. They would all laugh big! David wanted to become a racecar driver. Phillip planned on pursuing music and becoming a singer and songwriter like our uncles and our cousin, Elvis. Terry was always the practical one, revealing his dreams of becoming a builder and architect. Little did I know these talks as kids would be my growing old years with them also.

Being a second mom to my brothers created a special love in me for them. I fully expected to grow old with them—watching them get married and have children…seeing them achieve at least some of their lofty goals. God knew I would need all the grit that he had Grandma Alice instill in me, because that was not to be.

When I was a senior in college, David was a freshman in college at night school. His day job was at Sunshine Pet Foods in Red Bay, Alabama. He was working while in school and preparing to marry his high school sweetheart, Joanne Hamm.

One night, David was planning on going to see Joanne in her senior play. It had been a long day, so he called to see if I would go with him. But with all of my responsibilities, I was just exhausted. I said, "I am so tired." That night, David fell asleep at the wheel, hitting a culvert in front of a house. He died at Red Bay hospital in the arms of my Aunt Linda, a nurse who just happened to be working that night. My mom said I should have been with him. She blamed me for not being there to keep him awake. I had all kinds of emotions. Grandma Alice was there by my side, steadfastly offering comfort. She reminded me, "Sometimes you need to walk away from a difficult situation so that you can find time to grieve." Hard times are sometimes just that. I sure learned that early in life.

David was the first man I ever loved. Having helped raise him and sharing a house near Florence State, I had a bond with him in his short

nineteen years. David's death forever changed me. It was my senior year, but I couldn't muster the will to finish school and graduate. I couldn't even talk to my professors. I was a wreck; I detached from life for months. I honestly don't even remember how many. Eventually, I moved forward and relocated to Birmingham to find a new life. Though I had moved, I had not moved on. Deep in my heart, I knew I had not grieved my brother's passing.

I took a position at the UAB Diabetes Clinic in Birmingham, worked at WVTM-TV as a community affairs coordinator, and performed in community theater under director James Hatcher. I met Lincoln Hand during this season in my life. We dated for a year and were married in a huge ceremony at Shades Mountain Independent Church.

There had hardly been any time for romance in college, so Lincoln was my first close male friend. I don't know if I was in love, but he was a man who loved me. He also had a wonderful family. Our families were very different. Mine was more of a working family, and Lincoln's had more of a family life. I needed that love and affection. I did fall in love with Lincoln. He was a good man but very gruff. In our second year of marriage, I became very ill with cancer in my right kidney. After I had surgery removing the kidney, they saw I was not recovering well and discovered that I was pregnant. I had to have another surgery and lost the baby. They told us we would not be able to have children, and we were crushed. However, a few years later I gave birth to a healthy baby boy, Lincoln Addison Hand.

When Linc was about three, ten years after my brother David passed, I got a call just after midnight that my second brother, Phillip, had died in a car wreck. He was twenty-three years old. This was a particularly bad wreck, and they told me they needed someone to come identify the body. My mother and father were hysterical and could not do it. They asked me to go instead. I agreed to do it. Lincoln asked me if I was sure and offered to go with me. But I said, "No, please stay with Linc. I can do this." That was a mistake. No one should do that alone. It is a memory burned into my mind that I will never forget. Another letting go for me.

Soon, I was traveling back and forth from Alabama to New York, working as an actress on *As the World Turns* for CBS and on special advertising projects. Working as much as I was created a wedge in our marriage. Lincoln and I were divorced when Linc was nine years old.

I applied to this season a lesson I learned from Grandma Alice. I needed to take a step back, because it can be all too easy to criticize. After the divorce, Lincoln's family did not stay in my life. I did not know how much I would need that family, and I missed their good sides. I hadn't planned on not having them around anymore. Communication is a beautiful thing. It was a deep wound for me.

God blessed me with good friends in my life. An unexpected friend and fellow University of North Alabama (UNA) alum was George Lindsay. A client hired Hand 'n Hand to film a commercial that would feature my character, "Pearl," and George playing opposite as his famous character, "Goober Pyle." George's good friend Sappo Black introduced us, and the rest is history. We shared a sense of humor, and I helped him found the George Lindsay Film Festival at UNA. It was a special season in my life. I had many other friendships with other folks in the showbiz world, like Ben Speer of the famous Bill Gather gospel music gatherings and the legendary music publisher Buddy Killen.

I just didn't plan on cancer again. I had to travel that road alone this time, and it sure changed my attitude. I felt like George Bailey in *It's A Wonderful Life*: no matter how hard I worked, every plan I had was completely derailed. I closed off and didn't tell anyone about my diagnosis. That was when I found out that my only surviving brother, Terry, had been diagnosed with a brain aneurysm. I snapped out of my darkness and refused to allow my brother to go through this illness alone. Again, I related to George Bailey—when he realized that his value was not in what he had accomplished but in how he had impacted others. The caregiving began. It took away a new world of work and social life for me, which became another hard road to travel.

My son Linc was in college at the University of North Alabama for a minute, but he chose instead to move to Hollywood and test his entertainment skills, studying theater and film out there. After twenty years, Linc is now an established and successful working actor and is married to a talented singer and songwriter, Victoria Renee. They have a home in Burbank, California—a continuation of the entertainment legacy of our legendary family.

The last ride with my brother is what inspired the song I wrote with the late great Buddy Killen. When I told Buddy the story about my brothers, he

said, "We're going to write a song! Your brother's story is the most moving thing I have ever heard." I remembered one of Terry's last requests to me. "Will you tell the Blackburn boys' story? You tell such pretty stories, Edie." I told Buddy I was a storyteller, not a lyricist. Buddy explained, "Well, you put a storyteller and a lyricist together, and we'll make a hit." He also told me that he would help me make the movie version of the story. We produced Buddy's last album together and wrote his last book, *A Country Music Christmas*, together, which included an album in the back with our song, *The Last Christmas Ride*, in it before his passing.

Although Buddy passed away before the Blackburn story could be told, I still made it come true with a little help from my movie friends. My brothers had all bestowed on me rich wisdom and defied odds—I couldn't just *not* tell their story. Despite his doctor's expectation, Terry actually lived for seven more years. He taught me the most about courage. David taught me the most about laughter. And Phillip taught me to seize the moment because tomorrow is promised to no one.

I was at Buddy's seventieth birthday party, and everyone who was anyone in country music was at that event. That was when I got the call that Terry was dying. I had promised him I would be there. I went over to Buddy and told him what was going on and that I had to leave. He was such a gracious host; he told me to go and be with my family. In many ways, Buddy was like another brother to me. I so appreciated his guidance and patience.

Nashville was two hours away from home. When I got there, I went straight to my brother's bedroom and crawled into his big bed with my sister, Kim, sitting there, offering her continuing loving support even though her heart was breaking.

I held Terry in my arms and told him all the stories of when we were children riding up to the Indian mound and planning our lives. I told him that we were going to let the horses run. His son, David, ran down to the barn to let them out. As the gate opened, the night air was filled with the sound of horses running wild. I said, "Do you hear those horses?" He blinked twice. Softly, I said, "You're about to take a ride, but I can't go with you. You'll go to that river we've been to so many times as kids running wild and free. This time, your horse is going to be white. It's going to have wings. And I know I'll meet you again." Tears streamed down Terry's face. He opened his eyes

and looked at me. I said, "I will always love you." He blinked twice. The hospice nurse said, "The room is filling with some kind of mist." My brother looked straight at me, took one last breath, and as the mist left the room, his spirit departed.

I laid my last brother down on his bed and went outside to the patio to get some fresh air. As I sat there, I felt the touch of three sets of unseen hands on my shoulders, and I knew that David, Phillip, and Terry were all together now, safe with their Lord and Savior.

Years later, as I worked on a documentary to honor my brothers and keep a promise to share a sister's love for the Blackburn boys, God gave me the true grit I needed to finally grieve for my brothers. Strength isn't always being tough. I mourned for a month. As I edited the documentary, I wore wear dark sunglasses most days; I cried a million tears.

We never know what hard things we may be called upon to do in our lives or just how tenacious we may have to be just to get through them. In addition to tragically losing my brothers at such early ages and having to say a forever goodbye to others who meant so much to me—Grandma Alice, my mother, my father, Lincoln, and so many more—I have also had to face— multiple times—one of the most dreaded medical diagnoses there is: cancer. These experiences taught me the lesson of perseverance.

The greater joys in my life today are my son and his wife, a renewed relationship with my sister Kim, and a wonderful relationship with her daughters and grandchildren. The joy that my grandnieces and grandnephew— Kyleigh, Beau, and Kadence—bring to me is indescribable. I get to share my love of horseback riding with them, I am their "movie buddy," and I get to see them enjoy their Mimi's farm. Sharing these things with my brothers and now getting to pass on these joys to the next generation, I see how God has brought my life full circle.

And just like George in *It's a Wonderful Life*, I realized that my destination in life was not what I had planned. This is my season to flourish and realize my purpose in life. I started on a ride to a different destination, but the horse I wound up on took me to the right destination after all.

When I look in the mirror today, I see that only when we love who God created us to be and love our neighbors just as they are can we love God. Now that I am old enough to live it, I am young enough to die.

That is one reason I am so proud to be able to bring stories of exceptional women to a wider audience as *Women of True Grit.* Those decades of owning an advertising agency prepared me for this uplifting project in my third act. My goal is not to exalt or glorify, but to show other women how these remarkable people did what they did and how they accomplished the things for which they are famous. Despite seemingly impossible challenges and obstacles, they persevered. These women are powerful role models, mentors, and examples of what can be done if we simply do not allow life's rough patches to derail and defeat us. After all, these women's stories and my story are your stories.

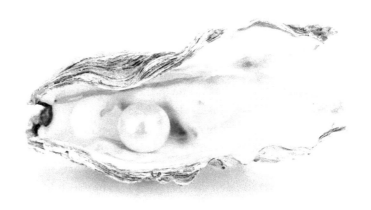

BUSINESS

CHARLOTTE FLYNT

TRAILBLAZER, BUSINESSWOMAN, POLITICIAN, WIFE, MOTHER, GRANDMOTHER

Well-behaved women seldom make history.
—LAUREL THATCHER ULRICH

I was born in late October 1945. Life in the United States was beginning to find a new hybrid of normalcy after World War II. As a kid, I got dirty, threw rocks, rode bikes, played ball, and built pine straw forts in the woods. There were lots of kids to play with, and we all knew that when the street lights came on, we had better be at home. My parents were my mentors. I am so proud of all they were able to do with what life's opportunities provided. They worked very hard. We were raised in the church and respected our elders. We didn't take anything for granted. My mom sewed, making almost all of my sister's and my clothes by frequently using her own patterns. As a sophomore in high school, I entered the McCall's Sewing contest, advanced level—and won. I still have and use Mom's portable Singer. When you think about it, that was one unnoticed event that foretold my career in construction—only it was high rises, not dresses, that became my passion.

After high school, it was off to the University of Florida. *Go Gators!* That was where I met my future husband, became an advocate, and realized the real power of voting, not necessarily in that order. Two years into college, it was my turn to take over my tuition and living expenses. It was also my time to claim my right to vote. The County Supervisor said I had to register where my parents lived, but I was self-sufficient and living in Gainesville. After a protracted event with a county judge, I was finally allowed to register to vote. I worked very hard after that to see that that judge was unseated in the next election. That was my entry into student government and the political arena. This was the mid-sixties. Vietnam was front and center in the news, and campus riots were becoming commonplace and, sadly, tolerated. As a

strong conservative, I had to learn to deal with adversity. My takeaway was, "Be true to your values and self and you will make it through wiser, stronger, and with an inner strength you did not realize you possessed."

I met the man who would be the love of my life, Michael, in Institutions class my freshman year. He was a sophomore and a recent transfer from Emory University. He liked to sit practically under the professor's nose. My class before my Institutions course was all the way across the campus, so I would come running in as the bell was sounding, and the only seats left were in the front row. One day, Mike handed me a note asking if I knew anyone who did laundry for compensation. I was not paying attention but reading this note when the professor called him out and told him to do his courting after the class; I was oblivious to this exchange as I pondered what he meant by "compensation." After class, Mike apologized and "joe cool" said he had never been caught before. He offered to buy me a Coke at the local college hangout. Ticked, I told him I could buy my own, thank you, and walked off. My second semester brought Michael back into my life. There he was in my calculus class: on my turf. I ended up tutoring him in calculus and helped him get a glorious C. Mike hated math as much as I hate broccoli. Needless to say, we soon realized we had fallen in love and planned to marry after graduation. With the draft and Vietnam figuring into our life, Mike was able to enroll in the Air Force ROTC during his last two years at the university. After graduation, The Flynts were off to flight school at Moody AFB, GA. There, he had fifty-three weeks to hone his skills from props to jets and all the stuff that goes with it. I was introduced to military life as well. Back then, wives of student pilots were given a book called *Mrs. Lieutenant,* and a crazy commander's wife referred to us as "student wives." There was nothing student about it. The seven classes of student pilots' wives elected me to represent them with the cadre. In spite of that, Mike still earned his wings, our marriage survived, and we started our family. We had twins: a boy and a girl. Over twenty-six years later and many moves, including Texas, Nevada, Washington State, four different tours in Florida, the Pentagon, six years in Hawaii, and a solo tour in Thailand, we "retired" from the AF. It was a great phase in our lives. We chose to look at each assignment as an adventure to learn, grow, and enjoy it all.

We were reassigned from Hickam AFB Hawaii to MacDill AFB Florida as the twins were entering junior high. That was when I decided to reenter the workforce. I went to work as a construction coordinator for a local home-builder. I became involved in every facet of construction, from laying out subdivisions to keying the final locks on the houses. I was a human sponge. It was the perfect transition to our next assignment. I was a construction estimator and office coordinator, and the kids went off to college as we made the move to the DC area, where I landed my dream job. I was hired by one of the largest and most prestigious construction companies in the area as a project engineer. I oversaw several projects from bid to completion while there. Donohoe gave me every opportunity to succeed or fail—the choice was mine.

A defining event for me was going out on my first job site working with them. I took a laborer with me to make markups on this huge, paved parking lot that was soon to be the building site for "my" office building. Having been given the bid package, I had the top three subcontractors for every phase. It was time to build the team. I had the lowest bidder for site utilities meet me on-site to discuss the scope and his bid. As we walked the site, I noticed that when the subcontractor answered my questions, he was directing them to the laborer. We stopped, and I asked him if he had an issue with the fact that I was in charge. I had written his contract, reviewed and approved his requisitions for payment, and scheduled the project. I let him know that there were two more subcontractors waiting in the wings to take advantage of the opportunity. There was silence followed by acknowl-edgment, and over the years he became one of my best subcontractors. The lesson learned is to rephrase your questions and comments to an authorita-tive International Labor Organization (ILO) inquisitive presentation.

My number one cheerleader, Mike, was also my number one sounding board. With Mike's support, I jumped into the local construction pond in Hurlburt, Florida, and formed my own commercial construction company—and the rest is history. I retired ten years ago with my FL Certified Contractors' license still current and emeritus status with my CPC recognized internationally.

My dad often bestowed his wisdom upon me as a kid. One thing he said that I often share with folks who attend rallies or political meetings hoping

to meet the guest of honor is "Be polite but remember, the MEEK do not inherit the earth." My time in the various professions, whether it was social, political, or the construction world, was well served. I built alliances through the years that helped students find their own compass and improved my community. My fellow colleagues have told me that they appreciate me being an open book. They never have to second guess what my beliefs are. It is okay to respectfully have differing opinions—if nothing else, it gives us something to work at. Now I have many projects. I have six grandchildren who bring me such joy. I am an elected Fire Commissioner in my district, I presently serve as a trustee at our local college, and I was elected to represent my area in the state political party. I realize it takes true grit to traverse the many obstacles life tosses in your path. What is true grit? Having the stamina to push something meaningful through to its completion. I had it, and I still do.

COLLEEN EIKMEIER

DAUGHTER, WIFE, FINANCIAL COACH, AND PRAYER WARRIOR

Hope.

—UNKNOWN

*T*he testing of my true grit began on March 1, 1998. It's a day that is still burned into my mind more than two decades later. Four months before, I had gotten married for the first time at the age of forty. The right person had not come along before that, and I had made up my mind that I was not willing to settle.

As it happened, the right man had been there all along. I had known Jeff, my new husband, my whole life. We grew up in the same small town and attended the same schools from kindergarten through high school. We went to the same church. His mother was my confirmation sponsor. We were both good at sports. My dad coached him over the years in baseball, from little league to his adult years. I was a cheerleader who cheered for many of the sports in which he played. He watched and cheered as I performed in sports, as well. Athletics were a big part of small-town life—and that was certainly the case in our lives.

We graduated high school and moved on with life, going to different colleges and settling in different cities for our working careers. And yet, somehow, through the next twenty years, we maintained a distant friendship. Oh, there were sparks of deeper feelings, but they never went any further. For some reason, the timing never seemed quite right.

Until it did! We suddenly fell hard and fast for each other and got married in November of 1997, ready to begin a long and wonderful life together. Then, four months later, I received a telephone call at five o'clock in the morning from the emergency room of a local hospital. Jeff had been seriously injured in an automobile accident. He was unconscious and needed emergency surgery to stop the bleeding in his brain.

My world changed in an instant. I faced fears I had never felt before. I had to make decisions that I had never anticipated before—certainly not at the age of forty. Though Jeff survived the surgery, he remained in a coma due to massive brain injuries.

I recall thinking, "Really, God? We finally got our timing together and this happens?" I asked the "why" question millions of times during those unbelievable times. I tried my best to maintain the hope that Jeff would come out of the coma, that everything would be okay. I surely did not want to have to endure the ultimate reality.

I spent the next forty-five days at the hospital. I had to deal with making medical decisions and choices that dealt with life and death. My head spun as doctors explained the tests that needed to be done and then what their results meant. I had consultations with so many doctors that I couldn't even keep track of their names.

At some point, it became obvious that Jeff was not going to come out of the coma and that even if, by some miracle, he did, he would likely be in little more than a vegetative state. So now, the decision staring me in the face was to keep him on life support or pull the plug and allow him to slip away.

Jeff was one of eight children. Both of his parents were still alive and, of course, I cared deeply about the feelings and wishes of his family. But as his wife, I was the ultimate decision maker. Most of them agreed that Jeff would not want to live his life this way. His mother told me, "He would haunt us the rest of our days if we kept him on life support." I knew she was right.

However, his father disagreed. He maintained the hope that time would deliver a different outcome. Most of the siblings agreed with Mom but a few with Dad. I sobbed uncontrollably as I showered each morning. That was because we had a house full of family and it was the only place where no one could hear me. I anguished over the day-to-day decisions I had to make, and especially the horrible turn my perfect life had taken.

Ultimately, I turned to the only thing I knew to do. I asked God to guide me. I trusted that it had been Him who had led Jeff and me to meet with a lawyer friend to complete our wills and health directives even before we got married. It was God who knew I would need to focus on the fact that it had been Jeff's wish to pull all life support in a situation like this, and that it was not my wish to keep him alive at all costs. It was God who knew that

Jeff's family should now see his signature and read his words in which he specifically declared that he would not want to live like this. As a result, there could be family unity to support the decision to follow Jeff's directive. It was God who gave me the "grit" to make these decisions. Just because we don't always see the way, it does not mean that God doesn't have a way.

As far back as I can remember, I always wanted to be a teacher and a coach. However, after college, I was recruited by a financial services firm, and I have now spent more than forty years there. I have served in the roles of sales, recruiting, and training, and I now hold the position of life coach to successful advisors. As it happens, the different responsibilities have always put me into a teaching and coaching role. So, in a way, I have held my dream job. Even so, I was not aware that my career and those gut-wrenching days, months, and years of grief were preparing me for more.

The grief journey requires a level of emotional grit that cannot be described. I believe that the degree to which I hurt was in direct proportion to how much I loved. While the way we feel grief might change over the years, our grief journey never ends. I know that until I take my final breath, I will continue to mourn Jeff's passing. Since then, I have lost my father and a brother to cancer. Yes, more grief. But I have come to accept that if I truly want grief to end, it means that I would have to quit remembering them, quit loving them. That is not an option for me. Instead, I started looking for ways to channel my pain. That allowed me to focus on helping others, and doing that never fails to make me feel better.

I've noticed that God weaves people and experiences into our lives. One of the things I do in my role as a life coach is text inspirational motivational messages to my clients each day. I have been doing it for years. One day, I learned that the husband of one of my friends had died of cancer. As you can imagine, my heart breaks for anyone who loses a spouse. So, in addition to my daily texts to clients, I started texting her about my own experiences with grief and shared what I hoped would be words of encouragement with her. She would often tell me that receiving that daily text helped her get out of bed and kept her going when she felt like giving up. I continued to do so.

Not long after that, another friend lost her husband, so I added her to my texts. It has now been more than ten years since I started this practice, and at last count, more than fifty people now receive these daily texts. Many

tell me they forward the messages to others who are grieving. I'm not sure how many people have been touched by my words—maybe hundreds—but I know that they are not mine. They are God's words of encouragement. Plenty of days, I wonder where I will find meaningful messages so I can continue to share. But every time, God delivers. Some article, picture, or quote comes my way and I am provided with inspirational words or powerful reminders of my experiences that I can share.

One thing I know: my lessons of grief have prepared me to be something of a mentor to others. On any given day, these messages are a lifeline to like souls who need hope when everything feels so hopeless. God does use all things for good! Even the very worst things we could ever have imagined.

I am always seeking joy. While I have certainly experienced sadness in my life along with times that were very far from being joyful, I have never stopped wanting to experience joy. I believe that life is not an obligation—it's a gift. We can get on with dying in life or we can get on with living. That is a choice we can each make. I choose to accept the gift and live with joy.

I believe that choice led God to deliver another blessing in my life. Along came Bill, who is also a widower. We met on a blind date. We talked for four hours over dinner and have never stopped talking since. I often hear that we are lucky to have found love again and yes, I wholeheartedly agree.

However, I still have moments of panic and fear that I will have to live through something happening to Bill. It takes plenty of courage—and no small amount of grit—to once again open my broken heart to love. It was emotionally risky to pursue our relationship and I confess that I questioned myself. It would have been far safer to *not* put myself back out there. Especially when you consider that Bill is eight years older than I am. That means the statistics are not in my favor.

So, I had to ask myself, "Are you living your life *big* enough, *bold* enough, *courageous* enough that you will be able to grow into the person who can achieve that life? Or are you going to play it safe and move on?"

I had to convince myself of a basic truth: the risks in life we are afraid to take could well be the ones that change our entire world.

That was just one lesson I learned from my primary mentor, a man of incredible grit. That was my dad. I admit that I was a daddy's girl. Despite that, he did not lower his expectations for me compared to my brothers. He

challenged me to use my gifts and talents, even when they were different from the boys'. When I wanted to learn to drive a car, he asked if I knew how to change a flat tire. He knew the day would come when I would need that knowhow. And, as usual, he was right.

I saw his real grit as he battled cancer for more than eight years. While he didn't beat cancer in the end, he certainly did in my eyes. That was because of how he handled the fight. And most importantly, he loved the Lord and taught me about God through his actions during that trying time.

He was a man of few words. His actions taught me the most. He parented in a style that I term "disappointment." I have no memory of my dad ever spanking me. Often, when I did something wrong, I wished he had. That was because nothing hurt me more than the look of disappointment on his face when I made bad choices. He was an entrepreneur—a farmer who wasn't given land. He bought it. Then he took the risk to buy more land over the years and built a successful farming operation. He took tremendous risks along the way, praying that the weather would be kind, that the markets for cattle and crops would be strong…all the while knowing he had no control over those things. He just knew he had to farm to the best of his ability and work hard. The man had an incredible work ethic. The work of a farmer is never done. A rainy day was his only day off. Believe it or not—although I certainly didn't think so back then—I am so thankful that we were expected to work and that he instilled that work ethic in us.

Dad was always the first to give a helping hand to neighbors and friends, and he generously shared his time, talent, and money with our church. He did the right things even when it was hard to do so, and my siblings and I watched and learned from that. He loved sports, especially baseball. He played the game as a young boy and well into his adult years, and then he coached in his fifties. I'm sure I got my passion for the game from spending many summer nights at the ball field.

He taught us so many important things, like never giving up hope. This may sound crazy, since the outcome I prayed so hard for with Jeff never came to be. Yet I still believe hope is essential to help us through trying times. Hardships prepare us for an extraordinary destiny. Life ends when we stop dreaming. Hope ends when we stop believing. And love ends when we stop caring.

He taught us the power of faith. I've heard faith defined as belief without evidence. My faith has convinced me that God's plan is the best and that good will come out of all situations. Yes, I have had my times of being angry with God. I certainly have questioned his plan at times. But, in the end, my faith is my source of strength.

My dad instilled in us an attitude of gratitude. After all life support was removed, Jeff lived another two and a half weeks. We will never know how or why. He just did. One evening, as I sat with him in his hospital room, I chatted with one of his nurses, a very special lady that I so much appreciated. She had been so kind and caring throughout this horrible ordeal.

Then it dawned on me. I would have never met her if Jeff had not had this accident. So what else positive had come my way from this tragedy? I pulled out my yellow legal pad I always keep nearby and began to write. I listed all the blessings that had come my way since Jeff's accident. And I was surprised that there were so many. Almost two pages of them.

That list is still my reminder that blessings are always coming our way. It is up to us to look for and recognize them. But their effect is amplified if we take the time to be grateful for them and to pass them along to others. In this way, more people will be able to find the grit that it takes to get through the painful times so they, too, can live big, boldly, and courageously.

What does true grit mean to me? HOPE! As long as I have hope, there will be possibilities. It comes from accepting that it's not possible for someone to simply hand us success in life—it will only come as the result of our own sheer will, discipline, and effort. And, in a word, that is true GRIT!

DONNA STONEY

DAUGHTER, SISTER, ENTREPRENEUR, PHILANTHROPIST, THE FIRST BLACK FEMALE WINEMAKER-ENOLOGIST IN OREGON, AND THE FIRST BLACK FEMALE CASE MANAGER FOR MULTNOMAH COUNTY'S DEVELOPMENTAL DISABILITY SERVICES AGENCIES

In life, it is what it is.
—UNKNOWN

I grew up in Corpus Christi, Texas. I had a wonderful and supportive family. My mom was my rock. It was a sad day when she passed away in July 2020. This was a lady who had eight kids. She was a teacher, nurse, dental assistant, and even a hairdresser at one point. My mom was one of those women where you could just throw something out at her, and she would just take it in like nothing and keep rolling. She is the reason I am who I am.

Everything that she has done, I've tried to follow in her footsteps: inspiring people, lifting people up, and supporting women. There are just so many traits that I have inherited from my mom. I know that without her I wouldn't be where I am right now. I just watched her and observed everything she did. She laid the stones so that I would have a paved way.

I also remember the lessons from my late sister. She was a special needs teacher. In high school, I remember going into her classroom, scared. My sister said, "You don't need to be afraid. Come in!" I replied, "Oh my god, no, no, no." But she said, "Come on in!" Watching her work with special needs kids was the moment I found my calling to become a social worker. I decided that I was going to work with people with intellectual/developmental disabilities. And thirty-eight years later, here I am.

When I was a girl, I spent a lot of time on the farm with my father. The farm was located sixteen miles from our town. I got my love of agriculture from my father along with a sense of dedication and purpose. He taught me that hard work, dedication, and perseverance will always help you reach your goals. My father was a foreman for Reynolds Metals. When he was transferred to Oregon in 1978, I got a summer job scraping metal slag from the huge pots that they made aluminum in to help pay for school. I even operated a jackhammer that would break the leftover slag free.

I was determined; I knew that I wanted to finish school and go to college, but I needed to figure out how to get there and to pay for my education. Growing up, I was always moving and playing sports; I loved sports! I received a four-year basketball scholarship to play at the University of Texas at El Paso. While there, I set the record for most scoring in a single game. I scored thirty-two points; to this day, nobody has broken that record. Hitting seventeen out of eighteen shots, I missed only one shot, which was a free throw. My coach called me Sparkplug because I would always come in and hit a lot of points off the bench. I would get spunk and just run in there and hit twelve points in no time.

I loved the basketball program at UTEP, but I went to school to pursue my education in social services. I knew that I was going to help the elderly, children, and people with disabilities. Social work was my calling, and it was my passion because of the example my sister and mom inspired in me. It motivated me to pursue my career.

I remember I worked in a group home for people with special needs, specifically Prader-Willi syndrome. They had to be on special diets and exercise programs every day. I just kept pursuing and pursuing my passion. Then I got a job as a county case manager and went on from there. I believe that you have to love what you do—if you don't have passion, then what is the purpose of pursuing it? We're all on this earth for a reason. We all have a purpose in life. And I believe that my calling is changing the world one person at a time. My career has been incredibly rewarding, and I have not regretted the pursuit of it.

I had two dreams in my head. My first dream was to be the best social worker, and the second was to be the best winemaker. But to get to

that point, I had to save money and pursue a winemaking career while I continued to work as a social worker. I couldn't afford to do both, so I just kept that second dream in my head. But I would not let anything get in my way. When I retired from Multnomah County, I started pursuing my career in winemaking. As I built my career as a winemaker, I built my grit. They go hand in hand. Even through hardships, it made me pursue my dream even more.

In the middle of pursuing my two passions, I got a divorce. My kids were young, and I lost my home. I didn't tell anyone anything—I didn't even tell my parents. I went to the county to ask for assistance with withdrawing money from my retirement account, but I couldn't access the funds in my retirement account unless I quit my job, which I could not do. Even if I had quit, I'd have to wait six months to gain access to the funds. In the meantime, my house was up for foreclosure and ready for auction. In the end, my house sold for more than I expected, and I was able to have money to move into my new rental home.

I call this time in my life, the "chicken breast story," because I had this huge bag of chicken breasts in my freezer. I remember thinking to myself, "Oh my god, I don't know how I'm going to feed my kids; I have no food." I wouldn't tell anybody about my situation. I had enough money for milk and cereal, so breakfast was covered, and the kids were able to get free lunch at school. So all I had to worry about was dinner. I learned every way to cook chicken during that time! Food was never taken for granted in our house from then on. My best friend cried and was so upset with me when she found out how we had been living. I told myself that I was in a situation where I would just have to deal with it.

Looking back, I try not to get emotional about this, but those were truly hard times. I tell this story not to make people feel sorry for me, but to remind them to stick up for each other and be strong. When I look back on it, I think to myself, "I should have told my family and my friends." I just couldn't do it, because I was so determined to do it on my own. My lesson from all of this is that no matter how hard times get, you should trust your family and your friends with what you are going through.

I knew that I was going to make this work. I was going to figure it out—and I did. What I want to say to empower women is that sometimes we need to uplift each other instead of putting each other down. You never know what's going on inside of that person's life. So don't judge outside of the door until you look inside of the door.

I worked so hard to get the group homes up and running. I started with one, and now I have six homes. I'm currently working on my seventh. The county and the state right now want me to open up more, because they know I do a good job of caring about the people in these homes. But now I am pursuing the second chapter of my life, which is winemaking.

My family is in the business now. My mom and dad supported me in my business, and when I needed additional money to get started with my businesses and my career, my mom and dad were there for me financially and emotionally. I believe that you need to have grit and persistence even if it's hard. And somebody at some point is going to hear your dreams and believe in you. They may give you that chance.

When I began my journey in winemaking, someone mentioned Bertony Faustin, the first Black winemaker in Oregon. He owns Abbey Creek Winery in North Plains, but he was difficult to track. Some people said that he would not help me. I decided to go there anyway; I introduced myself and said, "I want to be a winemaker." He said, "Really." I was a persistent learner and went back to ask more questions about winemaking. I would go see him most Saturdays. I just kept showing up, and showing up, and showing up! Eventually, he introduced me to someone and said, "Donna is going to be a winemaker." Today I am doing my production with Andreas Wetzel at Chateau Bianca, learning how to make wine in the old-world fashion. Stylistically, this is the type of wine I want to produce.

I have been saving all my life to make my wine dream come true. My dream now is to pave the way for the next young lady or person of color. And my goal is to have my tasting room and wine production facility in the next two years. Then I want to mentor someone young and enthusiastic about the wine industry and share the knowledge I've gained over the years. I'll help support their dreams of becoming a winemaker.

Dream the dream that you want. Keep it in your head. Don't let anyone get in the middle of anything that you're thinking. Go forward with it. Invest in yourself. Believe in yourself, and then make it happen for yourself and others.

True grit to me means that when you want something wholeheartedly, just grab things and go for it! You become fearless even when the fears are coming right at you, and you just don't know what to do. My grit helped me get into social work and winemaking. I have faced so many obstacles in my life. But through these obstacles, I have learned that as we go on through this process of learning, it's all about supporting each other.

JANA WHITE

ACTIVIST, ADVOCATE, MOTHER

MARY WHITE

A MIRACLE DAUGHTER

Suck it up Buttercup!
—MARY WHITE

Life comes with challenges—some we expect and others we don't. I never expected one of my children to be born with a life-threatening condition, but they were. My Mary was born with hydrocephalus, which is a buildup of fluid on the brain. At birth, her head was enlarged, and she had her first brain surgery when she was only one day old. Mary has spent much of her life in the hospital due to complications that have resulted in forty-three brain surgeries. In 2009, Mary spent six months at Children's of Alabama and underwent a total of fifteen surgeries during that time. When Mary remembers that time she says, "I ended up with a bald head because they did so many surgeries and kept taking patches of hair until they finally just shaved it all off. I rocked my bald head!" Mary says her greatest act of courage has been facing brain surgery over and over and not complaining about it. According to Mary "It just is what it is. Everybody must deal with something, and this is what I have to deal with. I just stay strong and keep a positive attitude."

None of these challenges have stopped her from living life to the fullest. She not only learned to walk but also learned to run! Mary was a member of the cross-country track team in middle school. Mary said, "I knew I wasn't going to come in first place, but my goal was to never come in last, and I didn't!" Mary set a great example for others on the team. Mary was also a

member of the track and field team at Lakeshore Foundation, a Paralympic training site where she competed on the national level and won multiple awards for her division. As she entered high school, the curriculum became a bigger challenge, and Mary was placed in a special education program. At that point, she was told that she was no longer on a college path, so going to college seemed like an impossible goal. But Mary proved them wrong! She was accepted into the ACCESS program at Mississippi State University. This highly competitive program is for students with intellectual disabilities. ACCESS stands for Academics, Campus, Community, Employment, Socialization and Self-Awareness. She is learning life skills, job skills, and how to live an independent life when she graduates. Her goal is to work at either Children's of Alabama, Lakeshore Foundation, or United Ability when she graduates in 2023.

I have enjoyed being Mary's mother even through the tough times. Throughout her journey, I have always been her biggest advocate and cheerleader. According to Mary, "My mom has always supported me in everything I do. We laugh a lot and have fun together. My mom works really hard at her job, but she always makes time for me whenever I need her." I own an advertising and public relations firm that specializes in nonprofits. It's a priority for me to teach all my children that giving back is important.

Mary has become an advocate for people with disabilities and a sought-after public speaker. Most people have a fear of public speaking—not Mary! She never seems to get nervous speaking in front of big groups of people. A few years ago, she was the emcee for a United Ability event, and there were over six hundred people in the audience. She was a natural and kept the audience laughing. Mary has also spoken at numerous universities including Auburn, Mississippi State, University of North Alabama, and Birmingham Southern, in addition to elementary schools, local and state civic organizations, and even national disability organizations. Mary is the "star" of her own YouTube show, "The Awesome Mary Show." NCHPAD, the National Center on Health, Physical Activity, and Disabilities created a series of videos featuring Mary. The topics range from how to communicate with a person with a disability, reasons to hire a person with a disability, and college options for students with an intellectual disability, just to name a few. Mary says, "Many people don't know how to act around people with disabilities,

and I wanted to tell them how to do it. It's okay to ask people what is 'wrong' with them. I always say, 'Just ask me, I'll tell you anything, I'd rather be asked than ignored!'"

Mary considers me to be her greatest mentor, just as I consider my own mom to be mine. Mom taught me how to be a good person and mother. I grew up in Blount County and was lucky to have loving parents who encouraged and convinced me that I could be anything I wanted to be when I grew up. I've made sure to teach Mary the same lesson.

When I started my career, Jan Sowell took me under her wing and taught me the business of selling advertising. She was new to management, and I was new to television sales. Jan used to call me "the sponge," because I loved to soak up her knowledge. I also had a great college instructor who encouraged me along the way. Dr. Ade Anast was tougher on me than the other students, and one day I addressed this issue. Without hesitation, Dr. Anast said, "You're right, I am tougher on you, because I see something in you that I don't see in everyone. You've got what it takes to succeed, and I know you are going to do great things." And I did. I've been recognized as one of the Top Ten Women in Business by the Birmingham Business Journal, Media Director of the Year by the Birmingham chapter of the American Advertising Federation (AAF), and Public Relations Person of the Year by AAF. That one conversation made a huge impact on my life and gave me the confidence to achieve my goals.

My greatest act of courage was choosing to become a single mom. It took a lot of courage and faith to make it as a single mom with three children, but I did it. When Mary was born, I had no idea what the future held. From Mary's diagnosis of hydrocephalus and forty-three surgeries to my son Ben being diagnosed with type 1 diabetes at two years old and making sure my oldest son, Jake, didn't feel neglected while I was taking care of the medical needs of his siblings. Keeping a positive attitude and having fun is what kept me strong during those days. I often say, "We don't get to choose the hand we are dealt, but we can choose how we play it." I chose to persevere through it.

To Mary, true grit means to be brave. You can't fake being brave, and she's been able to be brave in face of the obstacles. Mary has a strong faith, and her faith has gotten her through many tough times. Mary is just getting

started in her career of advocacy, and I can't wait to see where it takes her. She wouldn't have been able to achieve the accomplishments she has if she didn't possess true grit. Through my own journey of raising three children, I've learned that true grit means that you have to be resilient and persevere, no matter what.

JUDY SPENCER NELON

DAUGHTER, MOTHER, SINGER, PHOTOGRAPHER, AND PR MANAGER

You can meet the nicest people.
—UNKNOWN

Through tears, sobs, and worry, I wondered what I was going to do the day I realized my husband had left me alone to raise our two teenage daughters, Julie Anna, sixteen, and Jamie Aleia, fourteen. There had been times in our twenty-year marriage where one might have thought divorce was possible. But not now.

Ten years earlier, we had suffered the loss of our beloved son David, who was tragically killed in an automobile accident at seventeen years of age. The entire family was in unbearable pain. The three boys, Steve, Mike, and David, had come to live with us from their mom's home in Arizona when they were young. Stepfamilies have their unique challenges. Now, Steve and Mike were married with three adorable grandchildren added to our family. Julie and Jamie had never known life without their wonderful brothers. I love my stepsons dearly. The unkind implication of anyone being a step-anything had not seemed very nice. We were a close family despite our challenges.

Everything looked promising. Julie had celebrated her sixteenth birthday with the family on March 15. My husband's choice of leaving our family on March 16, the day after her special day, caused extra pain on Julie's birthdays in the years to come.

I had decided at the beginning of his departure to move on quickly. We had hurt enough. He left us in March, and the divorce was finished by July. No unkind words were spoken. There was no need to say anymore. We settled the business, and we decided he would live in Oregon and I would bring the girls to Nashville. I suggested he have our daughters on the first

Christmas, since he was the one who was happy where he was. I wanted Julie and Jamie to be amid happiness on this first Christmas.

This first Christmas would be different from the last twenty. I had always looked forward to Christmas with our big family, with both sides gathered in our home. This Christmas, I would be alone. Or, so I thought! Suddenly, my telephone rang. It was my dear friend Debby Kartsonakis Keener, who was married to Ken Estin, an Emmy Award–winning writer (for shows like *Taxi, Cheers, The Tracey Ullman Show,* and *The Simpsons*).

She invited me to bring my camera to her home on Christmas Eve and take picture ornaments for their Hollywood guests. I said yes, excited to have a holiday project to look forward to. When I arrived at the party, I discovered that their house was a castle in Beverly Hills and it was filled with some of the biggest celebrities on television. Of course, that made it more exciting for my lonely, wounded heart. In my sadness, I hid behind my smile and asked others to smile for the picture ornaments, gifts from Debby & Ken.

The ornaments were a hit! Christmas morning, I was invited to take more pictures at another Hollywood Christmas party hosted by the Lettermen, a group of four-part harmony singers from the 1960s. Christmas night, I was invited to another party at actress Joanne Dru's home attended by more Hollywood celebrities. The first couple I ran into at the front door was Ernest Borgnine and his wife Tova. I knew Joanne's brother, Peter Marshall, from being on *Hollywood Squares* years before. He immediately took me around and introduced me to his friends. Joanne's granddaughter was married to another friend from the TBN Tripp family. All of the parties were filled with recognizable Hollywood names, and they were all so friendly—not to mention generous with their presents for me.

The day after Christmas, both of my daughters asked to come home early from their dad's. They felt out of place. I was disappointed for them, but I had plenty of love and gifts waiting. After my amazing Christmas, I felt that life was going to be fine. We soon sold our family home in California where we had raised our five children. We were ready to make the move to Nashville. We sat on the deck signing papers on March 16.

My mom and sister Sharon drove me and Jamie across the country to our new life in Nashville! Julie came later.

In the years to come, my friend and neighbor Lisa and I bonded as we adjusted to being divorced, single moms. We did a lot of praying. We were able to lift each other up as sisters in Christ, and eventually we were able to laugh again. A lady had put a scripture verse in Lisa's hand at the altar, and she passed it on to me, "'For I know the plans I have for you,' declares the Lord, 'plans to prosper you and not to harm you, plans to give you hope and a future'" (Jeremiah 29:11). Today, Lisa is happily married to Ken Abraham, an amazingly wonderful man of God. He is a *New York Times* bestselling author and a devoted husband, father, and grandfather to her three adorable granddaughters. We have spent most holidays together in Nashville for twenty-nine years.

Not unlike my first Christmas after my divorce, I planned to be alone on my first Nashville birthday. And again, to my surprise, the phone rang. I heard the sweet voice of Dale Evans Rogers. I had often heard that voice in the Western movies we watched on our neighbor's new TV in the early 1950s. Dale was a family friend, but not close enough that I would expect a phone call on my birthday. Dale explained that she had gotten my number because she was in Nashville for a speaking engagement. She asked to have breakfast for my birthday, and she insisted on paying. To this day, I love the picture the waitress took of us. We enjoyed our time together. She asked if I would like to drive her all weekend. Yes! Our last event was Dale's appearance on TBN, where I had friends, including founder Jan Crouch, a lifelong friend from Columbus, Georgia, where both our dads pastored. At the hotel, Dale complimented me for doing a good job making sure all the arrangements were easy that weekend. She said, "You are the best at this." Years later I did PR, and I remembered that Dale Evans, the Queen of the Cowgirls, said I was good at PR. I liked that.

More importantly, she gave me the best advice ever. She said, "Remember, God only wants us at His footstool, and when He is ready, He'll bring you to the head table." I have truly felt this in my life.

By March 1999, both of my girls had married. For seven years, I didn't date. Love came unexpectedly. My friend Jake Hess said, "You better grab Rex Nelon, he's one of the last of the great southern gentlemen." We loved our big wedding the day after the Dove Awards, with everyone in town

making it easy to attend. The Gaither Vocal Band sang "Loving God and Loving Each Other." Jake sang "I Love You Truly," Janet Paschal, Geron Davis, and Johnny Minick chose songs about love. Gloria Gaither read her marriage creed. Amos Dodge performed the ceremony.

Eleven months later, on a Gaither Homecoming trip to England, Rex called my name out in pain during the night. We rushed him to St. Mary's Hospital in London. A big group of our friends, including the Hoppers, the Dodges, and Mark Lowry, came and met us for support. They comforted me as the doctors gently said that Rex had died from a heart attack. We held each other as we gathered around Rex singing songs and telling stories, until I knew we had to go, as Rex would not want to have interfered with the London Homecoming taping, which would take place in a few hours.

As we were leaving, someone suggested I take his diamond wedding ring. It stuck, and I couldn't. I asked Amos, who had married us, to take his wedding band off. He reminded me that he had to put it on at the wedding so he should be the one to take it off. I was thankful to have Amos and Sue Dodge there with me.

True grit to me means persevering through life's trials and tribulations while remembering what I knew then, and I trust now, twenty-one years later, that God has me firmly in His loving hands! He has you in His hands, so fret not and persevere through life's storms.

KRYSTAL DRUMMOND

WIFE, LAWYER, COMMUNITY LEADER, PIONEER

God, grant me the serenity to accept the things
I cannot change, the courage to change the things
I can, and the wisdom to know the difference.
—REINHOLD NIEBUHR

My earliest mentors were definitely my parents. I come from wonderfully strong and God-fearing parents who knew that they couldn't always do everything right and wouldn't be able to, but they were going to do it walking with the Lord. My parents were high school sweethearts. They met at Walker High School (which now goes by Jasper High School). Together since they were sophomores, they both went to different colleges. My dad, Bryan, attended Samford, and my mom, Melody, attended Auburn. They eventually relocated to Tampa, Florida, where I grew up. Even when it was difficult or tough to discipline us, they were going to do that. They really just were great role models for us. I remember my dad was tough at times, and then we didn't get along. But, you know, especially now as an adult, I look back at that and think how hard it is to parent. I don't have children of my own, but seeing my nephews and my friends' children, I recognize how challenging it is to actually do those difficult things that are not just developing the child, but developing your child to be a good adult.

Early on, my siblings and I were given a lot of independence. I think my dad did recognize that you train the child in the way he will go, and when he's older, he won't falter from it. My dad really took that to heart. I had three younger siblings, and my parents were busy running on extracurriculars with them. My little sister was an elite gymnast, so she trained all day every day, which took a lot of my mom's time and back and forth. Therefore, one year I decided to go to Spain for the summer. I think part of my decision was rebellion, because I felt I wasn't getting enough attention anymore.

I didn't fully appreciate or understand what a big change that was going to be for me. But I did a lot of growing up in the three months I spent there. I learned very quickly how important my parents were and how grateful I was for my upbringing. I think up until that point, I had been surrounded by a lot of people who were similar to me. I went to private schools and didn't really understand how much I had been given and how wonderful my family was. I had a family that loved, cared for, and encouraged me and sent me off to Spain to have this awakening. I stayed in Spain for a while as I studied at the Universities of Salamanca and Complutense in Madrid. I obtained a bachelor's in marketing and went on to get my Juris Doctorate from Cumberland Law School at Samford University. I also became certified in underground mining at Bevill State Community College, as it aligns with my family business, Drummond Coal Company, where I am currently serving as the Director of Employee and Community Engagement. I never thought I would stop practicing law. I felt shaky when I first made the decision to transition to my directorial position, but I reminded myself that "you end up where you need to be" and after much deliberation, I am at peace with my decision.

My grandfather, Garry Neil Drummond, had one of the largest hearts, but it was hidden behind one of the most intensely disciplined, critical, structured, and hardworking people ever. I think a lot of people didn't see his heart, because they saw the success and the drive and the "Energizer bunny" type—well, let's get it done: the work ethic of not quitting. My great-great grandfather, H. E. Drummond, founded the H. E. Drummond Coal Company in Sipsey, Alabama, as a coal provider for farms and households. He took a loan for $300 from Walker County Bank in Jasper, Alabama, using three mules as collateral and it has grown to a multi-million dollar family-owned private company that now goes by Drummond Company.

The moment I really realized what my family had done and what this company does was when I moved to Birmingham and started interning with my grandfather. That was when I saw the full reach of what we had accomplished. I didn't take my time with my grandfather for granted, and I made sure to jump at whatever opportunity he suggested I take. My family and I were blessed to make it to the position we are in today. My grandfather often said it was luck, but I deem it a blessing and a result of not quitting. Other

miners would often give in if they hadn't hit the sweet spot by a certain time, but my great-grandfather kept going. Don't quit before you see the dawn—you never know what can happen.

When I lost both of my grandfathers within ten days of each other, it was just very unexpected—overcoming the grief of it while appreciating the blessing that I had them in my life until my thirties…I was grateful for what they were able to teach me and what characteristics they were able to show me. It's still hard to overcome the sadness, but I think that's part of it: the understanding that we're going to go through those storms and those storms can be weathered, and we will eventually be able to grow from them and look back on them and not be consumed by them. During the time of my great-grandfather's death, my family came to learn of the man's good deeds. My great-grandparents were orphans, and my grandfather would often donate loads of coal to local orphanages during the winter. My family wasn't aware of this until we met one of the orphans who benefited from the donated coal, who came to my great-grandfather's funeral. It's important to pay it forward by giving back to the community and affecting people's lives in a positive way. You never know the lives you may change.

I inherited grit. I think grit to an extent is genetic—whether it's nature or purely nurture. I do think the mentorship and the impact of the people in my life have derived from that grit. I wouldn't have been able to make such achievements without having true grit, which I received from my grandfathers. The first step of having grit is purpose. That purpose comes on a foundation of character and loving others. And just understanding that we all have a purpose. It doesn't matter who you are and what level you are: we all have a calling, and no calling is better than any other calling. And we were put on this earth to do that. And as long as we're working to those ends, if that path changes ten times in between, then that's wonderful! What a scenic journey. But I think, you know, there is a balance between keeping your eye on the goal and the pressure not to quit and persevere and to continue on…and the wisdom to know the difference. My mother often pushed me to be extraordinary and accountable for myself. Don't sell yourself short by pursuing ventures that are within comfortable reach. Push yourself to go above and beyond. Don't just float by—soar.

I think that every single thing we do every single day, and the things that we don't do every single day, matter. They matter not today and not tomorrow, but for generations to come.

LINDA COONS

REALTOR, MOTHER, MUSIC TEACHER

Do justice, love mercy, and walk humbly with God.
—Micah 6:8

Two things I've recently learned are that in order to survive and *thrive,* you need to accept grace, from God and from yourself, and you need to have some grit. Meaning that you better know how to endure and tackle life's obstacles. Yes, there will be obstacles. *Many.* By the grace of God, He has helped me to have true grit!

My mom and dad were both in their thirties when they married. Everyone was so excited. They had thought my mom was going to be an old maid. My parents were both from farm families, dad from a wonderful, loving Christian family and mom from an alcoholic father and God-fearing mother. Dad was the next to the oldest of ten children. His mother, Mama Lucy, taught them scripture, and Papa John Sandy was known for being hard working and having good Christian character. They took all ten kids to church in a buck wagon every Sunday. Mom was the only daughter with six brothers. She had a very hard life growing up.

Grandpa Hamilton was a hardworking man, but he was also low on morals. Little Mama, as we called her, loved the Lord. She prayed and prayed that God would provide a church close enough to her that she could go, and later in her life, her prayers were answered. Fish Pond Baptist Church was built within talking distance. My mom was determined that her girls would have the things she never had, such as piano lessons and being reared in a loving Christian family. Dad had come home from World War II, and farming was what he had been taught to do growing up, and that is what he loved.

I am the oldest of three girls. My dad said he would have filled the yard with children to have a boy, but that wasn't God's plan. I am told that I was

Dad's favorite, but I didn't know it growing up. My dad had an upright character and loved us all very much. For example, one day he and a few friends were in the field outside our home at the end of the day. They had brought some beer over. I saw Dad in the field and started running toward them. The men told Dad that he should send me back home so I wouldn't be around them when they were drinking. That was the last beer my dad ever drank. He said if he couldn't do it around his daughter, he wasn't going to do it.

A two-bedroom farmhouse with a big screened-in front porch with spring chairs, two miles off the main road, was our home. Dad and Mom moved there when I was two. My grandfather, Papa John Sandy, had passed of pancreatic cancer, and Dad built Mama Lucy a smaller home down the road next door to Aunt Sue. He and Mom then moved into the farmhouse, and Dad farmed the Lloyd and Hunter places just as Papa John had farmed them, including two dairies.

We were rather isolated from the world except when we went to church. Mom made sure we went to church every time the doors were opened. We loved being around our friends, singing and learning about God and his plans for our lives. Dad taught me to drive the tractor and a truck with a stick shift, and I learned to bale hay and milk cows. We helped Mom in the garden, and she taught us to cook and sew. We made our own clothes. In the fall, my grandmother, Mama Lucy, Aunt Sue Houston, my cousins, and a few neighbors all picked cotton together. We would sing songs and hide out in the bottoms (where the cotton grew tall), and our cousin Janice would tell us ghost stories.

At times, my sister Patsy and I would have Dad drop us off in the field at 4:30 in the morning to try to keep up with and pick as fast and as much as the Greenhaw family. They picked from sunup to quitting time, and they were fast. We asked Dad why everyone else got paid and we didn't. He said we had clothes on our backs and food on the table, and that was all we needed. Looking back, it was a good life, and we had everything we needed—love and stability. I believe the unconditional love our parents gave us is why I have a song in my heart, I always look at situations as if the glass is half full, and I find it easy to put my trust in God for everything.

I never heard Mom and Dad argue. If they had anything to discuss, they did it before we got up or after we went to bed. My mom had two nervous

breakdowns: one post-delivery after my sister Vicki was born and the other during menopause. Dad kept everything calm and let us know that Mom needed to get help at a hospital, but everything was okay. Mama Lucy came to stay with us during those times. She read us the Bible every night and taught us to memorize scripture. Psalm 100 was the chapter I remember best: "Rejoice in the Lord always and again I say rejoice..."

At the time, patients like Mom were treated with electric shock therapy. Dad told us that when Mom came home we had to be very good. Mom was very quiet. She had lost a lot of her memories of the past. She knew she had had a baby girl, but she couldn't remember her name. She said some things came back to her in time, but she completely lost some of her past. Growing up, we would have sleepover parties and fill the living room and screened porch with girls. Those girls tell us today how fortunate we were to have such wonderful parents. What stood out most to them was Mother always having devotions with us during breakfast.

After graduating, I studied at John C. Calhoun Jr. College during the summer, and then I transferred to Florence State University, now the University of North Alabama. That's where I met Edie Hand—she was my first roommate. My major was music, and I was in the concert choral, orchestra, drama department, and a Lionette, but I felt unfulfilled. After three semesters, I transferred to Bob Jones University in Greenville, South Carolina. There I met the most handsome, tall, blond-haired, blue-eyed guy. We were married the next summer and moved to Findlay, Ohio, his hometown. I was now Mrs. Timothy Lynn Cox. I loved being married, and we were blessed with three boys in four years.

At church, they had a marriage and family seminar taught by Terry Angles from Thomas Road Baptist Church in Lynchburg, Virginia. Tim went with me. We learned about the four temperaments, about God creating marriage to be forever, and much much more about rearing your children in a Christian environment. I was determined to be the best wife, the best mother that God would want me to be. I studied all the material and put it to use.

Tim was a good provider, but he was jealous of the time I took with the boys. He seemed to still be much of a boy himself. He was raised by a domineering mother who did not set a faithful example for him.

We discussed as a family the pros and cons of me working outside the home. Do we want more money, or do we want Mom to stay at home and have time to spend with the family? The boys voted to have less and have more of Mom. I loved being a "domestic engineer." I learned to stretch the money, shop sales, cook healthy, and save for the future. I also taught piano one day a week to help save money for our vacation. One thing I appreciated about my husband was that we sat down at our table twice a month and paid bills together so that we would both know where we were financially.

During the twenty-one years of our marriage, I observed that we had good times when Tim was right with the Lord and bad times when he was away from his relationship with God. He was chasing a restlessness that would never be quenched. He had a very bad temper. After a tantrum, I would set the boys down and calmly ask if they felt how their dad acted was right. They would say no. Then I would tell them to remember how it made them feel and to never act that way to their own children. He was also unfaithful many times and twice asked me for a divorce. I wanted to keep our marriage together for our boys, to have a family as God planned. Of course, God didn't plan for him to be so rebellious. I would always tell him that he didn't know what he wanted and that he should think long and hard before filing for divorce. I would pray a lot and go about my way of being the best wife and mother I could be. The affair would always cool down and things would go back to normal.

The boys never knew until they were adults. When the boys were teenagers, the youngest two got into an argument. Their dad went upstairs to break it up, lost his temper, and started throwing Ben around the room, I went upstairs to break this up. Later, I went to talk with Ben and found him packing his clothes. He said, "Mom, you have always tried your best to make things all right, but this time, you can't. If I don't leave now, I fear I will kill my dad." That was the final straw. Tim could hurt me, but not my boys. A marriage counselor told me that when a tornado comes through and blows a house down, it can be built again piece by piece, referring to our marriage. I responded that when termites eat at the house bit by bit and it falls apart, it can't be rebuilt.

When my youngest graduated from high school, I decided that working in music wasn't a good fit at forty-two years old. I considered my options

and decided to take classes to become a Realtor. Alice Rice was my first broker and mentor. She was hardworking—not the typical prima donna agent most think of when they picture female Realtors. She loved getting out on construction sites with the men and learning about the building of homes from the bottom up, and she didn't mind getting a little dirty. That was my kind of lady. She taught me to talk real estate everywhere—don't be a secret agent. During my time as a Realtor, I learned discipline, organization, and the importance of following up with clients. I liked being on the same plane as the male Realtors and also being able to set my own schedule. I realized the importance of education in making you more professional, and I eventually earned my ABR, GRI, CRS, and other certifications. In 2007, I was named president of North Alabama CRS, and today I realize the importance of leadership. At RE/MAX Madison, I was twice voted for the Cooperative Spirit Award by my fellow agents for being kind and helping others (they would only allow you to have it twice). At Crye-Leike I have been the top producer in our office for the last twelve years. My motto is to make the real estate process seem simple and easy while providing an honest and professional service.

The hardest thing that ever happened in my life was the death of my son Telly. He was helping my dad harvest cotton, and the corner of the cotton picker caught an electric line. Not one of the ten electrical fail-safes worked that day. Telly was instantly electrocuted. Telly was six foot five, lean, blond-haired, and blue-eyed. He would walk into a room and light it up with his dimpled smile. He never met a stranger and was loved by people of all ages and walks of life. He had won the state art contest and took the ROTC color guard to a national competition and won. He also competed in the Junior Olympics in small-bore rifle. Telly excelled in anything he put his mind to. Two weeks after he died, Telly came to me in a dream. His face was in a bright yellow glow, and he wore a big, dimpled smile, as only he could. He said, "Mama, don't grieve for me. I am in heaven." Since that night, I've had peace knowing that he is happy and I will see him again. My son is experiencing heaven, and isn't that where all of us want to be someday? His death took music from my life. I loved to sing, but I could no longer sing without crying.

During my single years, I prayed that if I were to marry again, he would be honest and faithful like my father and would have a quiet nature. Greg

and I met online. I was doing it for the fun, not necessarily to find someone to marry. He was all the things I prayed for. We were married on 9/14/11, right after 9/11. What a marriage bummer. All of his friends who were going to fly in had their flights canceled.

Before we married, I told Greg that in order to date me, he had to go to church. He asked God into his life after a Christmas concert at our church. It was a delight watching his life change. His friends would ask me what I did to Greg. He would tell them that he had Jesus in his heart and they needed Him in their hearts also. Our music director found out I could play keys. The lady who played at the church moved out of town, and he asked if I could take her place. It was a paying position. Greg told me I should do it. I told him he had no idea of what he was telling me to do, but I did take the position. It was hard at first, but it put music back into my life.

Greg was the vice president of operations at World Linc Corporations. After we had been married for two years, he told them they needed to close down because they weren't making the profits they needed to stay in business—who does that? Only my honest Greg. Little did we know that God had planned that music position at church to help us financially, as it was now needed. Greg became a Realtor and filled in for me when needed. He eventually ran Coons Rental Properties, which was a nice family venture.

Greg and I had a full, happy life together. He gave me ten grandchildren—what a delight! He was one of the many soldiers who came back from Vietnam with Hepatitis C, and before they found a cure, it had ruined his liver. He put up a long, hard fight. We learned to lean on and listen to the Holy Spirit during his illness, and we experienced the power of prayer. Greg passed to heaven on my birthday, after seventeen years of marriage. He always had this hilarious dry sense of humor.

After Greg's death, I decided to stay busy. I took the fourteen-week class to become a Master Gardener. I have always loved digging in God's dirt and seeing the creations that come forth. My sons helped me plant a hill of two hundred daylilies overlooking the creek at the end of my backyard. I love sharing and helping people make their yards happy with God's creations. I took classes to be a chainsaw operator and chaplain for Alabama Disaster Relief. Before my cousin Jennifer passed away from lung cancer, I promised

her I would be the guardian of her autistic daughter Jessica, which I am. I love going on mission trips with my church! I have a very full and happy life.

When life gives you lemons, make lemonade. I declare that I AM a woman of true grit!

LORI KELLEY

DAUGHTER, WIFE, MOTHER, CPA, CHAIR OF THE BOARD FOR NORTHWEST FLORIDA STATE COLLEGE, DIE-HARD FSU FAN, AND CRAFT BEER CONNOISSEUR

We don't drift into good directions. We discipline
and prioritize ourselves there.
—ANDY STANLEY

There was one blinking light in Freeport, Florida, where I grew up. My father had a soybean farm and kept animals as well. At an early age, I learned that nothing on a farm takes care of itself. I believe this contributed greatly to my work ethic. Eglin Air Force Base was nearby, and the jets' flight path was right over the farm. The pond on the farm was my favorite place to watch the jets and sunsets. Though I didn't have the typical Florida beach girl upbringing, we loved taking day trips to the beach in the summer. The time spent on the farm and at the beach instilled a lifelong love of nature. We lived a simple life, and we didn't want for anything. My biggest champion early on was my father. In his eyes, there wasn't anything that I couldn't do or be. My father always told me that I was going to college. He drilled this into my mind so hard that I truly didn't believe it was an option not to go to college. Being the oldest of five, I felt a supreme responsibility to make college work. I knew I would have to work hard. I said to myself, "Failure is not an option. I'm not afraid." You come up against challenging situations and adjust. And I was the first person in my immediate family to earn my degree.

My aunt Nan "Nana" Cuchens was a huge inspiration to me. She was the first in my family to graduate from college. She went to Florida State University (FSU) to become a nurse and went on to run the emergency department at the hospital. She is now an assistant professor at FSU. To me, she seemed fearless, and she was my reason for studying nursing.

As farmers with five children, my parents could not afford to send us to college. I applied for grants and scholarships and I worked a job (which would turn out to be more than just a financial blessing). God, through my hard work, brought it all together, and I was able to attend Okaloosa-Walton Junior College (which would become Northwest Florida State College). Inspired by my aunt, I enrolled in the health sciences. It became apparent that chemistry and microbiology were not my strengths, nor were they things that I enjoyed. I was talking to my boss, who owned the grocery store where I worked, about how nursing wasn't quite working out. He asked me if I had ever considered taking a business class. Since I needed electives, I took an accounting course, and the rest is history. I got it! Unlike some of my biology and science classes, accounting just clicked. It was a great feeling. I was finally in a field that suited my talents. Not long after that, my boss, who had given me such great advice, became my husband. I initially transferred to FSU, but that required me to live in Tallahassee, and between wanting to be near my fiancé and starting our life together, that was not going to work for me. I transferred again to the University of West Florida, where I earned my degree. Becoming a certified public accountant (CPA) was not the original plan. Even though I had found my calling as an accountant, I didn't think I wanted to be a CPA. The hours seemed awful. When I graduated, I looked at working at banks and accounting firms. Even though I hadn't been interested in working for an accounting firm, I decided to give it a try. And once again, taking a leap of faith and trying something different paid off. I loved it and knew it was where I belonged. I am a very organized and disciplined person, so the regimented nature of public accounting was a perfect fit for me.

Through my firm's various mergers, I have been with Warren Averett, LLC, for twenty-seven years, and I have built a successful career with a successful firm.

I love the young women I have worked with and coached over the years. Sometimes I think, "Who am I to be giving advice?" But then I realize that I do have a story to share, and I want to encourage these young ladies and see them succeed. Each year, I review how women are succeeding in the CPA business, and I am sometimes disheartened by the lack of women as partners. However, I recognize that much of this is due to choices that each person has

to make to fit their life. I was driven to become a partner; it was a priority for me. But I have loved every minute of being a mom as well. As a result of wanting to succeed in both of these realms, I had to make hard decisions, and I had to live with the consequences of those decisions. Luckily, I work for a very family-friendly firm, but I was still expected to work hard. If I was going to take off early to go watch a baseball game, then I had to get that work done. And that sometimes meant working until ten o'clock at night or later some days. It added more stress to my life, but that was my choice. You have to figure out what your priorities are; otherwise you'll feel like you're floundering. Trying to be a good mom, a good wife, a good daughter, and a good accountant is hard work. For example, I made the decision that I would work through lunch during tax season to ensure that I could be home with my family by seven. It's important to talk to your bosses and teams about what you need. I've learned that if you are happy in what you do, are good at what you do, and go into conversations with a nonconfrontational spirit, then people are happy to help you come up with solutions.

My best advice is to look inwardly and truly understand what makes you happy. Then take that and use it in your professional life. For example, I'm good at tax planning and preparation, but what I like most about my job is the people. Working with my clients is what brings me joy in my work. Clients allowing me into their lives gives me the energy to keep going and become even better at what I do every day.

Honestly, I don't believe you can "have it all" without consequences, but I do believe you can have what you need to fulfill your own needs and happiness. I was fortunate that I had a mother-in-law who wanted to make sure my kids had a home-cooked meal every night. I was burning both ends of the candle, and she stepped in to help. She was not the mother-in-law who was trying to do my job for me. She genuinely saw a place where she could step in and help, and she did so out of the love in her heart. I had encouraging parents and in-laws and a supportive husband. I would not have been able to achieve what I have without these wonderful people.

I value love and people the most in my life, and as a result, my goal is to be intentional. For example, I heard that one of my clients had passed away, so I made a point of sending his widow a sympathy card. People don't know what you think. People can't read your mind. If you're not intentional,

how will people know that you care? One of the things that made me realize just how much people and family mean to me was the tragic deaths of my younger cousin and a beloved uncle within one year. It further emphasized that after God, family is my priority. One of my favorite ways to show intention to my family is Christmas. I do Christmas *big*! My mother loved Christmas and instilled that love in me, and I have continued that tradition of making a warm, fun home for my children to all come home to for the holidays!

God knew I would need this support system, because in 2015 I was diagnosed with breast cancer. As a partner in my firm, I realized that I was ready to quit working as hard as I was in order to take care of myself and live my best life. I decided I was going to empower my team to be better and to take care of my clients. Through all the radiation and treatments, I decided that when I got out on the other side of this, I would slow down. I learned to work smarter, not harder. That meant rearranging my priorities again, and I believe that this has made me more successful than I was before. I would not have been able to make it through the many challenges in my life without completing them by having a joyful heart. True grit to me is recognizing that there is a job to be done and doing it with joy in your heart. It makes it easier on everybody, especially you.

SVETLANA KIM

DAUGHTER, STOCKBROKER, WRITER, AND PUBLIC SPEAKER

When you get, give. When you learn, teach.
—MAYA ANGELOU

My grandmother's parents were the first generation of what we call *Koryo-Saram,* which means "Korean person." They were the people who came to Russia during the Joseon Dynasty. They came to Russia in November 1899 after a poor harvest and famine in Korea in order to pursue a better life. They were country people, very down-to-earth and hard-working. They had no electricity or plumbing—no bath or shower. These are the people from whom White Pearl, my grandmother, and I are descended: people of courage, tenacity, and grit. White Pearl's grit, compassion, and tenacity kept her strong and kept her going. I inherited her grit, and now I would like to share it with you.

My paternal grandmother was called *Bya-ok,* which is Korean for "White Pearl." She had true grit and was my greatest inspiration through every obstacle I've faced. The word *failure* did not exist in White Pearl's vocabulary—she instilled this attitude in me. Instead, she called life's diffi-culties and challenges "life lessons." I once read that every single pearl evolves from a central core. This core is simply an irritant—a fragment of shell or fishbone, a grain of sand. To protect itself from this irritant, the oyster secretes multiple layers of nacre, which, over time, forms a beautiful pearl. I think of this process when I think of my grandmother. My central core was my grandmother. She experienced some very difficult events in her own life, but despite it all, she became one of the rarest and most beautiful of pearls. Undoubtedly, my grandmother was gritty. Nearly two hundred thousand Koreans had been forcefully deported to Central Asia in the former Soviet Union in 1937 by Stalin. My twenty-two-year-old grandmother was among

them. All of them were left destitute. Thousands of people perished from starvation, cold weather, and disease. My grandmother, however, survived and lived to be ninety-four years old.

My grandmother gave me grit, but my grandfather inspired me to use my imagination and keep learning. He was a prolific reader. When I was five years old, my grandfather told me that he was going to the library. I did not know what a library was, but I was excited to go with him. I said, "Yes! I'll go with you!" We took the bus downtown and walked to the library. My grandfather checked out two books. A librarian asked how old I was and gave me a temporary library card. I was thrilled! I loved reading books when I was a child. I'm grateful to my grandfather for opening a new world for me, a world of possibilities, magic, and stories! Most people didn't even have a telephone when I was growing up. We read books, played games, and played with our friends. Being a writer, I owe my inspiration to him and to my grandmother. Today, I'm writing in English, which is my third language after Russian and basic German.

I was lucky to grow up in a loving family. My parents are a great example of tenacity and patience. Nearly twenty years ago, my mother had a stroke. One day, my parents and their friends were driving to a lake for fishing and swimming. My father, who was a medical doctor, noticed that my mother was quiet. He pulled the car to the side of the road and said, "I'm sorry, but we have to turn around and go to the hospital." He had patience, and she had the tenacity to recover. She slowly recovered. Today, they are enjoying their golden years. I was living and working in San Francisco at the time, and they did not want me to worry, so they kept it a secret. My mother was determined to get well. I'm grateful to my father that he was there for my mother, not only to help with cooking, cleaning, doing laundry, running errands, and working, but for being caring, loving, and believing in her recovery. She recovered after one year. From my parents I learned about true love, tenacity, and patience. Not everyone has loving parents, but if you have love, tenacity, and patience, it will take you far in life.

It was December 1991 in Leningrad, Russia, when my life was turned completely upside down. It was just three short months before the collapse of the Soviet Union. It all started with a loaf of bread that didn't even exist. Standing in the bread line for the third day in a row, I listened as strangers

discussed the impending fall of the Berlin Wall. My life as a student in a crumbling country offered few possibilities. I met a mafia guy at the bakery and bought an airline ticket to New York City. I arrived in New York speaking no English, with only a dollar in my pocket. With the help of a Good Samaritan, I traveled by bus to California, hoping to connect with an acquaintance from home. Little did I know how much my own life was about to change. Three weeks later, I was on my way back to New York City.

When I came to America, I did so with an open-date airline ticket that would expire in ninety days. I had to go back to Russia. After three difficult months in America, the night before my return ticket to Russia was due to expire, I didn't sleep at all. My pillow was wet with tears. This was my last chance to go home. Making decisions is difficult, but making a decision that will affect your life once and forever is nearly impossible. Should I stay or not? I agonized all night long. I felt that even the angels were worried about me. I had faith in the American dream—faith in things unseen, the courage to embrace one's fear. For the next ten years, I prayed to become a US Citizen, and I accomplished that on August 18, 2001. It took me ten long years to do it. I vowed to remain forever grateful for my life in America! I'm also grateful for every lesson I had to learn, every teacher who taught me some things, and the women who inspired me to be and do the best.

My grandmother told me "anything is possible," and this belief is the reason I live in America. I arrived in New York City on December 18, 1991, with one dollar in my pocket. I had one dollar and one dream. I didn't speak a single word of English. I had no place to stay. I know very well what it means not to have a steady job or a place to live. All of my belongings fit in one backpack. I know what it's like to have no change for bus fare and to go hungry for three days. I don't know of any soul who does not dream of being fearless, successful, and happy. Even the most successful people I know have faced big challenges. Reality's demand is constantly pounding on their doors. We must have the grit to face challenges with grace and gratitude. Look, I had every reason to give up on my dreams. I almost quit. But I was taught the opposite. I was taught to use my grit. I learned English, I worked as a nanny, I worked in retail, I became an account executive with a cosmetic company, I became a stockbroker, I worked for a PR company, I published

books, and I eventually spoke at Fortune 500 companies. I spoke about how grit, tenacity, and courage are the new "rich."

I've met a lot of people who inspired me. One of the people who inspired me was Elaine LaLanne, the wife of Jack LaLanne, known as "The Godfather of Modern Fitness." Three years ago, I was interviewing Elaine for a project at her house. We were taking a quick break. It was a hot day. Elaine asked our crew if they would like a glass of freshly squeezed juice that Jack used to make. She made a glass of juice for everyone; we were touched by her kindness. That was the beginning of our friendship. I was introduced to Elaine LaLanne by our good friend, Allen Joe. I was impressed by Elaine's creativity and compassion. She had mastered many things in her life: success, fame, body, and mind. But the trait I admire most in Elaine is the way she treats people. She is generous with her time, creative, and wise, and she gives great advice. Elaine is my role model and inspiration. At ninety-five, she does full-body push-ups, speaks at major fitness conferences, writes books, and runs her company. Today, Elaine is working on an upcoming book titled *Pride and Discipline: The Legacy of Jack LaLanne.* Elaine inspired me to exercise, use weights, and stretch.

The global recession during the COVID-19 pandemic represents unprecedented opportunities for growth. Behind every crisis lies the greatest opportunity and endless possibility. Taking the opportunity is hard-wired into many of us and often emerges at an early age. One of my all-time favorite quotes by John F. Kennedy is, "The Chinese use two brush strokes to write the word 'crisis.' One brush stroke is for 'danger'; the other is for 'opportunity.' In a crisis, be aware of the danger, but recognize the opportunity."

If you embrace gratitude, resilience, inspiration, and tenacity, you will thrive in your life and build the grit needed to forge ahead. I cannot think of a better way to live our lives. Think how blessed we all are to celebrate our greatest freedom—life, love, and the pursuit of happiness. Go for it! And tell us all about your grit!

TAWANA LOWERY

THE SERIAL OVERCOMER, WOMEN'S EMPOWERMENT COACH, LEADERSHIP MENTOR, INTERNATIONAL SPEAKER, AND FOUNDER OF OVERCOME4GOOD

Therefore I tell you, whatever you ask in prayer, believe that you have received it, and it will be yours.
—MARK 11:24

I didn't arrive at my position in life today without some personal setbacks that impacted my perspective on life and the relationships we forge. I was married for over two decades, had a beautiful home, and shared many wonderful intimate moments with my husband. Then one night, all that changed when I read a text message on my husband's phone from a woman he was seeing. In an instant, I felt my heart drop from my chest to the lowest levels I could imagine. I came to discover that during our twenty-five-year marriage, my spouse had only given me about two years of faithfulness! What a devastating emotional blow.

Fast forward a few months. I was standing in front of a large gathering of friends and family in a chapel. Their love and kindness surrounded me like a soft summer breeze. Gazing at their sweet smiling faces, I could feel their unified support as I stood to offer the eulogy at my father's funeral. Still reeling from all the betrayal and breakup of my family, I now had to find the strength to say goodbye to my father.

The day after the funeral, I was looking at a picture of my dad and me. It took me back to happier times. The photo was beautifully framed and perfectly displayed on my living room credenza among several other photos of family times during my marriage. It's funny how we sometimes focus on the "frames" in our lives and not the quality of the content in the frame.

This triggered a nauseating feeling in my heart. Staring at my former "trophy case of success," I realized there was not a single picture of me and my husband that did not represent a year of betrayal. At that moment, I dropped to my knees and screamed toward the heavens, and I came to the hard realization that life is unfair, but with God's help I would overcome this anger despair, and frustration.

My emotional anger was not just about the betrayal and untimely death of my father; it was also about the resurfacing of a long list of tragedies and heartache I dealt with over the years. I was raised in an abusive home. I was date-raped at age fifteen and forced to have an abortion. I suffered through abandonment, homelessness, low self-esteem, poverty, bankruptcy, and severe anxiety. To top it off, six months before I learned of my husband's betrayal, my mother had died very suddenly.

In a matter of moments, forty years of suppressed hurt and pain gushed forth like a raging river. Recalling those memories carried me headlong through a horrific series of category-five emotional hurricanes that eventually tossed me on the shore, completely exhausted.

Facedown on my hardwood floor in front of that gallery of deception, I then heard the kind, soft voice of God whisper to my wounded heart. "Tawana, did you *have* to overcome, or were you *able* to overcome?" Then He continued, "I know all about your long, painful list. I know every detail of it. But you're not looking at it the way I do. You don't see what I see. Think about it…you did overcome. You overcame every single thing. And you overcame it because I gifted you and pre-packed you to be an overcomer."

That startling revelation was life-altering. It shifted my thinking about my long list of setbacks. God illuminated my mind to gain a heavenly perspective on my years of personal tragedies. From his eternal vantage point, that long list of wreckage was not a list of liabilities that needed to be hidden. It was, in fact, my very powerful résumé. It was my "overcomer résumé," and it would catalyze a divine calling, one that placed a fire in my soul to help other women overcome.

And now, a few years later, God has enabled me to use my various platforms as a women's empowerment coach, international speaker, radio personality, blogger, and published author. Each has put me in a powerful position to help other women overcome.

The past I was so ashamed of has become the staff in my hand to help ambitious women of faith escape their captivity. The life lessons from my painful experiences are serving as a roadmap, directing them to their over-comer's Promised Land. And yet, we have only scratched the surface. There is still so much more to do.

I focused my energy and my faith on new projects, including my book, *Five Easy Steps to Life-Changing Prayer*, which is full of practical, easy-to-follow advice on how to enjoy prayer and enhance your ability to hear God's voice. Plus, I share a lot of my dirty laundry as life lessons, and that makes enlightening reading as well!

My coaching workshops, like "The Secret Sauce of an Overcomer Lifestyle," are all about the seven key ingredients every woman needs to over-come obstacles and cook up the abundant life she's been craving. I packed twenty-five years of overcomer secrets in that seven-step program. And it is truly powerful!

And of course, my speaking opportunities share my overcomer story and the incredible faithfulness of God! I love using my painful experiences and my life lessons to encourage the overcomer in other women. Recently, I was the guest speaker at a women's conference in Pakistan. There I was, standing in my living room, sharing the "good news" with women halfway around the world. I cannot begin to tell you what an incredible experience that was!

The bottom line is it's just plain humbling for me to see the hand of God truly give beauty in exchange for ashes. And do so in many practical ways. Though I would not wish my hardships on anyone, I would not change any of them.

That is because now I can say, with joy and praise to Almighty God, "Look at all I've overcome!" And with God's help and the power of prayer, so can you!

All of this hardship that God led me through inspired my current project, called "One Million DOVEs." DOVE stands for Daughters Of Vision and Engagement. One Million DOVES is a unique story-sharing training program for overcomer women with a message! I believe every woman of faith has an important role to play in changing the world for good. The purpose of the DOVE program is to empower and equip one million women with the

personal skills and tools needed to share their compelling stories with clarity and confidence. Through workshops, conferences, and personal coaching, One Million DOVEs teaches women how to craft their own authentic and compelling stories (because every woman has one), identify their unique signature message, share their valuable life lessons, and inspire others to take action, all while maximizing their influence for eternal good.

I believe that every woman has an overcomer testimony that can save another person's life. That powerful message that demonstrates the goodness of God can transform communities—and even entire countries—for eternal good.

When I hear the term *true grit,* I think of a woman with a strong determination to overcome. That is not because she is a "superwoman," but rather because she consistently stands up to challenges and works to overcome them with persistence and courage.

EDUCATION

ALIE B. GORRIE

DAUGHTER, ACTRESS, PHILANTHROPIST, DISABILITY INCLUSION CONSULTANT, AND DOG MOM

Dwell in possibility.
—Eleanor Roosevelt

I was born with low vision. Those who don't have a disability tend to see it as something they could never handle, but my disability has made me tenacious. I ask for what I need when I need it. I stand up for myself and what I believe in. My disability has made me bold in a way that I don't think I otherwise would be. But I don't see being born with low vision as adversity in some ways, as it is all I have ever known. It's hard to see it as an obstacle when it's just how you go through the day. There are times when it feels like a hardship. Like when you have an acting lesson, and you tell the director that you can't see the camera, and they respond with, "Well, just don't pursue this." Luckily, my mind is not wired to be easily discouraged.

I was born and raised in Birmingham, Alabama. My parents were very supportive of me. Their strategy was different from most parents who were raising a child with low vision. Alison and Jim Gorrie never told me that my disability would be limiting. They even let me sign up for baseball. Parents tend to keep kids with disabilities in a bubble, but mine just said, "Find out what you like and figure out how to make it work for you." They gave me the space and the freedom to fall in love with acting.

I was in first grade when I wrote a book called *Ali B's Audition*. It was about me and my fictional pet sheepdog, Harry Garry, moving to New York and auditioning for a Broadway show. So I've always known that I wanted to be in theater, and it is that dream that has grown and shifted. In high school, I realized that in addition to theater, I wanted to give back in some capacity. I learned that when you are focused on the next show or the next performance,

you go through high highs and low lows, and that's not sustainable mentally or emotionally. I knew that I wanted to create art in dance, theater, and music, but I had to do it in a way that wasn't about me. And that's part of how I got into becoming a disability inclusion advocate.

I had a wonderful voice teacher who helped me to accept my disability. Amy Murphy helped me realize that if I didn't embrace my low vision, I would not be able to move to New York and function independently as an actress. I'm so thankful that I had a mentor who was willing to tell me that I needed to learn how to talk about my disability and communicate it to others. Ms. Amy taught me to be an advocate for myself. And when you learn to be an advocate for yourself, you learn to be an advocate for others.

I also had an acting teacher, Jen Waldman, who was a wonderful mentor to me. She taught me more than just acting; she gave me an important piece of advice. And that is to have a personal *why* statement. This means asking yourself in a non-selfish way, "Is this the best thing for me? Is this opportunity meant for me? Does this align with my values, beliefs, or goals?" It has been a great self-coaching tool. It helps you to remember your worth and to be purposeful with your time and energy.

As a young girl, I found it frustrating to go to doctors' appointments and be told time and time again that I would not be able to do normal activities. I was used to being given a list of things that I could not do. This made me defiant, taking things on these lists, like riding a bike and playing baseball, as a challenge—a challenge I overcame in those instances. One thing I had ruled out, however, was driving a car. But when I was in eighth grade, I went to an appointment at the UAB center for low vision rehabilitation, and a new specialist told me that Alabama had passed a law that with specialized technology, I would legally be able to drive a car when I turned sixteen. This was a huge deal for me, not just because I'd have the freedom to drive, but because it was the first time a doctor was encouraging and handed me a list of things I *could* do. I was so elated. I didn't know what to do with myself.

My first reaction was, "What can I do for you?" When you are given an opportunity for independence like that, it feels odd to just leave. So I went home and brainstormed with my family. I was inspired by one of my friends at school who was fundraising. We were only in middle school, but I was determined to do something for this doctor at the low vision center. My

parents helped me out. They told me I needed to pick a junior board and that I needed to get people from the hospital involved.

With UAB's support, I founded Songs for Sight. We have had three concerts and have raised over a million dollars, not only for research into low vision and the low vision center but for kids with low vision all over the state. Many kinds of glasses and magnifiers that young people with low vision need are not covered by insurance, because they are not considered necessities. We have given funds to help families obtain those things. We've sent kids to camp and hosted support groups for kids with low vision as well as parents of children with low vision. It's not easy having low vision, but it's also not easy knowing how to best support a child with low vision. We are all about supporting families at Songs for Sight.

I'm a determined girl, but I'll be the first to admit that I believe I can handle it all. Before I know it, I've packed eight more things into my schedule. And I'm only one person. But I have a God who encourages me and nurtures me through His word when I'm feeling overwhelmed. I do feel that God has placed in me a passion and drive to show His love through my work as an actress, disability inclusion consultant, and acting teacher, and through my charity.

To me, true grit means having tenacity and a sense of purpose. True grit is having a deep connection to what you do so that nothing can stand in your way. Confidence is quiet and insecurity is loud.

BEVERLY KEEL

DAUGHTER, EDUCATOR, WIFE, STEPMOTHER, JOURNALIST, AND ACTIVIST

Just say yes!
—UNKNOWN

My father died two days after my eighteenth birthday. I was a senior in high school, and on top of the grief of losing my father, I still had to finish a term paper, graduate, and pick a college. Before he died, I had no idea what I wanted to do. But somehow, I got interested in journalism, specifically broadcast journalism. My father was an amazing journalist. Unfortunately, I never paid any attention to it when he was alive, because I wasn't really interested in journalism. However, I can see now how I was shaped by all the magazines in our house and the nightly dinner conversations about current events and fascination with what's going on in the world.

My mentor is Ruth Ann Leach. (She is now known as the philanthropist Ruth Ann Harnisch.) She was the first woman on television in Nashville. She was a self-made media mogul who had a newspaper column and radio show. Ruth Ann was also the anchor of the CBS newscast affiliate in Nashville during a time when there really were few women on air. When I was growing up, she was famous in Nashville because she was on television.

I met Ruth Ann Lee at the funeral home. It turns out that my father was her newspaper editor. I told her that I wanted to study broadcast journalism, and she took me under her wing, where I remain to this day. Ruth Ann invited me to a station party so that I could begin making industry contacts. I'm fortunate that I started working at the *Nashville Banner* in college, the same newspaper where my father had worked. Not only did I get my father's eyes, but I also inherited the newspaper ink that coursed through his veins. I fell in love with print. I was so happy with my job.

Ruth Ann is the person I go to when I don't have it all together, when I have a broken heart, when I'm crushed something didn't go the way I had hoped, and even when I'm facing family issues. She is the one person I completely trust. I don't have to put on a happy face with her. She has saved me over and over! I want to share two things that I learned from my mentor Ruth Ann Harnisch. She believes in the importance of mentoring others, just like she mentored me, and giving back. She is a philanthropist who has changed lives with her generosity of time, guidance, and resources. The older I get, the more time I try to spend giving back and mentoring others.

I have never had a game plan with my life or career. How did I navigate it? I said yes to everything. So, yes! I added jobs. I didn't get rid of a job. I would teach and write while also teaching and editing. When I started in journalism at the *Nashville Banner,* I was a business writer, because that was a position that was open. That's when the Nashville music industry was exploding due to the Garth Brooks boom. I covered it from a business perspective. I didn't know anything about it, but I met people who were working in the music industry. That led me to a job at a record label. Working there was a disaster; it was the worst time in my life. I worked there for eighteen months and left. I started to doubt myself. I thought maybe I'm not as smart as I thought I was…maybe I just need to become a secretary for the rest of my life.

I would go home and stare at the ceiling. That's when you need true grit. I had been an adjunct professor since I was about twenty-four years old. I left the label and became a full-time professor in 1995. And now I'm in my twenty-fifth year at MTSU. I became a freelance journalist on the side. Everything I learned as a journalist I shared with my students. It helped me to be a better teacher and professor for my students. I began covering the entertainment industry just as Nashville was becoming a big deal to the nation. I reached out to *People* magazine. It turned out that their long-time contributor was stepping down. I was in the right place at the right time, and it happened to be a time when celebrity journalism became a big thing. I was a Nashville correspondent for *People* magazine for ten years.

I want to encourage women to shine. My sister called me Sunny Delight, because I'm optimistic by nature. Last year, I wanted to honor one woman every day for 365 days on Facebook. I wrote a tribute every day. In addition, people posted messages and comments on how much the women I

celebrated meant to them. As the series evolved, I realized that my project was a God thing. I honored a woman whose mother later died, and her mother was able to read the tribute before she passed. I honored at least five people, including my sister and mother, who are no longer here. It touched hearts in a profound way, especially mine.

What is spectacular is that women who were honored last year have committed to keeping the project going this year. They are stepping up to write a tribute each day to a woman they admire. This project showed me that women are too hard on themselves. Women only see the things they haven't done or focus on what they don't have. They don't see all their benefits and the wonderful things they do every day. They don't know how amazing they are. In today's culture, we are made to feel bad about ourselves.

One thing I noticed when I wrote these tributes to women is that they all have grit. These women survived breast cancer, divorce, the death of a spouse, and job loss. If you work in the music industry, you'll be fired at some point. I admit that I've had to work on not defining myself by my job.

I've never thought that I was a courageous person. In 2010, I took a leave of absence from MTSU to become a senior vice president at Universal Music Group Nashville. I ran the publicity department. Looking back now, it was a bold move to step up and do that. I'd worked as a publicist in 1995 for a year and a half, but I hadn't worked in publicity for about fifteen years. It was like stepping into an unknown world. While my philosophy is to try to say yes to everything, it took courage to accept the job. These artists were releasing their albums, and you've got one shot to make a good album launch. And I'm proud that we did it. The Lionel Richie album became one of the biggest albums in the year of all genres. I'm a work in progress, because life is going to be up and down. Nothing lasts forever. Don't believe good press, because it won't last forever. But your low times aren't going to last forever either.

While I have been blessed to have an exciting and multifaceted career, there was a decade when I worked so hard that I hurt. At one point, I was writing a daily column for a newspaper six days a week while teaching and running the university's First Amendment Center. I know I chose to do it all. I told people when I had enough, I would quit. I was driven by some internal force that kept me striving for more and better. I wanted to break as many stories as possible and write the greatest articles that had ever been written on those I had interviewed.

To be honest, I don't know what I would do differently. I had an opportunity to fly to the White House to interview Laura Bush. I interviewed the Reverend Billy Graham just outside of his kitchen. I interviewed Joe Namath and Joe Montana. I still have a problem saying no. I enjoyed my work as much as I enjoy breathing.

I am blessed to have a stepson, David. He was nine years old when I began dating his father, whom I dated for eight years before we married. When we married, David was sixteen years old. That was when I was working the most in my career. I do feel bad that I was not more present for him. But he didn't want me hanging around then anyway. Still, we are exceptionally close today.

I have used humor to facilitate communication at work. My secret is I tend to be lighthearted. While I take my work seriously, I don't take myself seriously. I'll be the first to poke fun at myself or make light of a situation. I want young women to know that the older women that they see who are successful have faults and failures too. They are just like everyone else. Of course, different lives have different sets of challenges. Perhaps the main difference is they didn't wait until everything was perfect in their lives to step up to ask for that promotion or speak out when they perceived an injustice. Don't wait until you know everything or know more before you think you are ready to make a difference. Go for it now! Put your name in the hat, apply for that job, and go for it. There was a study that showed that when a woman would look at a job opening, she would say that she only had seven of the ten qualifications, so she wouldn't apply. A man would say, "I have three of the qualifications, so I've got this!" Step up and find your confidence. Here is the great secret of the professional world: No one knows what they're doing. Nobody knows what they're talking about. So just act like you do and you'll fool everybody.

We all have days that we just feel we're failing. Other people looked at me as a female senior vice president with a nice corner office. They didn't know what I was going through, especially when I felt like I was failing every day. I wrote tributes to some of the most successful women CEOs of multimillion-dollar companies and they would say to me, "I needed to hear those words today." These women have been on the cover of *Forbes* magazine. You never know what's going in someone else's life.

I wrote a profile on a woman named Lura Bainbridge, who was a prominent Realtor. Lura was one of the first to recognize the value of Music Row property. She was beautiful and elegant and so well-dressed. She also worked like a dog. Lura told me, "The harder I work, the luckier I get." And that stuck with me. Malcolm Gladwell wrote about ten thousand hours. It's about putting in the time, it's about getting experience. I remind my students that your hundredth article will be better than your tenth. Your thousandth article will be better than your hundredth. It's all about getting better.

If I can do it, anybody can do it. Oprah didn't start off being a media mogul. She started off being a radio reporter in Nashville. She outworked everybody. It's not easy for anybody. But you just keep going. Instead of saying, "I couldn't do that, why me?" You say, "I could do it, why not me?"

Please support other women. Don't be threatened by other women. There is room for more than one woman at the table. Sometimes when we look at somebody who is thinner, prettier, richer, or more successful, we feel bad about ourselves. We have to stop that! We don't know what they've been through. They could have buried a child or a spouse or had a drug addiction. Life is hard sometimes, but you find the grit to get up and keep moving forward. I often say that instead of standing in the corner, hoping somebody will rescue you, go and rescue somebody else.

I've always wondered how the death of my father has shaped me. I do think that it made me far more independent. I don't know what my life would have been like if he had survived. That is a great unknown. I have to say that I'm fortunate to have great female mentors. These include Patsy Bruce, who was a legendary songwriter; Ellen Jacobs, who founded Sailair Travel; Lura Bainbridge; the music publisher Donna Hilley; and many other women. Remember, a hand-up can change a life and maybe save one.

I always say, "I don't know what I did to make these women take care of me, but I hope I just keep on doing it, because it's a blessing." True grit means having the strength of character and resilience. To have true grit is to be able to survive through bad times. We can all do great things when everything is going well. But true grit means not giving up when things get tough.

ANNE BISHOP, PH.D.

DAUGHTER, SISTER, WIFE, MOTHER, AND MISSIONARY

Life is a classroom; the grade doesn't matter as long as you do your best.
—UNKNOWN

Like many people, I learned life lessons from my mother. Thelma Conomos Williams was pregnant when the Japanese bombed Pearl Harbor. The next day, my young father signed up for the US Navy. She gave birth to me the next month and moved in with my grandparents, next door to my other grandparents. I lacked for nothing, being the only grandchild; but I can only imagine her worry and fear as she bravely put on a good face, despite her inner loneliness. When my father returned, as did so many veterans, he was drinking and smoking for the first time. I loved him, but we all suffered the pain of his alcoholism. My mother loved him passionately. She protected us and showed her love for him until the end. After being treated in the same hospital room for weeks, they fell victim to cancer. She was forty-six and he was fifty; they both passed away.

There is a milestone in my life that encourages me almost every day. That milestone is the day my doctor called and told me that I had cancer; but that was also a day of great encouragement for me. I still can't believe what my doctor told me on the phone. As it turned out, someone else was more caring. As she completed that sentence, a voice spoke to me. He said, "Don't worry, Anne. You will be all right, whether you are here a little time or a longer time." I have always been a little bit skeptical when people say that God has spoken to them. It had never happened to me; yet, through the next very sick year, I felt no worry, no fear, no sadness. I knew I would be "all right" because I had been promised by The One who had my life in his hands. After a double mastectomy, strong chemotherapy with the one they call "The Red Devil," and severe infections that led to having half of

my colon removed, I regained my strength. Once again, faith, family, and friends came through. That was thirteen years ago, and I have lived, as Jesus told us in the Bible to live, with no worry, no fear, and no anxiety.

While my faith in God was strong, I regret all the times I did not tell a person about God's love for them. It takes courage and I put avoiding a potentially uncomfortable encounter above my conviction that a person I was speaking to needed to hear how much God loved them.

I love people—all the world's people. For twenty years, I served as the Alabama area director for People to People (PTP), recruiting and training leaders to take students abroad. I organized six months of orientation for the students, then traveled with them for three weeks. The experiences were life-changing on those twenty trips, as well as many others with family and friends and mission trips. In all, I have been to sixty-nine countries, almost all of them multiple times. The PTP guideline was to respect all cultures and faiths and make friends for America. A few months before my second trip to China, a pastor told me of his trip to Southeast Asia, teaching pastors who had secret churches. They bicycled or walked for up to one hundred miles and would not let him stop. "We have never been taught like this," they said, and they shared with him the hunger for The Word their people had. I went home and ordered hundreds of gospel tracts in Mandarin Chinese to take with me, never telling anyone. I hid the tracts in my luggage (I don't advise doing this), and every day I would secretly slip them to someone, inside a book in a book store, in a phone booth, under my plate at dinner, under my pillow when checking out of a hotel. I had the most fun with God and prayed over every pamphlet that would bear fruit. I'll find out someday.

I have found that life is an educational process. Three things I have learned from others and my personal experiences will always get me through trying situations: faith, family, and friends.

While each of us is unique in some way, we are often more similar than we realize. My story is like that of so many other working wives and mothers. Daily life has myriad opportunities to "be tough when the going gets tough." It is true that during those years I have been awarded honors, worked hard to earn my doctorate, and achieved some worldly success. Perseverance was certainly the operational word; but I count those things as far less important than my husband, my children, my grandsons, and now a great-grandson.

While my life is full of wonderful memories, one that stands out happened during the year of my cancer treatments. My husband was very caring and tried to help in every way. He was constantly asking me what I needed, if could he get me something to eat, and so on. If I rolled over in bed, he would wake up and ask me if I was okay. One night, being independent by nature, I flew the coop. I just wanted to be on my own. I had heard that a meteor shower was occurring that night, and I wanted to see it. I slipped out of bed very quietly, took a blanket and pillow, and went out to my pasture to lie down and watch for shooting stars. They took a long time to appear. I waited and continued to watch. What to do? I began to recite Bible verses. As I was saying the Twenty-third Psalm, it struck me. "The Lord is my shepherd; I shall not want. He maketh me to lie down in green pastures" and there I was lying down in my green pasture. "He leadeth me beside the still waters," and there I was beside my pond, my still waters. This has become my favorite quote or passage.

I was teaching school, mothering two young children, and my parents were dying with cancer. Stress? Yes! My husband had a stressful situation too. He was teaching at Samford University, coaching a debate team to a national title, and going to law school full time. I really looked forward to our upcoming wedding anniversary, to have time for just him and me. Unbelievably to me, he stayed out that anniversary night with law school friends. When he arrived home around one o'clock in the morning, he found his clothes all thrown out on the lawn. Sounds funny after sixty-one years of marriage to a good man. It *was not* funny then.

The lesson for me and for other young working mothers is exactly what Bear Bryant has been quoted as saying: "When the going gets tough, the tough get going." You might be talented, educated, or beautiful, but the world is full of talented failures, educated fools, and unhappy beautiful people. Persevere. Be tough. In my mind, true grit means perseverance. How do you do that? God gave you natural equipment; but you need to walk with Him every day. Talk to Him. Listen to Him. Love the people around you. It worked for me.

BOBBIE KNIGHT, J.D.

DAUGHTER, WIFE, MOTHER, ALABAMA POWER EXECUTIVE, PHILANTHROPIST, AND PRESIDENT OF MILES COLLEGE

You don't just luck into things as much as you think you do. You build step by step.
—**BARBARA BUSH**

True grit is simply inner strength, and I am fortunate to have been raised around and by some very strong and independent women. I believe that made me strong and independent too. To me, having true grit means planting. My mother was that way. So were my aunts. Yes, they were of a different generation, and they did not have the advantages I did. That's why they were adamant about our seizing every opportunity we had, particularly when that opportunity did not come easy.

My mother told me and my sister, Phyllis, that we *were* going to college. Period. No debate. She never wanted her girls to have to depend on a man. And, by God, we didn't! We would learn to stand up for and take care of ourselves.

One of my aunts was Loretta Knight, and she was dynamite. She was a lobbyist for the teachers' union for many years, so you know she knew how to stand up for herself and the rights of others. I will give you one personal example. My mother had passed away years before, yet the cemetery had still not put her death date on her grave marker. I had called several times over the years, but to no avail. Aunt Loretta found out that my requests had been ignored and told me, "I'll take care of it." She went down to see them and called me within twenty minutes. "It's taken care of," she reported. "But how?" I asked. "I've not been able to make them budge." She said she had simply told them that her niece had a law degree and was a big executive

with Alabama Power Company, and that she was going to sue them if they didn't get it fixed.

That was how she approached everything. She was very direct. She called me one day, and I could tell immediately that she had something she wanted to address with me. "I hear you referred to me in a conversation as 'Loretta.' Is that right?" I replied, "Well, I was talking about you." She told me, "I am and always will be Aunt Loretta to you. You're getting too big for your britches down there at that big company, up in there with the CEO and all those other people. Do not think you can call me by my first name." It was some very innocent comment I had made, but I did refer to her as "Loretta." I simply told her, "Yes, ma'am." There was nothing else I could say. But she was "Aunt Loretta" from then on.

My mother was an amazing lady, a true Renaissance woman. She could do absolutely anything that needed to be done. She was raised on a farm, and she was the youngest of ten children. Her father farmed as a business, which was unusual for people of color at that time and place. Though they were certainly not wealthy, that qualified them as people "of means" in Conecuh County, Alabama. How do I know? My mother told me that they would ride to school in a mule-drawn wagon, but they would make their father stop well before they got there and let them walk the rest of the way. They did not want the other children to see that they had transportation to school and feel bad, or think my mother and her siblings were "putting on airs."

Even from an early age, my mother could sew, cook, garden, and put up food by canning and making preserves. This woman could do anything! She was very organized, keeping a detailed ledger of our household bills and expenditures. She seemed to always have a plan.

This was during the 1960s, and it was a time of racial segregation. We lived in a segregated community. It was an insulated village, one in which parents looked out for everyone else's children. If we were chastised—or even punished—by someone else, my mother did not get mad at the other parent. She appreciated it. And she did the same with their kids. Ours was a village of amazing women—nurses, teachers, school principals, and more. The mother of one of my best friends was a school teacher, and she also gave piano lessons. I thought she was fabulous! And they all knew how to dress. So did my mother. She always smelled so good too. Her clothes were always

clean and folded neatly. She even ironed her pillowcases, her slips, her other lingerie, and her handkerchiefs! To me, she was the perfect woman. And I still do many of those same things because she did.

She also had a wonderful sense of humor. When I lost her to Alzheimer's, it left a hole in my heart. I still tell people it felt as if someone had scooped out a part of me. For a long time, I felt as if I was disconnected from the world. But that sense of humor of hers helped so much during the time I was taking care of her. There were days when I had to laugh to keep from crying. She would say some of the funniest things, sometimes on purpose, sometimes because of the nature of her illness. Often, she would not even remember saying them. But they were truly funny.

One thing I insisted on, though, is that I would not allow people to correct her. She was living in her own reality. I did not come up with that on my own. A clinical psychologist told me, "Bobbie, there is nothing wrong with your mother. Your mother has Alzheimer's. The problem is with you or other people trying to fix her. You can't fix that."

After her death, I had to go to grief counseling. My father had died when I was fourteen years old, but I don't remember feeling the same grief when he passed. Perhaps that was because my mother was there to take care of me, physically and emotionally.

Then, about five weeks after I buried my mother, I met a truly wonderful man. I still feel as if she sent him to me because she knew I was hurting and didn't want me to be alone.

The man she sent me is Gary Burley, a former player in the National Football League. He and I happened to be attending the same event one Saturday afternoon at Ross Bridge. I walked around the room looking for an empty seat at a table. I finally saw one, next to this big, burly man. I asked him if the seat was taken. He told me it was open.

There were all these athletes there, including several other former NFL players. Honestly, I thought he was still a player—he was so buff and in such good shape, and he looked much younger than he was. After I sat down at the table, he looked at me and said, "Excuse me, but I have an observation to make." By now, I'm saying to myself, *Now what could this big jock want to say to me?* Frankly, I was still mourning the loss of my mother and was not in the mood to hear much of anything, but I told him to go ahead. He said,

"Ma'am, I notice a sadness in your eyes. Would you mind sharing with me what put it there?"

His question put a tear in my eye. When he saw the tear, he said, "I am so sorry." I told him, "It's okay. I recently buried my mother. I didn't know I was wearing it on my face." There were other people at the table, but he did not seem to care. He said, "I know that feeling. I recently buried my mother. I know how badly it hurts." So Gary and I started talking, and we haven't stopped. We quickly became very good friends. And he is still my best friend. I honestly believe that my mother, Lillie Bell Knight, and Gary's mother, Mary Belle Burley, brought us together. We were married under two bells in honor of our mothers. Gary and I will soon celebrate our fifteenth wedding anniversary.

I had an amazing career at Alabama Power. But they say timing is everything. I started right out of college, at a time when it was not common to see women or minorities in positions of authority. I was fortunate to be there when opportunities started opening up for women.

I wanted to be in radio broadcasting. I had majored in communications at the University of Alabama and worked in the communications area there. I had developed this late-night jazz radio program, and I went around to different stations trying to sell my show and my concept. I didn't have any experience or any sponsors. I was told that I would need to walk into the door with sponsors, but I had no network nor any idea of how to build one.

It was my mother who told me, "Why don't you just find yourself a job and try to grow that show on the side?" That seemed like a good idea, so I went looking through the newspaper. There was an opening at Alabama Power Company in the Customer Service Center, and the hours were 2:00 p.m. until 10:00 p.m. That would give me time to develop the radio show in the mornings. Well, I got the job, and the radio show never happened. I had found my niche. But I did use my communications degree. Communication, and especially the ability to write well, was an important skill in my various jobs at Alabama Power over the years.

When I have an opportunity to mentor young women, I always tell them to find their passion. When you are passionate about something, you are going to give it everything you have. I have been in some jobs with Alabama Power that I liked more than others, but it was easy to develop a

passion for that company and the culture. I wouldn't take anything for that experience. It was an amazing place to have a career. And the company is still a trailblazer when it comes to women and minorities in the workplace as well as the C-suite.

Now, here I am in the next stage of my life, and in an area in which I never would have seen myself. When I was approached with the idea, I thought, *Bobbie, you have lost your mind, becoming the president of a college.* But the more I learned about Miles College and its students, and the more I discussed the idea with people I trusted, the more I saw this as a way to continue to give back. Of course, I had no idea of the challenges I was about to face.

I was elected permanent president on March 5, 2020. Two weeks later, we were shutting down the campus, sending the students home, and going online because of the global pandemic. By that time, I was becoming more and more familiar with many students' situations, and I found them to be heartbreaking. Then this new problem called COVID-19 was going to make life even more challenging for them. One young man told me, "Madam President, I'm from Chicago, from the side of town where I would much rather take my chances with COVID-19 than with the bad things that happen every day there."

Another young man was from Los Angeles. We learned that when the campus shut down and he had to go back home, he had no home to go to and ended up in a homeless shelter. I called my niece, Wanda, and asked her to reach out to him to see how she could help. The thing about women— and this is something I am always preaching to my nieces—is that we usually form a strong network and are always there for each other when needed. They will help you get done whatever you need to do. Wanda's response to me was "Absolutely, Auntie, I'll do it." She called on her network and kept in touch with him to make sure he was doing okay. Fortunately, he was able to leave the shelter.

Higher education was never on my radar. I was quite happily retired, and Gary and I were finally able to travel. I was already on the Board of Trustees for Miles College, and I had spent plenty of time fundraising for nonprofits like the historic Lyric Theater, Railroad Park, and the A. G. Gaston Boys and Girls Club in Birmingham. Then the more I thought about it, the more

I knew I could do it. I was accustomed to being out in the community, to being effective in fundraising and creating support for philanthropic and charitable initiatives. And that is a major part of being a college president.

But first, I reached out to my friend, General Charles Krulack, the former president at nearby Birmingham-Southern College. When I told him what I was considering, he enthusiastically said, "Bobbie, do it! Do it because you will be such a great role model for those young people, and they need to be around people like you. They need to learn from people like you." He, too, knew one of the reasons I had been offered the job. "You know they're primarily bringing you in there to raise money. But do not immediately go out and start trying to raise money. Start by raising friends. Do 'friend-raising.'" This was sage advice that I still adhere to.

There were other factors in my taking the position. Gary was having health issues that had curtailed our travel. Yet I still needed to be sure he was okay with my being away from him and in such a challenging role. I told him, "Gary, you would be 'First Man' at Miles College, so that means you've got to do some work too." He assured me he would do whatever he needed to do. And to prove it, he wrote the school a $25,000 check for the athletic program. As a former athlete himself, most of the work he has done has been with the athletic department at the school.

You know, I do believe that I was born for this new job, just as one of the board members told me. When we found out that we were going to have to temporarily close down the campus in the wake of COVID-19, I brought my staff together to discuss the situation. I could see the distress on their faces.

I have always been that person who avoided panic. I simply took a deep breath and told them that everything was going to be fine—that we were going to work out a plan together and then we would implement it. I reminded them of my years at Alabama Power Company, and my experiences with hurricanes, tornadoes, nuclear drills, and much more. Granted, I had never been through a pandemic as president of a college, but the planning for any type of emergency is the same. And the number one thing is to remain calm. Secondly, be prepared. Calm and preparation allow you to put a good plan together and implement it, relying on key people to make it a success.

My favorite quote is by former First Lady and presidential mother Barbara Bush. She said, "You don't just luck into things as much as you think you do. You build step by step."

Every time I hear that quote, I think of my mother. I know she would have liked it too. She and my aunts were adamant that my sister and I seize every opportunity we had, particularly when that opportunity did not come easy. They didn't have the same advantages we had growing up, so we made sure to seize them. That takes true grit. True grit is simply inner strength, and I am fortunate to have been raised around and by some very strong and independent women. I believe that made me strong and independent too.

JUDY KURIANSKY, PH.D.

DAUGHTER, PSYCHIATRIST, PRESIDENTIAL AND UNITED NATIONS ADVISOR

Turn scars into stars.
—ROBERT SCHULLER

When I was eight years old, my mother asked me, "What do you want to be when you grow up?" At the time, my response was not, "A sex therapist!" No one knew that field existed back then. I didn't even say "a psychologist." Years later, my mother reminded me of my answer: "I want to do something for world peace." Whatever caused me to say that certainly set the tone for my life's path. During my childhood, my father always encouraged me to take risks, to be bold and adventuresome. I remember going to California with him; we bought a map of the stars' homes and drove around to see them. On impulse, when we were in front of Tony Curtis's home, he said, "Go out and say hello and say how much you like his movies." I did! I was so impressed that Mr. Curtis gave me his picture and signed it. I kept that photo on my desk for years.

Once, my father and I were driving in the hills of Kentucky, where we lived. We got lost, and I started to cry that we would never see our family again. My dad said, "Judy, don't cry. We're not lost. We're on an adventure." That reassurance taught me the importance of feeling safe, no matter what, and of embracing adventure.

My mom was like an angel with a heart of gold. She taught me about having a kind heart, about having love and empathy. Her devotion to me is unending. She listens to and records all my radio shows and keeps every newspaper clipping about me. She especially cherishes the *In Touch* magazine article where I advise President Obama and his wife on having a happy relationship. I value my mother's advice: "Always trust everything you say and do. You have worked so hard and know so much. Trust your judgment

and feel pride and pleasure in your accomplishments." Granted, she may have been a bit Pollyanna with my brother, sister, and me...always believing that everything would work out for the best and that everyone has good intentions. My career has mixed my profession of clinical psychology with media, including television, radio, magazines, newspapers, and new media.

I am a "media psychologist." While I do see patients privately in an office like a traditional therapist, I also discuss psychological issues and advise on public venues. I've been a pioneer in this field. People often ask me how I discovered such a path. My mother wanted me to be a French teacher, and my father wanted me to go into computers—it was certainly very prescient of him to suggest this career path in the 1950s. I considered those subjects and majored in math in college for a while; I even got an A-plus in advanced trigonometry. I also studied French in Switzerland and read Descartes and Beckett in French. But I wanted to work with people, so psychology presented a perfect field...unraveling the mystery of the mind and people's behavior...figuring out why people do what they do. Now, in my career, I help others feel safe, especially after disasters, and I continue to see every experience as an adventure.

Getting into the field of sexology was serendipitous. At the very beginning of the academic field of sexology, I was a *just-out-of-college* research scientist working with a group of psychiatrists at Columbia Medical School who were asked by the famous sex researchers Masters and Johnson to evaluate their treatment methods—essentially the first notable American "sex therapy." I found it encouraging to see how people's lives could become happier with such a short intervention in this area of life. When I was invited on television to present my research concerning topics like depression and anxiety, producers found out I knew about sex and started asking me to talk more publicly about that topic. The interest was there. I was hired by a local ABC television station as a feature reporter and then asked to host a call-in radio advice show. I agreed and went on the air, answering questions five nights a week, three hours a night.

Being a psychologist came naturally—working out the puzzles of people—and the broadcasting aspect of my career also evolved naturally, a special blessing, considering that I was starting in a top market like New York. But it was not always easy being a sex therapist in the early years. There

was controversy, especially from religious groups, about "sex talk on the air," and I went through some painful experiences and tough criticism that was hard to face and talk about. At the time, sex was still somewhat taboo. Dr. Ruth, the famous sex educator who started broadcasting at the same time, was more easily accepted, because she was a grandmother figure. She also had an unmistakable German accent that people liked to imitate—especially her famous sayings "have good sex" and "use contraceptives."

Criticism came from groups affiliated with the arch-conservative religious right. A senator wrote opinion pieces in the Atlanta newspaper protesting our show. A group of Philadelphia parents picketed one of our stations, trying to get our show off the air and get me in trouble with my profession. Yet we were exceptionally popular. To this day, young people tell me they listened through earphones under the covers and talked about the calls at school the next day. They still thank me for helping them feel better about themselves and helping them find healthy relationships and learning about self-esteem and sex. My heart sings as they are so successful and such nice people. I am honored to be part of their development.

Experiences like that were painful to me, since I truly don't like controversy. I like to be liked and to do things people like and want. I lost sleep. I was depressed. I questioned myself. I sought support from family and friends. The attacks seemed unfair. The critics considered the content morally wrong—that it was corrupting youth. But everything we experienced on the air reaffirmed the opposite—listeners and fans found it empowering, uplifting, valuable, and responsible. Youngsters would tell me, "Dr. Judy, you changed my life," or "I don't know what I would have done without you," or "You taught me to love myself." I understood why; I never thought I was talking about sex, per se. It was more about self-love and healthy relationships. The listeners realized that.

Over the years, thousands of people asked me how to make their lives happier and more fulfilling emotionally and sexually. It has been very satisfying—and touching—to help people express feelings and work through the important and private parts of life they can't easily talk to anyone else about. The reason my radio, TV, and magazine audiences have grown so large is that people need a public outlet and someone they trust to talk to. Talking about such sensitive subjects publicly was challenging. It was so new and

controversial. It took a great deal of courage. Fortunately, a lot of people wanted me to continue what I was doing. In the end, I believe God put me in that role for very specific reasons. It must have been God, because it certainly wasn't my plan. I had started out helping people with disorders like schizophrenia and depression, and I ended up being an on-air sex therapist and psychologist. Somebody's hand was in that besides mine, guiding me to say the right things to uplift and help others.

When my radio show ended because the world and media companies turned to political debate—I was depressed. But looking back now, I can see that it opened up space for me to channel my time and energy at the United Nations. My time at the UN led me to advocate with governments and become a policy advisor. It confirms that when the door closes, not only does the window open, as my mother said, but a *bigger* window opens.

Ultimately, I expanded from helping people find inner peace in their relationships to facilitating a more global peace—essentially going from the microcosm to the macrocosm. I have spent many years as a citizen ambassador for peace in the world. I have been called a "bridge of peace" by government officials in China. I have worked in disaster relief all over the world, writing books about resolving conflict and representing two international NGOs at the United Nations. After many years, I'm finally at peace with what I do. I've brought together all the aspects of my interests and dreams. I played in an all-women's band in the 1970s just for fun. Now I coproduce and perform in a peace anthem band called the *Stand Up for Peace Project*. We have played original peace anthems at an international summit against nuclear war in Hiroshima and for Peace Laureates like the Dalai Lama and Reverend Desmond Tutu.

One big regret I have is that while my brilliant, wonderful husband Edward and I had magical experiences together at home and all over the world, we both worked so many hours that we drifted into our own worlds. Facing regrets, I tell myself that I have to accept responsibility and mistakes and believe in a higher destiny. I also regret not having children, but I find strength in working with millions of kids and with selected students who feel like my kids.

I feel blessed to create my own life every day now. I don't do things that I *have* to do. I spend a lot of time in volunteer work—living like Bill Gates,

without his huge billions! I am happy and satisfied with "who I am, where I am, and what I am doing."

My advice to others is the same I give myself: "Realize your dreams without letting fears of money or people or other circumstances block your fulfillment." Be strong and ask for what you need and want. The same lessons I gave young girls for years on radio and in newspaper advice columns and books is to love yourself. Value yourself, and never depend on other people's feedback. If someone leaves you, it's their loss—be grateful to be open to something better. Enjoy every moment for you first. Treat your inner child well, enjoy her company, and love her.

Be confident that you are special and have something unique to contribute. If something doesn't work out, then it wasn't meant to be and may even have saved you from a potential disaster. Put your energy where you are embraced. I believe that *what your mind can conceive, you can achieve.* I also like the similar phrase, *Where thought goes, energy flows and manifestation grows.*

Most importantly I urge you to be a leader. That is what possessing true grit means to me. It means having confidence, self-esteem, no fear, a strategy, and a passion to do good and be an agent for change and peace.

TREVY MCDONALD, PH.D.

DAUGHTER, WRITER, AND PROFESSOR

God gives us joy.
—ENGLISH TRANSLATION OF
THE YORUBA WORD *REYOMI*

When my mom, Juanita McDonald, retired from Chicago State University at age seventy-eight, she was the only person in her office who could reach the bottom filing cabinet drawer. Her colleagues were much younger, some by as many as twenty-five years or more. They frequently stacked their files on her desk, because she could easily squat down, file the folders, and rise to her feet. She would have worked a few more years, but she retired to care for my dad, who had Alzheimer's Disease.

The granddaughter of women and men who had been enslaved, my mom was reared in the company-owned coal mining town of Ward, West Virginia, during the Great Depression. Her father, George, who was also a Baptist minister, worked for Kelly's Creek Colliery Company. Her mother, Florence, birthed and reared thirteen children. Juanita was the ninth, and understandably her parents could not afford to send her to college. Those were difficult financial times for many Americans.

The day after high school graduation in 1945, my mom boarded a train to Washington, D.C., where she shared a room in Lucy Diggs Slowe Hall, a private dormitory for Black women, with her older sister, Carlene. Lucy Diggs Slowe Hall was near the campus of Howard University, where my mom wished she could attend as a nursing major but was not financially able. Instead, she got a work permit at age seventeen. Her first job was in the clerical pool for the Office of Scientific Research and Development during President Truman's administration. The classified assignment she was part of? The Manhattan Project.

Juanita got her true grit from her mom, Florence, who was under five feet tall and lived independently for nearly twenty years after becoming a widow at age seventy-three. What was my grandmother's secret? The pistol she kept in her apron pocket and once had to draw on teenaged boys who knew she lived alone and tried to intimidate her. That only happened once. I guess you could say I got it honest, my true grit that is, from my mom and grandma.

Although my mother was unable to pursue higher education, it was a desire she had for me. When I was six years old, she told me I was going to get a scholarship to attend college. By age eight, she convinced me I would also earn a master's degree. This stuck with me and inspired me to perform to the best of my abilities in my studies.

My heart was set on attending college in sunny Coral Gables, Florida. This was in the late 1980s, and *Miami Vice* was extremely popular. Florida would give me a chance to escape the brutal Chicago winters. The day after I decided to attend the University of Miami, which offered me a partial scholarship, I received a letter offering me a four-year full-tuition scholarship to the University of Wisconsin-Oshkosh. I cried. And they weren't tears of joy. Oshkosh was a place that I did not see as warm and sunny. The winters were more brutal than Chicago, and it was much less racially and ethnically diverse than Miami. When I attended UW-Oshkosh there were roughly one hundred Black students on a campus of more than ten thousand.

I kept my sights set on Coral Gables for a few hours until my mom sat me down and told me that I could go to the University of Miami for one year with the money she had saved, or I could attend the University of Wisconsin-Oshkosh, earning a degree without the burden of student loans. I decided at age seventeen that if I had to attend this university in cold and snowy Wisconsin, I would map out a plan to earn my degree in only three years. I reached that goal. Oh, and I was right about the brutal winters. I often walked to class with icicles on my eyelashes during the winter months.

At UW-Oshkosh, I majored in Radio/TV/Film, where we were encouraged to get involved with campus radio and television as freshmen. Our radio station broadcast 24/7, and our student-managed television station produced seven different shows weekly. One show was a soap opera called *Dorm*. We also produced a weekly live newscast, where I served as the

weather anchor for a semester. I enjoyed my time working with student media. We were inspired to lead. I worked my way to station manager my senior year through the ranks of programming. As program director, just before my senior year, I was successful in keeping the station on the air continuously for five and a half months, except for the evening of the annual department banquet. All the announcers and most of the majors attended the banquet. I was only nineteen at the time. It was through my participation with the campus radio station, WRST, that I decided to become an educator. I thought my radio professor had the coolest job and decided that teaching would become my career.

I was able to begin that pursuit in 1990, when I started at the MA program in Radio, Television, and Motion Pictures at the University of North Carolina at Chapel Hill. At age twenty-one, I moved more than eight hundred miles away from my family to a city where the only people I knew were the friends and relatives of my college boyfriend. That relationship was over before the Radio, Television, and Motion Pictures department received my application much earlier that year. I went anyway, and I didn't just survive—I thrived.

My cohort was small, with only eight students. I was the youngest and the only African American student in the program. I quickly developed a passion—no, a responsibility—for examining representations of Black women in media. It started one afternoon when I was at the laundromat and saw a young boy, preschool age, wearing a T-shirt with a warning to "never trust a big butt and a smile." This was about a popular song named "Poison," by the group Bell Biv Devoe. I was outraged and wondered how his mother could let him wear that shirt. I complained to my graduate advisor, Dr. Anne M. Johnston (another woman of true grit). She told me to write a paper about it. It evolved into my master's thesis and inspired me to shape the image and narratives of black women through fiction writing.

When I finished my MA degree, I continued my educational pursuits as a doctoral student in the School of Journalism and Mass Communication, also at the University of North Carolina at Chapel Hill. I would return to my alma mater to teach in 2008 and became the first Black woman to earn tenure in 2018. In 2020, I became the inaugural Director of Diversity, Equity, and Inclusion for the School of Journalism and Media.

In 1995, at age twenty-five, I found myself armed with a Ph.D. and unemployed, so I asked myself a very valuable question: "Trevy, what can you do right now to make yourself more marketable?" I still wanted to be a college professor, and I knew that college professors were expected to publish. During what is now called a "gap" semester, I laid the groundwork for three book projects. The first two were scholarly: *Nature of a Sistuh: Black Women's Lived Experiences in Contemporary Culture* and *Building Diverse Communities: Applications of Communication Research*. I also got the idea to write a novel.

I remember telling my family about my decision over Christmas break in 1995. My mom told me I needed to get a job. My dad shared some of his books on writing with me. I grabbed his books and flew back to North Carolina, where I was to start my teaching career as an adjunct faculty member at North Carolina State University, and snow was in the forecast. I thought, "Big deal. I'm from Chicago and went to college in Oshkosh, Wisconsin." I thought I would be entirely unfazed by snow. I quickly learned that a southern snowstorm is in fact a great big deal. Six inches of snow, followed by two inches of ice, topped off by two more inches of snow kept us in for a week. This was when I came to embrace the essence of the words in a haiku I would later write.

Commit to your dream
And the desired resources
Are provided now!

I used a book my dad loaned me titled *The Weekend Novelist* by Robert Ray to develop three women of true grit who would be the protagonists of my novels *Time Will Tell* and its sequel *Round Bout Midnight*. A year and a half later, I was in Chicago during summer break, and writing the first novel became a family project of sorts. My dad, who was retired, stayed with me to complete it and even helped me write dialogue for some of the marital spats. I finished writing *Time Will Tell*, a coming-of-age novel about the power of friendship in the lives of three women as they attend their ten-year high school reunion, at 2:41 p.m. Central Daylight Time on Saturday, July 24, 1997. I remember the exact time that I celebrated—with an Italian Beef sandwich. This was just weeks before my own ten-year reunion.

The words of the haiku would particularly ring true later when I made the decision to start Reyomi Publishing and self-publish *Time Will Tell* in 1999, after the novel sat in a manuscript box underneath my bed for a year and a half. The company name comes from the first two letters of three keywords in my favorite Bible verse, Romans 12:2: "Be not conformed to this world, but be ye transformed by the renewing of your mind." Once I committed to the dream of publishing the book, several people appeared to help me with the things I didn't know how to do. In a mere week, the novel was ready to go to press.

When I published *Time Will Tell* in 1999, I was conflicted. My three book projects had snowballed. *Nature of a Sistuh* was published in the fall of 1998. When I was heading to Chicago for the release party for *Time Will Tell* in April 1999, I received a contract for *Building Diverse Communities.* I loved working with my students at North Carolina Central University, where I had been hired as a tenure-track assistant professor in 1996, but at the same time I was quickly approaching thirty and single with no responsibilities other than myself. I didn't want to look underneath my bed at age eighty and see the novel manuscript. *If not now, when?*

So I stepped out on faith, left academia at a time when I could have applied for tenure, and moved to Chicago without a job in sight to pursue that dream. I met with Dr. Anne Johnston just before making the decision. She encouraged me to pursue literary entrepreneurship, and she reminded me that academia would always be there and I could return to teach one day with even richer experiences to share with students.

That part of my journey wasn't perfect or easy. It was extremely challenging. I remember judging the success of a month by whether or not I sold enough books to pay my American Express bill. But during that part of my journey, I built networks with people from different walks of life, honed skills I didn't know I had, and gained greater confidence than I could have ever imagined. In 1999, a single mom shared that she was inspired to finish college by the grit of the women in *Time Will Tell.* In 2003, while waiting for a flight after a book signing at the Pentagon, I met a Nigerian woman who told me that Reyomi is a Yoruba word meaning "God gives us joy." That is my life's purpose. To use my God-given talents to uplift, inspire, and empower people in an entertaining and informative way that brings them

joy. That is what I identify as having true grit, it's being able to have joy in the journey and pursue your dream calling, because you never who you may end being blessing to.

ENGINEERING, MEDICINE, SCIENCE

ASTRONAUT JAN DAVIS, PH.D.

DAUGHTER, SISTER, WIFE, ENGINEER, AND ASTRONAUT

We may not always reach our goal, but there's recompense in trying.
Horizons broaden so much more the higher we are flying.
—UNKNOWN

My mother was the best example of a woman of true grit. She was a very determined person and achieved so much in her life. She did all this at a time when obstacles were much greater for women. She always encouraged me to do my best, to dream big, and to not let other people's opinions or the limitations in their thinking affect me. That resulted in my growing up believing girls could do anything they wanted to. I never considered that I couldn't become an engineer, or that I should avoid math or science just because so many girls chose to do so.

I have always liked figuring things out, analytical things, and I like to build things. Growing up—and even now—I especially enjoy reading biographies and autobiographies. I would read about Marie Curie and other women like her. I am always trying to learn what made them the way they were—and why they made the choices they made, even when theirs was not the usual path chosen by females.

Throughout my growing up years, I was enamored with the space program. Part of that, of course, was growing up in Huntsville, Alabama, home to the US Space and Rocket Center and the Marshall Space Flight Center. I had some teachers who were very influential in sparking my interest in math and science. There was one woman engineer from NASA—one of the few at the time—who helped me with a junior high school science project. She was a role model and a powerful mentor. I went to school with the children of Dr. Wernher von Braun and still stay in touch with one of his daughters. The engines for the Saturn V were tested in Huntsville, and

it was so exciting to feel that vibration across the city, knowing that we were going to the moon.

When I was in college, NASA was not hiring. They were laying off people. I saw friends of mine from school having to move away so their parents could find work. For that reason, I was not necessarily thinking of working for NASA. After graduating, I went to work in the petroleum industry, because that was where the jobs were. Then people told me that the Space Shuttle program was coming soon, and NASA was once again hiring. That was when I came back to Huntsville and went to work there on the Hubble Space Telescope team.

As it happened, just before I started working there, they picked the first women to be astronauts for the Space Shuttle program. I was not among that group, and I had never really thought about going into space, but women like Sally Ride opened the door. Until that point, astronauts had all been men from the military, typically test pilots. I was none of those things. The women they chose to be astronauts for the Space Shuttle program were engineers, scientists, and doctors. I applied to be an astronaut for the first time in 1984, and although I was interviewed, I was not selected. That was one of those "true grit" stories!

I could have quit, but I decided to keep trying—to persevere. I did my research, including talking with some astronauts who were visiting at the Marshall Space Flight Center in Huntsville. I thought that becoming a pilot might help. I had always wanted to learn to fly anyway, so I signed up for flight school. I also knew a Ph.D. would be required, since all of the women who had been selected so far had their doctorate degrees or medical degrees. That was why I pursued both a pilot's license and a Ph.D. at the same time… all while working full time on my wonderful project, the Hubble Space Telescope. Thank goodness I had a very supportive group of supervisors and mentors at NASA who encouraged me to pursue my astronaut dream.

I was selected in the 1987 class, which was my third try at becoming an astronaut. That was just the beginning of a lot of hard work. I am a lifelong learner. I love to learn. And believe me, as an astronaut, you learn about so many different things. How to fly jet aircraft. So many new things about science and planet Earth. Meteorology. Geography. Photography. Astronomy. Orbital mechanics. These were all things to which I had never

been exposed before. We also began actual training on the shuttle simulator. It's a very complex vehicle, and we had to know what to do if something were to go wrong. While in space, you have to know about a lot of different things. For me, though, this was all great.

As an astronaut in training, finally, the day comes when you are assigned your first flight. Then you start learning about that specific mission, what the experiments are, and more. In our case, it was a three-year period, which was a lot of hard work, but it was worth it all. It was an international flight, so that meant undergoing training in Japan, a place I had never visited before. That gave me the opportunity for even more learning, about the culture and the people. I made lifelong friends while I was there.

Teamwork is so much a part of what we do. I recommend that anyone aspiring to be an astronaut—or really just about any endeavor—should get involved in activities that help develop teamwork. That can be sports, church activities, or working as part of a team in just about anything. All three of my flights were international, so we had to have teamwork around the world.

It is also important to be well-rounded. It will benefit anyone to have an active social life, develop strong friendships, read, go to lectures, and learn about a wide variety of things. Stay involved with all kinds of activities outside of work, like sports, church, travel, and charitable pursuits. I like water sports, kayaking, water skiing, ice skating, and snow skiing. I am also a quilter and have done embroidery for most of my life. During the pandemic, I took a lot of online classes too. I think being well-rounded and adaptable is important, whether you are on the Space Shuttle, the International Space Station—or even going to Mars. You need to be able to adjust, be flexible, and learn how to improvise and be creative. No matter what you do in life, you will certainly run into things you have not trained for or expected to happen. You will have to figure it out.

People always ask if it is difficult to look ahead and see that you are about to do something many consider very dangerous. It is not difficult at all for me. It is a mind-set of risk and reward. Is the risk worth the benefits of all that we would accomplish in space? Look, there is risk in everything we do. Driving a car. Climbing onto an airplane. We don't usually think about those risks when we drive or fly. We just accept the risks and go on. For me,

flying on the Space Shuttle was simply my commute to work. My job was to work in space. The way I got there was on the shuttle. I knew many of the engineers and technicians who put together the Space Shuttle. They were as dedicated and smart and hardworking as anyone I had ever met, so I was confident everything would be okay. Besides, we are so busy when we are sitting there on the launchpad and getting ready to lift off that we don't have time to worry.

One thing I learned from not getting the astronaut position on my first try—and something I always pass along to other people—is that whether you get what you are going after or not, you are a better person for having tried, for doing the things you had to do as you worked toward the goal. The first time I interviewed, there were eight thousand applicants, and they only interviewed 128. Then they selected seventeen. I decided that just to be chosen to be interviewed from eight thousand people was a significant accomplishment.

Plus, I knew I would try again. Being in that elite group gave me the perseverance—the true grit—to keep on trying...and to do things even better next time. That included completing my Ph.D. and doing the best job I could in my position at the time. We should all find our passion: do something that we enjoy doing and that will make us even better at what we do. That kind of attitude is what they look for in an astronaut. Of course, you have to be realistic. If I wanted to be an Olympic athlete, that would not be a realistic goal for me. But once you have set that goal or have established your dream, work toward making it come true, and do not let others tell you that you cannot do it.

It was just after I failed to be chosen the second time that we had the *Challenger* accident. I was put in charge of the redesign team for a different part of the booster than the area that failed, but it was a pressure-packed time of more hard work. Therefore, I was not focused solely on becoming an astronaut. I just concentrated on doing what I needed to do for our country, for NASA, and for the space program by helping to get the shuttle flying again.

When I interviewed in 1987, I think they recognized those qualities in me, along with my abilities and background. Eventually, the time came when my skills matched up with what they were looking for and I was selected.

All the work and sacrifice has been worth it. It is amazing to look at the Earth from that unique perspective. You go around the Earth about every hour and a half on the Space Shuttle, and you see a large portion of the planet at any given time, such as whole states or regions. While we did not get much time to gaze out the window, seeing the Earth go by below was like a dream. It is incredible how beautiful Earth is, but also how unifying that view is. We all live down there together, and we have to take care of the planet and each other.

That is one reason I want to encourage other women to pursue careers in technical fields. I believe that engineers and technicians will be needed to make our planet a better place. Two other women astronauts and I started a nonprofit organization to reach out to girls and encourage them to consider STEM (science, technology, engineering, and math) careers. We wanted to do something as former female astronauts to encourage more girls to consider these fields. We now have twenty former astronauts involved, along with about twenty other women who are successful in STEM fields. We have already reached more than ten thousand girls across the country. So far, we are targeting girls in fifth through eighth grade, since that seems to be the point at which girls often turn away from science and math for a variety of reasons. But that is also when so many of them are deciding what they want to do in life. The organization is called Astra Femina, and our website is astrafemina.org.

Women are beginning to move to the forefront in technology fields. Jody Singer is now the director of the Marshall Space Flight Center in Huntsville. The new CEO of the US Space and Rocket Center is Kimberly Robinson.

Yes, it takes hard work and plenty of true grit, but the future is brighter than ever for those girls who want to reach for the stars. To me, true grit is simply persevering and working hard to overcome obstacles, whether they are external or internal. It means keeping on keeping on for your dream or goal, learning the whole way from missteps or failures. Of course, it helps if you have people who push you and support you along the way.

KIMBERLY ROBINSON, PH.D.

DAUGHTER, WIFE, MOTHER, ENGINEER, CEO OF THE HUNTSVILLE SPACE AND ROCKET CENTER, AND DOG LOVER

The greatest glory in living lies not in never falling, but in rising every time we fall.
—NELSON MANDELA

I grew up in Birmingham, Alabama, in a happy home with a wonderful mother and father. I was a very shy child. I always preferred to do things quietly and on my own. But I was also an observant child, and I learned quickly that maybe this wasn't the way the world liked people to be. My first-grade teacher was so concerned that she called a parent-teacher conference to discuss the fact that I had not spoken a word all semester. Personally, I was very happy being quiet in my own world, but I decided to push myself to get out there, start conversations, and overcome my shyness.

My mother was a stay-at-home mom, and my father worked for an aerospace company that worked on planes for military aircraft. He was one of those people who could take something apart and put it back together. I was always at his elbow watching him work, handing him wrenches and having a great time. I believe I got my engineering skills from him.

When I was a senior in high school, I was told to show up on a particular night and that I would be receiving an award. They wouldn't tell me what kind of award it was, but I showed up. I was presented with an award from the Society of Women Engineers, which I had never even heard of. I didn't know what an engineer was, to be honest. Astronaut Anna Fisher came in her blue flight suit and presented me with the award. I thought how wonderful it must be to climb onto a spaceship and blast off into space. To me, that was the ultimate in travel and exploration, and I was in awe of her. I asked her how she had become an astronaut. She told me that she was an

engineer and that after she completed her engineering degree she had gone to work for NASA and applied to the astronaut core. From that moment on, I decided that was my path. I was going to become an engineer, whatever that was.

I attended Vanderbilt University and earned my degree in Mechanical Engineering, and then I went on to receive my master's in Industrial and Systems Engineering from University of Alabama–Huntsville. My dream was to be an astronaut, so I applied to work at NASA and got the job. I spent thirty-one years there and tried three times to become an astronaut, but sadly it did not work out. I did get to build rockets and develop payloads, and even though I did not get to be an astronaut myself, I did get to become an astronaut trainer. I trained astronauts for six different shuttle missions. We would train in modules that had simulators that would be just like what they had in orbit. I would train them on the experiments they had to do, how they had to perform them, and I would inform them on what they were trying to get out of the experiment. It was a great job, and I made many good friends that way. Sometimes I still can't believe they essentially paid me to teach space camp.

I've also had the privilege of getting to work on one of my other passions: informing people, and specifically young women, about NASA and space exploration. I want to help women see their potential. Women make very good engineers. They are very good problem solvers. We also have excellent "soft" skills that help with communication. At NASA, we work on some very large projects with people from different departments and skill sets; when you don't have good communication, that can be detrimental to a project. I am encouraged by the women I see coming into NASA after me. They seem to have more confidence, and I take that as a sign that we are improving. Sometimes change is slower than we would like, but we have to keep pushing for it.

I had in mind that when I retired I would work for a nonprofit, so the US Space and Rocket Center was a natural fit. You never know who your docent is going to be: experimental test pilots, engineers, and astronauts. I get to work with some amazing people at the Space and Rocket Center.

Besides working at NASA, I volunteer with an engineer friend of mine that I met at Vanderbilt. She has an overwhelming love and passion for

saving animals. She founded A New Leash on Life, which helps pets get fostered until they can be adopted. Her passion is contagious, and I caught it. I currently serve as the vice president of the organization. We have raised enough money to operate three thrift shops that raise money for the animals. It's wonderful to see these animals in good homes; they are so helpless, yet they bring us so much joy.

True grit to me means resilience, that you are going to get back up when you get knocked down. It's about not being distracted by the negativity, not being distracted by situations that are outside of your control. It also means to me being grateful…even when it is hard to be grateful.

LISA WATSON-MORGAN, PH.D.

WIFE, MOTHER, HISTORY MAKER, HUMAN
LANDING SYSTEM PROGRAM MANAGER

You can either lead, or be told what to do.
—UNKNOWN

I was, in a way, lucky. I was an only child and was very close to my parents. I was treated as an adult; my ideas were heard, and we had genuine conversations. That was very advantageous for me, because in my developing years, I perceived myself as independent and strong because of it. I was very close to my mom, and she was my first example of true grit and a true role model for figuring out a way. She wanted me to go to a private school for phonics and took a job as a bus driver to afford the tuition. She would do whatever it took, and she was very resourceful. She and a neighbor once started a business, leaping at the opportunity when the neighbor pitched her. Together, they made speaker cables, and that idea thrived as a local business for years. My dad was more steadfast; he was a graphic illustrator. While contracting for the Marshall Space Flight Center, he saw the respect and refinement that the NASA engineers had garnered from their colleagues. "I want that for you," he said.

My dad had always supported me and wanted great opportunities for me. I'd never thought that, at a young age, I would have to support him.

My mother's passing was abrupt. Just four months before her diagnostic, she went to the doctor and had a passing physical. Then we learned she had adult-onset leukemia. I remember exactly how I got the terrible news. I was going out of town for a summer trip after my junior year of high school. As I got into my car in the driveway and started backing out, I realized I hadn't hugged my mom goodbye. I jumped out of the car and went in, hugged her, and told her I loved her. When I had arrived at my destination, I called home to tell her I made it safely, but nobody answered. It was then the odd feeling,

one that persisted in the following days, settled into my stomach, forming a heavy knot. I tried calling later and again, nobody answered. Maybe the family had gone out to dinner? It wasn't something they usually did, but I was trying to rationalize. I called again the next morning and, again, no answer. I called that night and still no answer. By this point, I was freaking out. I needed to find answers, so I reached out to a neighbor, who promised to check on her. The second day of my trip, I got a phone call to come home. My mom was in the hospital; she had actually been admitted the night I left for my trip, and she was doing poorly. I rushed home and saw that my dad wasn't looking good. While she was in the ICU, we could only see her five to ten minutes at a time. She held my hand, and I asked her (perhaps in a more commanding tone than I intended), "Can you eat or drink something?"

"Honey," she said in her soft but firm voice, "you are not twenty-six years old, and you do not get to tell me what to do." (I don't know what being twenty-six had to do with the price of tea anywhere, but later, when I did turn twenty-six, I smiled at the memory.)

Eight days after I returned home, she passed away. Dad and I were like robots. It was so devastating.

"Why did she pass?" The question continues to buzz in my head like a pestering wasp.

My dad started crying in the hospital, and he was *not* a crier. I knew at that moment that I did not need to cry. And so, I instantly changed in that moment. At seventeen, I told my weeping dad, "It's okay; we are going to get through this."

There are obviously still hard moments. I hardly remember my senior year of high school—everything came in a fast blur. I was just going through the motions, doing what I could to just get by and pass. I won a couple of awards in high school at that time. I remember I ran excitedly to the payphone to call my mother and tell her after receiving one. Before I got to the last two numbers, I hung up, shock once again cruising through my body. I am very grateful for my close childhood friends, because they remember my senior year, and they remember what my mother was like too. They are proof that this loving woman was once walking, and that her influence is still around. Going off to college was hard because she wasn't there to see it.

I learned a very valuable lesson during this time. You *have* to find ways to live for yourself in their honor. They don't want you to die with them, as much as you might feel like you want to. You simply have to go on.

I hold on to the thought of making history when things get tough. There are very difficult aspects of the job—even the small things can wear on you. But we are making history. The project of the Human Landing System and sending the first person of color to the Moon is important for the societal aspect of representation in science. I think it is very important for women and all minorities to see this, because it may aid those who need to find their voice. Because of societal pressure, women and people of color may have trouble articulating how they want to present either their position, some data, their information, or themselves in the workplace—or in life, for that matter. While the job is tough, I am very glad to be a woman working on this project. My time as an engineer has aided me in being able to trust and rely on people while being gracious. It truly takes a village. I think planning ahead as much as you can and being prepared for any outcome is so important. If I go into something mostly prepared or thoroughly prepared, I'm so much better off. And if I prepare prematurely, I will still use it later. So it's never time wasted.

The astronaut crew members are a part of the program from the very beginning. Even when we first put in our request for proposal, and when preparing for the proposals to come in, we have someone on the selection who is a crew representative who writes it, because we need early buy-in. Now as we're in execution, there are things we constantly check over—like the conditions of our simulators. We need a good simulator, because it teaches and prepares the astronauts for space conditions, similar to learning the basics of driving from watching people drive when you are younger. We have a really cool apparatus called a vertical motion simulator, which gives the astronaut crew the feeling of less gravity and prepares them for flight. Typically, many of the crew members are pilots. We do have some scientists actually training for the space trip as well. We have a neutral buoyancy tank, which is a big tank full of water that the crew goes down in, and they can practice certain maneuvers and get the feeling of wearing the extra vehicular activity suit. That's the suit they use when they do the moonwalk. They will prepare for the timeline, which is the sequence of events of the things that

they have to do in order to execute the science and research on the Moon, as well as all the things they have to do as the spacecraft is descending to the Moon. They may not like the landing location, and they may decide they want to land at point A versus point B, as we have some predetermined areas that we're going to land. There's extensive training, but there's also a whole psychological aspect of this Moon trip as well. The crew must be okay with being in a small space for a good bit of time. We have our team at the Johnson Space Center that helps us with crew training as well as providing a crew for us.

NASA is an outstanding place to work. They were voted best place for employment among federal agencies. It is easy to get behind the vision of NASA and what it stands for—doing things for all mankind. NASA invests heavily in its people, and one of the ways they do this is by providing mentors. I took training classes, and they constantly provided me with opportunities and coaches. My independent nature and steadfast mindset are pushed to the limits at times, and it is difficult to not get irritated when someone says no. I think, "I'll show you!"

My time in Huntsville, Alabama, has introduced me to great opportunities and great people, including my husband. We did not meet until I was twenty-five, though he swears he saw me a couple of times in high school. He is supportive of what I do. He's the B team and I am the A team—a bit controlling at times—but this something he knows about me, and we often joke about it. When I have to go out of town, I'll say a million reminders, giving out lists and repeating stuff, thinking, "Okay, the B team's in charge. Are we okay here?"

He grounds and comforts me. When I am feeling overwhelmed, I either go to him or outside. I love to hike, especially on a nature preserve trail. I've picked up jogging, and most mornings I'm out the door at 6:00 a.m. to get three to five miles in. Like many, I started this new practice at the beginning of the pandemic. I felt like I was losing my mind, as so many others did at that time. I felt out of control of my typical, daily life. Typically, I'm very measured with my emotions, but I thought I just needed to do *something*, so I started out slow. And now I'm up to five miles when I have the time. There are great walking trails where I live, and there is an older lady—probably twenty or thirty years older than I am—who power walks every day. It's

almost a jog. And she inspires me. I see her out there, and I think, "She is still out there pounding the pavement, and if she can do it, I can do my part."

I mentor to pay life forward and to do my part in the community, and it's one of my favorite things to do. I wish I had known some of the things I discuss when I was younger. Recently, I was able to talk to a group of interns. I told them stories about the things I've learned and gave them advice, such as not taking things personally, trying to do your best, taking feedback well, and finding your voice. Being able to pass that down to people earlier in their career brings me a lot of joy.

To me, true grit means finding your voice and being able to hear no and pivot to turn it into a yes later. You have to be able to persevere. Keep your eyes on the prize, be positive, and overcome challenges. This is key to developing the right mindset. The lady I see walking represents true grit. All of us who decide to get up every day and try our best to make a difference represent grit. It's treating people with the dignity and the humanity that each of us deserves and passing that down to the next generation. I am very honored to be an engineer for the Human Landing System and to be making history while I do it, and I hope my story inspires all women to chase their dreams.

SHELIA NASH-STEVENSON, PH.D.

DAUGHTER, WIFE, MOTHER, AND
DOCTOR OF PHYSICS

Rejoice in hope, be patient in tribulation, be constant in prayer.
—ROMANS 12:12 (ESV)

If you are in a room full of scientists in Huntsville, Alabama, chances are there are very few native Alabamians in the room. I'm one of the proud few. Hillsboro, Alabama, in Lawrence County, is where I grew up; well, more specifically, I grew up in a small rural community called Fishpond. Like most who grow up similar places, we did not have much, but we had everything we needed. The farm animals were our playmates, and we often improvised our toys; we slid down hills in cardboard boxes.

Of course, it wasn't all fun and games. From an early age, we helped my grandmother in the garden. While we picked and shelled peas, watermelons were our favorites. They pulled double duty, because you could eat them and play in them. My first paid job was chopping cotton. I made five dollars a day for a total of twenty-five dollars a week. I started my first bank account with those twenty-five dollars. But I quickly realized that chopping cotton was not what I wanted to do for the rest of my life, so I studied hard and did well in school.

Math was my favorite. There are no ifs, ands, or buts about math—there's just one answer, regardless of whose class you are in. I enjoyed English too, but one teacher may like a sentence one way, and another teacher might hate it that way. The beauty of math is that it is exact, and I loved trying to solve problems in my head. At home, I would watch my mother balancing her checkbook to the last penny, and I learned from her to do the same thing. My love of numbers extended from home to the classroom.

I attended the same high school as my older brother. He is no longer with us, but he was brilliant, getting straight As all throughout high school.

He even went on to become a surgeon. Having a brother who did so well meant that my teachers expected a lot from me. At the time, this didn't feel great, but I realize now that it was really good for me. In particular, my math teacher expected a lot and based his classroom seating chart on who had the highest score on the test. Now, I always had the highest score, so I always got the best seat. Once, I got the second highest score. He was so disappointed in me, and I felt so bad that I never did it again.

My experience chopping cotton made me realize that I wanted to make more money and not spend all day in the hot sun doing hard manual labor. At first, I thought I wanted to be a math teacher. But then I found out that math teachers didn't make as much money as I originally thought, so I went back to the drawing board. One day, I was watching TV and there was a commercial that said something to the effect of "if you like math and science, you should go into engineering." A friend told me that engineers make good money, and that was it, I decided to become an engineer.

I didn't have any role models in engineering, but I was resolved to get as far away from chopping cotton as possible. And I liked math and science. I graduated high school at sixteen and, not wanting to go too far from home, I attended Alabama A&M University, where they offered me a scholarship. I got all three of my degrees from Alabama A&M, and I was the first woman to ever earn a master's or a Ph.D. at A&M in physics.

It's funny how I got my Ph.D. I was nineteen, and I had just graduated with my bachelor's in engineering. The chair of the physics department, Dr. M. C. George, was trying to convince me to enter the master's of physics program. He was the kind of professor who could write the entire textbook from memory. He was a wonderful teacher, and I did well in his class, but I had no intention of entering the master's program. I was applying for jobs all over the county. There were none in Huntsville, Decatur, or anywhere near my home. I was at home contemplating my interviews when I got a call from my professor. He said, "I thought you were coming back!" And I said, "Well I'm getting ready to interview." He replied, "No, no, no, no, no, if you come back to school, I'll get you the money." I was still a little hesitant since it was physics, not engineering, but I was relieved that I wouldn't have to leave home. So I went back for my master's. During that time, my professor

got me a graduate fellowship with NASA. Taking classes during the summer, I was in school year-round.

After receiving my master's, I got married. And then that same professor started a doctorate program in physics about two years later, and he wanted me to join the program. This professor was so invested in bringing these programs to A&M, and after all he had done for me, I couldn't say no. But as I said, I was newly married. I was working full time, trying to have a baby, active in my church, and serving in many public service organizations. I had coworkers who said I couldn't do it all, but I reminded myself that those people didn't really know me. I took it one class at a time…literally. I would take one class a semester. Dr. George was a great encourager of mine. I would not have pursued my career in physics if it had not been for him. I started my doctorate in 1986 and finished in 1994. My best advice is: never, never, never give up!

I also have my wonderful husband, Kirby Stevenson. He is incredibly supportive. He's kind of like my PR agent—always posting on Facebook about my accomplishments. I am so grateful for his encouragement through all my work. We are parents of two wonderful children, Keegan and Kecenia. For a long time, I thought that I was a mean mom because I expected so much from my children, until one day, we were all talking as a family and my son was telling me about the mother of a friend of his, describing her as mean. I said, "Oh, you mean like me?" He replied, "No, mom, you are not mean." I realized that as my children had gotten older, they did listen to me. To them, I was not mean but respected. Though they do laugh at me from time to time. I know they still appreciate me coming to their rescue when they get in a bind. My favorite poem about motherhood is "Mother to Son" by Langston Hughes, which reads:

> Well, son, I'll tell you:
> Life for me ain't been no crystal stair.
> It's had tracks in it,
> And splinters,
> And boards torn up,
> And places with no carpet on the floor—
> Bare.

But all the time
I'se been a-climbin' on,
And reachin' landin's,
And turnin' corners,
And sometimes goin' in the dark
Where there ain't been no light.
So boy, don't you turn back.
Don't you set down on the steps
'Cause you finds it's kinder hard.
Don't you fall now—
For I'se still goin', honey,
I'se still climbin,
And life for me ain't been no crystal stair.

I didn't always have people encouraging me in my field. There were places I worked where I knew I was not welcome. And it took almost every ounce of energy that I had to walk into work and be a professional. There was a lead at an office who made it very clear that he did not want me there, but I was interested in the work. So I told myself, *When this is over, you will have the knowledge from working on this to carry into the next project.* You realize over time that sometimes God puts us in places to learn lessons. Sometimes it may not be the lesson you think it's going to be, but it's always a learning experience.

I don't think of myself as a particularly unique person. I don't mean to say that I don't think I have value. I know my worth. But on the whole, I prefer to be in the background. I prefer to encourage and lift others up, and I can do that perfectly well from the background. There is a special place in my heart for children, the ones who feel that they don't have a reason or a purpose in life. I want them to know that they are valuable and that they have potential.

The best advice I can give to someone on a similar path to mine is prayer and lots of it. Prayer is essential to keeping your sanity. Prayer keeps me focused on the right things. It keeps me grounded and helps me prevent external negative influences from directing my decisions; that's what having true grit looks like to me. And as I tell people, "I have a good God, and he

has me firmly in his hands." He takes care of me all the time. You also can't have true grit without determination. You must be determined to do the things that will work best for you. Don't compare yourself to anyone else. Your success depends on your definition of success, not anybody else's.

ZSILA SADIGHI, M.D.

DAUGHTER, PEDIATRIC CANCER SURVIVOR, AND PEDIATRIC NEURO-ONCOLOGIST

I can do all things through Christ who strengthens me.
—PHILIPPIANS 4:13

I am one of those people who is lucky enough to have known that I wanted to be a doctor since kindergarten. I always had plan A, and I never really had a plan B. School was important to me, as well as having a wonderful extracurricular life. I knew that I needed to have the best grades possible to go to medical school, so I studied hard and got involved in as many activities as I could. Which I think is fantastic, because it helped shape me into the person I am today. Being involved in so many different types of activities helped me relate to more people. Keeping busy felt normal for me. There wasn't necessarily an element of grit—other than perseverance and passion. I knew what I wanted to do.

By the time I made it to high school, I knew that my childhood dreams of being a doctor were real. I still wanted to be a doctor, and I hoped to become involved with medical missions. I had made a lot of mission trips with my church, and God had given me a heart for the underserved. The true test of my grit didn't come until my junior year of high school. Everything was fine until I started getting relentless headaches. My first thought was dehydration. I was involved in multiple activities. I was a cheerleader. I figured that I must be tired or dehydrated. I'd had migraines before, but these persisted for about a year. Then one day, my left leg was paralyzed transiently. That's when the whirlwind started.

I arrived at the emergency room and they thought I was fine; they initially thought I was dehydrated and had a migraine, just as I had thought. But then the doctor came back and said, "I'm so sorry. We have to get a CAT scan." When he came back, shocked, with tears in his eyes, he said, "I'm so

sorry. We're calling the on-call neurosurgeon right away. You have a very large mass in your brain." I had a brain tumor. It was December 30, 1994. I was seventeen years old.

I was immediately admitted to the hospital. They had to elevate my head. The pressure was so intense. Behind the scenes, the doctor had warned my family that he might not be able to get it all out and that I might not survive the surgery. I was told this after I'd been informed that I had a maximum of two days left to live. It was a trying time. I had to cling to my faith as I had never done before. I knew the Lord had already given me a path, but I was left wondering, "How can I answer His call?" I remember visibly trembling under the sheets, wondering if I was going to be the same. God told me that I was going to make it. He told me to be confident of this, "God, who began the good work, and you will be faithful to complete it until the day of Christ Jesus" (Philippians 1:6). So I knew I was going to make it. I just knew that I might be different.

They were able to postpone my surgery until January 2, 1995. My doctor warned me that I was most likely going to be paralyzed on one side of my body. As a teenager, this made having my head shaved much less serious. I just wondered how I would be when I woke up, knowing that my tumor was 40 percent of one hemisphere of my brain? My faith was tested. I remember thinking about what my last words on earth would be. I realize that no teenager should have to go through that and have those thoughts. I was going through one of life's most challenging moments.

For this type of surgery, they brought me down to minimal brain activity. And as I went into deep anesthesia, I thought again, if I didn't make it, what would my last words on earth be? But I remember, the Lord gave me peace. And the last words that came to my mind were, "I can do all things through Christ who strengthens me." I had nothing profound to say of my own; it had to be God's words that I wanted to return to Him.

I remember waking up from surgery and saying, "Are we done yet?" I wiggled my hands and my toes. There was no paralysis. The surgeon was able to completely remove the tumor. It was a miracle from God. I asked my neurosurgeon if I would still be able to attend medical school. "Are you sure I'm allowed to do all this?" I asked. He responded, "You can follow your dreams and do whatever you want to do."

That struggle confirmed in me that I was meant to be a doctor. Of course, there were some curveballs and some detours along the way. Initially, I thought that I wanted to be an adult neurologist, but God put a good mentor in my life who told me, "No, you are supposed to be a pediatric neuro-oncologist. I'm calling M. D. Anderson, and we are going to build a program." I never imagined that I would get back in the same area I had been a patient.

One thing I noticed is that you must have mentors in every area of your life. My greatest mentor is my mom. She's a woman of true grit. You learn the most from your direct mentor. She raised me as a single mom and did a beautiful job. Her sacrifice afforded me such fortunate circumstances. Because of her, I was able to go to the best schools, be involved in the best activities, and make the best grades. She was my constant cheerleader and champion.

When I was training in Houston in pediatric neuro-oncology, I said to my program leadership, "I'm willing to do a rotation anywhere. Where should I go? Where can I get the best training?" I wanted to have more exposure and an outside experience. They unanimously said, "Doing an away rotation at St. Jude Children's Research Hospital." So off I went for two months to Memphis, Tennessee, thinking this would be just a little blip on my life's journey. I got to do some external training at St. Jude. I never thought that I would end up working there.

After I finished the rotation, lo and behold, multiple comments were made confirming that I just belonged there. They offered me an opportunity to interview for a job, and I was offered the job. It's a dream place to work. Incredibly, everything is provided for free. St. Jude also offers some of the most incredible research, ensuring that the right clinical trials are offered to patients. I spent six years at St. Jude, and it was indeed a blessing to work there. I was a sponge, absorbing all that mentorship. I give credit to a great community of people who were mentors throughout my life. God brought good people into my life to help pave the way.

My biggest goal is for children to live their dreams. I was afforded the opportunity to live my dream, and I want to afford them the ability to make the most of every moment of their life. That is the biggest blessing and most significant reward. I believe that it's my duty.

I will say that the courage I had came after overcoming brain surgery and then going straight from that into the formative years of college, then medical school, and then residency. I mean, the path I chose is one of the longest training programs out there. The sleep deprivation you deal with is intense. And after having brain surgery, I was at risk for seizures. In my senior year of high school, I had a life-threatening episode of seizures. My biggest fear was, "Am I going to be able to do this?" The number one cause of seizures is sleep deprivation. I'm so thankful that I was able to able to overcome that. At one point, I even went to mentors in the program and said, "Is there a way to do this where I can, you know, not be on call as much?" They said, "Do you want to do twice as many years?" I was already signed up for seven years of extra training outside of medical school. I thought, "No, we will do this; we will get through this." And it all worked out.

I think my personal story has been the fan for the flame. No matter what work environment you are in, there will be behaviors, personalities, and communication styles that don't necessarily jibe with yours. There are certainly some toxic environments. I think knowing who I am and remembering why I'm doing what I'm doing has helped me persevere through all the different situations and challenges in my life.

The stress you see is a minuscule portion of what's going on. Try to consider where others are coming from. We are more than just our jobs. You don't know what they others are dealing with in their personal life. When they project onto you, don't take it personally. Try to let it go over you and not through you—that can cause you harm.

If we can realize that what we're going through is truly small, that helps realign our priorities. If we have perspective, I think we can have a better balance, and having balance is vital for me.

I would say that becoming a pediatric neuro-oncologist is probably one of the best things I could have done. I wanted to be a doctor, and I was actually thinking of a different specialty. But knowing that I have been given a purpose, having survived multiple life or death encounters, praying about where I can best be used, and having mentors encourage and guide me is the best confirmation that I am where I am meant to be.

Danny Thomas, the founder of St. Jude said, "All of us are born for a reason. But not all of us understand why success in life has nothing to do

with what you gain in life or accomplish for yourself. It's what you do for others." I could not have said it more perfectly. I knew that he wanted to give back in a way that God had given to him. He wanted to pay it forward by having this hospital. That is a success. It's not what we gain for ourselves. It's what we do for others that matters most.

What true grit means and looks like to me is my favorite verse, "I can do all things through Christ who strengthens me" (Philippians 4:13), because surviving my tumor was a pivotal moment in my life. It gave me the understanding that I can make it through any adversity and that there is a purpose even in adversity. The reason why I understood that I had a purpose and was going to make it is because of Philippians 1:6: "Being confident of this, the beginning good work in you will be faithful to complete it until the day of Christ Jesus." Therefore, I will continue in my work until Christ Jesus has returned to bring His children home.

ENTERTAINMENT:
TELEVISION,
FILM, ARTIST

BRENDA EPPERSON-MOORE

DAUGHTER, ACTRESS, AND
MOTIVATIONAL SPEAKER

I want to affect the world and not let the world infect me.
—BRENDA EPPERSON-MOORE

I cannot say that there was one single person who has helped me learn to rely on grit. There have been so many, but my mom would have to be at the top of the list. My father died when I was a little girl; I idolized him and saw him as the most amazing man ever. I would sit at his feet while he played his guitar and sang to me. I still have that Martin guitar. He died tragically in a car accident when he was on his way to Mexico to make a movie. I was so young, and my whole world suddenly flipped upside down. Nothing would ever be the same again.

I looked for strength from the closest women in my life, my mother and sister. I cannot even imagine how hard this was on my mom. Dad was between roles at the time, so the life insurance, car insurance, house insurance, and everything else had been put on hold. When he was killed, mom was left with nothing. I did not know what it was at the time, but I realize now just how much true grit she had to have to make it through. She had no degree, but she did have a couple of years of studying in a design school. She turned our garage into a studio and began sewing for people. My sister and I would play there as she worked, rolling around in the fabric and crawling under her table. That's how she made a living for us. I remember her hiding our car in a friend's garage so it would not be repossessed.

She refused to give up. She chose to stay the course. She did not rush out and start dating, looking desperately for another man in her life. She was very aware that she had two young daughters who depended on her. And she was determined to make a great life for my sister and me. She never knew this, but I saw her crying many nights, not knowing how she

would pay the bills or what she would do next. But she persevered. That's just one of the traits she passed on to me. She and my father were both creative, of course. I probably inherited the entertainment thing from him. That common interest drew me to him. I recall standing in front of a mirror with a hairbrush, pretending it was a microphone. I would try to sing like Donna Summer or Karen Carpenter. I loved all kinds of music.

My mom gave me a book that was life-changing for me. I was not a heavy reader except for my Bible, but she told me, "Brenda, I see something in you that is unique, something special; I want you to read this." It was *I'm Out to Change My World* by Ann Kimel. It tells the true story of a woman who had a great life. Everything was going well for her. And then everything changed. She ended up in a wheelchair. She could have just given up, but she took a tragedy and turned it into a triumph. She said, "I'm going to change my world, even though my world right now is sitting in a wheelchair." She did just that, inspiring so many people to carry on. And I thought, *wow*!

So I started changing my world by changing the little things first. Little things are so important, because they show the true character of someone. You can be lovely and wonderful on camera, but when the camera goes off, if you treat people horribly, you are only lying and cheating. That is not a person of good character. We all make mistakes, I understand that. But it is the little things that so often make such a big difference, not only in our lives but in the lives of others.

It had been so very hard when my father was killed. We had no money, so we moved in with my aunt and uncle. During this time, I was also holding a very dark secret. I was raped as a young girl, but no one knew. I kept it inside. I started to hate myself, everybody, and everything. And yet, God pierced that darkness that was inside of me and showed me the light of His love. We moved around then, from California to Nevada, and then to Oregon. I had a lot of struggles in school. I was bullied, I was spit on, I was called names. That was because I was a very heavy girl, a size 16 and 180 pounds. I know now that was mostly because I felt so much shame and discouragement in my life after all that had happened to me. The bullying only made it worse. But my mother was doing all she could do. Every Sunday, she made us go to church, and I am so thankful that she did. I started singing in church, tried out for choir in school,

and started doing pageants. I was sick of being bullied and went to work on my appearance.

About that time, I started to feel the power of the Holy Spirit. I would pray for kids and see them healed. I witnessed the supernatural power of God. That gave me the determination to want to better myself. I would just say, "God, I need help. I need to lose weight." And I did. Then I kept it off. I began to feel better about myself. As I lost weight, I became more confident, and people reacted to me differently.

I went to a small Christian college in Orange County, California, but because of money issues, I had to drop out. I wanted to get into acting, and I decided to see if God might help me live out that dream. And you know, He did! I was working as a waitress, making calls, looking for acting jobs, and doing auditions—all with no roles coming my way. Then one day, I was working hard, putting food on the tables at a big event at which several soap opera stars were making an appearance. My manager, who just happened to be there that day, pulled me aside and said, "I want you to go up to that girl that everybody says you look like. She just walked across the runway and she is backstage. Give her a glass of champagne and introduce yourself."

I did what he said. What did I have to lose? I walked up to her, sweating from all the hard waitressing work, food all over me, and I gave her the champagne. I told her, "You don't know me, but everybody tells me we look alike." She looked hard at me and said, "Oh my gosh, we do!" She could have told me to get lost or to stop bothering her, but she didn't. When I told her I was an aspiring actress, she went on, telling me, "You know what? I'm not going to renew my contract with the show. You should try out for the part."

I had done one little commercial job and a few odd jobs with the catering company, earning just enough money to pay my apartment rent and car payment. No food. No clothes. Not even money for gasoline. I rode my bike to the first audition at CBS—an audition for a part I had no business going after with my very limited experience. I had no agent. I bought clothes on credit from Nordstrom because I couldn't even afford the suit they wanted me to wear for the audition. I had to get my neighbor to take me to the callbacks. But I booked the job. I got the role of Ashley Abbot on *The Young and the Restless.*

I believe we so often stop running before we reach the finish line because we doubt ourselves and we doubt God. God is bigger. He just is. We have to keep moving forward through the doors that he opens.

When I advise other women who want to be actresses, I tell them to be who they are. Do not want success so much that you are willing to lose who you are just to get it. I had a chance to do *Playboy*, and quite often I was asked to do things I did not want to do to help secure a role. But I refused. Do not want something so badly that it becomes an idol you worship. My husband has a great saying: "If you want it bad, you'll get it bad." And that is so true. Now, with three daughters of my own, I am so proud that, with God's help, I held my ground and stayed true to who I was. I used to say, "What can I get and how much?" Now, I say, "What can I give and how much?"

I was sitting by the pool one day when I heard a voice in my ear saying, "I want you to do a women's Christian conference." I looked around. There was nobody else there. But I heard that voice three times, telling me to start the conference. Now, I'm not that kind of leader. I'm not an organizer. But I called Susan Weaver, a friend I had not spoken to in ten years, and told her what had happened. And without hesitation, she agreed to work with me on this project. She told me she had just been praying about starting the very kind of conference I was talking about. We had five hundred women attend that first meeting. Lives were changed. Souls were saved. Now we are a once or twice a year event and have been going for over ten years.

My life is so blessed. Like so many others, I have had to overcome adversity. I want to help people rise and find their calling. Imagine a world where all of us are moving along the path toward the purpose and the plans and the destiny that God has for us. Imagine that we are leaving behind anger, bitterness, unforgiveness, and pity. Instead, we are moving forward into the hopes and the promises and the bright future. Imagine what a world it would be.

Grit is being firm in our behavior, persevering, and having a passion for achieving long-term success and goals. It has nothing to do with your IQ, your upbringing, or any birthright you think you might have. It means to me that when you go forward undeterred, according to God's plan for you, then your life takes on so much more purpose and meaning. That is true grit!

Each one of us has a destiny. True grit does not discriminate. If we persevere, if we are determined, if we believe that we can overcome, we can do all things through Christ who strengthens us. I've relied on true grit to endure setbacks and have courage in the face of defeat. But to me, there is no defeat. We can all be overcomers. We are only as defeated as we choose to be. We do not retreat and feel sorry for ourselves. We pick ourselves up, and we move forward once again.

CAROLYN MCDONALD

EXECUTIVE PRODUCER FOR HBO'S *AMERICA'S DREAM* AND TRAVEL ENTHUSIAST

When the going gets tough, the tough get going.
—UNKNOWN

My great-grandmother, Martha-Jane, who raised me, exemplified more true grit than anyone else in my life. After becoming a widow in her early twenties, with two small children to raise by herself, she decided to move to Baltimore, Maryland, to try to find work. This was in the 1920s, which was an especially challenging time for people of color. She was a master seamstress, creative and talented. I am convinced that had she been born at another time and lived in a different place—and, of course, had been of a lighter hue—she would have been recognized as a noted fashion designer. But consider that in addition to these challenges, she also married a second time, to a man who was an alcoholic and a womanizer. She had no choice. She returned to the backwoods of North Carolina, where she contracted asthma and eventually passed away from heart failure. I am sure that was partly due to the stress placed upon her, and maybe, too, from the frustration of not being able to do the thing at which she was so gifted.

Despite all this hardship, Martha-Jane exuded true grit. She worked the farm, taught me to read and write before I went to first grade, and made just about every stitch of clothing I wore from the time I was born until the day she died, when I was twelve years old. She taught me the Lord's Prayer, which we dutifully said every single night, both of us kneeling beside my bed. She also encouraged my little-girl ambitions by making costumes for my school plays. She indulged my fantasies by giving me leftover fabric strips that I could use for my homemade "ice skates," which I constructed of magazine pages. While she did not appear to have much vision for herself, she enthusiastically fed mine. She never allowed me to harbor the perception

that I could not do or be anything I set my mind to because of the color of my skin.

There are no words to express my love for her, or the gratitude I feel for her sharing her spirit of true grit with me. She certainly played a huge part in making me the woman I am today.

Regardless of how dire my external circumstances may have appeared to be at times during my life, my inner faith in God, and this deep sense that I was born for a purpose, has always led me to persevere, to fulfill those big dreams.

Have I always found my grandmother's true grit when I needed it the most? Unfortunately not. The most notable time came as the result of an incidence of shaming. It was a classic example of the ever-so-cliché Hollywood backstabbing. But cliché or not, it happens. All the time. Severely more vicious, yet infinitely less necessary than a southern ass-whooping, Hollywood backstabbing can be as demoralizing as any other painful heartbreak.

This incident was complicated. It involved an agent who publicly humiliated me. She set up a situation that made it appear that I had lied to another powerful agent and that I had done so to keep his client from being stolen away from him and his agency. When I saw the so-called true story splashed across the front page of *Daily Variety*, one of the top industry newspapers, I had a panic attack. I could see a career that I had worked so hard to build—and a reputation I had built on honest, straightforward dealings—all swirling down the drain. I could even hear the musical soundtrack from the infamous *Psycho* shower scene shrieking in my ears.

I could see no way to salvage this situation. The more I denied the false charges, the more some would believe them to be true. I began a self-imposed exile deep in rural Tennessee and took a job answering the phones at a bankruptcy law office—far, far away from the "Hills of Beverly."

Even though I had won or been nominated for every film I had produced, my damaged psyche regressed to that of a hurt teenager. Without realizing it, I had forgotten my grandmother's true grit lessons. I had abandoned my hard-won expertise. I had allowed my passion for my dreams to be diminished by someone with an agenda against me. And I had done it all without even fighting back. By allowing what I thought someone thought of me to

rob me of my vision, my love for my art, craft, and expertise, I had simply given up.

I now realize that my situation was not at all different from what happened to the Apostle Peter when he was walking on the water beside Jesus. When he allowed the wind and waves to frighten him and he questioned Christ's faith and abilities, Jesus asked him, "Oh, you of little faith, why do you doubt Me?"

And that was how I ultimately decided that the harvest from this tumultuous situation in my life and career would allow me to return to my first love of writing. To create poetry, screenplays, essays, a comedy series, and endless journals filled with musings and rants. What I had seen as atrocities of mythological proportions had spawned creative work that ended up bringing me even greater personal satisfaction and renewed prosperity to all areas of my life. And I am most excited to be back in Hollywood producing works that I have created myself.

I suppose this ended up being an example of re-learning the value of finding the grit necessary to persevere. But it was not the only recent heartbreak that required me to dig deep and pull out the true grit I must have forgotten I had inside me.

As a self-declared globetrotting loner, I never thought I would meet a man with whom I would have so much in common. But I did! As I fell madly in love with him, as we shared our love for art, delicious meals, bonding trips, and playdates, I fell deeper and deeper. We traded stories about our dysfunctional upbringings, interlaced with our creative dreams for overcoming our pasts. And we made elaborate plans to travel together.

Then one day, with no warning at all, he discarded me. I felt as if I had been struck in the head with a two-by-four! As if my heart was being sliced and diced in a Cuisinart. In less than sixty seconds, someone I had spoken with daily for almost a year informed me that he wanted nothing else to do with me. I know. We have all suffered break-ups when the heart's well runs dry of passion for another. I had even been through a painful divorce myself.

However, not since I lost my great-grandmother suddenly when I was twelve years old had I felt such emotional despair. I cried for forty-eight days straight. But when I finally began to analyze the situation—and once again

called upon my inner grit—this emotionally excruciating labor gave birth to a bushel of revelations that helped me get over the trauma I was feeling.

First, just because someone can colorfully articulate their childhood traumas does not mean they are truly working to heal them. Sometimes their every action is driven by that upbringing that still plagues them.

Second, in the blink of an eye, anything can trigger that supposedly hidden trauma. And when it does, it can evoke a subconsciously unmerited response to what was intended to be the most loving exchange. After all, for someone who does not quite know how to love, or who has never experienced real love, such an exchange can trigger something self-destructive.

I certainly had my childhood abandonment sufferings stemming from my great-grandmother's unexpected death. Now, this abrupt rejection by someone else I had come to love triggered a sorrow that unleashed a wide spectrum of emotions. Great rage and anger suddenly blossomed into the discovery of healing truths. Hurt people will inevitably hurt people. Broken people are much more likely to break people. Anyone who would so brutally destroy someone who offered such great love was in far worse shape spiritually and emotionally than I was.

Give credit to true grit. Or to my great-grandmother. Or to God. But ultimately, the fruits of this painful situation resulted in something far more beautiful. It led to a transformation for me that included a whole new level of wholeness and self-love.

Several names come to mind when I think of people in my life who have demonstrated that unique quality we call true grit. The term itself, to me, means someone who maintains both stamina and integrity amid the most challenging times. And beyond that, it means embracing a negative— maybe devastating—situation and finding something good that ultimately can come out of it. To put it simply, true grit is the process of birthing greatness through pain.

CECE WINANS

DAUGHTER, SISTER, WIFE, MOTHER, BEST-SELLING AND MOST-AWARDED FEMALE GOSPEL ARTIST

I can do all things through Christ who strengthens me.
—PHILIPPIANS 4:13

My mom was awesome, and that's where I get a bunch of my grit. But growing up in the church, the truth is I had plenty of moms. Church moms. I had people who were older and more experienced pour their wisdom into me, and I am so grateful for that today. And there were people in the music business who were mother figures too. People like Tramaine Hawkins, who took me under her wing and was always available for me anytime I needed her. And she is such a role model, full of grace and with that incredible voice of hers.

As a child, I never really thought I would sing for a living. But music has always been a part of my life. I was probably eight years old, singing in the church choir, when I did my first solo. My mom and dad met in their teens when they were singing in the youth choir. They got married, and we all came along, singing in church. It was just something natural for us to do, and we probably took it for granted. When I was about fifteen years old, I started doing recording session work, singing background vocals. I did a session with Andre Crouch, and they get no bigger than him.

Of course, my family was always doing concerts around Detroit. We just grew up singing together. Eventually, I realized that what I had was a gift that was given to me as more than just a hobby or something to be taken for granted. He had a purpose. My singing ability became a call. As I grew older, both as a person and as a spiritual person, I knew that God had given me a gift and I was supposed to use it for His glory. My brother and I took the song "Love Lift Us Up" from the movie *An Officer and a Gentleman* and changed it to "Lord Lift Us Up." It was from that song that we started,

traveling all over, singing for audiences. I was seventeen or eighteen, but I knew God was calling me to bring joy and the gospel message, the good news, to people through songs.

But back then, I could have never imagined all the things that have happened to me since. I just had a vision of God, allowing Him to use me in the way He wanted to do His work. I had no desire to get wrapped up in the music business world, the industry, or becoming rich or famous. I just wanted to heed His call. When things were tough, or when I was not sure which way to go, I said a prayer. *Lord, lead me where you want me to go.* And you know what? He has done just that.

Mine was a big family. I had seven older brothers and two younger sisters. Ten of us! We were so happy just to be singing that we put on our shows there at the house. We even held our own Grammy Awards with fake crowd noise! So when I won that first real Grammy, it was like, *whoa!* I never really thought I would be there. That was all just make-believe. I never planned to win a Grammy or sell so many records. I could never say that award was mine. It was through God that I received it. Through him, my aim has always been to do things in excellence, but to be sure I landed where God wanted me to land. After all, He had told me to keep visualizing not what was happening but what I wanted to happen, and I would see miracles take place.

I am not saying you should not have a plan. A plan is a good thing. Growing up in Detroit, doing all that singing, I planned to go to school to be a court reporter. Singing was just something I did, like breathing. It was not going to be a career. My parents almost had to make me record that first song. Then, when I heard God's call to use my voice to deliver His message, I was on my way.

I did not plan to fall in love with and marry Alvin Love, either. I first met him at a bowling alley. I know—not very romantic. It was a youth church activity, and we were all bowling. He was visiting someone who was at the event that night, and then he was at church with his friend the next day. We just started talking. I liked him. He was cute. But you know what? That first weekend, as we talked with each other and got to know each other, he told me he believed he wanted to marry me. I was not thinking about marriage at all. Not at that time. We started dating, I talked with my parents and my

pastor, and we got engaged. We ended up getting married within a year of that first meeting at the bowling alley. It has been thirty-seven years now.

Things have not always been that easy. There are hard times and scary situations in all our lives. But life has never been scary for me. That's because when you put God first instead of all the other things so many of us put first, He knows the end from the beginning. He knows what we need to do to navigate that path, and He will show us the way if we only listen. I am a believer who happens to be a woman. I'm a believer who happens to be an African American. None of that matters because believing in God and putting Him first is the most important thing. Just follow the things He puts in your heart. When doors close, I thank God for all the doors that open. When you trust Him, you can take one day at a time, because you know He will bring the right people into your life at the right time. If you are not sure what to do about this or that, you should relax. Don't stress about it. Just trust God. He will show you the right thing to do.

I was blessed to have great examples in my life when it came to being married. My parents and grandparents did not know what "marriage counseling" was. They went to the Bible and our pastor for guidance on how to have a happy, long-lasting marriage. The pastor told them, and then he told Alvin and me, "Okay, you love the Lord. You love her. You love him. Get married." Then you pray the bad stuff away when it happens. Follow the Golden Rule. Do unto others as you would have them do unto you. My parents also told us to laugh a lot. Don't take yourself too seriously. Every marriage is going to have its ups and downs. But anyone can have the marriage they want if they just decide to do it. Oh, and have God in it, of course. I do not know how people can stay married if they don't have God in the partnership.

Naturally, both my son and daughter are musical. My son is a great writer and producer. He wrote and produced my last record, which won two Grammys. But you know, I had to humble myself because I was taking instructions all the time from him. He would say, "No, Mom. You need to do that part again." I wanted to tell him that I was doing this before he was ever thought of, but I knew he had an ear for what was best, and I needed to humble myself and listen to what he was telling me. Many don't believe it, but I think every generation gets better than the previous one. And it should.

As parents, we want our children to do more and have more than we did. My parents were the same way. So instead of arguing or pushing back, I listened to what he was telling me. And he was right.

My new album is a live recording. People are still recovering from this pandemic. People lost family members. We have been so isolated. Some people have not been to church in over a year now. That was why I wanted to do a live album, to create that experience of being in the church in the middle of a crowd. I want people to feel renewed hope and joy. I want them to have faith that things will get better. Hey, if you are breathing, you still have a purpose!

During the pandemic year, Alvin and I have been busy. We are renovating a building we bought to create a new building for our church: Nashville Life Church. The church is so diverse and filled with young people. It is hard to believe that it all started in our living room. So many young people today don't have strong mothers or fathers, people who speak into their lives like I was blessed to have. When we started the church, such a thing was not even on our radar. But God put it in our hearts to pastor. He made it clear. He wanted us to shepherd his people, teach them the word. And a big part of shepherding our flock is parenting. We believe that the older we get, the more valuable we become. Our culture may not necessarily believe that, but those who have lived more of life have gained more knowledge and understanding. And wisdom too. People need what we can bring.

There was a time when my son was growing up that he lost his mind for a while, as all kids do. I had met a lady—an older lady, by the way—who had been through a similar situation with her daughter. She taught me the importance of demonstrating the power of faith to your children, so I decided to try it with my boy. One day, he and I were having one of those heated moments, one in which he once again resisted my belief in God. I just could not seem to get through to him. I looked at him and said, "You are a mighty man of God. You will use every gift that you have to give God glory." He gave me that look and said, "You don't even believe that yourself."

You know what? He was right. And I knew he was right. I was only speaking what I hoped for, not what I believed to be true. But I developed some grit. I kept praying. For me and for him. He went away, all the way to Australia, to get away from us and to get away from God. But God found

him down there. And He got a hold of him when he went to a church service in Melbourne. When he came back home, he was a mighty man of God, just as I had prayed he would be. And you know what else? He is using that gift to give God the glory. Today, my son is the lead pastor in our church.

We all hit rough times. But you don't give up. You stay faithful. You stay consistent, taking one day at a time. You keep speaking not what you see but what you want to see, and you will see miracles happen.

One of my favorite verses from the Bible is, "I can do all things through Christ, who strengthens me." That tells me that even in our roughest times, we are not alone. God is with us. Somehow life has a way of mixing the good with the bad, but that mixture ends up being something great and powerful. If you are on the mountain top, you might not appreciate being in the valley, or the other way around. But they can both offer wonderful experiences. If you just keep walking, stay faithful, use that grit we all have inside us, and not give up, you will find that happy place, and things will work out for you, that is what having true grit is all about.

CONROY KANTER

MODEL, ACTRESS, MOTHER, PRODUCER, AND HUMAN RIGHTS ADVOCATE

In a world where you can be anything, be kind.
—UNKNOWN

My father was an engineer for Westinghouse. His job required us to move every single year. But, when you grow up this way, you don't think of it as odd, crazy, or difficult—it's just how life goes. My mother was a teacher with a master's degree. I don't think she ever made more than fifty thousand dollars a year. Even with all that education, she never made money, but she loved molding first-grade minds. She had a new job in every place we moved: Baltimore, Key West, Las Vegas, and even Tyler, Texas. We got to live in some incredible places.

We spent the summers with my maternal grandparents, Grandpa and Nanny McCain, in Cleveland, Mississippi. We eventually moved there after Nanny McCain had a stroke. Yes, I am a distant cousin of John McCain. And yes, I did get to meet him. Out of twelve years of school, I had gone to nine different schools. Being the new girl every year, I learned how to navigate walking into a room full of strangers. This instilled a sense of confidence and grit into my character at a young age. The constant change made me resilient and open to change. If I had always lived in one place, I don't know whether I would've traveled to forty-one different countries or hiked the Dolomites and Nepal.

The determination of my mother and my aunt Evelyn inspired me. During the second world war, Aunt Evelyn traveled all the way from Mississippi to Reno, Nevada, to see her fiancé ship out. I can't imagine traveling that distance knowing the whole time that this may be the last time you see the man you love. She was also a great cheerleader of mine. Aunt Evelyn

would always tell me that I was smart, I was pretty, I was brave, and I could do whatever I wanted to do.

I wanted to become a model, so I did just that. I was signed to Elite Modeling Agency. Modeling took me all over the world. I would be in Munich, then I would head to the Canary Islands, and then Milan. I got a great education from working in other countries and experiencing other cultures. It was an exhilarating experience to be twenty-one and have a thousand dollars in your pocket. I will admit I made good money. But it was during a photoshoot in New York City when my hair froze into icicles that I knew I was done with modeling. I had a friend in Los Angeles, and I decided "that sounds warm—let's go."

Modeling prepared me for my work on camera. After moving to LA, I started taking acting classes and studied for eight years. I had some bit parts. I did some commercials, and I even had a role in a Disney movie. Acting taught me a lot about myself: how to feel my emotions, speak up, and speak out. These would become essential tools in my future career as a social impact filmmaker.

LA is also where I met my husband. He had grown up in Hollywood, and he brought me into a whole new world of LA glamour. My father-in-law, Joe Kanter, was a true mentor to me. He was in the business for a minute and made two movies. One of them was *Ironweed*, which starred Jack Nicholson and Meryl Streep and was nominated for an Academy Award. But my father-in-law's main business was development. He built strip malls, mini-cities, and apartment buildings all over the Midwest and LA.

Papa Joe was a good mentor, but he did discourage me from working in the film business. He told me, "This is no place for a young lady." But I had been bit by the bug, and he knew that and helped me anyway. He never lent me money to make a film. But Papa Joe would help set up meetings and read over scripts. Once I had a few films under my belt, he was my biggest cheerleader.

My husband and I also gave him two wonderful grandchildren, a boy and a girl, and I embraced the Jewish religion. I was a good Mississippi girl raised as a Southern Baptist, but it was important to me that my children should know both. So I took lessons in Hebrew and Judaism. They both had

a Bar and Bat Mitzvah, and as a family we celebrated both Hanukkah and Christmas.

Things may have looked good from the outside, but my marriage was disintegrating. Even though my in-laws were supportive of my career, my husband was not. Sadly, we divorced. It is a devastating thing to build a life and family together, not only with your husband but between two families, and have it all fall apart. It took grit to overcome the sorrow of divorce.

I got into production because I was so genuinely curious about everything I was seeing on set. And one day, a director friend of mine asked me if I could help him acquire some locations in Malibu where I live. My philosophy is if you don't ask the question the answer is no. So I went around to all my neighbors asking: Can we shoot at your ranch? Can we use it for like thirty days? Can we shoot there for free?

You would be surprised at what people will say yes to. We were shooting a scene in a hospital room, and I had a doctor friend who allowed me to use his urgent care office to shoot. He told me we had the building from seven at night until seven in the morning, and then he handed me the keys to the building and said, "Just don't get into the drug cabinet." I thought, *This is too much responsibility.* But that's how I learned to be a producer: by doing.

In 2006, I opened KK Ranch Productions, Inc., in Malibu, California, after being an associate producer on my first film. I not only enjoyed being on set in front of the camera acting in this film, but as a producer being behind the camera as well. I had two young children at the time, but I knew at some point I would be an empty nester and a new chapter in my life would start, just as the previous chapters in my life had gotten me to this point.

Aside from giving birth to my children, there is nothing like being on set in pre-production for thirteen hours a day for weeks. And then you get to see all your hard work come together in the editing room.

It was God's providence that led me to the script for *Trafficked*. I had been invited to a producer screening at the Chinese Embassy in Los Angeles. And that's where I met Elizabeth Stanley, one of the executive producers of *Trafficked*. We started talking, and she told me about this project that she had been trying to get funded for six years. When she told me the movie was about trafficking I just thought, "That is such a dark subject." But she

gave me the script anyway. I have a rule when reading scripts: I have to want to read past page eleven. If I don't want to spend the next hour reading it, then I sure won't want to watch it. But this script reeled me in and wouldn't let me go.

I think this was the point at which my love for film became a "calling" for me. Social Impact Filmmaking has become my medium for change, bringing awareness to issues in our world. As a filmmaker/storyteller, my mission is to take an audience into a different world and inspire a "call to action." Working on *Trafficked,* I learned my passion for filmmaking could be used to incite change through the power of film.

The writer of *Trafficked*, Siddharth Kara, is a professor at Harvard University. He wrote the book on which his script is based, *Inside the Business of Modern Day Slavery*. Meeting him and reading his work opened my eyes. I didn't know that human trafficking generates $150 billion a year. I didn't know that the average age of victims was twelve. I didn't know that runaways were the main targets and that predators are looking for children from unhappy homes so they can coax them away from their parents. After learning all this, I could not be silent anymore. I was on board for the project.

While Ashley Judd was getting her master's at Harvard, she met Siddharth. She told him that she believed in what he was doing and told him that if he ever needed her help he should give her a call. It was a bit nerve-wracking calling her agent, Michelle Bowen, at one of the biggest talent agencies in the world, William Morris. I had mustered up all that courage only to find out that her agent was on vacation. The good news was that she had been waiting for my call, and she called me back shortly after with more good news—Ashley would do the movie! Not only was she generous with her time, but she also cut her rate so that we could keep the movie on budget.

When the movie came out, there was quite a bit of criticism that Ashley Judd's character, the social worker, would never traffic children. But we know that is not true. There are priests, police officers, coaches, and doctors who abuse and traffic children. You can't just look at a person and know who to trust. This world is full of wolves in sheep's clothing.

When we screened the film in Houston, Texas, for mayor Turner, we had a representative from a charity that seeks to end human trafficking on our panel. She told us that as violent as the film may seem, it is realistic. She

knew a young woman who had escaped her captors through an air conditioning duct. But the girl who had tried to escape before her was not so lucky. They caught her and killed her in front of the other girls to make an example out of her. Her willingness to die if caught tells you what vile things these people endure.

One thing we did to promote the film was to screen it at the United Nations in New York City. Siddharth works at the UN, so we were able to set up a screening for four hundred dignitaries to approve the film in their countries. When the movie ended, we got a standing ovation. We did have to cut a scene where Indian generals were involved in weapons and human trafficking. The dignitaries from India told us that would never happen, so we cut it so that the film would be allowed to screen in India.

As it happened, the next day at the UN there was a debate about legislation to give money to a country to fight human trafficking. The Austrian ambassador stood up and asked the room full of dignitaries whether the debate they were having was even necessary after watching our film. The legislation passed on the spot. I am so thankful that the story we told was able to affect people so deeply and directly.

I have discovered, though this wonderful world of filmmaking, that people can identify with a character in a movie and join them in a whole new world. Sometimes it's a dark world, like in *Trafficked*, which takes us into the world of human trafficking that is happening in our own backyards. When a person can relate to a film character, then they can imagine this could be them, or their child, or their sister; this can inspire people to action.

Seeing all the darkness trafficking has caused for young women during production of this film changed my heart toward the kinds of projects I wanted to be a part of in the future. I met a girl at a shelter who had been sold into trafficking at age eleven and rescued at age sixteen. This young woman was so full of life and happiness despite what she had been through. She told me, "I'm so happy to be here. Even though my family doesn't want me, I'm family to these other girls who come here. I can help them because I've been through it too." She was attending school and planning to go to college. With all the darkness trafficking causes, it was so hopeful to see this surviving, thriving woman.

During this latest chapter of my life, I have learned to appreciate my children and motherhood more than ever. I have also discovered how the power of one-on-one time with a person can really make a difference in people's lives. I believe true grit is finding the courage to push through life's situations and make contributions for better tomorrows. Although the Covid pandemic has stopped our travels, I am now working on two new productions. Stay tuned...

IRLENE MANDRELL

DAUGHTER, SISTER, WIFE, MOTHER, MUSICIAN, ACTRESS, AND WRITER

Help one another is part of the religion of our sisterhood.
—LOUISA MAY ALCOTT

Mom and Dad taught us to love God, country, and family. They didn't just say it. You knew their love was genuine. We always seemed to be pretty well off financially growing up, but as an adult I realize how hard my parents worked to make sure they could give us all we needed and wanted. One Christmas, when Louise and I were very young, we asked for these two red velvet dresses that we had fallen in love with. Santa had already bought us lots of toys that we had asked for. Mom sat us down and very matter-of-factly told us we could not afford the dresses we so badly wanted. But then, when Christmas came, there they were! When we were much older, we found out that Daddy had gone out and gotten an extra job before Christmas just to make sure he could buy us those red velvet dresses.

I could go on and on about how amazing my dad was, but this is about women with true grit. And my mother absolutely qualifies in that department. She is the woman I strive most to be like. As a young teenager, Mama played piano in her brothers' church. After she married Dad and moved away from where she grew up, she went to a business college. That was because she knew the value of having a skill, and she wanted to be able to get the best job possible. After just a couple of months, they called her in and told her the school could not teach her anything she didn't already know. Instead, they sent her to a local employment agency. They gave her an aptitude test and sent her straight to the state capital to start work. A bit later, Mom and Dad moved to Texas. Mom applied for work at a US Navy base. Once again, they gave her an aptitude, typing, and shorthand test. There was only one job opening, and she got it.

A few years later, they moved to California. My dad decided to start a band to perform at all the military bases in the area. By this time, Barbara was a teenager, and she already played steel guitar and saxophone and sang. So of course, Dad hired her as part of the band. He also hired Ken Dudney to play drums, but they needed a bass player. So Mom learned the bass guitar. She was good at it—as she was at everything else she did. Having played the piano, she had a great understanding of music, and it was easy for her to learn bass.

Even though my mom had a phobia of flying, she went with the band for two overseas tours during the Vietnam war. They did not perform with the USO; they were booked by a private promoter who sent them to places that normally did not get live entertainment. It was more dangerous for them to go to those places, but it meant a lot for the morale of our troops.

Meanwhile, back at home, Louise and I—both of us too young at this point to be in a band flying all over the world—were staying with Uncle Al and Aunt Lynda. We loved them very much, but we still didn't like being left behind. That was when Louise and I decided to learn our instruments and play so well they would have to let us join the band. Louise learned bass from Mom, who had decided she did not want to get on an airplane again. I learned drums from a few different people, but mostly Ken. He had been the drummer in the band but was leaving to become a Navy pilot. And, not long after, he ultimately became Barbara's husband and my brother-in-law. I also learned a lot by staying with my Uncle Al. Being a Dixieland jazz drummer, he had a nice set of drums. Louise and I worked hard and were certain we were now good enough to take our place in the band.

But then everything changed. After returning home from the second overseas tour, Barbara married Ken and announced that she was retiring from the music business at the ripe old age of eighteen years. Louise and I were so disappointed. After that, the family moved to Tennessee—but without Barbara. She headed to Washington state, where Ken was stationed with the navy. My dad's other brother, Uncle Ira, lived in Tennessee. He and Dad had decided to go into business together building houses. Louise would not let us give up though. She told me to keep practicing, because Barbara would never stay out of the music business. Louise might have been young, but she was wise for her years. When Ken was stationed in Europe, Barbara

came to stay with us for a while. We lived in Newbern, Tennessee, not far from Nashville. Being so close to Music City, she and dad went to the Grand Ole Opry several times. There, sitting in the audience watching everyone else perform in that historic building and seeing the reaction of the enthusiastic audience, she announced to Dad that she simply could not just sit there watching. She needed to perform again. Dad agreed to manage her if she promised him she would stick with it. So we moved to Nashville. Barbara got a recording contract, and the rest is, as they say, history. From the title of her hit record, "Do Right Woman, Do Right Man," she named her band The Do-Rights. And just as Louise had anticipated, she and I became part of the group.

I'm sure you can tell by the story that we were never told that a certain instrument was reserved just for men to play, or that there was anything we couldn't do just because we were girls. I did have many people tell me that they had never seen a girl drummer before. Or some would say, "You play good for a girl." I knew they were complimenting me, but I just wanted to be a great drummer, girl or not. Looking back, though, I am honored to be mentioned as being among the first female drummers and to hear that I opened the door for other females to become drummers.

When you think about true grit, you think about setting a goal and sticking with it no matter what. This is true, but sometimes you do give up on that goal. Your heart just changes. It is important to be willing to change when your desires change. I desired to be the best drummer ever. However, that would have meant spending every moment practicing. I enjoyed playing, yes, but there were other things I liked too. I had started modeling, and I began taking acting classes.

It all worked out very well when, not long after that, my sisters asked me if I wanted to join them in doing a national network television show. Everything I had been doing helped me prepare for the show. That included my mindset about wanting to do new things. Because of some health problems with Barbara, the show ended after a couple of years, but we still had great ratings. The doctor told her if she did another season, she might not be able to sing again. Louise and I hated it—for her as well as for us—but of course, we understood. Ending the TV show was the only option.

Doing the show did change one big thing in me. As a drummer in The Do-Rights, I hadn't cared about singing or working the front of the stage. Now, I realized just how much I loved being in the limelight. That realization led me to appear as a regular on the *Hee Haw* television show over the last eight years of the program's life. I did have an understanding with the show's wonderful producer, the late Sam Lovullo, that I would be able to start my family while taping the show. He told me, "Irlene, we love kids. That is not a problem at all."

I had my oldest son, Deric, and my oldest daughter, Vanessa, during my *Hee Haw* years. Later, my youngest daughter, Christina, with my second husband, came along. Even though Christina is the youngest, she was the first to get married, and she has given me a beautiful granddaughter named Blakely.

I married for the third time about five years ago, to Pat Holt. I had known him for a long time but hadn't seen him in about thirty years. I had never been that interested in recording before, but Pat was a wonderful producer and a Vietnam veteran. That led us to do something we had been wanting to do for a while: an album especially for our military and first responders. Both our dads were World War II veterans, and my dad had also been a police officer. So obviously, this project was very near and dear to our hearts. After that, we decided to cut some country songs, since that's where we both have our roots.

A couple of years ago, I wrote a book called *God Rains Miracles*. It was based on stories that I had kept in a journal about my family and friends. I believe that sharing miracles helps people realize that it can happen for them too. Since the book seems to be a blessing to people, I have started a radio show, also called *God Rains Miracles*. It's on the air every Sunday on Renegade Radio Nashville, and each show has a different guest who shares his or her miracles.

I am also looking forward to my next single record, which will be a Christian song. When I heard it, it brought tears to my eyes, because it touched my heart. God has blessed my life so much that I just love sharing His word in the best way I can, through music.

Even though I have been through a few deep, dark valleys, I have been blessed to live a truly wonderful life. It's been a great journey, and I have

never been happier than I am now. I plan to just keep following my heart and God. That has certainly worked out well for me so far.

To me, having true grit means navigating these dark valleys through inner strength while spreading the joy and love you want to see in the world.

JEANNIE SEELY

SINGER, ADVOCATE, AUTHOR, GRAMMY AWARD WINNER

Happiness is a choice.
—Unknown

I knew what I wanted to do in life and where I wanted to do it when I was eight years old, still in third grade. I sang in a little school program, and when I saw the kids smiling and heard them applauding for me, I thought to myself, "Jeannie, this is it! How could anything possibly be better than this?"

My family has a story that proves how destined I was for the stage. My dad was building what he intended to be a chicken coop. My mother told him she did not want chickens. "They make a mess everywhere, and I'm not going to put up with that," she informed him. While they were discussing the situation, I moved right in and made the coop my playhouse. My dad went ahead and put in some partitions and set it all up as a chicken coop. My brother played guitar, so he and I came up with an idea. We took the partitions down, strung a clothesline across the back of the coop, and draped a sheet across it. We made that chicken coop our little stage.

I was very fortunate, because my mother always encouraged me to do what I wanted to do and to not be so quick to give up. She was a strong woman, as we saw in the chicken coop incident, and she would tell me, "If you think you are beaten, you are. And if you think you can't, you won't."

Even though we grew up in the country, I never really learned how to cook, unlike most girls in that time and place. My parents would not let us, because they wanted to encourage our singing and playing. They would tell us, "You kids go play music. We'll cook supper!" We would perform at get-togethers in the area and family gatherings. That's where I learned the simple basics of being able to entertain people. I also got to sing on radio

stations around the area, and that helped me learn to communicate with an audience, even if you cannot see them.

The first thing I realized was that when you walk out on that stage, it is not about you. Don't worry about what you're wearing or what you need to do after the show. The people in the audience do not care. They want to see and hear you, but they paid to come have a good time and take their minds away from their problems. That's what an entertainer's job is. It's not about me. It's about them. I have to make sure they have a good time.

I also learned early that the music business can be tough. Anyone in the public eye is going to get criticized. That is a fact. But you may not know it until it hits you. At the beginning of my professional career, everybody was on my team. They all told me how great this record was or how wonderful that night's performance had been. But then, as my career grew, many of them were not nearly so pleased. I began to hear snide comments or hurtful gossip, and I was crushed. Then my ex-husband, singer and songwriter Hank Cochran, explained it to me. "When that kind of stuff starts, it just means you're finally doing it right. When they're all patting you on the back, that just shows they don't see you as a threat to them. They decide you don't have what it takes. So, when they start their criticism, it means you are on the right path."

I soon learned the importance of having people around you that you can trust, even if that is a very small circle. You need people who will support you and tell you what you need to hear. You don't need people who will tell you what they *think* you want to hear or who have a selfish agenda. My circle starts with my family, and they have always been supportive of me. I am the youngest of four. I've already mentioned my mother and father, who encouraged our music so much. My late oldest brother and the lady who would become his wife used to take me with them when they would go to dances. They knew how much I enjoyed listening to the music and that sometimes I would even get a chance to sing with the band. They were proud of me and didn't mind dragging the little sister along on their dates.

My husband, Gene Ward, is a wonderful guy and is also very supportive of my continuing my career. Of course, he is handy to have around sometimes since he is a lawyer—my in-house attorney.

Friends are certainly a necessity too. Since the early days of my career, country music star Dottie West has been one of the most valuable to me.

That was because she was always so dead honest. We were completely honest with each other, and that is a quality I seek in my friends now. The first time I met Dottie, I went to see her at the Palomino Club in North Hollywood. I knew about her because she used to perform on the old *Landmark Jamboree* television show near where I grew up in Ohio. After her set at the Palomino, I just marched right up and introduced myself to Dottie and mentioned seeing her on the *Jamboree*. She was mightily impressed somebody remembered, and from there, we ended up going back to my place, sitting, singing, and swapping stories most of the night.

If we cannot be honest with each other, then what is a friendship based on? Like I have one friend who, if she sees me in the wrong outfit, will come right out and ask me, "Jeannie, is your mirror broke?"

I also appreciate the support of my fans. Many of them have grown up with me. A lady once told me, "When we were first dating, my husband and I danced to your song, 'Don't Touch Me.' Then we rocked our baby to sleep to 'Can I Sleep in Your Arms Tonight?'" I told her thank you and said, "Well, we'll just need to grow old together then."

People always ask how I can keep going. The first thing is you have to take care of yourself physically. Growing up so far out in the country, we always had a garden, and we ate fresh vegetables. We had no restaurants and certainly no fast food. Plus, we did not have money for them anyway. I still do not like fast food, and I make sure to eat healthily.

You also need to stay healthy mentally. To me, that requires that you be who you are. Be true to yourself. Then tell the truth so other people know who you are. That can prevent all kinds of misunderstandings. And if you tell the truth, you do not have to remember what lies you have told and to whom—and that certainly avoids a ton of stress! You and I may not always agree, but we will know where we both stand. And I do believe you have to stand up for what you believe. That is not only a right but a duty too.

One place I have done that is in pushing to allow women to host a portion of the Opry. For many years, all of the hosts were men. Talented men, yes, but we had some talented women on the Opry too. When each new Opry manager started, I would make an appointment, sit down with him, and explain why I thought such a move was important. The response was always, "Well, Jeannie, it's just the tradition here at the Grand Ole Opry."

When Bob Whitaker took over as manager of the Opry, I found someone who seriously listened to me. He was not even aware of the "tradition." He thought about it for a while and then called me back. "Okay, Seely, I'm going to run you out there, but you better be able to do the job, or you and I are both in trouble." I am still doing it! There is still discrimination against women, of course, but things are changing, and I am proud that I was able to do a little bit to push things in that direction.

The business may have changed, but I believe you still have to keep doing the basics. Here is what I tell new artists all the time. Sing whenever and wherever they'll let you. Get heard and network. Network with everybody. Do not look at other female artists or writers as competition. Look at them as your ally—someone who understands you and what you are trying to do.

I often talk about my Grand Ole Opry "sisters." These are people like Jean Shepherd, Jan Howard, Skeeter Davis, and Jeannie Pruitt. I have more in common with them than with my real sister, who never understood my drive to be an entertainer, even as she supported my choices every step of the way. On the other hand, we women of the Opry all had the same dreams. And we still do. We have faced the same challenges, disappointments, and rejections. We understand what each of us is going through, and we do what we can to keep the dream going—and we're also there to celebrate each other's successes.

I love the Opry so much, and I push everyone to make it the well-rounded show we all intended it to be. We have some wonderful male bluegrass artists at the Opry, but no females. I knew a young girl named Rhonda Vincent way back when she was touring the country in a Martha White Flour bus. When I could, I made sure she got a look for the Opry. Now she is bringing a wonderful dimension to the Opry. It was a void that we needed to fill, since the wonderful Alison Krauss is so busy she does not have the time to be on the show very often.

Another thing that has kept me going all these years is perseverance. Michael Thrasher, the man who got me into acting, taught me an important lesson. He had me go read for parts that I knew were not right for me and that I was certain I would never get. Why? He told me it was because he wanted me to get used to rejection but to do so when it did not matter—when my

expectations were low anyway. "You will learn that it's not a case of them not wanting you. They just don't want you for this particular role."

I remain a proponent and advocate for the new, fresh talent that is coming up. I see it as our responsibility to help keep the Grand Ole Opry going. If we are going to keep it successful—if we are going to put people's butts in those seats—we have to have people on the stage that they want to see and hear. The Opry has always been pretty good about adding new people, but I am hoping they find more performers who have the Opry in their hearts and who love, appreciate, and have respect for the show, not just acts that want to use it as a stepping stone to something else. That is the legacy that I want to leave for future generations.

I give back when I can. I do the Dottie Birthday Bash each October to honor my friend and raise money for the Nashville Musicians' Emergency Relief Fund. I help organize fundraising for the Opry Stage Hands Christmas Gift Project and the Nashville Humane Society, for whom I have been a longtime spokesperson, as well as the George Shinn Foundation and the Opry Trust Fund, which provides financial help to needy people in the country music business.

It has just been amazing to me. I have been thinking my career would probably end next year for at least the last thirty or forty years now. So far, I've been wrong every year! I'm so grateful that there is still a place for me. I just feel so blessed to be where I am and to still be able to contribute. I wouldn't have been able to have such a lengthy career if I'd listened to the naysayers. It requires true grit to push away criticism of your ideas or beliefs. Especially the comments that come from the wrong places or for the wrong reasons. I urge you: don't let the critics get you; know that you possess that true grit inside of you that will help you to do so.

KELLY LANG

DAUGHTER, SISTER, WIFE, MOTHER, SINGER, AND BREAST CANCER SURVIVOR

If you want to go fast, go alone. If you want to go far, go together.
—UNKNOWN

I was blessed with a great childhood. The youngest of four children, I grew up in Oklahoma City. My dad and mom had been married thirty-nine years before he passed away. Dad was a grocery store manager, and one of his customers was a fellow named Conway Twitty, who just happened to live in our area when he started to become popular.

When Conway came home after being on the road, he would have huge checks he had been given for his shows. That was how acts were paid in those days. He needed a place to cash those checks so he could pay the band and other bills. If he couldn't find a bank open, my dad would cash his checks for him. They became friends. Of course, I was only a toddler at the time and didn't have any understanding of what a "Conway Twitty" was, but he was about to have a huge impact on me and my family.

Conway recognized that my dad was a very honorable and business-savvy man, and eventually he asked him to go on the road with him as his road manager. It was a wonderful opportunity for my dad, but he and my mom were accustomed to always being together. Also, my older brother was diagnosed with brain cancer and was not expected to live past two years old. (He did, thank the Lord, and is now sixty!) But Mom and Dad decided together that this would be a good thing for the family, so he accepted the job. And it did turn out to be a good thing. My mom even admitted it helped her to become more independent. This was quite a change for my family though.

Then came the next big decision. When I was six or seven, Conway decided he needed to move to Nashville to break through to the next level.

Rather than start over with his key people, he wanted everyone to relocate with him from Oklahoma to Tennessee. Of course, I had no idea at the time what a pivotal change this would be for me, growing up in the middle of the music industry in Music City, USA. There were about thirty of us, driving in a caravan from Oklahoma to Hendersonville, just north of Nashville, where Conway took the next big leap in an already booming career.

We all enrolled in school and started our new life. My older brothers hated it! They had left all their friends behind and did not like having to start over in a new place. But I loved it. I had already developed an interest in music, so I fit right in. I had started writing songs when I was six. I remember writing a song while I was in the bathtub. And you know what? I still do my best writing in the bathtub, in the pool, or anywhere in the water.

I think it's God who puts into you that desire for what you're supposed to do. Sometimes, He lets you try out several things so you can choose your true calling. Other times, we ignore it and go in a different direction. But I knew from early on that I would do something with music. It was my purpose! I started getting involved with musical things at school, and I began singing anywhere that would allow me. I was just so excited to sing, perform, and do my thing.

I don't think Conway ever knew about my desire to sing and write music—at least not until much later, not long before he passed away—but the truth is, I learned by watching him. I loved to sit on the stage next to him and watch how the crowd adored him. I knew I had to have some of that. I just had to!

When I was twelve years old, I started appearing on *The Ralph Emery Show* mornings on Channel Four television in Nashville. As I grew older, I became more of a regular on his show. I didn't realize how big a deal that was at the time. Naive as I was, I thought the only audience was right there in the TV studio. It never occurred to me that there were hundreds of thousands of people out there watching. I'm still that way though. Even if I'm doing a national TV appearance, I am in the moment, and I only think about the people I can see right there in the studio.

That got me into trouble sometimes. I would just say whatever I wanted to say on that show without thinking about the possible result. One morning, I said, "I'd like to send this song out to Officer David, the traffic cop who

let me out of a speeding ticket this past weekend." Well, that got the poor policeman into real trouble, but I didn't know.

I decided not to go to college. I was determined to make it with my music. Instead of school, I wanted to nurture my love for performing. And, bless them, I had encouragement from my family. Besides, I am convinced I learned more from being on *The Ralph Emery Show* and from interaction with the people that I performed for than I could've at any college.

That naivete did result in some mistakes to be sure. For example, I got married much too young, and I probably stayed in the marriage long after it should have ended. But even out of that came two wonderful things: my gorgeous daughters. I love and enjoy them so much. The oldest is most like me. She's work-oriented and career-focused. She is a fashion designer and stylist and has worked with Lionel Ritchie, Jon Bon Jovi, and *Dancing with the Stars*.

Conway died very suddenly in 1993, my dad passed away in 1998, and my divorce came shortly after that. I thought life was over. Up to that point, everything had revolved around music and my dad. Although I wasn't performing as much throughout my marriage, I had been writing the whole time. And you never know how or when things will happen. I had been writing a lullaby project for my daughter, Payton—not to sell or make a big splash, I just loved her so much and wanted to write music for her. It took fifteen years, but eventually the right people heard the songs and the restaurant chain Cracker Barrel picked it up and marketed it through their stores. Who knows how many children got to hear those songs I wrote and recorded for my little girl?

This sort of thing has happened to me several times with things that I had created, assuming there was no chance of them ever going anywhere, and then realizing that God had a plan for them. He does not simply allow us to create things for no reason. Not when others can get a blessing from them. Here's another example. I know the year 2020 was bad for most, but I experienced some truly rewarding things. Sixteen years before, I had written a song titled "I'm Not Going Anywhere." In 2020, someone heard it and decided it would be perfect for a national advertising campaign for the Ascension Hospitals across America. I had no way of knowing, sixteen years before, just how much that song would resonate in 2020. But if I had

not been going through rough times back then, I might never have written that song.

As I told *People* magazine for a story they did on the song, "I don't feel like I wrote it. I feel like God wrote it *through* me. I just held the pen."

I can't speak for other people, but the experiences I had that seemed so terrible at the time have often turned into positive ones. That is because I stayed tough and hung in there like a hair in a biscuit! Not giving up allowed me to work through them, learn from them, and sometimes use them to help others. Yes, I think having true grit helped me to remain determined.

My divorce is a prime example. Statistics say that those who go through divorce are much more likely to do so again. But I think I learned the first time and applied that knowledge to my second marriage, which was to country music star T. G. Sheppard, and we have certainly defied the statistics. I was married the first time for almost fifteen years, and T. G. and I have now been together almost twenty years. We did not jump into anything! We dated for seven years and have been married for thirteen. We have so much fun together, such appreciation for each other, and so much in common. Had I not learned the first time what was not right for me, I would not have recognized what was best this time.

Another example came when I was diagnosed with cancer. Things were on the upswing. I was falling in love with a wonderful man, I had just signed my first big record deal, and I had a record that was going out all over the world. I was so excited, so ready. My kids were old enough now, and I could start doing what I wanted to do. I felt some freedom. I felt confident. But one day I experienced a jolt of pain and a lump under my arm. I had been watching a little cyst there for a while but had dismissed it because I was—I believed—too young for cancer. But with the pain, I decided to go in for a diagnostic mammogram and ultrasound, which did not show anything. However, I somehow knew something was not right.

The lesson here is that we are often our own best advocate. I asked the radiologist if I could help her find this spot and look some more. I was diagnosed with stage 2 breast cancer, and it was already in my lymph nodes. If I had taken the time six months earlier to look more closely, I would have probably not been in that situation, but if I had not listened to my own body then, I almost certainly would not be here today.

I quickly learned to put a check on my vanity and concentrate on what is important. My children were nine and thirteen at the time, and though T. G. and I had been dating, we were not yet fully committed to each other. I certainly did not want him to feel like he had to stick around because of my illness if he did not want to. He did not deserve that.

One day I was especially depressed, bald, marked up from head to toe, scared silly, and feeling especially ugly. I had just gotten out of the shower and was looking at myself in the mirror when I broke down and started to wail. Not cry. Wail! In the middle of that breakdown, T. G., who had a key to my condo, unexpectedly showed up. I was mortified. He had never seen me without a head covering since I'd lost my hair. But he wrapped me up in a towel, pulled me down to the floor, held me, and rocked me like a baby.

When I begged him not to look at me, that I was so ugly, he began kissing my bald head and said, "You're the most beautiful woman I've ever seen in my life. I am more in love with you today than I was yesterday. I will never leave you." That was when I knew we were perfect for each other, that we needed each other. I had given him an "out," and he chose to stay with me.

Another important person in my life was the beautiful and talented Lorrie Morgan. I loved her music from the first time I heard it and had always looked up to her. Then, when I started doing the morning television show, I sort of took her place because she left to go do *Nashville Now*. Later, when my career seemed to be stalled, I was selling fragrances at Dillard's department store. Lorrie came in and asked me what in the world was I doing there and inquired about how my career was going. I just offered to give her a sample of Calvin Klein's new fragrance. Finally, I told her I was stuck, that I didn't know where to turn next. She gave me her card with her number on it and told me to call her. I figured that was a nice gesture on her part, but that would be it.

I did go ahead and take her up on her offer to look at some of the things I had been working on. A few days later, she called me and said she was taking me to the studio, that I needed to be recording. She took me in with a top producer, paid for three or four songs to be recorded, and paid for me to get my hair and makeup done and for a photo shoot. After that, I did

The Statler Brothers Show, and Lorrie and I ended up writing her entire next album, *I Walk Alone,* together.

Lorrie did not have to do all that for me. She was a very busy woman, but she saw something in me and wanted to help. More than anything, she gave me self-confidence at a time when I needed it the most. But she also reminded me of how much I love connecting people, introducing them to others who will help them grow.

That may be the biggest thing Lorrie taught me, finding happiness by helping others, paying it forward. That is a valuable lesson for all of us. When I was going through breast cancer, I promised God, "If you allow me to live, I promise to be a light for someone else." That is one promise you can bet I will do my best to keep. True grit is what motivated me to fight through cancer, my divorce, and various life trials. True grit means to not give up.

LULU ROMAN

AUTHOR, COMEDIAN, AND SINGER—*HEE HAW*

The joy of the Lord is your strength.
—NEHEMIAH 8:10

*B*eing an orphan is a traumatic thing. I never wanted to be an orphan. Soon after giving birth to me, my mother was committed to Terrell State Hospital, east of Dallas, Texas. She had been beaten and physically abused by most of the men in her life. One of those guys was almost certainly the dad that I never knew. Mom never shared that information with me.

My grandmother was a mean person. Even though I already felt unloved, unwanted, and unworthy, my grandmother never missed a chance to tell me, "You are fat. You are ugly. And no one will ever love you." When my mother was sent to the hospital, my great-grandma took on the burden of caring for me. I thought she was wonderful. I remember she always said, "Cleanliness is next to Godliness." She would love on me and feed me cookies. That began my love for sugar.

On Friday, November 17, 1950, my mother's mom picked me up from my great-grandmother's house. She told me, "We're gonna take a ride." She took me and dropped me off at Buckner Orphans' Home in Dallas. I didn't realize until later that night that I would be staying there and that my family had effectively abandoned me. The day they put me in the orphan's home was the day that food became my constant companion.

Being an orphan was bad. Being a fat orphan was horrible. Growing up in an orphanage system where most of the workers are simply trying to get through the day, break up fights, and take care of the basic needs for all the children, there was not much time for or an emphasis on helping children emotionally.

However, Mr. and Mrs. Alleum were the exceptions. Mrs. Alleum worked in the library, and Mr. Alleum worked in the woodshop of the

orphanage. They were very loving people. Mrs. Alleum was especially instrumental in pushing me in the right direction. She helped me to see that I had the right stuff inside me to survive in life. She showed me that even though I was an orphan, I could still build confidence in myself.

There was also a wonderful lady who worked in the kitchen. I helped in the kitchen, where we had these huge pots to clean. I would stand up in one and take on the character of "Maw Kettle." I would act goofy as I cleaned the pots, making a racket. And she loved it. She loved it so much that she encouraged my antics. I will never forget the day she stopped laughing long enough to tell me, "Little girl, I have never seen anything like you. You have the most expressive eyes I've ever seen in my life. You should be in the movies."

I soon learned to use my eyes to help me communicate. I became a professional at employing my facial expressions to break through, build connections, and make people laugh. That was because I wanted others to laugh with me instead of laugh at me. I always made funny faces and was very animated. That was simply the way I was able to deal with all that I was going through.

Nighttime was the most difficult part of the day, and holidays were even worse. For Christmas, we were given a stuffed animal. That was one of the things that brought me comfort, but the rest simply reminded me that I was, in reality, all alone.

At age eighteen, after graduating high school, residents of the orphanage were considered adults, and we were put out on our own. They gave me $50, which was considered to be appropriate in the '60s, and helped me get a job and an apartment. That was it. I was on my own.

My first job out of high school was with Southwestern Bell Telephone Company. I had a hard time simply answering phones seriously and according to the prepared script. I confess that I had quite the mouth on me. I was constantly saying things that I was not supposed to say. On the very first call I answered, the person on the other end of the line asked in a heavily accented voice, "Operator, I would like to call Ringo Starr." Without even thinking, I responded with, "You are *******
kidding me." Except I said the word. Before the man on the other end could even respond to my comment, my manager was right behind me

telling me that I could not say that. My response to him was, "Well, honey, I already did."

The truth is, from the very beginning, I had no filter. I kept my job for a couple of years. But my tendency to vocalize whatever came to mind would often get me in hot water with my supervisor. I had never been taught that if I wanted to be successful and have a bright future, I would have to be careful about what came out of my mouth. If I were going to maintain a job or career, or build a future, I would have to learn and practice this. But it was very difficult for me. I was, after all, a wild child.

By the time I came out of the orphanage, I had developed quite a bad attitude. I was determined to do and say exactly what I wanted, whether it was right or appropriate or not. I did not care at all what people thought. I realize now that I was very angry. I was angry at the world. I was angry at God. I was just plain angry at everything and everybody. Fortunately, I encountered a few people here and there who encouraged or helped me. But for the most part, it was through my own experiences that I learned to move forward.

The one thing I was blessed with was a strong sense of humor. From as early as I can remember, I have always enjoyed making people laugh. That was my comfort zone. I figured that if I could make them laugh, they would stop hurting me, being mad at me, or making fun of me. In reality, I was using comedy to deflect the negative feelings I sensed in people. I could sing too. In high school, I was in a concert choir, but I resisted doing a solo. I wanted to just be a part of the choir and not to stand out.

It wasn't long before comedy and singing led to opportunities for me. I was working the Dallas nightclub scene when I first met country music star Buck Owens. We hit it off and quickly became great friends. He was the first person who believed in me. He truly changed my life. Buck called me one day and said, "There are a couple of boys in Los Angeles who are doing a nationwide television show on CBS. I want you to come out to California and try out for a part that I think you are perfect for."

He explained that a couple of Canadians had come up with the idea to make a country music style show that included comedy, like the popular *Laugh-In* program. Buck told me to pack my bags and grab myself a plane ticket. He said, "Get here by Thursday at three o'clock." Then he described

the part I would be auditioning for as the "fat girl." I chose to ignore that description. I promise I did not hang up the phone. No, in my excitement, I threw that phone down! Thankfully, I did not break the thing, as I immediately called the airline and booked a first-class ticket to LA. Then I jumped on that plane and headed off to California.

They took me to the CBS studio, and I was amazed when I saw it all. The first thing I noticed walking into the studio was all the costumes hanging there. This was 1968. At the time, CBS was producing a wide variety of shows. Wherever you walked, there were costumes. One of my favorites was a dress that the great comedian Jonathan Winters had worn. There were people all around doing hair and makeup. They took me around and showed me all the costumes and different sets. It was so interesting, and I realized then just how desperately I wanted to be a part of it all.

Buck was a great guy. He was very quiet, but when he opened his mouth you listened. It was almost shocking to me that someone—and especially a big star like Buck Owens—could believe in me enough to help me the way he was. This show was a big step for him too, but he was still willing to stick his neck out for me. I had never before had anyone like that in my life. Buck was the one. That show was *Hee Haw*, and that quick trip to California for the audition started a long run for me. I was there on the very first show, and I was still around for the last one. Now, I am the only original cast member still living.

Things certainly changed for me after that. I was no longer alone. Now, I was part of a show that everyone loved. However, I could not get over the fear that someone would come along and snatch it all away from me. My life was too good to be true, and on some level, I think I was still not convinced I deserved it all.

The way I dealt with the fear, uncertainty, and anger was through substance abuse. I started doing drugs at a young age to escape the pain of being called fat and ugly. Drugs drove my life. As all addicts know, not knowing how to get out of that lifestyle only drives you deeper into it. For much of my young life, I felt there was no one I could go to and ask for help. But I was about to find someone who could—and would—work a powerful miracle in my life.

I split my time between living in Dallas and filming the show in Nashville. We were all expected to be in Nashville from June through October for the

production of the show. The rest of the time, I was back in Dallas. It was while I was in Dallas one year that, out of the blue, a friend who had been at the orphanage the same time I was, Dianna, invited me to go to church with her. That was something I had never done before. She could see that I was searching for something, looking for a purpose, for a serious change in my life.

As it turned out, she took me with her to a spirit-filled Baptist church. Right away, God started opening doors for me. I got saved. A big factor in all of this was that the people in that church were so different from the "Christians" I had encountered earlier in my life. From the first time I stepped foot in the door, I felt welcomed and accepted. The people at this church were not ashamed of who they were or how they worshipped. I loved that they were authentic, and that was exactly what I wanted in my life. I needed this in my life more than even I had realized.

Despite my previous experience in choir, I was not a singer. But Dianna and I could sing and harmonize with each other, something we had done before at the orphanage. We decided that we were pretty good together, and we joined the church choir. I admit that I was not a very good singer in the beginning, but the church was gracious and let me do it. I got so much better.

I will never forget the date, April 11, 1973, when I got down on my knees and gave my heart to Jesus. I had an Earth-shattering spiritual experience. Jesus took a 3000-pound yoke off my back and threw it away for good.

When the Spirit hit me, I jumped up and started dancing all around that church house! But then I caught myself and stopped. I thought people would judge me, look down on me, or make fun of me. But Pastor Howard stepped in and told me I better not stop dancing. "Praise God and be authentic!" he told me. "As long as it is authentic, the way He moves you to feel, you should praise the Lord any way you feel like it. And He will receive that heartfelt and genuine praise."

Later, he told me to never be apologetic when it came to praising God. Then he quoted scripture after scripture to me to back up what he was telling me. He helped me understand that people can worship any way they feel like. He permitted me to experience God without shame. After that experience, I no longer had to seek a way to stop the drug use. God just took away the desire. It was a miracle. I learned something else too. One miracle

can lead to many more. People around me noticed the difference. Some had tried to help me and were frustrated. Now, everything had changed!

The evangelist Kathryn Kuhlman had invited me to appear on her national television show, *I Believe in Miracles*. While I was there, I thought I would run by the *Hee Haw* offices to say hello. I stuck my head in the door to say hi to my friend Marsha. I had to say her name twice before she recognized me. She told me, "Lulu, girl, I didn't even know who you were." And it was true. My whole countenance had changed. I did not dress the same. My makeup and hair were different. My whole demeanor was not the same, because God had cleaned me up. Marsha took care of everything for everyone at *Hee Haw*. She asked me what had happened to me. I told her that I had gotten saved. She may have been a good Jewish girl, but she knew exactly what I meant. She said, "My God, you are beautiful." She started spreading the word that I was different. Buck told me he was proud of me. I knew they were sincere too.

I had already noticed a change inside me, even before others commented on how my whole demeanor was different—different in a good way. The better I felt, the better I wanted to be and do for myself. I wanted to continue to do better. If there is one thing I can encourage other women to do in order to change their lives, it is to take time to *listen*. You might just hear something important! If anyone is offering you anything related to the Lord, sit down and listen. Let the Spirit show you God's will and God's way. Do not dismiss them. It could well be the very thing you need to move forward.

I now realize that God is very faithful. He knows exactly what you need and when you need it. My favorite verse says it all. It is Jeremiah 29:11–14. "'For I know the plans I have for you,' declares the Lord. 'Plans to prosper you and not to harm you, plans to give you hope and a future. Then you will call on me and come and pray to me, and I will listen to you. You will seek me and find me when you seek me with all your heart. I will be found by you,' declares the Lord." I have that verse in my home, there to remind me every day that I should depend on the Lord and not just myself.

The future for me includes walking from this stage to His stage. And I am so looking forward to it. It has been a privilege and a blessing to share laughter with others and later to have a singing career to give worship to my Lord and lead people to God.

I believe true grit means standing up for what you believe and doing so unashamedly, with pride. For me, that included standing up and wearing the name of Jesus, the one who changed my life completely. And I have been doing that since April 11, 1973.

MEREDITH VIEIRA

NATIONAL TELEVISION REPORTER, TALK SHOW HOST, MOTHER, WIFE

When you have confidence, you can do anything.
—SLOANE STEVENS

My mom was a tough lady, and my dad was a rock. As for me, I was one of those little girls who idolize their father. Only when I was older did I appreciate my mom as a role model. I would talk to her about being a nurse since my father was a doctor, and she would tell me if I wanted to go into that field, I needed to be a doctor. I had three older brothers, and my mom felt I was as good as they were and even better. My mom had spunk. Once, she took on the bishop in our community because she thought he was annoying and the church was sexist. During my First Communion, all I wanted to do was get the host and go, but she was angry with him. So she sewed these blue flowers on my white dress…it was her way of putting up her middle finger at the bishop and saying you are not the boss of me. I was praying God didn't strike me down! Also, I think she was a feminist. She wanted so much from me. I don't want to say she pushed me into a career, but she wanted me out there in the world to make a difference.

When I eventually gave up career opportunities for my family, it was hard for my mother to wrap her head around that thought. But I know now that it worried her; she was afraid I would regret it. As time went by, she understood. When I first started in television in Providence, Rhode Island, I came home crying one day because I was told I was too slow and I wouldn't make it in television news. My dad told me a lot of people are going to tell me I don't have what it takes and unless I believe in myself, I will always be taking three steps back. I went back and confronted my boss and told him I didn't care what he said. I was going to make it in this business. He just said, "Okay, you can come back"!

My father was always comfortable in his own shoes, and he instilled that in his children…that faith will come from within and everything else will take care of itself. Over the years, timing has played an important role in my career. I am not going to lie…there were economic reasons as well. I always felt it was important that I brought home a salary. That means a lot to me. My dad was "save, save, save," and I am too. I never knew when the floor might drop out from under my feet and I would be bankrupt! Working for *60 Minutes* was the easiest decision I have ever made. There was a lot of build-up to it. It was the only job I wanted in the business. It was the best TV news magazine, without a doubt. It was 1989. I was pregnant with my son, Ben, and it was the Friday before I was to give birth by C-section. They brought me into a meeting and offered me the job. I really didn't know what to tell them, so the president of CBS News said, "You just go home and think about it, but we'd love you to come back after having the baby to start this new job." Here I was, about to have a child, and I didn't know how my life would change. But I knew it was going to change permanently. Then to be offered the best job in my business? I kept going back and forth, torn. Finally, I convinced myself I could do this. I can juggle this. I'll be a better reporter for it. I can be a better mother for it. Soon after I started, I realized what a struggle it was going to be. I just had that feeling from Don Hewitt, the executive producer of the show. Even though he was supportive, he didn't seem to get it. I don't know if he didn't get it or if he thought I would just fit in once I got there. I thought that if the whole baby thing would just compartmentalize a little bit I could still be part of the club. I tried to be, but I just never felt comfortable. I loved the people and worked very hard, but the culture was hard for me. I felt guilty. I wasn't with my son and family. There was always tension between Don and me. It began under the surface and then became apparent to everyone else too. When he moved my office next to his, I knew the die was cast.

The beginning of my end was my pregnancy with Gabe, my second child. I didn't tell anyone but a small circle. I told them I had a history of miscarriages so the doctor said I couldn't get on planes. But I wasn't worried because everything was just a train ride away. I hadn't told Don, because I knew that would be a big deal, and besides, why say anything until I was through that initial twelve-week period? The likelihood that I was going to

be able to carry the baby was in question. Don called on a Saturday morning around 8:30. Richard and I were still in bed. Don was in Europe, a story had broken, and he wanted me on the Concorde to Paris. I froze. I told him I couldn't go. He said, "What?" As if to say, "Whatever it is, I'll fix it so you can get on the plane." I told him I was pregnant. I knew that would be it.

He followed that up by wanting me to go to a toxic waste dump in Russia. I called Al Gore, who was involved in the story, and he said I shouldn't go near the place. I called Don and told him I couldn't do it. Near the end, I said to Don, "I'm going to take my six-month maternity leave as a part-time employee, so there is no way I can do twenty stories. I am already doing ten stories, and it is impossible because I am not going to be here." He said, "It is that or nothing." I didn't lose any sleep that night. It was very clear that if I had to choose one over the other, I was going to go with my personal life…I was going to go with my family. To not do that would be such a disaster for me on every level. At the time, it was big news. Right after I decided to leave *60 Minutes*, Richard and I attended an event and a woman confronted me. "You can't leave *60 Minutes*! Your leaving suggests to women that we can't have it all. It sends the wrong message." She was offended. I was firm in my conviction. "No, my staying, when I feel it is wrong, sends the wrong message."

Everyone has to make up their own mind about what is right for them. I don't think you can have it all. Life is about setting your priorities…making decisions…and not just assuming that anything you can *put* on that plate, you can *have* on that plate. It is about balance and choices. I wanted to exceed at the experiment of having a family and having a job I always coveted. I think the decision to leave was the right one, but you always wonder, "What if I had played the political game more?" I never missed an interview opportunity to say, "My life is my family." I'm sure Don would hear that and say, *"Shut up—family shmamily!"* After I left the show, it felt like a smear campaign. Don was quoted in the paper saying, "Whoever heard of the Meredith Vieira story anyway?" It was very vicious of him to go after my professional life. No one had ever questioned that before. I felt it was a real cheap shot, below the belt. Go after me in any way you want, but don't go after my work. He made these statements just to take away from the notion that "Don took a job away from a pregnant lady." And that wasn't fair

either. That was bologna. He had women at the show sign a letter saying I was not doing my fair share, having babies, and not working as hard as the men. I was very hurt and angry, but not at the women. There was just a lot of pressure in that place. Some people felt that way, and that was okay, but I know my assistant felt pressured and refused to sign it, and she suffered for that. He strong-armed people. Pitting women against each other is wrong. Now, of course, they are much more flexible in this business. I will always regret the pain that Richard and I were put through. My next venture was to anchor the CBS Early, Early News. I didn't know if it was the right spot for me, but it was all they had. I had to have a job. I think to this day, that's why I got pregnant again so soon after I took the job at *60 Minutes*. I may have felt like I failed because that is my M.O., so I don't like to attach too much significance to it. I am one of those people who think they aren't good enough. I don't know why, because I received nothing but positive reinforcement as a kid. I beat up on myself a bit. Insecure…the banana peel is right around the corner! I later moved to ABC News, hoping for a better feeling about work, family, and myself. And I found it there. When I had Lily, my third and last child, things were working great until they told me I would have to start doing *20/20* and *Primetime* stories, along with my regular job. I said to them, "Why would I leave *60 Minutes* to come and do the same amount of work here?" That was when the opportunity to do *The View* came up. The producer's biggest concern: was I funny enough? Someone said I was crazy, but they didn't know if I was funny! I didn't want to do it at first; I pooh-poohed the idea. But Richard sat me down. "Go do it…you are a reporter who doesn't want to report, and that is sort of a dead end, don't you think?" Then he gave me one of his looks. I came home after the audition embarrassed, thinking here I am with twenty years in the news business, and now I am considering a talk show. Excuse me for thinking I was some big deal, but I didn't watch morning television. I thought it could be fun, but I figured there was no way they would hire me anyway.

But then they did! And I loved the show. I loved the people, and many of my friends are still there. I worked on *The View* for nine years, and then I was asked to do the *Today Show*. What a surprise! My whole career has been a surprise. I was surprised when Jeff Zucker, head of NBC, asked me to host the *Today Show* at fifty-two years old. I jokingly told him he was skewing a

little old for this job. He told me he was looking for experience. Joking again, I said, "You could have said I'm not old!" It may be unfair to say this is a young people's business, especially when it comes to women. I look around and I see Diane Sawyer at *Good Morning America*, and she is older than I am and looks fantastic. Nobody would question her credentials or say she is getting a little long in the tooth. I think it is great that my offer came from a man too. The show was in a predicament of sorts, losing Katie Couric after fifteen years. She is an icon in the business. I think they checked out the landscape and thought, wait a minute, this person has the skill set we need… news and entertainment.

While considering their offer, I was in a fetal position for several months in my home, crying. I carried the list of why I should take the job and why I shouldn't in my coat pocket all the time, afraid I was going to throw it out. I had a cushy job with *The View*. I could almost do it with my eyes closed. I had another job with *Who Wants to Be a Millionaire* on top of that. Why would I want to switch this life? Do I really want to go back to the news? Oh, I would just cry. Richard thought it was a no-brainer. He said I came home saying I was bored and I was too young to be bored. The children played a part in the decision too. They had all asked me to stop talking about them on *The View*. That's what you do on the show: you talk about your life. For that reason, it was time for me to think of doing something else, because I needed to stop talking about my kids on television! Unless I became a jet setter and started talking about my wild partying, it wasn't going to change. My middle child provided the greatest contribution to the decision. I said, "I'm not going to be here for you at breakfast," and he said, "What are you going to miss? We fight." I had fear of failure, taking over after Katie. It was scary! Fear of success too. What if this works? Then I'm stuck. That's the difference between men and women: a man never says "I am scared of success." Maybe it's a gender thing or a conditioned thing because they are taught to go out there and be a success and win, a macho thing. Eventually, I decided to stretch myself and do it, since it could be the last traditional job I would ever have…because I would be dead at the end of it! The night before the first show, Richard and the kids gave me a gold bracelet that is all scratched up now because I never take it off. It says *We are with you. Love, Richard, Ben, Gabe, and Lily.*

The way I see it, the nicest thing you can say about me is I am a decent person. I am real.

It is important to find the real you, your real essence. Everyone will tell you who you are or what you should be. Believe in yourself and have the conviction to follow your heart. Find your inner voice, honor that voice, and follow that voice when nobody else wants to hear it.

That's the way I see true grit.

RHONDA VINCENT

DAUGHTER, SISTER, WIFE, MOTHER, SINGER, AND GRAMMY WINNER

Live each day as if there is no tomorrow.
—UNKNOWN

I grew up in a musical family, so it was natural that I had this love of music from the very beginning. And I also had the opportunity to see someone demonstrate true grit early in my life. When I was two years old, my father was in an automobile accident. He broke his neck and was paralyzed from the neck down. The doctors did not expect him to live, much less ever walk again. But he prayed to God and said, "Lord, if you give me one good leg, I will drag the other one." And that is exactly what happened! He regained mobility by walking with a cane. In the beginning, he fell quite a few times, but he didn't want anyone to help him up. He told us if he needed assistance, he would let us know.

Of course, I was only two years old at the time, so I don't remember him being any other way, but when people who knew him before saw him getting around, they were amazed at how he was able to do it. He had a way of hooking his walking cane in his pocket so he could stand and play his banjo when we were on stage. I watched him fall on the ice and refuse to let anyone help him up. He wanted to prove he could do it himself. And I have seen him crawl on his elbows up the steps into the tour bus. You better believe he taught us what true grit was all about before we even knew the term.

From as early as I can remember, music was just something we did. It was our way of life. But from the beginning it was a business, because that was how we made our living. I remember one time we had a date in Oregon, and we drove our motor home from Greentop, Missouri, where I grew up, to Medford, Oregon—a forty-hour drive—to play a ninety-minute show. Then we got back into the motor home and drove back to Missouri. It was

a job, and we had to do it. But it was special, because we were all together as a family.

Of course, because of my father's injury and our being so young, my mother had to drive that big old motor home. The first time she drove it, she was so nervous she had a migraine headache. Somebody had to do it, though, and she was a pretty good example of true grit when she climbed into that seat and drove that big old vehicle to wherever we needed to be. Same thing when we bought the old bus from the country music duo Jim and Jesse. It had been on the road with Greyhound for millions of miles before they got it, and then they drove it forever. It was in rough shape and had to be double-clutched to make it go. Of course, she had never driven anything like that, but when we bought it, she climbed behind the wheel and steered it five hundred miles back home.

We played music all the time, and I just assumed everybody lived the way we did. I mean we had people over every night we were home, playing music. My dad would pick me up from school, and we would go play music until dinner. Then, after we ate, people would come over and we would play until bedtime. By the time I was five years old, we had a radio show and a TV show.

I guess it was inevitable that when I met my husband, Herb Sandker, it was through music. He was a disk jockey, and I was a senior in high school. He had put this band together to play on St. Patrick's Day and needed a fiddle player. Somebody told him about this girl in Greentop, Missouri. He called my dad and asked him if I could play "Orange Blossom Special." He told him, "Yes, standing on her head. But I'm a guitar player and I come with the deal." So he hired us both. That was just my dad's way of protecting me.

After I started college in Kirksville, Missouri, Herb hired me for another show, we started dating, and it was magic. We have been married thirty-seven years last Christmas Eve and have two daughters. They have kept it a musical family. When they were in college, they started a band. They told everybody they might not be Rhonda Vincent but they were the next best thing. So that became the name of the band: The Next Best Thing. They are both amazing singers and very accomplished on their instruments of choice. I am so proud of both of them, and my youngest has carried on one other family tradition.

She met her husband when he joined their band, and they have now been married going on eight years.

It's funny how things happen. I was in Nashville for the funeral of a friend and ended up in a limousine with Jeannie Seely, who is not only a country music legend but the matriarch of the Grand Ole Opry. Somehow the subject of songwriting came up, and she sang me a song that she had just written. I loved it and told her I wanted to record it. She was thrilled. And so was I. Then a few weeks later, she called me when she was in the studio recording her latest album. She had a song she was going to record with Vince Gill, but he told Jeannie that she needed to do it with me instead. And she was calling to ask if I was interested.

Well, yeah! What a thrill to have Vince Gill recommend that Jeannie Seely record a song with me! But there's more to the story. After Jeannie and I finished recording our duet, I learned that the next session that had been booked in the studio had been canceled. I decided to go ahead and snag that opportunity to record Jeannie's song, "Like I Could," right then and there since I had been having trouble getting the time to do it. I found musicians and put together a session in about thirty minutes. It's a great song, and it turned out pretty good. We debuted it on the Grand Ole Opry, did a video of that, and it went on to become the number one song on the bluegrass charts.

You never really know what God's will is for you. What were the chances of having Jeannie Seely as a friend? Of recording her song and having it be such a big hit for us? She inspires me with her passion and love. You know, she really doesn't have to do anything if she doesn't want to, yet she is there on the Opry, and she is still writing and recording. And still generously helping people like me. To me, that is an inspiration.

The music business can be so dog-eat-dog. But there are still people like Jeannie who are willing to help others. This is something I also learned from my husband. These people do so many things that others don't know about. They do not have to offer advice or help or share, but they do. Jeannie will still help me out by telling me how to do something that she has been through and I haven't, even though I've been in this business a long time. Even now, I still sometimes have trouble believing that we are "Opry sisters."

I am a big believer in women understanding the business, whether it is music or something else. I look at Dolly Parton as a role model for this. I am always asking myself, "What would Dolly do about this?" It is so important to have a husband or wife or partner. Many times, women do not have the same opportunities as men do. There is also the issue of sexual harassment. I give my husband a lot of credit there. He was willing to stay home and be "Mr. Mom" to our girls, and he has always been supportive of my career. He misses me when I am gone, but he always encourages me to do what I need to do to be successful and live my dream. Not many men are willing to do that. Herb is one of them, thank goodness.

In my case, being secure in my marriage is a great comfort and help. I am on the road with six men, but we have respect for each other. So many families are split up when the man or woman in the family is away from home and traveling for work, regardless of the kind of work they do. My advice to women in any business is to have that strong commitment to your spouse. Keep your family intact. This does not just apply to the music business either. It happens in offices and other workplaces.

I guess some of that goes back to growing up in a family where we were so close. Family rules. My husband has a brother with special needs. They never expected him to live past five years old, and he is now sixty-two. That is one reason the Sheltered Workshop program is so important to us. They help people with disabilities to have as normal a life as possible. Herb has served on their board. We have done many things for them, but as the Bible says, when you do a good deed, keep it to yourself. But when there is a need, we try to help.

Most people do not know that I am an introvert. When I got married, I would rarely talk to people or say anything on stage. My husband got me a radio show so I would have to learn to open up and talk. I used to script it out and read it! But it helped me be more outgoing. And now I never shut up!

One of the hardest things I have ever had to face was the loss of a baby girl back in 1990. That is a hurt that runs so deep, and I feel a special bond with women who have lost a child, no matter the age. Once again, it was my husband who helped me push through the pain. I just wanted to stay home

and cry. Our other daughters were two and four years old then, and they did not understand why their mommy was crying all the time.

There were women in my life who told me to call them anytime I needed to talk. I appreciated the offers, but I was often ready to talk at three o'clock in the morning. I couldn't call them at that time of the night. Others suggested medication, but I didn't want that. I wanted to feel the hurt. I believed that was part of the healing process.

Then I got a great suggestion from a lady who worked in the mental health field. She suggested I keep a journal and write down all my thoughts every single day, with the understanding that no one else will ever read what you put down there. Then, a week later, go back and read what you have written so far. That did help me.

My favorite musical instrument is the mandolin. It was the first instrument I learned to play, and it still makes me happy. Sometimes I just pick it up and play for myself, even when Herb says, "Stop it, Rhonda. I'm watching TV." Or my brother-in-law, Steve, will tell me to quit. I remind him that people pay good money to hear me play, but he still just tells me to be quiet. Oh, well. That can be humbling sometimes.

We all have decisions in life. I remember when we were getting started and thinking about moving the family to Nashville, the center of the music business. But Herb and I wanted our kids to experience a small community, the one in which we grew up. We may have missed out on some things by not being in a bigger city. My hometown is a hundred miles from the nearest interstate highway or shopping mall. But we never locked our doors. We left our car keys in the ignition. We felt safe there. Everybody knew everybody else.

When our youngest daughter graduated high school, she wanted to go to New York or Los Angeles. Herb put his foot down and said, "No!" She did go to Atlanta for a year, but she soon grew tired of the big city. For college, she moved to Johnson City, Tennessee, a town much more like where she grew up.

It has always been a dream of mine to be a member of the Grand Ole Opry. I was shocked when Jeannie Seely told me about my invitation to join, right there on that historic stage. It was almost a year from the night I

was invited that I was formally inducted. I had a year to think about it and get more and more nervous. After the induction ceremony, they ask you to perform. Now how was I going to sing after that? Being on that stage where so many greats have performed, but this time as a member of the Opry?

But I did it. Nobody will ever know how much true grit it took to get through that song though. To me, having true grit means you are dedicated and have made a commitment to whatever it is that you want to accomplish in life. That could be in music or anything else. Nothing worth having in life comes easy. And you have to do hard work to perfect your craft. As I told my daughters when they were in high school, you will have to do something in life to make a living, so you might just as well make it something you love to do. Then you will love your job and look forward to going to work every day.

You cannot be too quick to give up. It sure helps if you love what you do.

SUNNY BROWN

WOMAN OVER 50, MOM, WIFE, LATE BLOOMER, COMEDIENNE, ENTERTAINER, WRITER, HAPPY

It takes courage to grow up and become who you truly are.
—E. E. CUMMINGS

That's my favorite quote. And, I would add that you could exchange the word *grit* for the word *courage*. It takes grit to grow up and become who you truly are.

Whenever I think about my childhood or talk about my early years growing up, I have so many fun stories to remember and tell. I had a lot of fun growing up. But I had a lot of scary, sad, and confusing times too. My childhood was one of extremes, between lots of fun, freedom, and laughter and lots of arguing, uncertainty, and volatility. That's what it is like growing up with an alcoholic father.

I am sure that I am a late bloomer because I never really thought about who I was or what I wanted to do "when I grew up." Because I never knew what would set my dad off and make him angry, I was always just focused on getting through the day. And sometimes the night. My parents would argue loudly…a lot. I didn't think much about the future.

My dad was a Dr. Jekyll and Mr. Hyde type of personality. He was very charismatic and fun and had a great sense of humor. He was always the life of the party. And the party was always at our house. My parents enjoyed entertaining and going out dancing. But as my mom would say, he just didn't know when it was time for the party to stop. He laughed easily and often. Which of course made it even more confusing when he would suddenly turn angry.

I remember that my parents used to laugh at things I would do and say, and they would always call me "Gracie." It would annoy me because I was trying to be serious. I would ask them why they called me Gracie, and

they would say that it was a woman who used to be on television and was so funny and I reminded them of her. Of course, I had no idea who she was, and there was no Internet back then and only three channels on our television. I just accepted that they found me funny, but I knew I was not intentionally making them laugh.

I was fifteen when my parents divorced. I don't remember having any feelings about it one way or the other. I think it was probably pretty obvious that it would happen. By this time, I was taking dancing pretty seriously, especially jazz and Broadway type dancing. I ended up studying dance at Birmingham-Southern College. I didn't see myself as dancing for a living though. I had also fallen into modeling during this time, and I had regular jobs and made pretty good money. I even spent three months working in Japan. It was during this time that I met my husband, the award-winning photographer Billy Brown. We fell in love and got married. When we had children, I knew that I wanted to stay home with them, because my mom had worked and my friend Tinna's mom stayed home. When I was younger, I would stay with them in the afternoons until one of my parents got home and picked me up. And my aunt Carolyn stayed home, and I remember pretending to be sick so she would come pick me up from school and I could go stay with her. So I knew I wanted to be a stay-at-home mom.

My husband and I met when he was taking my modeling photos. We enjoyed a creative partnership as well as a romantic one. But after we had kids, I did not let him take my picture for almost twenty years.

I always had this other side to my personality that I didn't always understand or feel comfortable with. It took me a long time to realize that it was my "performer" side. I couldn't reconcile that side of myself with "being a mom."

It was only after my son went to college and my daughter was about to go to college that I had my epiphany and realized that I was a comedienne and comedy writer. I guess I was facing the "Empty Nest" and began to ask myself what I was going to do now. What did I want to do? Who was I? The answer startled me.

I had heard the word *epiphany*, but I'd never thought much about what it meant to have one or even what one actually *was*. But one day I was sitting in our den thinking about my first one-woman show, "Confessions

of a Glamorous Mind," which I had just finished. I was thinking about how surprisingly successful it had been and laughing to myself about how much the audiences had laughed. It was based on my popular column that I write for *B-Metro* magazine. I had been writing my column for about a year, and although people seemed to like it, for me, there was something missing in it. I couldn't quite figure out what it was. So there I was sitting in our den, enjoying the successful run of my show and being surprised at how much people were moved by the message in my show as well as how much laughter there was. I began feeling a little blue about it being over and found myself wondering—again—what was next. What do I do now? And out of the blue, just like something cracked open my brain, I had the instant revelation that I was *funny*. Immediately, every funny or humorous thing I had ever heard, watched, witnessed, or experienced flooded into my consciousness. I got a pen and paper and for the next four *days* all I did was write. It was like I was just taking dictation. I couldn't write fast enough. It was like I was blind, and all I could see was the information that was pouring into my head. I wrote while I ate; I wrote with my head and hands sticking out of the shower; I woke up in the middle of the night and wrote. I pulled into parking lots and wrote. After four days, it stopped. When it was over, I had pages and pages and pages of stories, ideas, monologues, whole jokes, partial jokes. I was overwhelmed. I didn't understand what had happened or what it meant or what I was supposed to do with it. I was exhausted. But I realized that what had been missing in my column was humor. And that *I was funny.*

My life took a completely unexpected pivot from that moment on, and I have been on this journey of entertaining and inspiring people with humor and comedy ever since. It was the most profound and spiritual experience I have ever had. I have since learned to "turn it on and off," as they say, when I sit down to write. But sometimes I think I am sitting down to write one thing and it becomes something completely different. It excites me every time. And sometimes a joke or inspiration will come to me out of the blue, and I have to write it down right then and there or it will be lost forever. I know that I am not the one creating this material. That it just comes *to* me and *through* me from a Higher Power. Whether one calls it God or The Universe, I know that I am just receiving the material; I am the co-creator. Sometimes when I am writing, my husband will walk by and say he hears

me laughing. And I am laughing so hard, just in awe of what came to me to write. And I feel as if I could put it away in my drawer and be happy. But I realize that I have another part of the bargain to keep. And that is that I have to put it out into the world so that other people can enjoy it too. It's not mine to keep. I have to share the laughter.

After my epiphany, I spent the next couple of years working to find ways to share my comedy with people. Usually it was late on a Tuesday night in an empty bar with a couple of drunk comedians. I will tell you that that takes grit to make yourself do that.

Other people can see us in some way, but until we see ourselves in that way, it doesn't have any meaning for us, for our identity. It's all about how we see ourselves. Our self-identity.

My dad had always told me that no one was any more special than I was, and that I was no more special than anyone else. I grew up believing that I did not have anything special about me at all. For this reason, I was always too embarrassed for anyone to find out that I modeled or was a professional cheerleader or had any success of any kind, for fear that they would think I thought I was special. But what I now know is that *we are all special*. We all have something special and unique to only our individual selves. And it is up to us to find that part of ourselves and to share it with the world.

Despite my self-doubts and insecurities, my set point has always been happy. It's the happy times that I choose to remember and that come flooding into my mind when I think back to my early days of growing up. We can choose to focus on the good or bad things in life. Because everyone has both. Having the grit to acknowledge the hard times and not let them define you or take away your joy; having the grit to ask yourself some hard questions and answer honestly; and then having the grit to take action on the journey to become your true self—leads to true happiness.

And it helps to have a sense of humor and a sunny outlook on life.

VICTORIA HALLMAN

DAUGHTER, SISTER, WIFE, SINGER, AND HEE HAW HONEY

If you don't ask, the answer is always no.
—NORA ROBERTS

It should have occurred to me that Buck Owens might be hanging out backstage between his matinee and evening performances. Since I was an aspiring young singer, it also should have occurred to me to arrange a run-in. Neither had entered my mind when I rounded a corner and ran smack into him. Bam! I rocked backward on my heels. Righting myself, I came eye level to his plaid shirtfront. Looking up and up until the back of my head was almost resting on my shoulders, I raised my eyes to his face. At six-feet-six, counting boots and cowboy hat, Buck presented an imposing edifice. Our collision hadn't moved him an inch, but he did look surprised. Before I had a chance to apologize, my manager Bill Loeb appeared out of nowhere. "Great show today," he said as he shook Buck's hand, "But you could use a girl in your act." Bill opened his palm in my direction. "This is Vicki Hallman, and she's a good little country singer." My head whipped around to Bill. *What?* My current gig was as an opening act for Bob Hope—which didn't include a single country song. Buck said, "What do you think, Jack?" speaking to the portly gray-haired man standing next to him. "Go tell Don to bring his guitar to my dressing room, and let's see how she sounds."

Jack went off to get Don. Buck, Bill, and I trooped down the hall to a dressing room, where Buck grabbed a red, white, and blue guitar from the corner and sat down on the sofa. Jack entered the room, followed by a tall, dark, bearded fellow carrying a guitar.

I had perched myself atop the dressing table, for a bird's-eye view of the action. Buck gestured in my direction, "This is Vicki Hallman, Don, she's going to sing for us." Don smiled and said, "Nice to meet you." I returned

his smile vaguely, still trying to figure out what was going on. Then Buck said, "What would you like to sing?" The four men stared at me expectantly, which did nothing to help me think more clearly. I wasn't so addled that I didn't recognize a lucky break when I ran into one. While half of my brain puzzled over what was happening, the other half searched for a country song to which I could remember all the words. I swept my eyes around the faces, wondering exactly how long they had been watching me try to come up with something. *Thirty seconds? Five minutes?* Buck's hands rested loosely on his patriotic guitar as if he had nothing better to do than sit there waiting for me to decide what to sing, but my manager's smile was stretching into a grimace. Just as I was about to betray Bill's lie and confess that I was not really a country singer, I heard myself say, "'Help Me Make It Through the Night,' key of A." When I finished the song, Buck said, "Come out onstage and sing it with us." I didn't even blink; I looked Buck Owens straight in the eye and said, "Okay." While my manager checked with Buck and Jack on the ins-and-outs of my impromptu performance, I assessed my attire. I decided that the lavender silk blouse with skin-tight jeans tucked into brand-new stack-heeled gray suede boots were not at all a bad wardrobe choice for my debut as a country music star.

Hair and makeup were another thing altogether. I hadn't even known Buck Owens was appearing at the Orange Show that day. I had convinced my manager to let me tag along from Hollywood to San Bernardino. Not so I could go to a concert, but because, as booking agent for the Grandstand show, Bill had free ride tickets for the midway. I had used up a whole roll of tickets, and was still dizzy, when I ran into Buck Owens. Between roller-coasters and the run-in, most of my hair had escaped its ponytail, and the lip gloss I'd dabbed on that morning had stuck to the caramel apple I'd eaten for lunch. Checking my disheveled appearance in the mirror, I headed to the dressing room of a troupe of *Solid Gold* dancers. They were appearing a few acts down the bill from Buck Owens, and when they heard the story of my lucky collision with Buck, they clucked over me like mother hens, combing, powdering, and polishing, until I looked like one of those beauties Buck swapped corny jokes with on *Hee Haw*. Giving me a final once-over in the mirror, their dance captain, said, "You'll do, break a leg." The Buckaroos were already playing, and Bill was waiting for me in the wings, stage-right.

I listened to the music for a minute then turned to him and said, "These guys are really good." He laughed and nodded. "Yes. Really good." Then he kissed my forehead. "But so are you." When Buck came onstage, the crowd went wild.

Growing up in Centreville, Alabama, with only three TV channels to choose from, I had seen *Hee Haw* a time or two. I'd always found Buck Owens oddly attractive. Had he been a woman, the French expression would have been *jolie laide.* Now I saw that his on-camera persona revealed only a fraction of his stage presence. I was so mesmerized that I didn't realize what he was saying when he yelled into the mic, "…big round of applause…" Then I heard, "Vicki Hallman!" and I vaulted onto the stage, waving to the crowd with one hand and grabbing the mic with the other. When I finished the song, a roar rose in my ears and the whiteness of hands fluttered in the audience. "Thank you!" I shouted. The Buckaroos played a chaser, and I turned to exit stage-right. "Y'all want her to sing another one?" Buck's voice came from the monitors, "All right! Vicki Hallman!" I stopped in my tracks, spinning to face Buck. He twisted his head sideways, speaking into the microphone, looking at me, "They want another one." Then he mouthed, "What song?" Again, I had no idea what to tell him, but somehow the words "When Will I Be Loved," came out of my mouth. "What key?" Buck asked. I threw up my hands, shaking my head, *I don't know.* "Just play it." He raised his guitar pick in an upstroke, calling out "'When Will I Be Loved' in D!" And when his pick came down, the whole band hit the opening chord with him. They followed my every nuance, down to the final "lo-oo-oved." The three Buckaroo voices blended with mine in perfect harmony. Buck took the microphone from my hand and spoke into it: "Vicki Hallman, everybody!" I sprinted off with my arms lifted in a double-handed wave to the audience and watched the rest of the show from backstage. When Buck unstrapped his guitar and exited into the wings, I stepped forward and offered my hand, "Thank you." "My pleasure," he said with a nod. "We'll be in touch." It didn't sound like a job offer to me, and I knew better than to get my hopes up.

But Buck called the next day. And as they say, the rest is history. When I told my friend Kathy Mattea the story of my spur-of-the-moment performance with Buck Owens, her jaw dropped and she said, "Wow, that took guts!" I shrugged. "It was my shot at stardom," I said, "what would you

have done?" "Probably just asked if I could send him a demo," she said. I nodded. "Mm-hm, and you wouldn't have gotten the job." Of course, Kathy was destined for stardom anyway. One thing's for sure: If I hadn't had the guts to walk out on that concert stage with a country music superstar and give the performance of a lifetime, I would never have become Buck Owens's opening act or female vocalist with the legendary Buck Owens Buckaroos Band. And certainly the producers of *Hee Haw* would never have cast me as one of the iconic *Hee Haw* Honeys or given me a starring role as Miss Honeydew for eleven glorious years, hanging my star in the firmament of classic TV forever. All it took was "true grit."

(This abridged excerpt is from Victoria Hallman's memoir *Hollywood Lights, Nashville Nights: Two Hee Haw Honeys Dish Life, Love, Elvis, Buck, and Good Times in the Kornfield*.)

VICTORIA RENÉE HAND

SINGER, SONGWRITER, ACTRESS, MODEL, WIFE, OVERCOMER

Attract what you expect, reflect what you desire, become
what you respect, and mirror what you admire.
—DEB SOFIELD

*A*nyone in entertainment has to have true grit, *especially* women. It is arguably the most cutthroat industry there is. If you don't learn to let things roll off of you like water off a duck's back, you'll become bitter and beaten down quickly. But if you *know* your value, take notes and constructive criticism gracefully, decide for yourself if it's true, and pivot when appropriate, it *really* is the most wonderful and fulfilling industry in the world, and there is absolutely nowhere else I'd rather be. I love it: the good, the bad, and the ugly. And it *can* get ugly…you should have seen my feet during tech week (or "hell week," as they call it in the industry) for *Cinderella*.

Grit isn't just about going through something hard; it's about going through the grittiest, grimiest of situations and, with discipline, coming out a pearl with grace and class. Especially when no one would have blamed you for losing it.

I had a complex childhood. At first it was a very happy one. I had fun-loving parents, lots of toys, and a big sister to play with me. My big sister Sara was my best friend. Everything she did, I did; everywhere she went, I wanted to be too. She was my "sister-mother," a sub-genre of sisters, nurturing and kind, that usually comes with a little age gap. She would walk me around the house, giving me hints on where mom and dad hid the Easter eggs we had made the night before, never actually giving it away because she wanted to be sure "I found it on my own."

She was nearly eleven and I was about four or five years old when it happened. I was certainly not big enough to take a bath by myself in the

jetted bathtub (which is obviously a fan favorite of every five-year-old). So being the sister-mother that she was, she accompanied me, as requested by my parents, in the two-seater Jacuzzi tub in the master bathroom. I wish I would have known that would be the last night I had with her...*we* had with her. I don't remember how it happened; I'm not even sure what our last words were. What I do remember was playing with my mermaid-shaped shampoo bottle, zoned into my own little world—as children do. My father walked up to check on us and asked where Sara went. I pointed down and continued playing with my mermaid. Little did I know the moments that followed would change the entire course of my life. His face, in that moment, will be one of those images that will be permanently engraved in my mind, along with everything that happened next.

My big sister Sara's little head was lying face down in the water, her dirty blonde hair floating alongside the food particles on top. He pulled her out and performed CPR, she sat up, and her eyes rolled back into her head. She projectile-vomited blood, and my father turned around with blood all over his face and told me to go get mom. I'll spare you any more scarring details, but that's what happened. I thought she was washing her hair under the water; I hadn't even thought about the concept of death. The coroner said Sara had hit her head, was unconscious, and drowned in the tub. They found a two-inch bruise on the back of her neck. It was a devastation to my family that no one ever got over. My parents fell into a deep depression, and I stopped talking. I had what is called selective mutism, a symptom of PTSD. I stopped communicating in any way...I just wanted to be as close to not existing as possible. I was afraid to be alone, yet I didn't want anyone to get too close...because in case you haven't heard...people just...die. So that was something I had to always be prepared for in my mind—my parents, my friends, anyone...it could happen to anyone. And even worse, it *will*. The thought had instilled so much fear into my little body that I just shut down. Completely.

And that's when my miracle happened. In my two years of silence, in my stillness, I found the light in my dark place. Out of nowhere, I just began belting out the song from *The Little Mermaid* with the control of a trained adult vocalist. I'm not exactly sure why or how, but I remember feeling like I can't *not* sing right now. And that moment changed my life. My parents

were in utter shock. "She sings! She sings?" They didn't really know what to do with that, but I think they were pretty sure putting a kid who moments ago had selective mutism on a stage wasn't it…but I had this overwhelming desire to perform, so I did, and that was it for me. One performance led to another, and then another, each one bringing new opportunities. The next thing you know, I was twelve years old with two songs charting in Europe at the same time and big contract offers. The more I sang, the more confident I became in who I was. I had quite literally gotten my voice back, just as Ariel did in *The Little Mermaid.*

Music healed me. It is how I handle whatever it is I am going through. I recognize that in a sense, if it had not been for Sara's death, I may never have found the healing power of music—something that I can now share, hopefully with a whole lot of people who need to be transmuted by the power of music as well. I'm pretty sure this is my calling. Some of the most beautiful music comes from the deepest pain. I continued to sing because I loved the way it felt, and my career followed. I just followed my bliss—that's what brought me here. I made "A Better Tomorrow" four years ago, and out of nowhere, it got picked up for a CNN special, playing every thirty minutes, according to a comment on YouTube. I had no idea!

My experience with mentorship wasn't all rainbows and butterflies early on. These people loved me, but were, and sometimes still are, hard on me. And thank God for that. Looking back, it was often the most difficult lessons, the people I wouldn't have considered mentors but rather…bullies… who were really a lesson in disguise—that *had* to happen to get me to where, and more importantly, *who* I am now. Each one is important for different reasons at different times, in a way that sort of piggy-backed off of each other, guiding me step-by-step in perfect, divine order throughout my life. I've had a lot of mentors throughout my life. Sometimes it was a teacher, sometimes it was my vocal coach, and sometimes it was one or both or all of my parents. Later in my life, it was my husband, Linc, and Edie.

My dad taught me to never give up, my mom taught me to work smart, and my stepdad Randy and husband Linc taught me to do the right thing even when no one is looking. My vocal coach taught me that practice does *not* in fact make perfect, but rather, *perfect* practice makes perfect. Sometimes, in a way, I didn't feel like hearing that, but I am forever grateful. My mom, my

dad, my stepdad, and my vocal coach constantly edified me. They instilled positive life values in me and gave me the confidence and self-esteem that I would need to do what I do now.

And then there is Edie. When I met Edie, she and I instantly hit it off. She never had a little girl, and I never had an Edie, and we were just a match made in heaven. We bonded over the losses and tragedies that had occurred in our lives and the people we have become in spite of tragedy. Edie made a documentary about how she found her light in dark places after her brother's death to encourage other people to find that light as well, in whatever they may be enduring in their lives. And from that came my song, "A Better Tomorrow," published by Edie and partnered with St. Jude Children's Hospital, with a percentage of proceeds going to St. Jude. You can imagine, from the story above, how much it means to me to help children, in whatever way I can. Edie did that. She made that happen for me…for us…for them. I never would have even thought it was an option. "A Better Tomorrow" was one of the most organic songwriting processes I've ever experienced. The song just kind of spat itself out. It means so much to me, and it always will.

My parents didn't really watch TV, so I watched a *lot* of Disney movies. That brought me to the moment I began to sing. Which brought me to my primary vocal coach, Jeanie Logan, who gave me the technique and stamina to do whatever I wanted with my voice. I learned how to perform from my first boyfriend, who encouraged me to move to LA and pursue my dreams on a bigger level, and who just so happened to become one of the biggest names in the dance industry. Had I not gotten performance and dance experience from him, I never would have gotten into Forever Heart Break, Day 26's sister group from Puff Daddy's *"Making the Band."* When we broke up, I was devastated and heartbroken—but it opened the door for me to be the opening act for superstars like Ariana Grandé; touring all over California, the United States, and four countries in Europe; landing the role of Cinderella in Rogers and Hammerstein's *Cinderella;* and so many other wonderful opportunities.

I can also thank entertainment for bringing me to my husband, Linc. Linc is my rock, and I get to lean on him and he gets to lean on me—we encourage each other with an understanding that only someone who works in this business has. We grow and build together. Linc is the most

amazing man I have ever met, and I can say confidently that finding and marrying that man was my biggest success to date. My husband has shown, and continues to show, true grit. He became successful in a town and in a career where *very* few people will ever in their lifetime do what he's already done, and he's a wonderful human being on top of that, authentically and effortlessly. He is a constant reminder that you *should* bet on yourself, you *can* do hard things, and you *can* be a good person while doing it.

Being a woman of true grit requires a certain outlook to sustain yourself in this industry. Have I endured hardships by being a woman? Ha... yes. Could I name names? Yes. But the truth is I don't see being a woman in a man's world as an ailment. I see it as more of a superpower. Listen, observe, and flip it to your advantage. Every person you meet knows something you don't. Be kind and graceful while also standing your ground and maintaining integrity; let them think whatever they want to. Go for the long game. Being underestimated because I'm young and a woman has been my greatest advantage. They won't see you coming.

The biggest lesson I have learned—and am still learning—is to trust. Trust God, trust the universe, trust that things will work out for you, trust that you are going to be okay, and trust that this hard moment is not going to last forever. Trust that you are enough. Trust that you're bigger and stronger than any life situation or any ailments you may have. Trust that you're capable of hitting the note; trust that you know your lines; trust that you can be yourself and people will love and accept you (yes, the real *authentic* you). And trust that even if they don't, that's okay too. As long as you like yourself. Nothing else matters. Remember that people's behavior usually has more to do with their own internal struggle than it does you, so try not to take things personally. As Maya Angelou would say, "If they knew better they'd do better."

I am blessed to have found my husband, his awesome mother, and other wonderful people around me who support me and have my back, and who I can confide in. I am blessed that I never really had to go through that lost "why am I here," phase because I found my bliss and instinctually knew to follow it. I see true grit as perseverance. Perseverance through the things in life that you wouldn't choose to go through but are better for. The hardships

I faced growing up brought me a grounding that can only come from deep pain. In that deep pain, that grit made a pearl.

A BETTER TOMORROW

Music/Production by: Andy Kautz |
Lyrics/Melody by: Elle Vee & Victoria Renée Hand
Featuring: Victoria Renée

(Verse 1)
There'd be no sadness to cry
There'd be no selfish to lie
There'd be no reason for crime
There'd be no empty no why

(pre-chorus)
I see it when I close my eyes
Peace on earth and peace of mind

(Chorus)
Let it go
We have to restore this planet's soul
Teach it something more than what we know

Give it water, give it sun, room to grow
We can build a better tomorrow

(Verse 2)
There'd be no nightmares only dreams
There'd be no evil people with angel wings
There'd be no war zones just simple things
There'd be more love than diamond rings

(pre-chorus)
I see it when I close my eyes
Peace on earth and peace of mind

(Chorus)
Let it go We have to restore this planets soul
Teach it something more than what we know

Give it water, give it sun, room to grow
I can see a better tomorrow

(Bridge)
We share this place, we all belong
Light the way
Til dark is gone
Walking away
Still means your strong
Rise above hope isn't gone

(Chorus)
Let it go
We have to restore this planet's soul
Teach it something more than what we know

Give it water, give it sun, room to grow
I can see a better tomorrow

ENTREPRENEURS

ANGIE ALLEY

VIDEOGRAPHER, PHOTOGRAPHER, BUSINESSWOMAN, COMMUNITY ORGANIZER, MOTHER

For I know the plans I have for you, declares the lord,
"plans to prosper you and not harm you, plans
to give you hope and a future."
—JEREMIAH 29:11

*L*ife has definitely thrown me some curveballs. I had a uniquely difficult childhood. My father traveled regularly in his career with National Cash Register (NCR) and as a result, my family moved all over the country starting my second grade year in school. Throughout my elementary, middle, and high school years, I lived in places like California, Illinois, Texas, Pennsylvania, and Colorado. In ninth grade, my first year of high school, I attended three different schools in that year alone. I was a shy girl and was forced to become the "new girl" way too many times in my life. I lost track of how many times I was brought to the front of the class and introduced as, "the new girl." On one hand, I was very blessed to have a happy life living in beautiful, scenic locations and meeting new kids, but each move took a little out of me. I began to experience a sink or swim mentality...so I decided to swim. It was during these tough early years that I began learning the lesson of a lifetime called "adaptability" that I believe laid the foundation for the grit that got me through the many challenges that awaited me in my future.

As wonderful and different as my childhood was, all the moving around was the hardest on me. I had loving parents and siblings, but I spent a lot of alone time due to the relocations. It was during my alone time that I would daydream about my future. I quietly began dreaming of becoming a doctor. My brother began pre-med courses at sixteen years old and then medical school. I would sneak into his room and read his medical books. I

didn't know what it meant at the time, but anything covered in yellow magic marker in his books especially caught my interest. I began to memorize and was fascinated. I did many extracurricular activities and was accepted to two Pennsylvania state colleges. Before I was able to make a decision about college, though, my father was transferred yet again, this time to Dallas, Texas. Going to college in Pennsylvania would mean living far away from my family, and I wasn't ready for that, so I put college on hold, moved with the family to Garland, Texas, and began working. I kept my nose in my brother's medical books, but my dreams of being a doctor began to diminish and new dreams began to take shape: marriage, motherhood, and stability. Looking back, I see that what I was longing for the most was what I never had growing up: the ability to put down roots for the first time. My folks were then transferred to Chicago, and it was there that I met my husband of twenty-eight years. He was stable, he was safe, and I loved him.

I may not have been a woman of education or a woman in a man's arena, but I do believe I was successful in my choices. Motherhood was my success story, but it didn't come without some curveballs. One of the hardest things I have ever had to push through was three heartbreaking miscarriages. To carry a baby and then lose it is a new kind of heartache. However, I have three little souls in heaven waiting for me that I can't wait to meet. My fourth pregnancy produced my greatest success story: my son, Jordan. He is my pride and joy. He is a wonderful husband to my amazing daughter-in-law and father to Rosie and Lily—our flowers. He loves God and is a successful songwriter and producer in Nashville. He has won Dove Awards and BMI Awards, and he is changing lives with his music. I have experienced more joy and love than I can put into words mothering Jordan, and God has surely blessed me.

The year 1998 threw my family a devastating curveball. My sister, Kim, at the age of thirty-three, died tragically in a house fire in her condo. She was a single mother and had asked my parents to babysit her daughter that evening. We are forever grateful, because her now thirty-one-year-old daughter's life was spared because of that. As with any house fire where there is loss of a life, an investigation took place, and this case turned out to be a high-profile case in the media at the time. My elderly parents could not handle any more than her loss in this tragic manner, so I was asked to be

the spokesperson for the family. I saw photos I didn't want to see and heard horrifying details about Kim's cause of death that I still carry with me today. Friends told me they worried about me for two years after her death. I could hardly leave my home. Her case remains in the unsolved homicide section of our local sheriff's office. Her boyfriend was the prime suspect at the time, and to this day, he has not been charged.

Children are such a blessing, especially during hard times. They don't allow you to stay down for too long. It's easy to want to crawl into a hole of depression and sadness, but the responsibility that comes with having a child with needs and a schedule forces you to push through the darkness and keep moving forward. Kim's daughter and my son deserved a happy childhood. I had to push past my own grief, help my parents raise Kim's daughter, and work overtime so this tragedy would not define us as a family.

On February 18, 2019, on my deceased sister's birthday, my mother passed away at the age of eighty-seven. She was robbed of so many of her daughter's birthdays, and this was not going to be another one without her. She was going to be with her daughter. It was sheer will pushing through her dying state to pass on her daughter's birthday.

My mother was my biggest mentor and my best friend. She was extremely wise and a brilliant businesswoman. I admired her beauty, her fashion sense, and the way people were drawn to her. Her kindness toward others, the way she adapted to her ever-changing environments, and her ability to never miss a beat always inspired me. I longed to be like her. I could always count on her for the best advice. One of my favorites was, "When in doubt, do nothing." Such simple advice, but I have used it repeatedly in my life.

I was hit hard by a new kind of grief when my marriage ended after twenty-eight years. This description of grief, written by Jordan Sarah Weatherhead, defines exactly what I felt.

"The chemistry of your insides are disrupted. Your heart has a tick to it, a skip in beats every now and then. Now your stomach has a permanent knot in it for quite some time afterwards. And your soul, well, your soul takes quite a beating. It's damaged and scarred, but it doesn't mean that you're dead. And then someday just out of the blue,

when you're least expecting it, you'll feel a little better. Then a little better, and all at once, you'll feel whole again."

Three years after my divorce, I met Dak Alley, and in 2015, he became my husband. He is my love, my protector, my friend, and my business partner. He loves my family in every way, which is evident in how he helped me care for my elderly parents before their passing, and he tells me every day how great I am. Dak brought it all together for me. I was scared and uncertain about finding love again, and he put me back on solid ground. We are co-owners of an elopement wedding photography business called "We Eloped Nashville." He is my greatest encourager. We hold hands and share each other's losses and dreams, and I know where I stand in his heart. He surely feels like home to me.

My story is one of many changes and loss. Between my unstable child-hood, my miscarriages, losing my sister, and the end my marriage, grief has plagued my life, but I wanted no part of it. To me, true grit means having stamina in the hard times, staying strong-minded, and pushing through the barriers when you're tempted to give up. I've also heard grit described as "sticking with your future, day in and day out, and working really hard to make that future a reality. It's living life like it's a marathon, not a sprint" (Angela Lee Duckworth). That definition resonates with me so much, because I have come out on the other side of each situation stronger than I was before. I believe that with God's help, the support of a mother who loved me, and lots of practice and lessons learned along the way, I made it through the hard times and am indeed a *woman of true grit!*

CATHY NAKOS

DAUGHTER, WIFE, MOTHER, AND
SINGER/SONGWRITER

Smile and the world smiles with you.
Cry and you cry alone.
—UNKNOWN

My life has been filled with many challenges. When my mom and dad separated, we had nothing. My mom, my brother (three years younger than me), and I moved into an apartment that had rats in it. I was determined never to live like that again. And to this day, seeing any animal with a long tail sends shivers up my spine. When my dad came back, my mother cried so hard that she passed out. I was determined not to let anyone do that to me, and I decided to always take care of myself!

My father was not perfect by any means, but he was a man of tenacity and hard work. He had a rough childhood. Despite an impressive academic performance, graduating high school as the Salutatorian, he was insecure emotionally. Dad always had something to prove. He was a great athlete, and that helped him learn that no matter how far down you are, or how many times you lose, it's your attitude that makes you a winner or a loser; he always found ways to win. He often talked about owning a restaurant, and at sixty-five, he opened his first one. He passed ten years later, having owned eleven restaurants!

I took the bull by the horns. I graduated from high school and got married the next year. My husband was diagnosed with multiple sclerosis just two years later. My first son was only nine months old at the time. I set out to beat the disease. Preparing for the worst, I volunteered for the National Multiple Sclerosis Society and became their lead volunteer fundraiser and public relations person. I became the leader of the household, making many big decisions, including whether to get pregnant again. I taught all three of

my children how to think, how to manage their priorities, and how to be responsible for themselves.

My children lost their dad when my twins were ten years old and my oldest son was twelve. I asked each of them before they left for college if they felt cheated because they lost him so young. My one son said, "The earth has been here for 4 billion years; whether we die at thirty or ninety is insignificant." This pushed me to constantly review my perspective. If we don't like something, we can choose a different way to look at it!

I have been blessed to meet many remarkable people who have affected my perspective on life. Paul "Bear" Bryant, an American college football coach at the University of Alabama, had a particularly profound impact. I asked him to be "roasted" to benefit the National Multiple Sclerosis Society, and not only was he a great motivator for me, but he guided me through the chairing of his event. As a twenty-three-year-old who knew little of my future, I definitely needed his guidance. He trusted me to call and invite key coaches, pro football players who played for him, the president of ABC, and other celebrities who would make the event a success. His support helped me realize that I can do great things. I still remember his answer when I asked him, "What made you so successful?" He responded, "I surround myself with successful people."

My grandmother exemplified true grit. Born in Greece, she was left to care for her grandparents at age nine while her parents and siblings took a passage to America. When she was seventeen, her grandmother passed away, and in 1917, in the throes of World War I, my grandmother took a boat from her Island of Karpathos to Athens, surviving a major storm, and then took a ship from Athens to New York City. It was unheard of for a young woman to travel alone, and she was petrified. But she had a strong faith. My grandmother turned her life over to God, knowing that she could overcome anything. She passed on that faith to me, and for this, I will be forever grateful to her.

Dudley Hafner, former executive vice president of the American Heart Association, influenced my life and became my mentor. He had aspired to have the job of executive vice president someday but had started in the mailroom. His leadership was so impeccable, encouraging, and motivating. When I asked him, "What made you so successful?" He replied, "My mother

never gave me an opportunity to lie. She didn't ask questions like, 'Were you drinking?' If I said, 'No,' that would be a lie. And if I lied once, I would lie many times. Instead, she guided me; 'You know, if you drink, you could do something irresponsible. As an example, you can drive and cause an accident or a death—even possibly your own. If you don't drink, it will clear your mind to make responsible decisions.'" Taking his mother's advice to heart, I raised three honor students alone, and my children are successful and responsible citizens.

Paul "Bear" Bryant, my grandmother, and Dudley Hafner never took their eyes off the goal and always found the strength to be positive in *any* situation so they could keep moving forward. They set goals and broke them down into tangible steps to carry those plans out. They identified their strengths and weaknesses and soberly evaluated their opportunities and threats. These are skills that we can all apply to our lives.

I am who I am because of my strong faith in God. I believe that for things to change, I must alter my perspective and delight in sharing this with others. I choose to look for the silver lining in all situations. I believe that I should give myself reasonable time to grieve, but as I am watching myself walk through it, I must also remember that there is something much greater on the other side. I can find strength in myself and others to reach our full potential. When I look back on my life, a life of no regrets, I feel that I sailed through many storms! And like my grandmother, my faith in God is strong and grows even stronger every day. My friend asked me what true grit means to me. I believe it's having the strength within to overcome any obstacle, and that strength comes from having powerful faith.

CHRISTY JOY CARLSON-SWAID

SIX-TIME WORLD CHAMPION JET SKIER, CHILD HEALTH ADVOCATE, MENTOR, MOTHER, AND WIFE

My expected delivery date was Christmas Day 1970. However, my four-year-old brother, Tim, needed help tying his shoes. When Mom tried to help, the pressure of bending over broke her water. That meant I arrived on December 19, six days early. She told me my life brought her Christmas joy, so she named me Christy (short for Christmas) Joy. Her love and faith define much of my life story.

My mom was a transparent and multifaceted woman, totally authentic. Her parents were a colorful, adventurous, and fashionable couple. Grandpa flew open-cockpit prop planes, became an architect, and played violin. He could hunt, fish, and golf. Grandma was a fashionista who also maintained an impeccable home and garden. They raised my mom and her brother in a loving home, teaching them to honor God and country while balancing hard work with lots of fun. My mom's favorite hobby was riding horses and barrel racing. She was fine with getting dirty, but she also knew how to dress and behave like a lady. My uncle Jim went on to become a colonel in the US Army, and Mom became what she always wanted to be: a wife and a mother.

My grandma Betty had cancer at a young age, passing away when I was only four. A year later, my parents' marriage fell apart. The combined weight of sadness was substantial. I was too young to fully comprehend what was going on; I just noticed my dad wasn't around and saw my mother's grief and anxiety. We lived in a small house on the south side of Chicago. My brothers and I walked to St. Jude's Catholic School a few blocks away. Mom got a job at the local fire department as a dispatcher and photographer. It was tough making ends meet. My grandfather lived a half-hour southwest of Chicago, in what would be considered farm country. His had a sweet ranch house with a large view of a hay field, two ponds, and a large oak tree. He invited us to move in with him, and that was the beginning of fresh new blessings.

Mom regained her health and returned to her first love, horses. We bought a cheap horse and arranged to board it at a farm that gave us a deep discount in exchange for me doing chores. At age twelve, after school each day, I groomed and exercised Mom's horse, fed and watered the other horses, and mucked all the stalls. I still had homework, music, and sports, so I eventually burned out and handed off my horse duties to my brother Rick. He was a natural and became a champion horseman and trainer. We acquired more horses, and my mother met her future husband, Don Yunker, a hay dealer, farmer, and elected highway commissioner. He was a perfect gentleman.

About this time, a neighbor invited Mom to join a lady's Bible study. We were dedicated Catholics who loved and feared God and never missed Sunday mass. As Mom soaked up the words and teachings of Jesus with the neighbors, the weight of the world began to fall off her shoulders. A softness came over her, and a rock-solid new faith and joy emerged. I watched her fear of failure and rejection dissolve. She glowed with confidence in the love and grace of God. She prayed we all would have a personal encounter with Jesus.

Within a couple of years, my brothers and I invited Jesus to be our personal Lord and Savior, followed by baptism for the remission of sins and receiving the gift of the Holy Spirit. This personal decision and commitment gave us peace, purpose, guidance, and drive. In high school, I prayed for God to guide me, but it seemed nothing was working out. I didn't qualify for scholarships or financial aid. My mother didn't have money for college. Then, from out of nowhere, an option presented itself: professional jet ski racing. It seemed ridiculous.

My dad had been selling timeshares at a resort on a lake in Austin, Texas, and he bought a dozen stand-up jet skis from a Kawasaki dealer that had gone out of business. Ever the entrepreneur, Dad started the first jet-ski rental business. My brothers and I spent the summer of 1978 with him in Texas. I was seven the first time I rode a jet ski, and my brothers thought it was fun challenging me to keep up with them. I strove to hold my own for fear of being left behind. Dad later moved his business to Florida, where it was warmer year-round, adding other recreational rental equipment and

working with fine resorts in the area. He taught us how to maintain and operate the equipment, run the business, and manage money.

The national jet-ski racing tour was gaining popularity during this time, and it came to our hometown of Ft. Myers. I begged my dad to let me participate. He helped me choose the best rental jet ski we had on the line, a hunk of junk compared to the professional racers' skis, but I didn't care. I borrowed a helmet and took a chance. It was so much fun, and my finish was respectable, surprising the sponsors. From then on, I entered any race I could. By the time I was a junior in high school, sponsors reached out to my dad and offered to help me to go pro. My mom and grandpa wanted me to go to college, but the financial roadblocks led me in another direction.

In 1988, as a seventeen-year-old junior year in high school, I was sponsored to race the national tour and compete in the world finals as an amateur. Once a month, after school on Fridays, I flew from Chicago to Los Angeles to train with my teammates. I did homework on the beach between training sessions. Then, I caught the Sunday night red-eye flight back to Chicago; I would arrive early Monday morning and head straight to school.

The national tour started on Memorial Day weekend and ended in mid-August, racing in a different city each week. We started in California and worked our way across America to Long Island, New York. After the national tour, racers took a short hiatus to gear up for the World Finals, which took place in Lake Havasu City, Arizona, in October. The winner of that single event was crowned the world champion.

In 1988, I won the amateur national title, sweeping races in almost every city. Then, at the Lake Havasu World Finals, I pulled a nice lead when a huge rogue boat wake—something I had been warned about—flipped me upside down on the back straightaway while at full throttle. I lost the championship and learned a hard lesson.

To afford to race the tour in 1989, I was required to advance from the amateur division to the pro class. To be ready for the pro class, I would have to graduate high school early and immediately move to California to train extensively. My intention was to go to college and let jet ski racing pay for it. To finish by January, I took extra classes to get the necessary credits, forfeited lunch to swim laps, stayed in the orchestra, and played on the soccer team

for extra fitness. I graduated in January and moved to California the next day, missing prom and graduation. The school mailed my diploma to my mom.

She and I prayed that God would lead my path and protect me. She offered unconditional support, which gave me the courage to try and maybe even fail. I memorized scriptures that drove me to "work wholeheartedly as unto the Lord." Whether anyone was watching or not, I knew God was watching, and that meant I always gave it my all. I had no idea how my performance would compare to the reigning world and national professional champion, Brenda Burns.

The moment of truth arrived on May 28, 1989, at Long Beach Marine Stadium. I was terrified of failure but had memorized the scripture 2 Corinthians 12:9, which says, "My grace is sufficient for you, for my power is made perfect in weakness. Therefore, I will boast all the more gladly about my weaknesses, so that Christ's power may rest on me." This scripture gave me courage. For when I am weak, then I am strong.

I ended up winning that first pro-national race as a rookie. No one could believe it. Especially me. That was the beginning of a series of wins in which I swept all titles: national, world, world cup, and several international invitationals. By 1994, when I was twenty-three, I had won four world and five national titles. I carried endorsements from fashion and fitness to fuel, oil, and spark plugs. My dad taught me to balance a budget, negotiate contracts, and live beneath my means. My mom taught me that God loves a cheerful giver, so I should always take time to volunteer and give to good causes.

There were many injuries along the way, and I had multiple surgeries. My competition crept up and took the title in 1994. I tried to compensate by overtraining and ended up worse off in 1995. Mom held me together— she was my faith when my faith was gone.

A sports performance and rehabilitation center contacted me about doing research on the physical demand of various sports. They took control of my training regimen, reminding me to slow down so I would be able to go fast. I healed and reached peak fitness like I had never experienced before, and I was even named one of the fittest women in America by *Competitor Magazine* and *Muscle & Fitness*. I also reclaimed the national and world titles in 1996. If not for injuries and defeat, I would never have received the science-based fitness education and experience that is now so much a part of

my health program that helps children in impoverished areas across Alabama learn about disease prevention through proper nutrition and exercise.

Eventually, the watercraft tour called me back one last time in 1999, with a contract to ride for Polaris in the runabout (sit-down watercraft) program. I went on to win the world finals. In 2000, I flew to the Atlanta Super Show (the world's largest sports trade show), to make an appearance to sign autographs and explain the benefits of heart rate conditioning. There I met Dr. Swaid Swaid, a world-renowned neurosurgeon. We appeared to be polar opposites, but it didn't take long for us to discover we shared a mutual passion for two important things: our common faith in Jesus and the desire to be the best at our craft. Our friendship grew over the course of two years, mostly long distance, because Swaid was in Alabama and I was in Los Angeles. We talked regularly, though, and any chance I had, I was 'Bama bound.

On December 28, 2001, the guy who said he would never get married again proposed to me. For me, this meant retirement and moving to Alabama. In my heart, I had always dreamed of being a good wife to a good man. Swaid's children were in on his decision, and it was unanimous. We immediately began planning the wedding, and I started the process of informing my agent, sponsors, and friends of this life-changing decision. I did accept one last job, a film directed and produced by Clint Eastwood. Besides being a legendary Hollywood actor, he was known for his impressive professionalism, and I was able to witness it firsthand.

A week after the honeymoon, I moved everything from Los Angeles to Alabama and began figuring out this new life of mine. I wasn't trained in the art of domestic living. I went to culinary school and hired a chef to teach me the basics of cooking. Blending a great protein smoothie or squeezing wheatgrass for an immunity booster was easy, but basic cooking escaped me. Though I felt bad for not being a natural southern homemaker, Swaid assured me he loved me anyway.

Swaid and I were hoping to have a baby. Extreme fitness over the years had made it difficult to conceive. While praying for a baby, my mind was focused on children. That's when I noticed the poor health of kids in our community, with one out of three statistically on the path to obesity and chronic disease due to inadequate nutrition and exercise. My husband

offered to help me develop a science-based and measurable plan, connecting me with his friends and colleagues, the brightest and best minds in medicine, education, and leadership. He brought innovative medical technology to the state of Alabama, recently building one of the most advanced outpatient surgery centers in the country.

He supports my passion, Healthy Eating Active Living (HEAL), and sees the dire need for preventive healthcare. HEAL began as an experiment in 2002, and it is now a 501(c)(3) nonprofit organization based in Birmingham Alabama. The initial HEAL mission was to transform physical education classes into a measurable personal health and wellness experience for children in elementary schools. The experiment proved to be a smashing success for the teachers and the students. Heart rate technology made it possible for the inclusion of students of all fitness levels as well as students living with special needs. Teachers could reward students fairly and appropriately for their physical effort. I was so excited to pitch my idea to a large obesity task force at a local university. However, I was told that my idea would not work, and I respectfully disagreed. The combination of my life's experiences with science-based fitness and the reaction the children had in the PE experiment led me to ignore the critics.

I became pregnant just after HEAL was born, and God blessed us with two healthy boys, Christian in 2004, and Cason in 2005. They helped develop HEAL over the years and today continue to illustrate and edit much of my work. We listen to the needs of those we serve and build innovative solutions. We provide internship rotations, college scholarships, and job placements so students can have long-term success. Today, we serve over 180 schools, 40,000 students, and 100,000 household members statewide, with measurable results and a growing waiting list. We began a pilot expansion in Arkansas and provided supplies for missionaries serving students in Africa. The same professors that originally dismissed me from the roundtable discussions later nominated me for the Outstanding Woman in the Community Award. That award was another unexpected blessing that came as a result of not giving up.

In June of 2019, my stepfather passed away. My mother was his caregiver, unable to travel and leave him alone. She considered it a privilege to be the hands and feet of Christ for those in need. She planned to stay in

Birmingham with us for a while after Don passed. We were excited to have her. I began preparing a living space at my house for her arrival around Thanksgiving. Then she had terrible back pain which a doctor found to be a result of widespread cancer. In January of 2020, she went home to be with the Lord, never making it to Birmingham. She was my best friend who related to me on every level. She was funny, serious, and unwavering in her faith. Even while dying she told me, "With Jesus, the best is always yet to come."

I'm thankful for the women of true grit that God has put in my life. Their love, prayers, and Godly character helped to fill the gaping hole my mom left behind. I feel moved to dedicate my story to Marilyn Waggoner, the embodiment of a steel magnolia. She showed me what it looks like to choose joy in the absence of happiness. I had the privilege to partner with her during her chemotherapy sessions. After a tough treatment, I asked a silly question, "How are you?" She looked beat-up, drained, and lost all her hair. Her answer was, "Grateful"!

To me, having true grit is extending kindness to others, and persevering through the hard times.

DALE SMITH THOMAS

DAUGHTER, WIFE, MOTHER, BEAUTY QUEEN, ENTREPRENEUR, AND MOTIVATIONAL SPEAKER

Think for yourself. Trust your intuition. Another's
mind isn't walking your journey. You are.
—UNKNOWN

I grew up way out in the country in Mississippi, where the nearest "big city" had less than two thousand people in it. To get one of the three TV stations, Daddy would have to go outside and turn the antenna. We did not have a lot of money, but we had plenty of love and all the things that mattered. I don't remember ever dreaming of leaving that special part of the world. I assumed I would end up marrying a preacher or somebody like that and stay there. I jokingly say I broke my mother's heart by not being married by the time I graduated high school. I don't remember when I made the decision, but I decided to be the first person in my family to go to college. My daddy had not graduated from high school, and my grandmother had only finished fourth grade, but she was one of the most talented women I have ever known. Going to college was going to be a big deal for me. I knew financially it would take scholarships, grants, and student loans for it to happen.

We were trying to figure out the finances for college when an incredible opportunity, a miracle, opened up for me and many others. Back in 1977, Mr. and Mrs. E. H. Sumner, who lived in Eupora, Mississippi, put their nineteen thousand acres of timberland into a trust. That trust allows students in five counties to attend certain state schools tuition-free. My education at Mississippi State is due to this gift. That one decision by this family has put more than $110 million into education. It reminds me over and over again of the opportunity we have to plant seeds of hope into other people's lives. I did not know the Sumners personally, but

their decision changed my life and has changed the lives of many other Mississippi students.

There have been many women with true grit in my life, and their mentorship has prepared me for many challenges I have faced. One of those was my piano teacher, who had been badly injured in a car accident at age eleven. She was told she would never walk again. But Cheryl Prewitt Salem went on to become Miss America in 1980. She was a teenager when we met, and I learned how her faith, her true grit, and her belief guided her life. She is now a minister and travels around the country singing and preaching. And yes, changing people's lives.

Now, I travel the world speaking on stages, to audiences small and large. Speaking is not just my career; it is my calling. I love being out there sharing a message and principles that have changed my life as well as the lives of others. I am sure that it is grit that has gotten me through grueling schedules, time zones, technical difficulties, and of course serious pain in my feet from those high heels I love so much. Trust me, I know what it is to grit my teeth and make that long walk to the airport gate yet again.

But May 2020 required the greatest amount of true grit. My daddy graduated to Heaven after contracting pneumonia, unrelated to COVID-19. He left us the day before Mother's Day. In June, my ninety-six-year-old father-in-law passed away. We could only remind ourselves—in the middle of a pandemic—that God had allowed us to have them for eighty-five and ninety-six years respectively, even if the virus kept us from properly celebrating their time here on earth. I took time each day to sit by myself to journal, pray, meditate, and look for a new way of doing things. I also began to recognize that during April I was able to be in Mississippi; if the contracted engagements I was supposed to have during that time had not been canceled, I would not have had that time with my daddy before he left this earth. In the middle of each challenge, each painful experience, if we stop and pay attention and truly look we can see God's plans.

Most of my work that was canceled in April of 2020 was in health care. I have had the honor of speaking across this country to so many people who have dedicated their lives to helping others. We heard and continue to hear about all of the health care heroes during this pandemic. They are heroes every day, but this pandemic put the spotlight on their incredible sacrifices.

During this time, I realized that any one of us can be a hero. What is a hero? Here is how I define it—Humble, Empathetic, Resilient, Optimistic. I vowed I would find resilience and optimism by being humble and empathetic. One of the greatest powers we have is perspective. We can be a victim or a victor, depending on how we look at things. I decided I would not be a victim of an external force—one I had no way to control. Nor could I sit there in the middle of darkness waiting for somebody else to turn on the light. Sometimes we just have to get up and turn on the light ourselves.

Whether it is a conversation with one person in an airport, speaking to fifteen thousand people in a big venue, or being on television in front of millions of people, my goal has always been the same: deliver a message of hope. I have always believed that hope is simply Helping Other People Excel. Even though I had to change how I dealt with hope in 2020, I continued to do it, and each one of you can also. It can be as simple as making a phone call to check on a friend or smiling at a stranger. We all can be hope dealers every single day.

Several keys have helped me cultivate true grit. First, I create a power hour every single day. I get up early each day, by 5:00 a.m. Why? I want to turn to the quiet and restore my soul. Maybe that's too early for you, but one of the first keys to truly changing your life is blocking out thirty minutes a day for your mind and soul. I do more than that, but you can find thirty minutes. Notice, I didn't say *add* thirty minutes, I said *find* thirty minutes. Give up a half an hour of television or scrolling on social media. If you need to, break it down—find fifteen minutes and the morning and fifteen at night. I promise you that if you are consistent and honor yourself, it will change your life.

The second thing I do during that power hour is meditating, prayer, and journaling. I have been journaling for as long as I can remember. I use that quiet space to get down on paper everything that is rolling around in my head and soul. If I have questions, I write them down and listen for the answers. If it is fear, I write it down. Get in the habit of writing down what you are afraid of, and then ask yourself why. Go seven layers deep. *I'm afraid.* Afraid of what? *I'm afraid I will look stupid.* Okay, why are you afraid of that? *Because people will not like me.* Why is that important to you? Why are you afraid of that? The deeper you go, the more you will discover. Maybe it's just

that you lack self-confidence, that you feel unworthy. Get real and get honest with yourself, and your journal can be your safe place.

The third thing I do is fuel my soul. I do that with books every day. If you are not a reader, then there are free podcasts available. Decide that just like you feed your body, you will feed your soul. I also take that time when I feel my soul make contact with someone in my soul pack. What is my soul pack? It's my small group of like-minded people that I know I can count on. They are the people who listen to me, tell me the truth, and lift me higher. They are the real connections in my life. They believe in me when I am having trouble believing in myself.

These daily practices and habits have been part of my life for a long time. I can tell you that they have changed my life, and I know that with consistency they can change yours also.

I was asked for this interview about my greatest achievement. Without a doubt, my greatest achievement is having my incredible son, Nick Thomas. He has been both my student and my teacher. My greatest professional achievement is having the privilege of being an author and a speaker. Whether that audience is ten people or fifteen thousand, I don't take it for granted. I look back and remember the shy, insecure little Mississippi girl who was too afraid to raise her hand in class. I was that little girl who was sure that I didn't have any special ability. I feel so blessed, and I'm in awe that my faith and grit have allowed me to speak on stages around the world, to appear on major network television shows, and to hear from people all over the world that this message has made a difference. I know that I am not the message—I am just abundantly blessed to be the messenger. So how did I apply all of my experience and life lessons during this past year and navigate through 2020? What did I do to not just *go* through this but *grow* through this?

Maybe your instant definition of true grit is similar to what mine used to be: that "do or die" attitude that says we will forge on and win by powering through whatever has gotten in our way. I think that is one meaning of true grit. In the past, it also meant for me being fast-paced, never stopping, and being very persistent. The word even had an edge to it. But this past year has forced me and guided me to face life and define grit in an entirely new way. It now includes grace, resilience, inspiration, and taking time to tune

in. Covid and 2020 forced all of us to slow down and, as I said, not just go through life, but grow through it. Our hearts, minds, souls, and bodies were tested in ways we had never dreamed. And as a motivational speaker, even I was not spared from that.

DONNA C. ROBERTS

ENVIRONMENTAL ADVOCATE, FILMMAKER, EDUCATOR, MOTHER

We must realize that when basic needs have been met, human development is primarily about being more—not having more.
—THE EARTH CHARTER INITIATIVE

I come from the land of Coca-Cola, collard greens, and Martin Luther King Jr. I have this clear childhood memory of a moment when my mother, Esther, and I were sitting on our 1970s, gold-colored shag carpet. Peanut-shaped key chains were scattered all around us. My mom was volunteering on Jimmy Carter's campaign to become governor of Georgia. It was just the two of us. She was a single parent working as a secretary to make ends meet. She was also an artist and a bright, beautiful woman with a huge heart. We had great fun together.

Ever since I was a little girl, I wanted to be a writer. So when I had the opportunity to attend the University of Georgia, there was no question that I would study journalism and mass communication. I started out in the news program, but that wasn't nearly as much fun as the TV production emphasis, where I could explore my budding interest in social issues with more creativity. After an internship at CNN Headline News and a first job in radio news in Macon, Georgia, broadcast news became my way to earn a living. Moving to Montréal the next year (for love) and getting a job in English radio, I was determined to lose my southern accent and acquire some semblance of Quebecois French. Within two years of leaving the Deep South, I'd started a production company with a colleague. Thankfully, my mother encouraged my move thousands of miles away. She likely wanted me to live my dreams, as she'd had to forgo so many of her own. And she'd have a great place to visit, which she frequently did.

By the late 1980s, I found myself immersed in learning about "the environment." The twentieth anniversary of Earth Day was approaching. So-called green living was becoming trendy.

It was as if I had an awakening about caring for the Earth and how human behaviors were devasting the ecosystems that sustain all of life. With this new awareness, I felt I had no choice but to devote as much time as possible to environmental advocacy and community education, while integrating these themes into my productions and working a broadcast news job to help pay the bills. In 1995, with two dear women colleagues turned friends, Judith Murray and Rosie Emery, I produced *Celebrate the Earth*, marking the twenty-fifth anniversary of Earth Day. The next year, we created a similar special, which was broadcast throughout the Americas. The shows featured indigenous celebrities such as Graham Greene, youth reporters, and well-known musicians. We were striving to educate while entertaining.

Attending an international environmental conference in Montréal, I met the organizers of the upcoming Rio + 5 Forum on Sustainability. They embraced my proposal to create a video for the event's opening plenary. My world was soon to expand beyond anything I could have ever imagined. The global gathering was to be the follow-up meeting to the 1992 UN Conference on Environment and Development (UNCED). My video illustrated where we'd been as a global society and where we needed to go if we hoped to save ourselves and the Earth. I never expected to travel to Rio de Janeiro. To my delight, I was invited to the conference not only to present the video, but also to interview conference delegates. While there, I had the good fortune of being able to attend several sessions, including a meeting with Mikhail Gorbachev, Steven Rockefeller, and other leaders who were drafting the soon-to-be-launched Earth Charter, a blueprint of values and principles for creating a more just and sustainable future. It's since become one of my treasured tools in life, education, and advocacy.

During my time in Brazil, I took a trip to the Amazon to fulfill a long-held dream. Then, a new friend at the conference suggested I travel to Salvador, Bahia. I did. There, I encountered the beautiful spiritual culture of Candomblé, an evolution of the lifeways of enslaved Africans who were forcibly taken to Brazil during the transatlantic slave trade. Brazil abolished slavery later than any other country, and it was the largest slave port in

the hemisphere. Those African traditions have persisted over the centuries, transforming Brazil's first capital city into what is commonly known as Afro-Brazil. When I learned that smaller communities within this large metropolis were led by elder women of color whose cosmology incorporated a holistic worldview where elders, the ancestors, and the natural world were revered, I knew I had to tell this story in a film. It took nearly eighteen years from conception to manifestation, and ultimately, a partnership with great Canadian filmmaker Donna Read, with narration by Pulitzer Prize–winning author and activist Alice Walker. The film's global launch took place in small-town Bahia, the home of the eldest woman in our story, the 109-year-old daughter of an enslaved African. *Yemanja: Wisdom from the Africa Heart of Brazil,* has won multiple best documentary awards. My husband Gerald Hoffman was the videographer; he also created a beautiful companion photo exhibit, *Goddesses of Nature.* I've traveled many places sharing the film and its story. Working with this project, this dream that insisted on manifesting, has been incredibly fulfilling and nourishing. Being a minority in Brazil on location, during filming and later academic research and production, and in many of the events featuring the film, has been enlightening and humbling. Despite our white privilege, white folks are the global minority. It would be helpful if we would live this truth.

My late, elder mentor Lanie Melamed opened my eyes to the meaningful intersection of women and nature and the common assaults both have suffered due to globalism, capitalism, and patriarchy. Lanie taught me about eco-feminism, which would soon become a focus of my graduate studies. (I later learned about eco-womanism, which centers women of color and their spiritualities and relationships with Earth.) Lanie survived breast cancer multiple times, and she earned her Ph.D. in her midfifties. When we met, I was a new mother and she was serving on the board of Breast Cancer Action Montreal, which was investigating and disseminating information about environmental links to breast and other reproductive cancers. Shortly after meeting these women, I became their volunteer newsletter editor, and Lanie became a beloved friend and teacher. She also introduced me to the field of popular education—developed by Brazilian Paulo Freire—where everyone's knowledge counts. Whether you have a Ph.D. or a grade-school education, you have

valuable knowledge and insights and deserve a place at the table, a voice in decisions affecting your community and life. That inclusive notion of learning was foundational to my master's research, which incorporated field work among female Brazilian socioenvironmental educators and activists.

A few years after my son Gabriel was born, he was diagnosed with autism. Naturally, I ended up broadening my advocacy efforts in an effort to fulfill the needs and enrich the lives of my son and children in other families like ours.

Gabe is the most brilliant, creative, intuitive, funny person I've ever known. He also has, at times, debilitating anxiety and OCD. Once, when I was picking him up from high school, the secretary said, "You're Gabe's mom? Your son is the smartest person I have ever met!" Gabe knows random facts about most things, and he will quiz you on them. His favorite book is Smithsonian's *Timelines of Everything*, a large book that he's likely memorized. Gabe takes his favorite books and other treasures everywhere in a backpack, which is a constant companion. I'm sure it's also about the calming pressure from the books—like a weighted blanket with benefits. Gabe's real love is music. He's a drummer whose tastes range from Frank Sinatra to Simon and Garfunkel (which we love singing together). His favorite is jazz, and "Miles," as Gabe says.

Unfortunately, Gabe's talents and intelligence can't be measured by IQ tests, and people often underestimate him. A therapist once said our family's biggest challenge would be helping others understand Gabe's abilities, because they often won't see beyond his disabilities. Gabe needs help with managing his schedule, impulse control, and social situations, among other things. He probably always will. And I will do anything to help him reach his potential.

At some point, I received a greeting card from my mother, Esther, who had a great sense of humor. On the front was a picture of a mother folding clothes in a laundry room as her young daughter watched. The speech bubble over the little girl's head read, "What do you mean you don't get paid for this?" My mom had no idea how meaningful that card would later become. (Or maybe she did.)

My graduate studies coincided with life unfolding as Gabe's mom. While I was being formally educated about environmental and women's studies, I was learning first-hand about all the unpaid domestic and caregiving work that moms do for years on end—decades in my case, supporting my autistic son. But I really started connecting the dots at an academic conference where one of my sheroes was the keynote speaker. Marilyn Waring was the subject of the film *Who's Counting? Marilyn Waring on Sex, Lies, and Global Economics,* which was made in the late 1990s.

As a young politician in New Zealand, she went on a mission to learn how the world's economies work—or don't work—for everyone. And what she learned was shocking. Most of women's work worldwide, including domestic and caregiving work (when one counts all those hours), as well as things like a healthy environment, simply don't count, because they don't generate income. If there's no money being paid for work or services, whether or not they are vitally important, they're not going through accounts and economies…and they're not counted in a nation's GDP (Gross Domestic Product). So they are considered not to have "value" but instead are considered "unproductive" in a formal sense.

Now, while I happen to consider caregiving work to be valuable, there is a lot to think about here.

Often, I've felt like I've lost part of a day or a week being pulled away from my paid, part-time work to be there for my son…whether it's going to doctor's and therapy appointments or meeting with school districts and agencies for appropriate programming, accommodations, and even basic understanding of Gabe's complex needs. As necessary as that work is to Gabe and to our family, *economically,* it is considered "unproductive." And think about this: if that *same* work was being done by someone I hired and paid to do it, it would in fact be considered productive, because that person would be earning money. That work would "count."

But back to the conference. I stopped in the bathroom, and there was Marilyn Waring!

I told her how much her work meant to me, how it was truly life changing. She hugged me and gave me a copy of her latest manuscript. Then came the keynote, and Marilyn started telling a story that felt very much like

my story. Not only has there been no improvement in recent decades, she said, but things have actually gotten worse. Women are more overworked than ever, working double and triple shifts to make ends meet—including that unpaid shift or two at home.

And then came the wake-up call.

Marilyn said, "Women who are mothers of children with disabilities have it even harder, because they must devote even more time to unpaid caregiving and over many more years than other women." I don't clearly recall what she said after that, because frankly, I was stunned. That was the first time I had heard someone outside of the autism or disability community not only discussing my motherhood experience, but also sharing research that validated my daily life and concerns...not only the caregiving, but also how I've had to forgo full-time jobs with benefits, among other things, because I have needed to be more available to care for my son.

As we know, this became the reality for many more parents during the pandemic, when we had to leave the workforce or reduce the hours worked at paid jobs in order to homeschool and care for children. Men left too, but many more women suddenly found themselves with a lot more unpaid work.

Also, during the early pandemic (by then, our family was living in Burlington, Vermont), after Gabe's supports and services abruptly ended, he had a crisis related to his anxiety and OCD. Gabe spent two weeks in the emergency department at University of Vermont Medical Center. Despite our efforts and Gabe's consent, he could not get approved for inpatient mental health care. Why? Because he has autism. They chalked it all up to his disability.

But aren't we allowed to be seen and treated as whole people? All of us?

Lately, I've been working to help Gabe succeed in his new job—a volunteer position. (Do we see a pattern here?) And it's going well! He loves his work and loves meeting and talking with people. Contrary to what some people think, many folks with autism are very sociable. Sometimes when I'm praying that his work goes well, that nothing triggers his anxiety—like too many people or too much noise, or confusing

explanations—I also say a prayer about my own work. You know: "Put on your own oxygen mask first!"

I worry about my son's future. I try to help him be prepared for life without me, because I won't be here forever. Gabe recently told me he doesn't want me to die; then he asked if he could have my books when I do.

I figure if he has a job and friends to enjoy music with, he's on his way. Gabe also wants a girlfriend but is aiming a bit high. "Are you sure Jennifer Aniston married Brad Pitt again?"

As for me, I'm increasingly using my passions and skills to help create and support solutions for Gabe. I'm developing a film about young people with autism reaching adulthood, and the stories of moms like me whose lived experiences are so often undervalued. The film will also cover ongoing advocacy to secure housing solutions for our offspring and paid employment that fits their interests, skills, and passions. You know, the basics.

It is important to be valued for our contributions, no matter how we spend our time, and to have the chance to be engaged in what fulfills us.

When I've had opportunities to teach college courses in environmental studies, and often to primarily female students, I tell them to listen to their dreams, to whatever may be calling, especially from our inner selves. Certainly, we must take care not to follow those voices outside of ourselves telling us to do something that may not feel right, or pointing us in a direction that we're unsure of. We all have something that we must manifest in this world. That is uniquely our path...our mission. It's important to try not to be tied to precisely how or when it is going to manifest. I believe that the universe, God, our ancestors, angels, higher self, whatever we each call our guiding or sacred energetic forces... they are supporting us. They want our success! The way will be shown according to what I call *divine time*; the outcome will likely be much greater than what we could have imagined.

To me, true grit means having persistence, perseverance, resistance, and resilience, while staying the course and doing your best to show up for your family, your community, the Earth, and yourself. We all have an inner compass and have values that we cannot compromise on. We all know what's right and what's ethical. And don't forget to help "the other"...especially

those with special needs or cognitive diversity. Befriend them, hire them if you have a business, and help give their parents a break.

A final thought: as one of Gabe's favorite drummers, Ringo Starr says, "Peace and love! Peace and love!" Thanks! Merci! Obrigada! Axé!

GENMA HOLMES

WIFE, MOTHER, MODEL, AND
SERIAL ENTREPRENEUR

Every day above ground is a good day.
So until you're dead it ain't over.
—DORETHA JACKSON

I come from a long line of women of true grit. Big Mama (Jamie Nichols) was my grandmother's grandmother, Murdear (Annie Turner) was my grandmother's mother, Doretha Jackson was my grandmother, and my mom is Dr. Joeretha Jackson Stringer. Each one was a gifted nurturer who passed down their caregiver genes to me. When I was young, whenever I spent any time alone with one of them, they would comment that I remind them of each other. These women are such a huge part of who I am. Their collective strength of being women who made a way out of no way gives me the courage that inspires me every day and helps me to continue their legacy of servant leadership that makes up a huge part of my life today.

I will never forget going to my grandmother's house and seeing five generations of women sitting around the kitchen table, quilting. I had no idea the role that quilts would play in my life. Until I was older, I did not realize that a quilt is more than just pretty bed covering—it is a symbol of generations of women who made the most from very little. Quilts conveyed messages of hope and dignity, and they were teaching tools at community gatherings. Today, a quilt made by my grandmother's grandmother is in the Smithsonian. My great-great-grandmother's quilts are symbols of family pride and artistry. Her history was captured in a book titled *A Communion of the Spirits,* by Roland L. Freeman. When I attended the *Creation Story: Gee's Bend and the Art of Thornton Dial* exhibition at the Frist Art Museum in Nashville, I could hear the voices of the women who came before me speaking to me as if they were standing right there.

Big Mama (Jamie Nichols) lived to be 109 years old. For many years, she was the oldest person in the state of Mississippi. Coming from this kind of lineage has nothing to do with money, but it has everything to do with character, determination, and grit! They made things happen, and they did not know they were making history. I was blessed to sit and learn at their feet. My grandmothers were not formally educated or trained. They were self-taught or received an education later in life.

My grandmother and grandfather had twelve grandchildren. The four older daughters were literally in school together, since they were so close in age. When they attended college, my grandmother also went to school to get an education. My grandmother put herself out there and humbled herself to be educated alongside her children. When you have that kind of determination, you are set up to do great things for yourself, and your family benefits from those efforts later.

Although they had limited resources, education became a passion for my grandparents, as they made sure to give their children and grandchildren educational and vocational opportunities. This was a setup for major wins for my family for generations to come. My mom is an educator in chemistry, her sister is a pharmacist, and my sister is a pharmaceutical sales representative. I could not have asked for a better background of supportive women, who have used their knowledge and expertise to help me develop a burn cream that is slated to be sold to burn victims. I cannot help but win at this endeavor with women in my life who understand what it takes to bring this type of product from a kitchen table recipe to the pharmaceutical marketplace. Because of them, I am willing to start another venture in life from the ground up.

Continuous reminders of my grandmother making a way out of no way, along with her fearlessness and her confidence that nothing is impossible, have allowed me to be an advocate for myself. Many times, during my years of modeling and acting, I was told that I could not be a woman of faith and work in the film industry or model professionally. That was simply not the case. When I started raising a family, the narrative changed. Now I could not be a mother *and* manage a family-owned pest control business. Nearly thirty years later, I am in still film, still in print ads, and still at the helm of Holmes Pest Control! When these comments arise, I remind myself that someone

else's no does not determine my future. The only person who determines my path is God. Where He has opened doors, I will go.

Whenever I am asked about the challenges I have faced over the years, I reflect on how I was built tough. The most challenging situations for me have come about because I was a woman in what has traditionally been a male leadership role. But because I understand that adversity can be a stepping stone, not a grave marker, I work harder and longer than most. I grew up in a community where there is poor, and there is *po*. I grew up in what was, and still is, one of the poorest counties in America, Jefferson County, Mississippi. We knew that if you had an opportunity to go to school or get a job doing something, you better take it. If you had a few pennies more than your neighbor, you were trained not to talk about it. You took your pennies and turned them into nickels, and then you worked until you got a dollar.

My parents were focused on helping their five children matriculate into adulthood with a solid foundation. They wanted us to have more than they had, like a quality education and exposure to the arts and various cultures. We attended Catholic school, but we were not Catholic, and my parents paid a premium for five children to attend as non-Catholics. At my school, the only thing that mattered was if you were Catholic or if you could afford the tuition. Usually at the start of the school year, my father would give us the *tuition-is-high* talk, and he'd say we needed to become Catholics and attend mass somewhere. We quickly learned that by attending a Catholic school, you learn Catholicism whether you want to or not. To this day, I still utter the Catholic prayers I learned at school, and I attend mass several times a year, even though I never converted. In many ways, it connected me to home when I left at seventeen, and it reminds me to never forget the financial sacrifices my parents made for us.

Attending Catholic school for me was the beginning of learning how to navigate being in two worlds at the same time. W. E. B. Dubois's *Souls of Black Folks* was not part of my reading repertoire at that time, but after I left school, I etched his writings onto my heart, because I knew he captured our family dynamics perfectly. We were Catholics at school until we got home, and there was to be no complaining about it. We knew our assignment: we were there to get an education—end of the story. What seemed awkward to me at the time was a setup for wins years later. After I became grown, I told

my parents how grateful I was for the experience. Going to Catholic school with a large number of Italian families prepared me for everything I could possibly run into in life. I learned how to communicate with people who were different from me, I learned to read a room, I learned Latin, which is the root to many other spoken languages, and I learned to be quiet and listen—these were just a few of the things I learned while often being the only person of color in class. When I went off to college and later lived on my own in several cities, I knew how to get a Lenny, a Jenny, or a Benny on the phone if I was ever in trouble or needed advice. My connections from high school are still with me today.

Once, I told my grandmother that when I left Fayette, Mississippi, that was it—I would never come back. She said, "Yep, unhem right. Home will always be home." And as I matured, I realized that my grandmother was right. I found myself longing to visit home every chance I could. The longer I lived away, the more I dug into my Mississippi roots. Society told us there was nothing good coming out of Jefferson County. I always smirk when I hear this, because my family was born and raised in Jefferson County. And guess what? I love Jefferson County. I miss the home-spun hospitality. I miss people being real folks. What you see is what you get. The glass bottles of Coke that only came out when guests were sitting around the dinner table, the thick white towels that were only used by the guests, and the newness of the decorative soaps; we might not have had much, but we knew how to entertain in style.

Life was not all fun. I had difficult experiences, but I learned not to dwell on them. And that's the difference: you can have difficult experiences but not allow them to keep you from moving forward. My parents gave me this armor. Our families are imperfect, but they taught me to be prepared for the unexpected. I knew from their instruction not to pull myself into a race conversation. My family is big, and we have many racial makeups; I truly believe we are beautiful in the skin God gives us. In ten years, we aren't going to have "races," because it will be one big melting pot. Race is taught. If no one told you your race, you would not know what it is. I truly believe that.

I am often asked how I became a model at such a young age. When I was a freshman in college, I was sitting on the school lawn reading, and a photographer came up to me and asked if he could take my picture. I was

wearing a yellow pleated corduroy skirt with a matching polo. He snapped his photos, and I asked him what he was going to do with them. He said he was going to use them for an ad campaign. I had no idea what an ad campaign was, but I remembered some advice my grandmother had given me: "Don't ask me what it means; go look it up." So I went to the library to look up *ad campaign.* The photographer called me back a few days later and paid me, but he also told me that he was going to set me up with an agent. There it was again—a word I hadn't heard before. I went back to the library to look up the word *agent.* I found out it meant to represent. I thought, *I can do that,* and I have practically been my own agent/representative ever since. This has taught me to be my own best advocate in other areas of my life. Too often, we as women are not the best advocates for ourselves or for other women. I am thankful for this experience, because I have taken this lesson with me throughout my life. As I approached my fifties, it became it more important that I advocate for myself.

My husband is an engineer, and we could not be more different. We came from very different backgrounds, but family was essential in both homes. He came from a two-parent home, but his mother was the only woman in the house. I love her, but when I first met her, I thought she was about as insensitive as any man I'd ever met. As I got to know her better and learned to understand her, not only as my mother-in-law but as my adoptive mother, I saw that to raise four boys in the city, she had to be tough. She raised four strong, athletic, and military-minded young men. She was out there making sure they got to practice and excel in school. She was on a mission of teaching them how to be independent men and not get in trouble. And I came from a family that said, "Don't wait on anyone to do anything for you." I realized later that in many ways we were cut from the same cloth. With our strong personalities, working together and raising strong-willed children, we should have received an award just for surviving the early years.

Years later, I own a pest control company, I run a media marketing company, I am launching a burn cream, and I have cared for my middle son, Cornelius, for over two years. My son sustained third-degree chemical burns in a workplace accident that literally left him faceless and barely able to walk. I became an impromptu burn expert after his accident. When life throws you a curve ball, you must swing your bat. Skin with higher melanin reacts

differently to certain products and chemicals. When my son had an allergic reaction after using the medicated creams, I called my mother, a chemist. She was right on top of things when I told her about his reaction. Not only was she a chemist, but she grew up in an era where people of color did not have access to doctors, and she also had a burn cream recipe from Big Mama, whose quilt is in the Smithsonian. She gave me that recipe, and I mixed it up over the phone. Since I mixed up that formula that my mother gave me, I have not used anything else on his body. Today, you wouldn't even be able to tell that he has been burned. I told my mother, "We are not going to keep this to ourselves." But as a businesswoman, and my own best advocate, I also know not to give things away. Tell me nothing good comes out of Jefferson County, Mississippi, now!

Where you come from does not matter. When you achieve your goals and some relative success in life, it is important to your wisdom and knowledge for others to know it is obtainable for them as well. A high tide raises all boats. You must take advantage of whatever opportunities come your way. Remember, college is not for everyone, but everyone can learn if they are willing to be humble. I believe everyone has a place in life, but not everything is for everyone. Water will always seek its own level.

I'm a country girl at heart. I was raised in a small town in Mississippi with two stoplights—where sometimes the light bill didn't get paid and it would just have one stoplight. Where I come from reminds me to live my life to the fullest. I don't want to become a prisoner of the world of things and not live my life. I truly believe that living beneath your means keeps both feet firmly on the ground. When I started to hit a few career milestones, I bought myself a nice handbag. That's what you do when you become successful, right? No, according to my grandmother. She gave me some sage advice. She said, "Honey, if you don't have the amount of money in your wallet that the purse cost, you should never carry that purse." Her main sentiment was never get something because it's a status symbol. I realized that I don't need the big fancy cars, the shoes, or the luxury handbag. I had a friend who had dreamed of getting a fancy car for years. In my eyes, it was super expensive. After two years, she had saved up enough money and she bought it. But whenever she talked about it, it was only to complain about

how much the cost of gas was to fill it up. It's great to sit at the table with kings and queens, but I don't have to pay to keep the lights on in the castle.

When I meet young women with an entrepreneurial spirit, I remind them that you have to be willing to be a green tomato. So often we want to be ripe so quickly. But anything that gets ripe too quickly falls off the vine. Don't rush the process. A young woman from my hometown asked me about starting her own business, and I told her, "I have started a lot of businesses on checks I could not cash." I've had my share of struggles, and you will have yours too, but that does not mean you stop trying to make a way out of no way. That's what true grit is: never giving up. If you do, you will never know the amount of success you could've achieved.

LADY DIDI WONG

DAUGHTER, ANGEL INVESTOR, PRODUCER, PHILANTHROPIST, WIFE, AND MOTHER

Success is nothing without someone to share it with.
—LADY DIDI WONG

One of the most important things I have learned in life is to be independent. Independence makes me happy. Independence gives me the power to empower and help others. This was a skill I developed early on when my parents sent me to an all-girls Royal boarding school in Kent, England. I was nine years old, flying from my home in Hong Kong to Gatwick Airport three times a year. Attending boarding school made me fiercely independent. This independence has made me very sure of myself. I possess a healthy confidence that leads me to make fast and accurate decisions to succeed. I think it also instilled in me an affection for the American way.

I was fifteen when I first visited the United States on vacation with my family. We went on the famous backlot studio tour at Universal Studios Hollywood, where I saw the most awe-inspiring flash flood scene from the movie *Big Fat Liar*. Thousands of gallons of water came rushing through, nearly drenching all the passengers, but it just missed us. Fake thunder and lightning crashed all around us, and the rain was piped in from above. It felt as real as can be. Those fantastic effects left a lasting impression on me. I am still stunned at how Hollywood creates magic with special effects. This experience changed me. I fell in love with America and entertainment. That was when I knew I wanted to move to Los Angeles.

My parents have old-school traditional values. My father is a criminal lawyer, and my mother is a housewife. My mother is extremely negative. Her remarks are almost 100 percent unpleasant to my ears. She picks on me every time we speak, and the expression of her opinions thrusts daggers into my heart. I am very cautious about letting her know what is going on in my life,

because she constantly judges me and always points out any shortcomings I have.

All my life I have wanted nothing more than my parents' approval—to make them proud of me. This is perhaps a sentiment that is common in all cultures. Therefore, it perhaps was not the wisest choice when I chose a career in public speaking, because this job requires me to be authentic, vulnerable, and willing to share (which means airing my dirty laundry to the world, including writing this chapter of this book). I had their approval for a brief moment when I received an award for my philanthropy work. Over lunch, their attitude and demeanor toward me were positive, although the word *Congratulations* was never uttered. Nevertheless, I was overjoyed, as I could feel their approval of me. But a few months later, as I was planning a big event in Los Angeles, my hired freelance supporters did not come through with sponsorship acquisition. The event was over my budget, so I called my father and mother to ask for some financial support. My father was angry with me for not having achieved what I set out to do, and I lost face with my parents again. I'm not sure if I will ever receive their approval again, even having just been knighted by the Royal Order of Constantine the Great and St. Helen, one of the highest honors that a person can receive in a lifetime. Perhaps with my father, yes, but for sure with my mother, no. My relationship with my parents is one of the biggest challenges I still work to overcome.

This is where I believe true grit has made a difference in my life. I think all women can decide what they want and how they want to achieve it. None of it comes without obstacles, of course, but women of true grit handle such obstacles with grace and resilience. That is how I operate, and it is what makes me a woman of true grit. I am bold. I am elegant. I am smart and worthy. I love to break the rules and find innovative ways to complete tasks. I am a leader. "I'm a sure thing," as Julia Roberts's character says in the movie *Pretty Woman.* I am not afraid to speak up when I see or feel that something is not right, even if it means defying my parents.

My grit tools helped empower me to start my businesses and write books that help other women find true grit. I believe in the four Ps: preparation, people, pitch, and perception. Preparation is everything that comes before your elevator pitch. You need to be fully prepared for "the moment"

you meet a potential client, mentor, or business partner. Remember, preparation isn't just about numbers and ideas. It's also about confidence and energy. Taking care of yourself is an essential element of your preparation. The second P, people, is about being able to walk into a room and assess the group of people there. You need to ask yourself, "Are the people here my kind of people?" This extends beyond networking; the friendships you surround yourself with can encourage or hinder your ambitions. Pitch, the third P, is about using the right language, the right attitude, and the right body language to convey a message. You have one minute before you lose someone's attention. Don't waste your time with too much information. Be concise. Find a way to show how you can benefit the other person. And the final P is perception. Remember that you are the delivery system for your message, and the way you dress, speak, and carry yourself is just as much a part of your pitch as the literal words you use. Channeling my grit in these directions has brought me to the success I have found today.

I could not have achieved this great success without my supportive husband. We met in acting school in New York. My husband is Sir Michael Duvert. He has starred in *All My Children, CSI: Miami, Numbers, NCIS,* and *One Life to Live,* and he was in a Tony Award–winning play on Broadway, which is such a huge achievement. We have four beautiful children together. We have learned how to invest in each other to grow our family life. This has helped us find a balance in our personal and professional lives. Building this family has been my greatest achievement. True grit to me is about having enough reliance to achieve your dreams in all areas of your life. Having children does not mean giving up on my dreams. I have a higher purpose on this planet, and I am going to use God's will to live my best life.

LAUREN ROBINSON

INNOVATOR, BUSINESSWOMAN, SURVIVOR, MOTHER

*You are not the darkness you endured. You are
the light that refused to surrender.*
—JOHN MARK GREEN

When I was little, I loved staying with my grandparents. My grandfather, Papa Harris, was my inspiration—one of the people who instilled my hard work ethic into me. I remember Papa Harris working in the mines. He was laid off three times, but every time he bounced back. "Well, that's fine," he said. "I already got something lined up." He couldn't just *not* work, and I look up to him because of that.

At first, I thought I wanted to teach. My mother worked at a high school, and she convinced me to work in special education to get the basics and to see how I would like it. My friend had just finished radiology school around that time, so I applied and got in. I was nine months into the program when the hospital went bankrupt. Of course, I was at my grandparents' house when I found out the news. I remember saying, "It can't close—I'm in school!"

After that incident, I was accepted into a radiologist program in Tuscaloosa. I drove 184 miles in total, there and back every day, and worked at Massage Envy. My time in Tuscaloosa opened my senses to a business mindset I didn't know I possessed. I realized the hospital treated workers and patients unethically, and that realization not only prompted me into business but also helped me realize some things about my own home situation—because, by this time, I had been married to a narcissist for two years. I found myself purposely working long hours at Massage Envy to avoid him. For the longest time, we didn't have issues because we weren't around each other much.

Growing up, I had never seen my parents fight. I met my ex-husband's father, and he was verbally mean to him. I rationalized it by thinking everyone's parental relationships were different, and I just accepted it. It wasn't like I had a choice—my ex constantly made excuses for his dad. My ex-husband is very charismatic, and everyone thinks he's sweet and loving. But under the veil of gentleness and compassion is the evilest person I've met in my life. We were married for ten years and conceived two children.

My ex was a cop. I had an office upstairs that doubled as a playroom that my kids would use while I worked. He would come to the door and do a "police stance," asking when I was going to be done working. He thought that when his work stopped, mine was supposed to as well. He was truly a bully—standing and hovering over me until I stopped what I was doing.

Another object in my house—a sofa—brings back such painful memories that I refuse to sit on it. My ex-husband used to fall asleep on that sofa. In fact, he was asleep all the time—such a polar opposite of my grandfather, who regularly wakes up at 5:00 a.m., even in his progressing age. While my ex slept, I was constantly working on my business. His need for sleep fueled my need to leave.

It was a Father's Day, the last one we would have as a married couple. While I always got simple gifts for Mother's Day, with no thought or care behind them, he had given me the most elaborate, outrageous request. That Father's Day, he asked for a $500 workout machine. I ordered it to keep the peace, but the delivery was going to be one day late. That day, the kids woke him up, excited for their father to open his gift. He screamed out, "Can't a man get any sleep in his home?" He then proceeded to call me out with bad language in front of the kids for "getting the date wrong." My daughter was broken and shaken. The gift sat in the box, unopened, for seven months.

I hid the abuse. Neither my parents nor any of my close friends knew of it. I didn't trust anyone, and he made it ten times worse. He purposely isolated me from reaching out. One time, I underwent a partial hysterectomy, after which I was explicitly advised to rest and not lift heavy objects. I had planned to send the children away to my parents so I could get some rest, but my ex interpreted the children staying with their grandparents as a negative. "I don't need your mama and daddy to babysit," he said, as if I was

sending the kids to my parents because I simply did not want to be bothered by them, not because I was recovering from surgery.

So I was up all night dealing with the baby after my partial hysterectomy surgery. Picking him up was too much, and as expected, I had to go to the doctor the next day. While I do not believe in taking too much medicine because of personal reasons, I was in a lot of pain. However, after searching for the pain medication I had been given and questioning my ex-husband, a revelation came over me that made me sick to my stomach: he had taken my pain pills. I kept this to myself and simply called my father to drive me to the doctor. I tried to keep my parents out of it, because I *needed* them to be nice to him—or else problems could arise.

My parents, however, were observant. In fact, they were the key reason that I realized how out of hand the abuse had gotten. Over the course of my marriage, I had acquired a bedtime. My ex would raise hell if the kids—and I—were not in bed by 8:00. One Sunday, the kids and I were having dinner at my parents' house. In the midst of reconnecting and laughing at inside jokes, I got a text a little after 7:00 from my ex-husband. I panicked and started rushing the kids to get ready so they could go to bed. My mother asked why I was so panicky. "Why do you freak out when he texts this close to bedtime?" I defensively dismissed it, explaining that the kids had to go to bed. In the back of my mind, however, I was realizing how controlling he was.

The day he left was the biggest sigh of relief; he no longer had access to me. I finally had peace. I could live my life and not be degraded for simply existing. Now, as a domestic abuse survivor, I've found that true grit to me means never giving up, no matter how hard the situation may be. All things happen for a reason, even though sometimes we don't understand them, so do what it takes to get through those times and learn from them.

I never thought I would eventually help other women and youth free themselves from abusive situations by allowing my house to serve as a safe haven for them. Today, I am grateful that my ex-husband and I, through counseling, have found better ways to communicate and be there for our kids. Sometimes, it simply takes time and distance to see a person through a different lens. I hope that sharing my story encourages victims or survivors

of domestic abuse to believe that peace, freedom, and hope is still alive and healing is possible.

Through my confidence, I now own my own business called LABikini, where I've reconnected my trust in men through my business partner—who has shown me I can redirect my energy through the business. My female coworkers have added an extended trust to my life as well. The biggest thing is just finding one person you can trust and depend on. You may not have to share your life story, but it is important to have a confidant. It brings me joy to help build women's confidence through my business and life journey.

Having true grit means to conjure the courage to face hard situations in life, persevering, and extending that message to others. I am a young woman of true grit!

SHEA VAUGHN

MOTHER, FITNESS AND WELLNESS AUTHORITY, MASTER TRAINER, CREATOR OF SHEANETICS®, AND WORLD-RENOWNED KEYNOTE SPEAKER

Embrace it, own it, live it!
—UNKNOWN

My childhood in Brantford, Ontario, was difficult. My mom was a hairdresser who worked hard to help support our family. My father was in his own world, working in the jewelry business. He wore custom suits and drove a new Cadillac. He always acted as if he had arrived but never allowed us to feel like a family unit.

I remember one winter afternoon when I was around seven years old, my sister and I were walking home from her violin lesson when our father saw us in the street. He passed right by us in his Cadillac and wouldn't even pick us up, because we were not allowed in the car. However, when we got home, we were punished because our boots and feet had gotten wet from walking in the snow. He started to beat my sister with his belt. I threw myself on top of her. My father said, "If you're stupid enough to take the punishment for her, then here it is!" Boy, did I learn a lot about my dad's self-absorbed mean side. My sister and I were each other's best friends. Our loving relationship was a saving grace; it helped us detach and keep moving in that dysfunctional household.

Eventually, my mom would divorce my father with the hopes of a better life for all of us in the United States. She left with only what she could pack in our suitcases, and we were off to Ohio, where I spent the rest of my childhood. My grandfather and his wife lived there, and my mom had planned on us staying in the main home with them, but as the old saying goes, "There was no room at the inn." We had no extra money, so we were asked to live next door, in the beauty shop that my granddad owned. He allowed my

mom to work at his beauty salon, and over time she built a good customer list. My grandfather was the local barber, but sadly, he too was not a good mentor for us girls. He was quite the ladies' man. My mom, sister, and I lived in the salon and slept in the chairs. This was a very challenging time for us.

Mom worked hard and earned enough to make a change in our living arrangements. Her determination and grit showed us how to tune out the noise around us and focus on the goal at hand. She encouraged and reinforced in us that things would get better. She had the perseverance to keep pushing through those hard times and fears, believing that good fortune would come our way. Eventually, her hard work did indeed pay off. We were able to move out of the beauty shop and into a place of our own. Mom built up enough of a client base that she owned three beauty shops and even started a beauty school. She was quite the entrepreneur!

Success for my mom afforded my sister and me more opportunities. I got involved in gymnastics, and we both got to enroll in dance class. These athletic challenges provided me with a great sense of self-esteem. I had a passion for these classes that made me disciplined. One time, I showed up for the class, but the teacher did not. The studio asked me, "Do you think you can teach the class?" I said, "Yeah, give me some music." My passion for dance and fitness was born that day. This set the tone in my life for future endeavors into health, wellness, and fitness.

I also learned from my mom that success requires credibility. So if I were going to pursue my love of fitness, I needed to get certified. Eventually, I had certifications in multiple exercise disciplines, which included a designation as a master trainer. Over time, this experience was what led me to start my health and fitness program, called SheaNetics, and soon I was traveling as a wellness speaker and master trainer of SheaNetics instructors.

The physical side of SheaNetics combines yoga, pilates, dance, Gyrokinesis®, martial arts, and more. I was ahead of the times in combining these programs, but I gained recognition and excelled because I wasn't afraid to mix various exercise genres. On the mental side of SheaNetics are my *5 Principles of Wellness*: Perseverance, Commitment, Self-Control, Integrity, and Love. Following the 5 Principles is what makes a healthy lifestyle sustainable.

My mom led by positive example. She never complained and never said anything bad about anyone. She showed me that taking risks is part of a successful strategy. Life had prepared me to face fears and push through to do whatever it takes to reach my goals.

I got married in my early twenties and we moved to Chicago, where I raised my children. It was there, too, that I was given the opportunity to be a fitness contributor for local television networks. Affiliates of Fox, NBC, CBS, and ABC *Windy City Live* were just a few that I had the opportunity to work with. I was asked to talk about nutrition. People would ask me, "What are you going to talk about tomorrow on television?" I would say, "I'm either going to be standing on my head or making smoothies for everybody."

This was a fun time in my life. My husband, Vernon, was the love of my life! He is a great guy, and we have three wonderful children, Victoria, Valeri, and Vincent, who are the heartbeats of my heart. My children have been my greatest teachers, and they have also given me the bonus of my grandchildren.

Our two girls went to college, but after high school our son Vince wanted to head to Hollywood. Vernon and I brought him out to California, and the rest is history. Vince did not have a plan B. He was going to make movies, and he worked hard taking acting classes. He learned to be persistent, a value I believe he inherited from both of his parents. Valeri and Victoria are writers and producers, and we all now live in California. My husband Vernon and I divorced. It was a challenging time for our family, but in the end, we remain good friends.

All of my life journeys have led me to find my breakthroughs. I wrote the book *Breakthrough: The 5 Living Principles to Defeat Stress, Look Great, and Find Total Well-Being,* to share the SheaNetics 5 Principles of Wellness with readers and to help them find and stay on their "Pathway to Well-Being." I continue to teach daily and use these principles as a guide for everything I do.

We all need to learn to breathe correctly, exercise daily, laugh more, enjoy music, and think positively. Remember the 5 Principles: Commitment, Perseverance, Self-Control, Integrity, and Love. Use these principles as a guide to making wise life choices. I believe the breakthroughs you experience are key to uniting your mind and body and finding great fulfillment.

Once I found the roadmap I needed for different seasons of my life, I have been kinder to myself. At this time in my journey, I have found my husband and soulmate, Steve. We share a lot of common interests, like health and fitness, and we've joined forces to develop a television network that will give families programming they can watch together. As you can tell, family is my priority. As I built my fitness brand, it was a time of growth, and I was able to apply the grit that my mom showed by example as she built her businesses. True grit to me means hunkering down and staying determined to persevere through the hard times in life. If my mom hadn't, she would not have reached her fullest potential as a business owner, and I wouldn't have such a stellar example to follow when building mine.

SUZANNE GARBER, DSC, MLA

DAUGHTER, SISTER, WIFE, CANCER SURVIVOR, AND CEO OF THE RISE UP FUND

Keep Calm and Carry On.
—British World War II Morale Posters

"We've scheduled you for an ultrasound-guided core biopsy of the left axilla based upon the outcomes of your recent CT scan, mammogram, and breast ultrasound. Does next Tuesday work for you?" I had recently finished twenty rounds of radiation for breast cancer earlier that year, and now to be told there was something "suspicious" leftover from my partial mastectomy—it was just going to have to wait. My brother's wife had just died unexpectedly that week, and I needed to be with him and his family. My family came first.

My brother and I had not been on speaking terms for the last three years since his wife and my husband had had a falling out. It all seemed so trivial now, and my immediate instinct was to rebuild the relationship while trying to be a source of comfort and assistance. I had missed spending time with his kids, one of whom looked like my twin. I wasn't sure what kind of reception to expect when I arrived at my brother's house. I told the oncologist I would need to postpone the biopsy until my return; I wasn't sure how long that would be. I wanted to stay for as long as needed, but given past events, I wasn't sure whether I would be wanted there.

Once I'd put a plan in place for the foreseeable future in my household, I hopped in the car for the ten-hour journey to my brother's house in rural South Carolina. While on the drive down, I texted, "I am so sorry." This was the first communication I had had with him in a while. Any worry or fear about how my arrival would be received was met with an enormous hug. And tears, lots of tears, from a six foot five, 280-pound man covered in

tattoos. No words were needed as the sorrow, grief, and forgiveness flowed between both of us.

During the time spent with him and his children, we had deep, raw, and sometimes painful conversations about past experiences—and expectations—that we'd never had before. Discussions about childhood transgressions and missed opportunities ensued, and we marveled at how years of frustration and sadness could have been avoided if only clear communication and grace had been extended. It was a time of forgiveness, reflection, and introspection that, honestly, only God could have orchestrated given our past situation. I was deeply grateful for the time spent healing old wounds.

Upon my return home, I had to refocus my energy on myself. You see, this wasn't my first cancer rodeo. Six weeks after getting married, I had been diagnosed with ovarian cancer. An oophorectomy of my left ovary was conducted, and in a follow-up appointment a year to the day later, I was diagnosed with an adnexal mass on my right ovary. Two decades later, during the COVID-19 pandemic, I was leading the 2020 Census for the nation's sixth largest city. I went in for a routine mammogram, where they found suspicious calcifications on my left breast. A diagnostic mammogram followed by biopsy revealed that they were malignant, and I had that portion of my breast and surrounding lymph nodes removed. To be told I might have cancer again was neither fear-inducing nor life-shattering to me; I had already come to accept my eventual death a long time ago. I like to think that I never feel more alive than when I recognize and acknowledge my mortality.

My actions followed the popular British phrase, "Keep calm and carry on." I did what I normally do: absorb the information presented, make a plan, and be flexible enough to pivot when necessary. I truly believe that complaining about my situation—or any situation—is meaningless unless there is a plan on how to improve it. I use that mantra in my professional life too. Don't come to me with a problem unless you have a potential solution for it. I am not interested in hearing complaints only.

The above advice has also guided my career. I have had the opportunity to be a corporate executive, global nomad, entrepreneur, healthcare advocate, author, and award-winning documentary filmmaker. All that plus a Jesus follower too.

I owe much of this drive to my parents. They always told me I could do and be anything I wanted. Their confidence in me and their strong advice stuck. I still believe what they told me. I always carry a little card my parents gave me decades ago in my wallet; it reads, "What is success? To laugh often and much; to win the respect of intelligent people and the affection of children; to earn the appreciation of honest critics and endure the betrayal of false friends; to appreciate beauty; to find the best in others; to leave the world a bit better, whether by a healthy child, a garden patch, or a redeemed social condition; to know even one life has breathed easier because you have lived. This is to have succeeded." Those are the inspiring words of Ralph Waldo Emerson.

As much as I love Emerson's written prose, I rely on another book to get me through life—the Bible. There are loads of lessons in every chapter on how to lead, manage, inspire, and grow. While I credit my parents for providing much confidence and growth throughout my childhood, they allowed me to make my own decisions about my faith. I came to accept Christ at twenty-five after a childhood spent mostly in Catholic and Muslim countries.

My father was an ex-pat working for General Electric. He was transferred all over the world. That meant I was exposed to a nomadic lifestyle from an early age, reared in Spain, Mexico, Algeria, Egypt, the Dominican Republic, and various US states. I had filled every page in my first passport by the time I was nine years old, and I fully expected to follow in my father's footsteps, career-wise. So being selected to be part of a small group of ex-pats during my initial career at FedEx that would be dispatched across the globe was a dream come true. Since then, my work and personal interests have taken me to every continent and over one hundred different countries.

To be sure, such a global lifestyle required just the right partner. I am grateful to be married to an amazingly understanding, supportive, and God-fearing man, Chris, who accompanies and encourages my every move. After my bout with ovarian cancer, Chris and I thought we could never have children. Much to our surprise, after nearly a decade of marriage, I became pregnant. Our excitement turned to tragedy when it was revealed that my body, ravaged by the previous ovarian cancer, could not sustain the baby.

Our hearts were shattered as we tried to understand why we would be allowed to have hope in creating our own family only for it to be taken away so cruelly. Again, absorbing the information and creating a plan put us to work on helping orphans in third world countries. We partnered with Global Action to build and support orphanages in India and Uganda, as well as independently support an orphanage in Brazil. We also registered and were certified as foster parents in our state. Because of our status as foster parents, when the time came to open our home to relatives needing respite from their own chaotic home life via kinship care, we were ready. Caring for parentless children is personal to Chris and me, because both Chris and my father were orphaned in their childhoods.

You might be wondering how we came to support an orphanage in Brazil. I had interviewed for a VP position but didn't get it. However, I'd impressed the interview panel enough that they wanted to send me somewhere else to gain even more experience, so that I would be ready should a new opportunity arise in the future. I was given five locations from which to choose, and Brazil was one of them.

I'd been to Brazil before, but the other choices seemed more favorable. Having grown up as an ex-pat kid, I was aware that half of all expatriate assignments fail due to family reasons. Of course, I had to involve Chris in making the decision. When I approached him with the choices I had been presented with, he told me he would fast and pray on it, and we would make the right decision for us. I knew New Jersey and Pittsburgh would be automatically rejected by him, but since he is a good midwestern boy, I thought he might choose Chicago. If he wanted to spice up life, he'd choose Brussels. But Brazil? It was so far away. We didn't speak the language. I would need ongoing medical care, and I wasn't certain of the quality of care there.

My first reaction was to reject Chris's decision. However, my husband and I had made a pact that if either of our careers got in the way of our marriage, our marriage would win. Nothing is more important than our relationship. So there I was, faced with an internal dilemma. Could I absorb the information, agree to my husband's plan that I had entrusted and encouraged him to make, and be flexible with it?

We moved to Brazil in April 2007. It was and remains one of the best decisions of our lives. Chris, who had been the US Army corps wrestling

champion in the 1990s, was asked to join the coveted Alliance Team, headed by Brazilian Jiu-Jitsu World Champion Fabio Gurgel. Chris went on to win the Brazilian national championship for his age and belt class just a year later. As for me, I required that the staff talk to me only in Portuguese, and I hired a private tutor to coach me twelve hours a week until I could speak reliably with employees and clients. In month four, I gave my first full meeting in Portuguese—with a few glitches and guffaws, much to the glee of the local staff.

Chris and I made sure that we were plugged into the community, feeding the homeless every Friday night and visiting the orphanage on Sundays. Both of our families came to visit, and I was able to work on projects I never would have had the opportunity to experience if I had stayed in the United States or gone to a developed region like Europe. We opened new markets in Colombia and Ecuador, started new flight routes in Uruguay and Argentina, and began negotiations for the acquisition of a premier Brazilian domestic delivery provider—the largest merger in FedEx history at the time. My team and I racked up multiple awards, including several trips to the coveted President's Club. And from a health perspective, the quality of care I received in Brazil was outstanding. That opened my eyes to an entirely different type of health system.

From Brazil and FedEx, I was lured away to an executive position at an international healthcare company, where I led teams involved in evacuating individuals out of danger zones. It was the job of a lifetime! What I thought would be a challenge to my marriage, my health, and my career ended up benefiting all three. The experience of living and working in Brazil was a springboard for my career and strengthened relationships in ways I never could have dreamed. Too often, we stay in our comfortable lane, avoiding risk. But inevitably, taking the seemingly less desirable option produces the most growth and accomplishment. Like a rubber band, life is best when stretched.

During my professional career, which has spanned industries like logistics, international healthcare, filmmaking, government, and real estate, I assumed a different position of increasing authority every two to three years. That meant moving frequently and placing myself in uncommon situations, particularly for females. However, instead of complaining about

the treatment, I encouraged others to find solutions to the business issues presented before me. I coached male subordinates to carry out strategies with male clients who were unwilling to accept me or speak with me, and I worked hard to learn new languages so that I could converse natively and expertly. I was determined to be seen as an equal, without protestation or victimization. Through all my global travels, I knew when to push back and when to observe. Protest and revolt are not always the key to meaningful change or respect.

This understanding of cultural norms, as well as absorbing information, planning, and pivoting, led me to leave corporate life and start an entrepreneurial journey by creating the company Gauze. Gauze became the world's largest database of hospitals outside the United States, connecting 1.4 billion international travelers (pre-pandemic) with healthcare facilities for when they got sick abroad. Having traveled so much in my life, I've been hospitalized in more countries than most people have visited for fun! So creating a useful technology to assist travelers in their time of need was extremely gratifying and was the result of—you guessed it—me getting sick abroad.

Getting sick abroad was also the impetus for the PBS documentary film *GAUZE: Unraveling Global Healthcare*, which led to me traveling to twenty-four countries and visiting 174 hospitals to explore the concept of *best* in healthcare. Through interviews with five dozen healthcare experts, the film explains the differences among various healthcare systems and what we can each do as our healthcare advocates in demanding better care for ourselves—at home and abroad. Never in my wildest imagination did I ever anticipate filming a movie—much less winning Best Short Documentary at the Hollywood New Directors Film Festival and being selected for five other film festivals! I am convinced that every one of us is given unique skills and a mission to accomplish while we are on earth. The challenge is often how to accomplish that in the very short time we have on this big, blue ball, especially since none of us know exactly how much time we have here.

As I look forward to my next round of biopsy results, I know that whatever the results reveal doesn't change anything for me. True grit to me means overcoming life's obstacles through perseverance. Overcoming these

apparent distractions with grit and perseverance cannot detract me from the mission set before me. To find the beauty in others...to leave the world a bit better...to help one life breathe easier...that is to have truly succeeded.

TAHIERA MONIQUE BROWN

DAUGHTER, SISTER, MOTHER,
SURVIVOR, AND THRIVER

In the end, what matters is this: I survived.
—GAIL HONEYMAN

When I was a little girl, we would get up very early in the morning and climb into the back of an old red pickup truck with a bunch of other folks. We were on our way to the fields, where we would pick cotton all day. Along the way, we would pass ramshackle shacks as the dust from the red Georgia clay billowed up behind us. We would also pass a gorgeous, majestic mansion with a beautifully landscaped yard. At five years old, I prayed that one day I would have such a beautiful home, with green grass and lots of flowers. I believed that was a possibility at the time. But then, I learned a horrible truth. One night, members of the Ku Klux Klan burst through our door. They were looking for someone else. Although I did not know the full story, I would later learn what they planned to do to that person once they found him. At that early age, I learned that people who looked like me had very few rights. The incident left a scar on me that I could not get rid of. Knowing what hate and discrimination looked like made me decide that I would never hate anyone. But with some of the things I would have to endure, it was sometimes difficult to keep that promise to myself.

I loved school and did well throughout. That was why it would be so difficult later, when those years were washed away from my memory during some of the most traumatic experiences anyone could ever imagine. Things started piling up on me during a harrowing marriage to a man who physically and psychologically abused me. I was a naive young girl from Albany, Georgia, who had never even dated anyone until him. We were married in 1974. My stepfather, a sergeant major in the Marine Corps, was killed in a car accident a few months later. If he had survived, he could have helped

me get out of the situation in which I soon found myself. By the time my husband and I had two children, I could see no way out. In those days, it was almost impossible for a woman to get help or to get out of an abusive marriage. Even the police would tell me, "He's the father of your children. You just need to try to make it work." He not only beat me; he stole the money I worked for to support our household. Ultimately, I told him I was stronger than anything he could do to me and that I was willing to risk dying to keep living. When he realized he couldn't hit me hard enough to scare me anymore, we finally divorced, after four years of marriage.

My children and I moved to Atlanta. That was where God placed me, but there were more trials to face. God gave me the grit to get through the death of my precious mother at the age of forty, after a series of strokes. That also meant caring for my special-needs sister, because there was just nobody else to do it. By God's grace, we persevered.

In March of 1986, I had worked myself up into a good position as a concierge at the Marriott Marquis in Atlanta. Every chance I had, I would attend shows and concerts. I had begun writing songs and dreamed of a music career. At the hotel, I had noticed another employee, a laborer, who seemed to be taking an interest in me. But I suspected that there was something not quite right with him. He started talking to me, telling me that he was a singer and a musician too, and when he made it, he wanted to record some of my songs. I tried to brush him off, but it didn't work. Then one day, he accosted me in an elevator. He put a gun to my head and told me he had killed nine already and didn't mind killing nine more, including me. I begged him not to hurt me for my children's sake. He finally let me go. Shaken beyond belief, I sneaked away from work early that day. I thought if I could just get home, everything would be okay. Unfortunately, when I got home, he was already there with my children.

The next day, he threatened to hurt my kids and forced me to go to his apartment after work. He locked me in a closet for a few days. My daughter and son, just eleven and seven years old at the time, were cared for by neighbors. That was only the beginning of a two-year ordeal—two years that were filled with deception and fear. He would lock me in the closet and stick knives in the door of my bedroom each night to keep me from leaving. He controlled and monitored every aspect of me, even when I was outside the

house. We went to shows and concerts, almost like a normal couple out on a date, but he always had a weapon with him. At home, he forced me to dress up and play musical instruments for him, his own personal "concerts." He liked to impersonate a minister, wearing a collar and robe he had stolen from a church. We went to church on Sundays, but stowed in the hollowed-out pages of a Bible, he always kept his gun with him. When neighbors or church friends would come over for a visit, he turned on the charm, but he always had a shotgun hidden under the couch pillows. The kids and I knew not to say or do anything to let visitors know what was happening.

He insisted on everything remaining as normal. The kids continued to go to school every day. They were too scared of him to say anything to anyone about what was going on. He and I continued to work at the Marriott until we both lost our jobs. It was impossible to do well, because he brought knives to work and threatened me if I did anything he didn't approve of. He monitored everything I did and everyone I spoke with. After we were fired, we began cleaning houses to try to make money. But we were eventually fired from that job too.

Toward the end, I had lost so much weight that I was down to less than eighty pounds. As he became even more erratic, I decided I had to do something, if not for me then for the sake of my children. I couldn't think of any other way to try to save my kids. I deliberately took an overdose of sleeping pills, praying that I would live and wake up in intensive care and that God would grant me the time to tell the doctors what was going on before I died. When the kids couldn't wake me up, they called 911.

When I woke up in the emergency room, one of the first faces I saw was that of my brother, James. He was another one I had resisted telling about all that we were going through. Though he is a nonviolent man, I was afraid he might confront my kidnapper, and one of them would die. He would be another black man murdered and another black man in prison. I know now that James felt guilty because he had noticed a big change in me; he could tell I had lost my usual cheerfulness. But he did not even suspect the true horror of what was going on. He just thought I was really into my kids and the new man in my life. He now tells everyone who will listen to be suspicious. If you see a big change in someone, get them away from the situation and learn what might be happening in their lives. When he talked with the

kids after my deliberate overdose, James found out something even I did not know. The man—I still call him "The Twerp"—had been sexually abusing my precious daughter. The police—many of whom believed my captor to be a minister—took action, arrested him, and he went on trial.

I still do not know The Twerp's real name. It is listed in many different ways on court documents. After three trials, he was convicted of child molestation and aggravated child molestation. He was sentenced to two twenty-year sentences, but they were to be served concurrently. He was out of jail in much less than twenty years. I left Atlanta and changed my name and Social Security number in the hopes he would be unable to locate me.

My ploy to get help almost killed me. I was in a coma for two days, and I still suffer from amnesia to this day, more than thirty years later. The worst thing is that I do not remember any of my school years—just that I loved school. When I first left the hospital, I spoke backward and had trouble forming sentences. My son had to teach me basic math.

Whether it is grit, God, family, or all of them, I am proud of what I have been able to accomplish. I was named one of my city's "Top 50 over 50" by a nonprofit that works to enhance the lives of senior citizens in the area. I am an author, a publisher, and a film producer. And I am an advocate for people escaping from domestic abuse, human trafficking, and the like. I see myself as a survivor, not a victim. I do remember that the only thing The Twerp was afraid of was my strong faith in God. I was involved with a vicious but smart psychopath who managed to stay ahead of everybody: my family, people from the church, and even the police. Everything I did during those two years was to keep myself alive, keep my kids alive, and keep him from killing others in my life.

I am now married to a wonderful man, Victor. I have also been blessed with some magnificent influences. My friend Jan Givhan Reed overcame her tragedies. Her son was murdered by one of his friends, and then she was seriously injured in an auto accident. But she still managed to get her other children through college and serves as a strong role model for me and for others. Not only that, but she prays for me every single day. Dee Voight is a casting agent in Atlanta, and she hired me as an extra in a film soon after I left the hospital. When she saw I was struggling to recover from the coma, she took me under her wing and asked me to help her to cast extras for movies and

TV shows. She gave me a job and a purpose when I needed both. And my aunt, Hattie Sibley, took the time to reintroduce me to family members whose names and faces were no longer familiar to me. In the meantime, she embraced me and loved me unconditionally, helping me to heal.

It took a lot of grit to overcome the things I have faced in my life. It took grit and courage to care for my mother during her last days before she died, to care for my special-needs sister—especially towards the end when she was dying of end-stage Alzheimer's disease—and to do all of that at the same time that I was helping my husband recover from open-heart surgery. But I am proud that I was able to overcome and do many of the things in life that I strived to do. The only thing I wish I could do is go back to school and re-earn those degrees that I can no longer recall.

As I reflect on my life, I realize that *true grit* can mean different things at different times. I think it depends on what might be going on around us at the time. Today, I can say that true grit means to be able to persevere against the odds and to be able to rise above the noise of opposition and still maintain the courage to stay focused on your dreams. Trials and tribulations will come, but a person with true grit will find a way to be positive, vigilant, and faithful.

GOVERNMENT
SERVICE

BRIGADIER GENERAL (RET.)
WILMA L. VAUGHT

I think courage is a central characteristic of leadership.
If you're not willing to go into dangerous places, you
have no business doing this work.
—BISHOP KATHARINE JEFFERTS SCHORI,
THE FIRST WOMAN LEADER OF THE EPISCOPAL CHURCH

*I*grew up in a man's world. I was the older of two girls, born in 1930, who lived on a farm in rural Scotland, Illinois. We knew the value of hard work, because we had very little money. I helped my father and went out with the horses and the tractor to help get the ground ready for planting and then later to harvest the crops. I lived a different life during high school compared to a typical teenage girl in the city in 1948, I can assure you. My parents were truthful people who believed in helping others. A major difference between my parents was that my mother loved to read and my father wasn't interested in reading. I became a reader, and I believe that was a major factor in my life. I read the *Bobbsey Twins, Nancy Drew,* and comics like *Batman* and *Superman.* I have worked hard to make people understand that you need an education. Reading is critical to education and having a successful career.

When I graduated, my high school had the largest graduating class ever… at twenty-four! There were twelve boys and twelve girls, most of whom had gone all twelve years together. We are still friends to this day, at least those who are still living. I went on to graduate from the University of Illinois in 1952, and although I immediately found a job in the corporate world, I saw little possibility for managerial advancement. After reading a US Army recruiting appeal that offered the opportunity to be a manager and super-visor, I joined the Air Force! My parents thought I would never make it in

military service, because they didn't think I took orders very well. There were few women in the service in 1957; the environment was very male-oriented. Based on my work on the farm with my father and my experience in my post-college job, I was accustomed to this environment.

My career really took off in the military; there, I realized my desire to manage and supervise—in other words, to be in charge. At the time, it was actually probably an advantage to be a woman. At one of the bases where I was stationed, in fact, I was one of four women. If I did well, it stood out, but if I did poorly, it would have shown too. I probably received more recognition because I was different and stood out compared to the males.

An occasional obstacle during my time in the military was the lack of restroom facilities for women, if you can believe it. This is just one small example of the difficulties of being a woman in a man's military.

During my career, I held many positions in the comptroller field at bases in the United States, Spain, and Vietnam. Toward the end, I served as chairperson of the NATO Women in the Allied Forces Committee and was the senior woman military representative to the Defense Advisory Committee on Women in the Services. My last assignment was as Commander of the US Military Entrance Processing Command in Chicago, the largest geographical command in the military. My military experience gave me an opportunity to participate in historic events, broaden my education, and work with a committed group of people who are fascinating, dedicated, and well-educated, and who rarely say "can't" and never say "won't"! When I look back, there are people I would now classify as mentors for every stage of my career. They guided me whether I wanted to be guided or not, and they consisted of both men and women.

One in particular stands out the most: Lieutenant Ruth Blind at Barksdale Air Force Base, Louisiana, my first base. She had served in World War II and was a personnel expert. She educated me, teaching me to recognize the things you needed to do in the military. She took me under her wing and had me doing things many others never had an opportunity to do. I did investigative work for administrative boards—something I was less than enthusiastic about doing. She told me this was something I needed to do. She was a tremendous person and my first mentor and role model in the military. When I became a lieutenant, I recognized that I was a role model

too. I was very aware that people were constantly watching me. Therefore, I have always tried to do the right thing, no matter how painful it is to me. Doing the right thing when faced with a hard decision might not be the easiest way, but to me, it was the only way.

In my life, there is one area I feel I failed—my family. My life was the military, and there were many times when I wasn't there for my family, but they recognized this and understood that my job was of paramount importance to me and all other things were secondary. An important door opened for me and other women in the military in 1967 when President Lyndon Johnson signed into law a measure finally permitting women to be promoted to the level of general and admiral. That same law also lifted the quotas that had been placed on women being promoted to the ranks of general and flag officer, which also allowed for new career opportunities. In 1980, my father had the honor of pinning a star on my shoulder when I became the first woman in the comptroller field to be promoted to brigadier general. Two years later, I was made the commander of one of the largest geographical commands in the military. When I retired in 1985, I was one of only three female generals in the Air Force and one of seven in the US Armed Forces.

I served as a member of the Board of Directors of the National Women's History Museum and on the Virginia War Memorial Foundation Board of Trustees. In addition, I have worked as a consultant with the Strategic Defense Initiative Organization. I have since retired. I spoke around the country about leadership and management, and I was frequently on radio and television programs. As a former president of the Women's Memorial Foundation, my philosophy was that we have a message to tell, and that is the story of women's service. This is what I have worked for since my retirement...not to tell my story, but to tell the stories of what others have done—their history, their progress. On October 18, 1997, the Women in Military Service for America Memorial, standing at the gateway to Arlington National Cemetery, was dedicated. Some forty thousand women veterans and their families and friends gathered to honor the past, present, and future of women in the military. It is the nation's only major memorial that pays tribute to the more than 2.5 million women who have served in our nation's defense, beginning with the American Revolution. It stands as a place where America's servicewomen can take their rightful place in history and where

their stories will be told for future generations. I also made history on July 7, 2022, when I was awarded the Presidential Medal of Freedom, presented by President Joe Biden. The metal, the nation's highest civilian award, recognizes individuals who have made an especially meritorious contribution to the security or national interests of the United Sates, world peace, cultural, or other significant public or private endeavors; it is bestowed only after careful deliberation of a lifetime of service from a distinguished career.

After nearly twenty-nine years of exemplary and trail-blazing service in the Air Force, I devoted another twenty-nine years to building and operating America's only major memorial to honor military women, and it is the most important thing I have ever done.

The memorial is important for servicewomen, because if you don't understand where you've been, you may not understand where you're going. We need to know what women have done and are capable of doing. It is not too much to believe that one day, we will have a woman president/commander in chief, shattering this significant piece of the glass ceiling. I firmly believe women are far more capable than some expect or give credit. My favorite poem, "Courage," by Amelia Earhart, is one I memorized in high school, and it is meaningful to me because I have faced many difficult decisions and have thought back to that poem to get me through.

Every time we make a choice, we are influencing what the rest of our lives are going to be…for the rest of the day…for the rest of the hour…or for our future.

COURAGE

Courage is the price that
Life exacts for granting peace.
The soul that knows it not
Knows no release from little things:

Knows not the livid loneliness of fear,
Nor mountain heights where bitter joy can hear
 the sound of wings.

How can life grant us boon of living, compensate
For dull gray ugliness and pregnant hate
Unless we dare
The soul's dominion.

Each time we make a choice, we pay
With courage to behold resistless day,
And count it fair.

The first and last verses say so much about living. To me, true grit means that no matter how tough the job, you don't give up. You must persevere and fight through.

COLONEL (RET.) JILL CHAMBERS

COLONEL (US ARMY-RETIRED), WIFE, DAUGHTER, MOTHER, AND WOMAN OF TRUE GRIT

Go placidly amid the noise and haste and remember
what peace there may be in silence.
—DESIDERATA'S POEM, FOUND IN
SAINT PAUL'S CHURCH IN 1692

I was blessed with two amazing parents and a wonderful grandmother, all of whom were responsible for my great childhood years. Grandmother lived with us until she passed away when I was thirteen. These three were my greatest mentors, always encouraging me to follow my dreams. They were full of positive affirmations that laid the groundwork for my future.

My father, Eugene Willig, was an officer in the Air Force, so we moved around quite a bit in the early years. This allowed me to adapt and adjust to all kinds of situations. My parents always made the moves fun and exciting. My happy home and positive experience as a military kid ignited my passion to pursue a military career.

My mother, Jean Elsie Taylor, had lost her father when she was nine, and after her mom remarried, they moved to Tacoma, Washington. My parents were married in May 1954, and my brother came along in March 1956. I arrived two years later. I learned later that my mother had three miscarriages. It was not until I was an adult that I understood what a challenge this was for my parents. I know it must have been difficult to overcome those hardships.

I looked up to my father and always felt safe when he was around. He left for a tour in Vietnam in April 1967 and came home in April 1968. I was finishing up fourth grade when he returned. In the days and weeks following his return from duty, I would hurry and do my homework every afternoon, patiently awaiting his arrival home from work. We would then play basketball, catch, or ping-pong. Barely a month after he came home, I was waiting

for him in the driveway sitting on my basketball. When he got out of the car I ran over, and he scooped me up into his arms and asked me about my day. Without missing a beat, I told him that I wanted to grow up and be just like him and join the military. Not only that, but I was going to outrank him. He had just made lieutenant colonel, so that meant I would need to achieve at least the rank of colonel. My dad looked at me after my declaration and said, "Yes, you absolutely will." He set the course for my future, and I love him for that. I achieved my goal of becoming colonel thirty-six years later.

I started my military career in high school. I was part of the first group of young women to join JROTC in 1974. This would not be the last time I broke through a glass ceiling in my career. In 1990, I would be the first woman to command a company in Korea that included Korean augmentees. (The US government allows Korean men to become part of the US Army. They are known as KATUSAs, or Korean Augmentee to the United States Army.) This was an especially difficult assignment, as I was told that women in charge were not looked upon favorably by Korean men, particularly in the military. I happened to have an entire platoon of KATUSAs in my company, and on the first formation I was in charge of for physical training, only the platoon sergeant was present. He told me that the KATUSAs were not going to take orders from a female. At that moment, I knew the choices I made would set the tone for my entire year of command. So I looked at my first sergeant and told him we were going to go to the KATUSA barracks, wake up the soldiers, and remind them of the physical training formation. My first sergeant told me that a female could not go into the male barracks. I replied, "Well, there's a first time for everything."

The rest of the seventy-five soldiers watched in amazement as the first sergeant and I headed off to the barracks. The very first room we got to had three soundly sleeping KATUSAs. The first sergeant unlocked the door, and I awoke them from their slumber by using my foot to "assist" in opening the door rather loudly. When I marched in, the first sergeant yelled "ATTENTION!" The three KATUSAs flew out of bed and stood at attention, all of them in nothing but their birthday suits! Fighting laughter, I explained to them that they were five minutes late for the formation, and they needed to be out in two minutes, along with the other forty-seven KATUSAs.

As I returned to the formation, all I could hear was the commotion of forty-seven KATUSAs yelling and slamming lockers in a panic to get ready. Within my allotted two minutes, all of the KATUSAs were dressed in their physical training uniform and lined up in their platoon.

I never said another word about the incident, and from that day on, I never had a single problem with KATUSAs. Several of them even invited me to their Korean homes to meet their parents, which is considered a great honor in their culture! Hopefully, many of them changed their opinions toward women in charge! Happily, my assignment in Korea worked out, and I was promoted to colonel in 2004. There were eighty-eight thousand women in the army at that time, and fewer than four hundred were colonels.

One of the hardest things I went through in my career was being inside the Pentagon during the 9/11 attacks. I was Chairman of the Joint Chiefs of Staff Military Secretary at the time. God gave me the cool, calm head I needed to lead my team. We located and evacuated three hundred people who worked directly for the Chairman and got them to safety. We then spent the next twelve hours getting all of those people home to their families through various modes of transportation and a lot of intense coordination. It was a difficult day, to say the least.

Through all the obstacles I faced, I remained confident that I would be able to achieve my goals, but I would not have gotten here without the support of my family and especially that of my husband, Michael Peterson. He is the light of my life. Michael has encouraged and supported me in so many ways and always lifts my spirits. We share many passions in life. One of those passions is the health of our veterans. Together, we have traveled the world speaking to communities of veterans and empowering veterans to take charge of their health. We work to provide tools for those veterans who are ready to follow the path of physical and mental health. Michael even goes above and beyond for the veterans by providing a musical program that includes thoughtful and moving videos. I am truly blessed to have such a best friend, companion, and love in my life.

We have a wonderful family together and have enjoyed military family life. In fact, our daughter enjoyed it so much that she decided to follow in my footsteps. She chose to apply for an Army ROTC scholarship (which

she won) and graduated from college as a second lieutenant. She served for twelve years, attaining the rank of major, and she is now in the army reserves.

I know I've been blessed, so I try to spend a bit of time each day in gratitude. But even when things are not so good, I've learned that when you look for the good, it shows up. But if I could go back and tell myself one thing, it would be to not take myself so seriously at times and to learn stress-relieving exercises sooner.

Looking back, I think that knowing my mind at the age of ten and declaring my career path helped me make good, healthy decisions early on that kept my journey on this earth successful. I've always had a good work ethic, and I love to laugh and play. I simply enjoy life, and when things go sideways, I see them as opportunities rather than obstacles. I just figure things out and happily move forward.

I believe the key to my success and happiness is balance. To find balance in my personal life, I had to understand that fear, control, judgment, and unforgiveness impede the progress of balance. Keeping that in mind, I find myself paying more attention to backing away from those four attributes and replacing them with peace and clear boundaries to move through whatever shows up in my life.

For young women looking to achieve this balance in their own lives, I have four key pieces of advice. One, always remember to do the "day after thank you" with a phone call or a personal visit to thank the person who helped you with a problem the day before. Two, never put anything in writing that you don't want the whole world to read. Three, learn to acknowledge that you can't fix everything, and learn to use your intuition to say, "This doesn't belong to me!" Fourth, and finally, when faced with a circumstance that is not in alignment with your greater good, be bold enough to say, "This is not a healthy decision for me."

For me, true grit embodies the strength of character of an individual. It means that in the face of adversity, resilience, honesty, and compassionate leadership prevails. I do feel that my life experiences have enhanced my grit, my confidence against all challenges, and my enjoyment of life's journey.

PATSY RILEY

DAUGHTER, MOTHER, FRIEND, AND
FORMER FIRST LADY OF ALABAMA

Great necessities call out great virtues.
—ABIGAIL ADAMS

I had a charming childhood in small-town USA. In the summer, we rode bikes and skated around the courthouse square. On hot days, we walked to the city pool, and then later we waded in the creek. I can still feel how good it felt to slip into crisp sheets, fresh off the clothesline, after a hot bath to get rid of all the red bugs from playing outside.

Daddy was the town druggist, and he came home every day for lunch, or dinner as we called it then. Daddy would never turn anyone with a sick child away. Many a Sunday dinner was interrupted by a knock on our wooden front door. When he opened the door, he would listen quietly to the problem before he ran for his jacket. "I'll be right up; you just wait out by the store across from the courthouse." Mama would fuss that we never got to eat Sunday dinner together, but Daddy always would say, "It could be one of our children sick and in pain. I'll be right back." We saw people sitting out on porches, and everyone knew everyone in town. Life was safe and quiet.

I got here from there by God's plan for my life and my husband, Bob Riley, the former governor of Alabama. We went back to our hometown in 1965 after we married on Christmas of '64. We thought we'd live there, raise our family there, grow old there, and die there. But in 1994, after many successful businesses, Bob decided to run for US congress. After six years in Washington, he decided to run for governor.

When he won, I became First Lady. What a life! I went from being a stay-at-home mom and housekeeper to First Lady of the great state of Alabama. I had thought my purpose in life was to be a good wife and mother to four children, educate them well, send them on their way, give them

all the words of the Rock, and give them the tools to minister to others and have a lot of joy in giving to others. I wanted them also to understand that you can give yourself away and then there isn't anything else to give. I wanted to teach them to find balance.

As First Lady of Alabama, a whole new world of purpose opened up to me. My children were all raised at that point...all married but one. I became involved with charities, helping in any way that I could while promoting Alabama as a spokesperson and ambassador. I had never dreamed anyone would ask my opinion on my great state of Alabama, but all of a sudden, I was given the opportunity to shine for Alabama and let Alabama shine through me.

I have done work with organizations that support women and children. We have a task force working on a project for abused children, because there are too many laws in place that protect the adult abuser. We are trying to change the laws so that a child does not go back to the abusive home and has a place of safety. A three-year-old can't verbalize what has happened, and since there's no way to prove the abuser's guilt, the child goes right back into the same situation.

Another project we are working on is called PALS. Walmart has come on board as a partner and agreed to put up signs and banners with a 1-800 number for people to call when their stress level reaches the point that they may abuse their family members. We will have billboard, radio, and television ads that say, "If you are not an abuser, but you feel your stress level taking you to that place, please call this number for help." Hopefully, we can prevent abuse before it happens. They say that sometimes physical wounds will heal, but emotional wounds may never heal. I don't believe I would have ever gotten over being slapped around or being told I was no good as a child. Growing up, I knew how far I could go. My mother would send me out to cut a "switch" so she could strike my little legs good and proper, but I never had to worry that either one of my parents would strike me and knock me onto the floor.

My life has been filled with purpose and success, but I have also faced times of anguish. The lowest point of my life was the loss of my daughter, Jenice. Elizabeth Jenice was thirty-three years old. She was diagnosed with cervical cancer, and then ovarian cancer. The doctors warned us that so much

chemotherapy would weaken her little organs by putting a lot of poison in her body. She never weighed more than ninety-four pounds in her whole life. She went through massive radiation too, and that weakens all your blood vessels. She survived three years, and then, at about three o'clock one afternoon, she had a massive hemorrhage and passed over at 2:58 in the morning. It was very peaceful. She didn't fight it. We didn't fight it. She simply went to sleep and didn't wake up.

I wish I could say it made my faith stronger, but it didn't. I already had an unbelievable faith and strength. I truly believed and fully trusted and put it on the throne of grace. As the Bible says, "You have not because you ask not" and "Where two or more are gathered in my name, it will be." But it did *teach* me. I have grown stronger every day understanding it. God was feeding me the information I needed at the time, and today I understand that God has an infinite plan. Long before Jenice was born, or you and I were born, God knew what day and minute we were going to be born and what day and minute we were going to die and be taken back to Him.

We are loaned out to be with our parents or children or husbands or families. We don't own them, and they don't own us. I belong to God, and the minute it is time for me to go, it will not matter who is praying for me—even if it is the Pope himself. When that time comes, my date Jesus will arrive at the door. He is not going to be a minute early or a minute late. He is going to meet me at the door.

I had to go through the experience with my child to know that all the prayers in the world weren't going to change it. All the doctors in the world weren't going to change it. My faith wasn't going to change it. Never once did I believe she was not going to make it, and not only make it but have her miracle ministry. My faith was stronger at that point than ever, but when what I believe would happen didn't happen, I promise you: it shook my world. When I had to stop and start reading and thinking to keep from losing my mind, that was when I realized, "Patsy, Thy will be done…not *my* will be done." I couldn't change it.

That is how a parent keeps from going off the deep end. It takes all the responsibility off you and all the guilt off you. "What if we had known sooner…what if we had gone to a different doctor…what if I had done something different when she was growing up…her female organs could

have been stronger." You don't have to go back over every decision that was made medically or emotionally or physically. You can make something of your life instead of continuing to worry "What if...?" I released it to God, because it was His plan, not mine. That was the lowest point in my life, and I hope it is the lowest I ever go, unless God takes one of my other four children or six grandchildren earlier than me or Bob.

I value multiple things the most—health, family, forgiveness, and true love and acceptance, but most especially Jesus and Jenice. I value life waiting for me in heaven. This is a stepping stone to the real life and home. This is just play-like living. As strange as it may sound, Jenice is my mentor. I wake up every day and say, "What would Jenice do or say?" She isn't with us physically, but she is with us spiritually.

I also have ten fantastic women from my childhood and a few friends from after being First Lady in my life to laugh with me. I think laughter is important. These women go to the theater and symphony with me. They have been supportive with whatever project I am involved in. They are wonderful friends and have been able to get me to that other world! I have learned that when you are involved in politics, you shouldn't think everyone is going to treat you fairly and say nice things about you. They want to win, and the best way they can win is to make you look bad. You should stay positive and stay on track of who you are and what you are trying to do. This is what I am trying to do. I always want to say, *take it or leave it.*

My advice to younger women is to learn to laugh at yourself and with others. Most things are not as serious as we think they are. As a young girl, most everything was pretty serious to me. Learn to laugh with your children and at your children when they make mistakes, and don't be so uptight over everything. Diligence and persistence are important. If you believe in something, and everyone in the world says you can't do it, believe in yourself. When the going gets tough, many people throw up their hands and say, "I am not going through that." We all need that southern toughness, that steel magnolia down in your heart that says, "I couldn't care less what anyone else thinks. God has given me this plan, and I am moving forward." Find your strongest talent, desire, or interest, and focus on doing that.

I believe education is important. I don't have a college degree. I made it through high school and announced that was it for me, but I think

continuing education is important to women going back into the work force for any reason. Be good to yourself. Young women need to understand this. My mom used to say, "Patsy, you physically work so hard. No one is ever going to take care of you, honey, more than you. Be good to yourself." Learn to take time off, even just taking a thirty-minute walk. If you don't give yourself the delights of the world, then you have nothing to give away. You are empty.

People would be surprised to know that I am a perfectionist. I grew up in a time when it was ingrained in us to "do it right or don't do it at all." I run a tight ship. I am also thrilled to help people. I am not a smart lady, and I haven't ever worked in business, but I have been able to help people in my position as First Lady. If Bob is not re-elected, I look forward to going back to Clay County and getting outside in my old grungy clothes and planting tulip bulbs in my yard, blowing off my sidewalk, washing my windows, washing a load of clothes, and baking a chocolate pound cake. I am a good cook! I look forward to being a full-time grandmother and never missing another soccer game.

My goals as First Lady of Alabama were to have improvements made at the governor's mansion. I wanted to finish the Hill House and open it up to the great people of Alabama. I worked hard on the task force and the laws to protect abused children first and adults second. I worked hard on the 1-800 number for stress, as well as the KidOne Transport for sick children. And naturally, I continue to support my husband in all his endeavors.

When the going gets tough, many people throw up their hands and say, "I am not going through that." To me, true grit is conjuring that southern toughness, that steel magnolia down in your heart that says, "I couldn't care less what anyone else thinks. God has given me this plan and I am moving forward." I have lived a true grit life, and my resolve and resilience has and will stand the test of my senior years. God has given me this plan, and I am moving forward with better tomorrows.

JAN DUPLAIN

AWARD-WINNING ENTREPRENEUR, INNOVATOR

We have to dare to be ourselves, however frightening
or strange that self may prove to be.
—MAY SARTON

My father, Joe DuPlain, graduated from Stanford University with dreams of becoming a foreign correspondent. Although it didn't turn out exactly as he planned, he did become the publisher/editor of his own award-winning independent newspaper in a small town in Southern California. And it was that weekly newspaper that allowed him to write and travel the world and, in his own way, become a foreign correspondent! I guess I was bound to follow in his footsteps by launching my own global enterprise, but before I arrived, there were many obstacles and challenges ahead of me!

My grandmother and father were the biggest influences in my life, and the values they instilled in me at a young age are apparent today. My father was on the road traveling until the day he died at eighty-three years old. He was fascinated by learning about new places and people. His love of learning about the world and its inhabitants encouraged me to pursue a career in which I, too, could enjoy meeting people of different faiths, nationalities, and backgrounds.

After graduating from American University in Washington, DC, my first job was at my father's newspaper, selling advertising. That experience led me to pursue a position at a well-known literary agency in Hollywood, representing authors, screenwriters, and actors for motion picture companies. I know everyone can't immediately jump into their career field, but I was blessed to have the opportunity as well as supportive elders to lead the way. After Hollywood, I launched my career as a public relations liaison at CBS Cinema Center Films, a motion picture company, in New York City.

I ultimately returned to Washington, DC, and crossed paths with Frankie Hewitt, producer and founder of the Ford's Theatre Society, who became a mentor to me. At that time, she was married to Don Hewitt, the executive producer of CBS's *60 Minutes*.

A turning point in my professional life came when I met a woman very much like my grandmother. Her name was Elizabeth Campbell, and she was the godmother of public broadcasting. She had founded Washington Educational Area Television (WETA), the third largest producer of programs for public television, and she became one of my greatest mentors. I watched and worked with Mrs. Campbell, who continued working up to her ninety-fifth birthday. As mentors, both Mrs. Campbell and Frankie left a profound impression on my life. Mentorship throughout life is so important. You can learn from women who have walked the same season of life as you and be warned not to make certain mistakes to prevent unnecessary heart-break. Mentors can help you stand strong in the face of opposition. I soon had to implement that at my next job.

My biggest career break came when I launched my own public relations company and sought projects on my own. Cultural Tourism DC, a nonprofit, hired me to knock on the doors of the embassies and find out if they would be willing to open their doors to the public. This was after 9/11, when security was a significant concern for everyone. One of my first calls was to a very high-powered journalist, an anchor who had been active in the embassy world for years, had written a book on this community, and was seen as the go-to person for the embassies. They told me in no uncertain terms that there was *no* way the embassies would open their doors. It was not too risky and was not going to happen—I was destined to fail. They had a lot of power with the embassies and reminded me that the embassy staff would all ask them, the journalist, if they should participate, and the journalist said in so many words that they couldn't support the project. And, they added, if they didn't support it, it was not going to happen! Intimidating, right?

I proceeded anyway, and guess what: that first year, approximately 20 out of 180 embassies agreed to participate, which was enough to get the Passport DC Around the World Embassy Tour launched. Over the past fifteen years, my critic would shake their head and wonder how I was able to get into this exclusive community. Well, not backing down and having

true grit was how! Years later, after Passport DC became a very successful program and we were listed as one of DC's best events—along with the Cherry Blossom Festival—that journalist asked for *my* help in introducing spouses of the ambassadors they wanted to cover for a local publication. That person became my biggest supporter. The lesson of the story is that you should *always* leave the door open to people who may not support you at first. As a result of my willingness to stay positive, this program is one of my greatest legacies, and it allowed me to join with some other folks this year to create the Washington Educational and Cultural Attaché Association (WECCA). This nonprofit is the most important gift I could give the city; it will be helpful for all the diplomats involved in cultural and educational programs to stay connected and keep current with what's going on in one of the largest and most important diplomatic communities in the world—Washington, DC, our nation's capital!

Now, if I had shrunk myself, listened to my critic, and not pursued my assignment, I wouldn't have been able to have a hand in such a powerful and prosperous program. Don't let the naysayers discourage you from pursuing your heart's desire—let their words fuel it. Be brave and courageous, and find people who believe in you. For me, one of the most important people in my life was my best friend and spiritual teacher, Natalie "Madama Awesome" Austin, whose moral creed was "a kind word from a good heart means every-thing." That message resonates with me every day. Another mentor, my best friend from high school (whose wit matched her brains) shared her own set of beliefs as we traveled the country together: "no guts, no glory!" she shouted, and fifty years later, her message still rings true!

I ended up being honored for my work in Washington, DC, when the mayor proclaimed January 1 as Jan DuPlain Day, to recognize my decade-long efforts. Through my journey as an embassy liaison and public relations director, I am living my dream. My company, DuPlain Global Enterprises Inc., specializes in global public relations and special events that represent a variety of media, international, cultural, and diplomatic organizations. I even dabble in the fashion world and am currently working on launching the first global fashion gala in our city. Everything in my journey has prepared me for the next steps in every stage of my life and career.

There is nothing more powerful than pursuing "a cause greater than oneself." I wouldn't have been able to achieve my past or future accomplishments without finding causes that are greater than my own and people who believed in me. These attributes help enormously in building true grit. When you are true to yourself, serve a larger cause, and are brave and courageous, you walk with a light that attracts others. With persistence and determination, coupled with a cause greater than one's own, the famous words of the celebrated suffragette Susan B. Anthony (whose great granddaughter was one of my dearest friends) will be your battle cry: "Failure is impossible!" Mentoring and supporting those who walk behind us, my friends, will assure us of living a life of true grit!

VICKI DRUMMOND

DAUGHTER, WIFE, MOTHER, GRANDMOTHER,
UNIVERSITY OF ALABAMA LECTURER, MEMBER
OF THE ALABAMA GOVERNOR'S TRANSITION
TEAM, MEMBER OF THE ALABAMA CONSTITUTION
REVISION COMMITTEE, CO-CHAIR OF ALABAMA
WOMEN'S HALL OF FAME, ALABAMA NATIONAL
COMMITTEEWOMAN, AND SECRETARY OF
THE REPUBLICAN NATIONAL COMMITTEE

For the eyes of the Lord are on the righteous, and his ears are open to their prayers. But the Lord turns his face against those who do evil.
—1 PETER 3:12

I've always enjoyed working with others. As a young girl, I loved team sports, but my desire was always to be in the background. Part of that desire to remain in the background came from having a stutter. And as much as that was a handicap, being in the background helped me develop a talent for bringing people together. I'm a people connector; it is a skill I use in the many roles I've occupied in my life.

I haven't always been gritty when it came to obstacles like my stutter. When I was about four years old, in Sunday school class, my teacher asked the students to read a verse of the Bible aloud. My heart pounded so hard, and I was so embarrassed. When I went home that day, I announced that I would not be returning to Sunday school. They asked why and I told them. My father calmly said, "That's fine, but let's try one more time." The teacher never asked the class to read aloud again. I realize now that there was probably a parent-teacher conversation that went on, but this is just one example of the kind and nurturing parents that I had.

My parents loved and feared the Lord, and they were very patriotic. They were active in both church and local government, and Mother and

Daddy taught me that I was not better than anyone else, but no one else was any better than me. Some of my earliest memories are of my parents discussing public policy and its effects on our family and our nation. They were always talking about church and scripture and how that played into our daily life as well as our political beliefs. It was a blessing that I had Godly parents, because they encouraged me, and when I was about nine, I remember praying to God saying, "God if you allow me to speak, I will never stop trying to do the right thing." And throughout my life, God has opened doors and provided me the opportunity to do the right thing.

My journey to becoming Secretary of the Republican National Committee was not a straight shot. In college, I was employed by the housing department and the Dean of Students' office. I studied education and became a teacher. Later, when I got married, my work focused on raising my family, but I continued working with both political and community organizations where I had a particular interest. Seeing projects achieve success and reach completion brought me such satisfaction. This was a sweet time in my life, not only as a mother but as a volunteer among many wonderful generous individuals who gave me the most important possession, their time, in order to make lives more rewarding.

Between my love of policy and my gift for bringing people together, some political candidates began to notice that I had a skill they could utilize. They were speaking, and I wasn't, so I was happy to get things together. And this was how I rose through the ranks. Running for office was not something I was terribly interested in, but my work ethic got me noticed, and people kept recommending me for work.

I was at a National Federation of Republican Women (NRFW) event, and a woman approached me, introduced herself, and asked me about my dinner plans. I told her I was going to go up to my hotel room, order room service, and arrive at a meeting early. She told me, "Oh no you're not! You are coming with me." Shirley is a wonderful woman with helium in her blood, and we became friends. I told her that she ought to run for NFRW president, and that I was going to be her campaign manager. She responded, "Well if I'm going to be president, what do you want to be?" I laughed and said, "I don't want to be anything. I'm going to be your campaign manager." Shirley replied, "No, I'm serious. What would you like to do?" I said, "Okay,

I'll be your chaplain." Well, our campaign was a success. Shirley became president of the NFRW. And she didn't forget her promise. Shortly after she was elected, she made me her chaplain.

Not all of life's accomplishments are about climbing ladders. I'm also proud to have a wonderful husband, Mike, and my two sons, Michael and Matthew. My husband is such a great encouragement to me, because we believe the same things about life. My work through the years has been seamless because I received such incredible support from him. Mike is also my most honest critic. I never give a speech without Mike reading it first. I am so proud of my boys; they are the light of my life. I'm sure there were times that they got tired of me dragging them from one church or political event to another.

I would remind young women that whether you are working in your role as a mother or working outside of the home, you are touching the next generation. Your family life should always take priority. Days swiftly pass, and the days of guiding and teaching your family will be over before you realize it. The days of a parent are long, but the years are short!

It is also important to be discerning when you decide who you will spend time with. In my life, there were toxic individuals who took up time that I could have used productively. They robbed me of my joy while I tried to placate them. These people took me off of God's course, wasting much of my time and energy.

I never set out to become Secretary of the Republican National Committee. It was a path I was led down, and I have done my best to be faithful to God in walking that path. My goal has been to make my life meaningful in the big things as well as the little. I live by the comfort that people will not remember who I am when I am gone, but those I encounter will always remember how I treated them. Whether it was attending my sons' ball games, the PTA, or church—it didn't matter to me. As long as I could use those opportunities to make my small corner of the world a better place, I've been happy.

To me, true grit means fortitude. And fortitude means standing behind principles and truth. It means standing firm in the midst of life's events, challenges, and temptations. It means treating those with whom you disagree with respect. I pray every day that I will have the fortitude to react

to situations in a Biblical way, and I pray that I will have the fortitude to treat others as Jesus treated those with whom He agreed and disagreed.

MINISTRY

DEBBY KEENER

INSPIRATIONAL SPEAKER, AUTHOR, SINGER, COMPOSER, GRAMMY-NOMINATED RECORDING ARTIST

Worry is like a rocking chair, it keeps you moving, but doesn't get you anywhere.
—CORRIE TEN BOOM, HOLOCAUST SURVIVOR

My life has taken me on a journey of twists and turns through various endeavors from professional singers to affiliations with faith-based organizations (Oral Roberts University) and even starting a ministry singing duo. Along the way, there have been emotional wounds and past traumas. My husband, Dino Kartsonakis, and I started the Evangelical Music Ministry duo "Dino and Debby," and we performed on TBN, CBN, and other networks.

This road has taken me from Hollywood and Beverly Hills to international destinations like Calcutta, India, South America, Europe, Bulgaria, and Israel. My experiences have often been challenging, but a strong faith in God has helped me stay the course and work with others to inspire them to achieve their goals.

THE DAY I BECAME THE MIRACLE GIRL

I always enjoyed riding in the car, standing between the seats, and looking out the windows of our new 1953 Cadillac with my brothers, Ken and Deakon. Since there were no seat belts, we loved standing, leaning on the front seats and side doors, faces pressed against the glass, enjoying the view. The door handles opened with a simple push downward.

One day, I had crawled into the back, and suddenly, I accidentally leaned on the handle; my three-year-old body immediately tumbled out of the car. Within seconds, my mother said she felt the bump as the tire rolled over my legs.

The car behind us pulled over and asked if they could help as they placed me back in the car. My mother frantically drove me to the emergency room while crying out to God to heal me. She wailed, "Please don't let there be permanent damage. Oh, LORD, PLEASE HEAL DEBBY NOW!" As she continued praying throughout the short drive to the hospital, the intensity gave me both a sense of fear and comfort. On that day, I was grateful she raised her voice in prayers. She finished with, "Oh God of Abraham, Isaac, and Jacob, please touch her legs, RIGHT NOW, in the name of Jesus."

My legs continued to swell as the medical team carefully cleaned the dirt off my knees. There were countless X-rays. The doctors were astonished that nothing seemed crushed or broken. My legs were bruised, swollen, and sore, yet they eventually encouraged me to stand and walk. I don't recall the details, but after decades of my mom sharing that I was their "miracle girl," I know that God served a great purpose for me and helped me to understand the depth of what transpired.

THE DAY I EXPERIENCED EVIL

Immediately after rape, one first goes numb. At least I did. Confusion. *What just happened?* I was so embarrassed. Thirteen-year-old girls didn't let a guy take them on a walk without permission. Yet it happened so quickly and seemed so innocent and safe, with friends nearby around the beach. Those fifteen minutes changed my life forever. Little did I realize the decades of emotional and self-esteem struggles that would ensue.

He came out of nowhere, mingling with people on the Santa Cruz cliffs and caves surrounding the beach. He was tall and muscular, and I was flattered when he briskly walked up to me and asked me to go on a little walk. He grabbed my hand and, in less than a minute, quickly pulled me into a cave. As the assault was happening, he was choking me by pulling up my sweatshirt over my mouth and nose. I could hear the distant voices of my girlfriends from our church retreat enjoying their time in the ocean. It was painful and frightening. When he stopped, he jumped up and ran.

I struggled to stand. I pulled my sweatshirt over my swimsuit. My mind went into warp speed. I thought, *I did a bad thing.* I had never heard the word *rape.* I did understand, however, that my mom had once said that girls who had sex before they were married were considered "damaged goods." I

had yet to have a boyfriend. The spirit of shame entered. From that moment on, I certainly did not feel like God had a great purpose for me. That toxic secret eventually grew deep roots in shame, low self-esteem, and subsequent bad choices. It seemed like the end of being the miracle girl.

I walked out of the cave and around the bend appeared my friends. They didn't seem to notice that I had been gone from the group activities. They waved and yelled, "Come on in the water!"

THE DAY OF SUDDEN SORROW

After graduating from high school, I began touring with a musical troupe. While in Tulsa, the director from Oral Roberts University attended our concert and invited me to be a member of The World Action Television Singers. He offered me a full scholarship.

I phoned my twenty-four-year-old brother, Ken, to share the great news. Since he was my big brother, he was always my greatest cheerleader. The very next morning, after our first show, the director came to lead me to the campus office to receive a phone call. It was my mother's trembling voice: "We have lost Ken. He drowned this morning in the Truckee River while rafting." I flew home to California. Ten days later, the search and rescue team found his body. He had two small children who were now without their father. I felt it should have been me. After all, I saw myself as damaged goods.

During this emotional time, I sought comfort from others and soon found myself pregnant. It could not have happened at a worse time, and I chose to have an abortion. This was another toxic secret in my life.

I went on to attend Oral Roberts University, and the toxic secrets of unworthiness grew.

Then I met and married Dino Kartsonakis, and we developed a ministry for seven years as *Dino & Debby*. We had our beautiful daughter, Christina. I didn't believe I was worthy of such successes. Feeling unworthy after our divorce, I struggled to find where I belonged.

THE DAY GOD GAVE ME AN ANGEL

I quickly married Keith Hefner, whom I had previously known around the time of my brother's death. A little over a year into our marriage I gave birth

to our special needs daughter, Hilly, in 1983. Keith left before she was a year old, making me a single mom.

I was grateful for my brother-in-law, *Playboy* magazine publisher Hugh Hefner, who was always very kind and supportive.

The doctors said Hilly wouldn't live to be two years old. Her swallow was weak, and she never was able to speak. They said it was as if she'd had a stroke in the womb. Evelyn and Oral Roberts called the day she was born and prayed. Five weeks later, doctors inserted a permanent feeding tube. Even though there were big challenges, I was blessed to have Hilly for thirty-two years. She moved to heaven in 2016. I look forward to seeing her again as we sit at the feet of Jesus. She was the essence of pure innocence, my angel. Even though there were moments of panic during struggles with her special needs, I often could feel the brush of an angel's wings surrounding us.

Many people have asked how I learned to do the medical nursing required to maintain Hilly's care. My response: it was simply on-the-job training. When we are in the trenches, our survival skills usually become acute. This applies to our other children as well. Every child requires special attention. They are our sheep. We are the shepherds.

There I was, alone with two girls, when I was introduced to Ken Estin. Ken is an Emmy Award–winning writer who worked on shows including *Taxi, Cheers, The Tracey Ullman Show,* and *The Simpsons.* We were married for eleven years. At the age of forty-three, I had our beautiful daughter, Alexandra (Xander). Ken is a terrific father, and he always treated Christina and Hilly as his own. Our differences of opinion broadened the gap in our relationship, which eventually led to divorce. Because of the love we have for our Alexandra, we have remained friends.

My daughters, Christina Kartsonakis and Alexandra Estin, are extraordinary women. They persuade me to be transparent in hopes of encouraging others. They remind me it is all about love. God is love. *"Whoever confesses that Jesus is the Son of God, God abides in him, and he in God"* (1 John 4:15). It's awesome to know that since God is dwelling inside me, there is no room for shame, guilt, anger, remorse, grief, pain, or self-loathing.

I understand the impact of a great mentor, and I have had many more than I am able to share here that have shaped my perspective, but I will talk about some of them. My mentors as a young girl were my father, Dee Keener, and my grandmother Lillian Keener. She was an evangelist in tent revivals in the South, and she encouraged people to understand the love of God. She would often tell me, "Pray every day, for everyone, because the Heavenly Father is listening; one prayer can change the world." My father was intelligent and kind, and he was primary in guiding me into the wisdom and confidence in trusting the promises in the Bible.

As I progressed through life, Shirley and Pat Boone became my mentors in my adulthood. They walked me through each marriage and the birth of each child. Their constant fellowship and encouragement helped me begin to feel worthy of God's love and taught me how to pray. Learning to forgive was the first step to healing my brokenness—forgiving anyone who had hurt me, and also forgiving myself. His love and grace make us worthy of all good things. It's about loving and praying with a forgiving and thankful heart. During this season of life, I am honored to encourage others as they seek a mentor and reach out. It is humbling and energizing to distribute pearls of insight from my experiences as I have spent seventy-three years on planet Earth.

If sharing my journey of the good, the bad, and ultimately the victorious, can encourage just one person, then I am eternally grateful. The day I surrendered and understood that He gave us authority in His Name is the day I stopped sabotaging my blessings and enjoyed being the miracle girl.

These past decades have brought restoration, true rest, and inner peace every single day. I've found that developing true grit for me means to stop worrying when life circumstances become overwhelming; persevere and push through it. Pray, meditate, make a plan, and keep your eye on the prize of a successful outcome.

"*Do not be anxious about anything, (DON'T PANIC), but in everything by prayer and supplication, with thanksgiving let your requests be made known to God. And the peace of God, which surpasses all comprehension, will guard your hearts and minds in Christ Jesus.*"

—Philippians 4:4–7

It is a joy to say, "If God can do it for me, He can do it for you."

MARY T. MAYNARD, PH.D.

WIFE, MOTHER, EDUCATOR, AND
SPIRITUAL LEADER

*Trust in the Lord with all your heart, and do not lean on
your own understanding. In all your ways acknowledge
him and he will make straight your paths.*
—**PROVERBS 3:5–6**

I was born and grew up in Ideal, Georgia, affectionally known as the only
"ideal town" in Georgia, with a population of 500 people. While today's
population stands at approximately 330 inhabitants, our town remains
unchanged!

Growing up among one of twelve children, we, the oldest seven,
attended a two-room school. While my parents had no formal schooling,
God blessed them with great wisdom and vision. We grew up believing our
God is Lord and master, omnipresent, omniscient, faithful, and powerful.
Actually, when reflecting upon my parents' teaching and training, I reference
them as strategic thinkers! We older siblings actually tutored our younger
siblings in helping to prepare them for a successful school day.

From the time we were little, my father would tell us that we were
going to college. He did not say if he had money we could go. He actually
said, emphatically: "My young'uns are going to college." And we grew up
believing our dad. We just knew we were going to college! Even today, I
encourage people to instill within their children a vision they wish their
children to achieve, and watch them make every effort to fulfill their dream.

My parents had a profound respect for God and the scriptures. We were
taught not use the Lord's name in vain, and when reading the Bible aloud,
we were expected to include every thus and thou. If we didn't, we got a pop
on the head. It forced us children to strive for excellence and, as a result, we
grew up relying on Him. My parents encouraged us—no matter where we

went and in all endeavors or engagements—to always take the Lord with us, always thanking and acknowledging Him in all things. Then everything would be all right! I continually carry this with me in each endeavor, and it has helped me through many situations.

Further, upon enrolling in college, we found that grants or work-study jobs were available for students whose parents lacked a "portfolio." I had, of course, experienced this before when it came to awards night in high school, for none of the students from the only "ideal town" in Georgia ever received awards. While never agonizing over the omission, my posture was to remain focused on striving for excellence, irrespective of the circumstances.

By the time I was of college-going age, there had only been two woman of my race who had graduated from college. My brother and I were talking one day, and he pointed out, "Before we went to college, none of those families in Ideal had ever thought about going." After my siblings and I attended college, some of the most renowned cardiologists in Georgia came out of Ideal. My father's vision paved the way not only for my siblings and me but for others as well!

Upon graduating from Fort Valley State University with a bachelor's degree in elementary education, I began my professional teaching career in the DeKalb County Schools. At that time, DeKalb was among the wealthiest counties in the nation.

Later, I found myself in a marital relationship where things were going in the opposite direction and everything was below where I wanted it to be. But rather than throwing a "Pity Party," I used the breakup as a tool of empowerment and began making mental plans to enroll in the master's program at UGA! My first priority was to begin preparing for my daughter's future. With great determination, my plan was to be prepared!

Thus, I enrolled in a summer program at the University of Georgia. While the class was solely for middle and high school social studies teachers, the professor approved my class enrollment. I was one of five minorities in the class, but as I looked back from whence I had come in my own education, I was encouraged to realize that I was in that classroom competing successfully.

When I had completed my summer UGA coursework, the professor said to me, "Why don't you apply to be to be a student at the University

of Georgia?" The Lord provided, and the school offered me a full-ride scholarship. This was my opportunity, and I seized it and made all As. I really grew in my time at the University of Georgia. People will ask me, "Well, you grew up when you met Bishop Maynard?" Yes, but if it had not been for my experiences at the University of Georgia, we probably would not have gotten together. God used my experiences there and in the workforce to prepare me for mentoring women and pastors' wives in the church.

Coming from a two-room schoolhouse in Ideal, I was proud of my hard work. It was the beginning of a whole new life for me. Again, I knew I had to provide an opportunity for my daughter. I worked hard and excelled in all my classes. I did not take a single final exam at the University of Georgia, nor did I earn any grade less than an A. I was also inducted into the National Honor Society.

After graduating, I applied to Georgia State University, where I was awarded an Educational Specialist Degree in Educational Leadership & Instruction. I only received one B at Georgia State, from a professor who was rumored to never assign a grade higher than B to a selected group of students. Nevertheless, that grade did not negatively impact my view of my intelligence or value. I just rolled with the punches and moved on. At the same time, I was also offered an assistant principal position. While I was working that job, my superintendent came to me and said, "There is a professor at Indiana University who's interested in your attending the university." Thus, I was awarded a full fellowship from Indiana University to earn my D.Ed. Leadership.

There was a woman at my church who was just starting out in her career as an assistant principal. She felt that her principal did not appreciate her work or care about her. As I listened to her story, I asked, "How old is your principal?" She responded, "Thirty, thirty-five." Then I asked, "How long was the previous principal at the school?" She said, "Twenty-five years." I told her, "Your new principal is scared to death. She's following a legend. I'm sure every time she talks to a parent, teacher, or anyone else, they tell her, 'That's not how the last principal did things.'" I reminded her that her principal is acting out of fear. The best thing she could do in this situation was to tell her principal that she was there to support her and remind her

that they share the same vision for the school. That young woman went on to become an outstanding principal.

When I was appointed to the position of elementary principal in the DeKalb County School District, I was referred to as a trailblazer: the first black woman ever to hold that position. More than 60 percent of our 950 students came from multifamily section eight housing. This was a real challenge, not only in terms of keeping the school well managed, but we also faced the challenge that some of my colleagues in the district were not exactly supportive. Being the first black woman to run a school of this size in such a large county intimidated many of the men who felt they deserved my position. A group of men came to my office to inform me that there had been a turnover of five principals in just a few years, and that I had been put there to fail. They told me no woman of my race had ever been principal. I knew I would have to rely on God to bring me through this season.

So I got to work designing a program that encouraged and empowered each parent to become their child's teaching assistant. While we never reached 100 percent involvement, most homes engaged in this school improvement initiative. This was essential in changing the school's trajectory. While this program empowered teachers and parents, my strategy with students focused on the principle of love. When a student came into my office, my first question was, "Do you love your mother?" When the student answered yes, I responded with a loud no, saying, "If you loved your mother, you would obey the rules of this institution of learning." Finding a loving and practical way to remind children that their actions affected not only them but those they loved was an effective means to curb disruptive behavior. God gave me the strength to carry on and be levelheaded, not just for myself but for the parents, teachers, and students at the school.

Upon graduating from Indiana University with a Doctorate in Educational Leadership, I was invited to lunch by Dr. Robert Freeman, superintendent of the DeKalb County Schools, for the purpose of me meeting one of his former students. Dr. Freeman was rather persistent that his former student and I had similar values. So one day, I found a note on my desk that I would be going to lunch with my superintendent and his former student that day. At lunch, I focused on Dr. Freeman and didn't even look at this former student, who was named Dr. Jerry Maynard. After

lunch, Dr. Freeman and Dr. Maynard accompanied me all the way back to my office. I thought I would never get rid of them. Dr. Freeman sat down in my office with Dr. Maynard and talked about how I should invite him to see my church. Well, we were having a revival the next day, so I thought I might as well invite him.

When we got to the revival, it turned out he knew more people at my church than I did. I was impressed. After the revival, we stopped to get dinner and coffee. We just could not stop talking. That was the beautiful beginning. I prayed that God would guide my steps daily in each aspect of my life's relationships, and He answered my prayers, thus forming the Bishop's and my beautiful union, as husband and wife!

If God had limited my life experiences through some of the trials I had faced up to that point, then I would not have been prepared to be with Dr. Jerry Maynard, and I would not have been prepared for all that came after—building the church in Nashville and expanding to Memphis. Seeing how many lives God has touched through the women's ministry has been a true blessing. I have been able to coach many pastors' wives as well, and to encourage them in the work they do in ministry. I embrace it based on my love for Christ.

I often look back on my life experiences in leadership and give thanks to God for empowering women to see opportunities instead of obstacles. Because as the scripture verse says, "I can do all things through Christ who strengthens me (Philippians 4:13), and "For as he thinketh in his heart, so is he" (Proverbs 23:7).

My faith in God has taught me not to listen to what man has to say but what God has said. Applying God's word to my daily life produces true grit!

MISHA A. MAYNARD

DAUGHTER, MOTHER, AND MINISTRY LEADER

Everything that I have gone through is working for God's good!
—ROMANS 8:28

My marriage to my high school sweetheart resulted in divorce, but God allowed two great blessings to come from it: our two sons. A few years after my divorce, I moved to Indianapolis, Indiana, with my seven-year-old, Scott, and six-year-old, Stavon, to begin a new life filled with new opportunities. Those career opportunities required long hours at work and less time at home. Though the revenue was good, the price I paid was painful.

In February 1996, I was working tirelessly, sometimes so hard that I did not notice little changes in my children's lives or even mine. Scott had never been athletic, but he was moving more slowly than normal. He needed help getting out of bed, standing up, and eventually walking. He was gradually losing the use of his muscles. He was diagnosed with polymyositis, a disease found mainly in adults. I went numb. The words rang in my head over and over, but I could not process them. Scott's motor skills declined tremendously and very quickly. He went from roller-skating to rolling in a wheelchair. How could this be? What was going on in my life? God was showing me favor in all that I had been doing—so what happened?

I made a difficult decision and relocated to South Bend, Indiana, to be around family for support. A few months later, Scott contracted pneumonia, one of the worst things for someone with his disease. To clear the mass from his lungs, he needed to use his muscles to cough up the mucus. Eventually, pneumonia took my son's life.

The moment he took his last breath, I felt a release in my body, as if my spirit had left me. I felt as if a part of my existence was just ripped from me. I had no strength to stop the force from removing me from myself. Amazingly, Scott knew he was leaving. He had told me earlier he was going

to fly with the fireflies. I stood there frozen as my son was on the verge of dying, wondering why I did not have enough faith to pray Scott through the sickness completely.

I felt vulnerable; I felt like it was open season for anyone or anything that wanted to attack me. No one said it, but I began to think that people would question my love for my son. I figured they would question why I had worked while he was sick. If anyone had questioned my love for Scott, it would just have killed me emotionally. I questioned the strength of my relationship with God. How could I have been in the favor of God and yet have my baby, the one I carried for nine months in my womb, the child who took me thirty-six hours to deliver, the one who gave me a reason to live, be taken from me?

How could I be in a family of faith, in a lineage of ministers, and have no power to prevent this horrific event? Why hadn't I received a warning that he was going to die? With all the prophets in the area, in the family, and in my life, no one could see this coming. Disappointment, guilt, and suicidal thoughts began to attack my mind. I felt that I had disappointed my mother because she fought so hard in prayer for a miracle. My worst guilt was not spending time with my youngest son, Stavon. I felt that I had betrayed him. How could my life bring so much pain to so many people? The enemy was playing with my mind! I remember hearing the devil say, "If you just kill yourself, everyone will understand. Or better yet, just stop talking to people. They will put you in an institution, and you won't have to bother with anyone anymore." The voice was so clear.

Ultimately, the voice of the Lord overpowered the enemy's voice, saying, "If you just praise me in the midst of your pain, I will lift you past this pressure and place you in the safety of my arms." The Spirit of praise came over me that day, and I could not stop praising Him. Though I was experiencing a normal response to death, I was having a unique, God-ordained reaction to the response. Although a flood of tears flowed from my eyes, praises were coming out of my mouth. Pressures were building inside of me, but God was pressing joy in me to strengthen me. Whatever my emotions were, my spirit was praising right along with them. God was not going to allow my loss to overshadow His power.

The death of my son caused me to think about all the days and years I had lived with no God-given purpose. The pain drew me closer to God and my assignment. It became so clear to me that time was of the essence and that I had to do whatever I could do to complete my earthly tasks.

God has given us the opportunity to live—I mean really live—and loss must not take that away. Paradoxically, my son's death brought new life to me, a new reason to live, a new reason to have hope, joy, peace, and love.

I was wounded by the loss of my firstborn, a son God had blessed me with, who had given me joy and a reason to live. He was gone, and I would never hold him again or see his smile or feel the touch of his skin. Prior to his death, I wore so many masks to cover every area and aspect of my life; I believed I had to hide to survive. After his death, I began to remove the masks. I no longer wanted to just survive—succeeding in life became my new goal.

Survival means barely making it. We survive storms by taking shelter beneath any covered area available. Our provision, however, could fall and bring us harm. We survive falls by breaking them with our body parts, though we may break bones in the process. We survive on a deserted island by eating animals or insects we would dare not even touch in normal conditions. We take the resources around us, and we do the best with what we have. There is nothing detrimentally wrong with survival if that is all we have. But success comes from perseverance, or grit!

"…But we also glory in our sufferings because we know that suffering produces perseverance; perseverance, character; and character, hope" (Romans 5:3–4). Success does not come without a sacrifice, price, or pain. We will go through some trials, tribulations, failures, and some victories, but our response to these incidents will determine our outcome. We can choose to survive or to succeed based upon our actions.

Additionally, success requires us to give up things we hold dear. When I refer to things, I am not talking about houses, cars, or finances, though the sacrifice of these may be required. I am speaking of sacrifices such as pride, self-worth, or a posture that says "that's just the way I am." To move forward and fulfill our God-given destiny—true success—we must put aside every injury, tragedy, failure, and sin that distracts us and

face the fears in front of us. And facing my fears was never so hard as this past year, because I gave up my second son, Stavon Eurice Williams, to a tragic car accident. He was my business partner and my main heartbeat on this Earth. To have now lost both of my sons has totally brought me to my knees. I really don't know how to explain this kind of depression. In life, I know that we cannot control certain situations, but we can control how we respond to them. Because of God's amazing grace, my ministry, my father's ministry, and the support of so many Christian families—I am taking one day at a time.

FACE YOUR FEARS

If any of you are facing fears that continue to hold you back from accomplishing your goals, dreams, and destiny, you have access to God's power to stand against the devices and tactics of the enemy. This will ensure your victory. I know personally that it's not enough to just say, "Press past the pain and discomfort that may come with the challenges that fear brings." Sometimes you have to do this one moment at a time. Pray to our Heavenly Father that He will provide you with the strength to look at yourself and recognize that you are created in His image and likeness. It is also important to find someone you feel safe with to talk, cry, or even scream with. It takes time to live with heartbreak. As you pray and meditate; listen for the soothing, comforting words that God will impart to you. Dig deep within yourself and draw strength from the experiences. "Consider it pure joy, my brothers and sisters, whenever you face trials of many kinds" (James 1:2). Remind yourself, *you* are still alive, so live with the passion to finish! I think it is important to take time for those who love us and those we need to love.

Remember, someone is following in your footsteps, so step with dignity, step with courage, step with value, and step with power. Put on your high-stepping shoes; make giant prints in life's path…prints that are big enough for the next generation to walk in successfully and with God's light.

The more we move forward in His will, the more we find freedom in just being.

True grit means, to me, finding resilience that can bring about extraordinary transformations. You too can learn how to do hard things and turn unfortunate circumstances into beautiful situations.

PAULA MOSHER WALLACE

MOTHER, EX-VICTIM, FOUNDER OF
BLOOM IN THE DARK, INC.

Use the fertilizer of your past to Bloom Today!
—Paula Mosher Wallace

*F*ertilizer. My story is full of fertilizer. It was tough to come up with a way to talk about the mess in my past without swearing. Fertilizer is stinky, messy, and nasty. So is my story.

But just like fertilizer helps plants flourish, my past boosts my success. Complex PTSD becomes my motivation for Complex Post Traumatic Stress Growth (CPTSG). *The Grit to Grow* should be my next book title, right? The pain in my story helps me encourage and support people who are hurting.

Because I felt alone and hopeless so much, the underlying theme of my nonprofit organization, Bloom in the Dark, Inc., is "You are not alone. There is hope."

The ways I've been able to use the fertilizer of my past to bloom have been the same ways I was told I couldn't. Despite the cult I was born into and the husband, bosses, and envious peers trying to stop me, I have been sharing my story and others' stories of hope and healing through media of all types. Books, magazine articles, blogs, social media posts, podcasts, events, television shows, internet platforms, radio interviews, and film have been avenues of influence and story-telling.

As a media missionary, I share the hope found in a relationship with God, through Jesus Christ, with the world. Born in Peru, I come by my international viewpoint automatically. My parents were missionaries. My oldest sister was born in Ghana, Africa. My parents lived in foreign countries for a dozen years.

While living on our church farm (cult commune) in Peru, my mom was pregnant with her sixth child. Having almost died in childbirth with both

my younger sister and me, she knew the heart palpitations could be fatal. So she spent six months in the United States to give birth to my youngest sister and recover. During that time, my younger sister and I were fostered out to women in the community. My dad took care of the three older kids.

My foster mom was an elder in the church. She was an authority figure who intimidated most people. A woman who lived in the same building has since told me what she witnessed. My foster mom would severely punish me—not just for disobeying her, but for not anticipating what she wanted. I was two years old. She would then beat me until I quit crying.

I learned at a very young age to dissociate, to separate myself from my body and emotions for safety. I also learned to fawn, or read the people around me and do whatever I believed they wanted me to do. I had a compulsive need to meet expectations while not showing my own emotions.

Since the Christian cult we lived with was focused around achieving perfection on Earth, my compulsive performance and perfectionism fit right in. Having also been raised to believe that performance was a way to stay safe, my parents were attracted to the cult. After six months of torture, I was returned to my biological family. This stopped the extreme discipline, but the damage was already done. I truly believed that I deserved to be used and abused.

From then on, I was an easy target. At the age of five, I was raped by a man in the commune. I knew I could never tell anyone. I was sure I would be severely punished. Somehow, it must have been my fault. When, at the age of sixteen, I finally did confess, I wasn't believed. I went through years of wondering if all my pain and torment about it was based on a nightmare rather than on reality.

It was a nightmare, indeed, but a real one that had I actually lived through. I was finally vindicated in my early twenties when my older sisters remembered finding my bloody underwear in the bottom of the toy box. They told me about trying to wash the stains out of three pairs of my panties. They had been too young and innocent to realize it was blood. They thought it was sap from banana plants. As adults, they recognized that it had to have been blood.

At nineteen, when I told an international female elder from Canada about getting raped, she told me to never let the words cross my lips. That

admitting my hurt was glorifying satan. I still wasn't allowed to talk about it. Using my voice never got me help. It just got me into more trouble.

This had always been true. At the age of nine, we were living in the United States and I was in a study hall with my best friend. I passed her a note with the words *rape* and *molest* on it so that she could look them up in her dictionary. We wanted to figure out which word applied to each of our stories. She'd been molested in a different commune. A cult elder confiscated the note.

Our punishment was not being allowed to communicate with each other in any way for a year and a half. This ruling was enforced by all the adults. Seeing my best friend every day but not being able to communicate with her was torture.

Talking and writing caused unbearable consequences. The fact that I have become a public speaker is crazy. The fact that I am an author of seven books is miraculous. The fact that my subject matter has primarily been abuse is unbelievable. The enemy has worked hard to stop me from my mission. But God.

As I write this, I'm dealing with symptoms of a variety of stress-induced medical issues. I have healed from so much. And I have learned that I *will not* let symptoms stop me from fulfilling my mission. And so, as I choose to feel my intense emotions surrounding what I'm writing, my healing journey continues.

"Every trauma trigger is an opportunity to heal" is one of my motivating quotes. As I work in the business of raising awareness and ministering healing to those most abused, I have many opportunities to heal. Because I am greedy for healing, that works for me. I never want to stop my healing journey. I want every ounce of available life, joy, and love.

Back to being a media missionary. I had been on television in two hundred countries for over a year before I realized I was a media missionary. I grew up wanting to be a missionary. My college scholarship application stated that I wanted to use speaking English as a second language (ESL) as my entry into foreign countries to share salvation.

One day, as I asked God when I would get to do foreign missions, He told me that I was already doing foreign missions. My face and voice were sharing the hope found in a relationship with Jesus Christ in foreign

countries at all times of day and night. Seventeen television networks had become forty-five over the last four years.

I realized that as a media missionary, I could live in the United States. I could be a single mom and a foreign missionary at the same time. I'm not just sharing hope with one town, city, or country—I'm sharing it with the world.

With Missionary Media, I'm also able to help other ministries and nonprofits do the same thing. I am extremely grateful for the technology that makes this possible.

I was raised to believe that television was evil—even Christian television. In fact, I did not have a TV in my house until after I got married and left the cult at age twenty-four. Because of this, I felt guilty about watching television for years. But God. Now, I am a host on over one hundred episodes of two broadcast television shows seen around the world!

Mind you, I had panic attacks before filming the first seventy-six episodes. Then God healed me. Just like He had with the panic attacks I'd suffered when writing the stories in my first book, *Bloom in the Dark: True Stories of Hope and Redemption*. God eventually healed me. I needed healing. The trauma surrounding writing or talking about abuse was drilled into me with spiritual, emotional, and physical punishments.

My abusive husband forced me to do the writing and speaking for our companies. He liked that it made me panic and kept him in control. From a business perspective, I was successful. And yet, I was constantly being told off and punished for always doing things wrong.

Later, the abusive boss kept raising the stakes on my performance in an attempt to force me to quit. Because I kept refusing his sexual advances, he didn't want me around. When he fired me, I officially stood up to him. That turned into a federal, state, and local lawsuit. This taught me that I could stand up for truth and that I didn't have to stay the victim and keep taking the hits.

Grit to grow. You see how I had fertilizer piling up. Grit is the result of not letting the fertilizer burry you. Grit is mixing the soil of your choices with the crap in your story. The resulting gritty soil can grow anything. Grit is how you can use the fertilizer of your past to bloom in your future.

From losing two babies to miscarriage, to raising three boys by myself... from my husband cheating on me with my best friend for years, to the

cervical cancer I got from her HPV…from the time my church fired me for my religious beliefs, to the time when no one would hire me because of the lawsuit…from the date rape at a conference, to the Bible study teacher who tried to seduce me while I was still married…I have had plenty of opportunities to develop grit.

I have gotten to choose forgiveness. I have gotten to fight to protect myself and others. I have started over and over and over again. I have repented and asked for forgiveness. I have gotten help. I have chosen spiritual intervention, counseling, and support groups. I have worked the twelve steps. I have chosen sobriety and recovery in a series of areas.

I have never actually given up. Suicide has been within reach. But by God's grace, I've survived and gotten help. God never abandoned me. God never allowed damage that He couldn't heal. God has systematically healed and restored area after area of pain for me. He has healed my body, my soul, and my spirit.

Not one area of my damage is the worst you've heard about. Yet the total number of areas of damage is kind of off the charts. The cool thing about that is how it has given me compassion for so many. I can relate to some aspect of most stories of abuse and addiction that I hear. I can offer hope and healing to so many, because I have actually walked in their shoes for a mile or two.

Recovery Strategies 4 Life: Healing for Your Spirit, Soul, and Body (RS4L. com) is the curriculum and television show that has come out of ten years of my healing journey. I got to work with a team of professionals to deconstruct my healing. Ten years were boiled down to one year's worth of recovery journey. Fifty-two videos and five workbooks walk you through the process of healing from the inside out.

As an ex-victim, I get to own my past. I get to heal. I get to use my journey to help others. I don't need to hide my story. I don't need to live in fear, shame, or guilt. I get to choose the grit to convert my fertilizer into beautiful blossoms and fruit.

If you have brokenness in your story, you're not alone. There is hope and healing available to you. Religion may have failed you, but God never does. A relationship with God through Jesus by the power of the Holy Spirit is available to everyone. No one is too broken for Him to fix.

Relationship. Not religion. God loved us so much that He gave us His Son to take our punishments for us. We get to claim eternal life through Jesus's sacrifice. We get to accept His grace and forgiveness. The Holy Spirit empowers us to have the grit to create a life worth living.

Join me. Choose Life. Choose the Grit to Grow.

SHELIA ERWIN

DAUGHTER OF THE KING, MOTHER,
GRANDMOTHER, WIFE, AND AUTHOR

*I have found meaning and purpose because I have
embraced a relationship with Jesus.*
—Shelia Erwin

Jesus always calls us to a task that is bigger than our abilities. That's what happened to me when God gave me children. I'm an only child, and I had never been around babies much, so everything about parenting was new to me. God taught me how to be a mom to not one but two sons. After our son, Andy, was born, I became a stay-at-home mom. I taught women's Bible classes, spoke at women's groups and retreats, owned a travel agency, and homeschooled my sons. In addition, I have been the wife of Hank Erwin for forty-eight years now. He has been a student, a youth director, a high school football team chaplain, a pastor, a teacher, a radio personality, a news reporter/anchor/director, a senator, and a businessman.

It didn't take long before my husband and I realized that our sons were creative dreamers—big dreamers. And from the time they were old enough to watch movies, we would hear them talking about becoming filmmakers. We knew very little about the business of creating movies and even less about Hollywood. But we encouraged them and their dreams. How did we do this with no knowledge of the film industry? We encouraged them in conversation. We told them that we hoped and prayed that their dreams would come true and that the result would not only be for their benefit but that something would use the power of this medium to draw people to the Lord Jesus Christ. (Hank's dissertation at the seminary, after all, had been "Ministry with Media.") Andy and Jon later became film directors and founders of Kingdom Story Company and Erwin Brothers Entertainment. Some of the movies they have produced

include *October Baby, Moms Night Out, Woodlawn, I Can Only Imagine,* and *I Still Believe.*

When Jon was entering second grade and Andy sixth, God directed us to homeschool our boys. This was not what I had been trained to do. I knew how to run a classroom and run a school, but give up my freedom to stay at home and teach two students? This hadn't been the plan. But long ago I had said yes to Jesus, and if this was my new place, then I would do what He had asked. So, day by day, I relentlessly and lovingly pursued teaching history, art, mathematics, and economics, embracing the essentials of our faith in every subject. Once when I told a skeptical gentleman about homeschooling, he condescendingly said, "Lady, you're a dinosaur. What a waste of your education." A waste of my education? Today, I don't think my sons would agree with that man.

Andy has thanked me so many times for being willing to invest in his life. Jon has said that if he had not been homeschooled, he probably would have been a dropout. As hard as this new path was, I learned so much about God's enabling power and that I can do hard things through Him who strengthens me. As Paul stated in 2 Corinthians 12:10 (interpretations added): "For when I am weak [in human strength], then am I [truly] strong [able, powerful in divine strength]." In other words, Jesus can take those weaknesses and turn them into great strengths. *I can do hard things.* I borrowed this phrase from my daughter-in-grace Mandii. *I can do hard things* is so often her mantra. Knowing we can do hard things is true grit.

Is God's plan without heartache, hardship, failure, and disappointment? No, but He has promised us that He will never leave us alone. When our children were very young, we began to teach them to bow the knee to the will of God as they watched us do the same. We taught them that God has a plan and that even if it is different from our plan, we will submit to it, even if it is painful to do so, and we will thank Him in the midst of it. God can be trusted to direct us both by giving us what we want and by withholding something from us. We taught them that we can even learn from our failure of not meeting the desired objective. Life is always teaching us to trust God more.

When Jon was about four years old, we were on a family fishing trip. Our older son, Andy, was quite the fisherman, while Jon had been fishing

before but was not very good at it. He never left the hook in the water long enough to catch a fish because of his ADHD. On this day, he had just put his hook in the water when, to his delight, he discovered he had caught a fish. As we were taking the fish off the hook, he looked up at me with those sky-blue eyes and said, "Thank You, Lord!" He continued to fish and eventually hooked another one, but before he could get this one up on the deck, it got away. I will never will what happened next. Jon again looked up at me and said, "Thank You, Lord. Mom, is that the way to do it?" That day he had learned to give thanks in all things, whether he caught a fish or not. *Thank You* means, "You are God and I'm not; I know that You have promised to make everything work out for your glory and my good. I will trust You, and I will submit to your will!"

Joseph is one of my favorite characters in the Old Testament. Joseph's life was not easy. He went through much pain and disappointment, giving him every human right to be bitter, angry, and vengeful. However, he chose to trust in God through every circumstance. He learned the wonderful truth that God was with him through all experiences. Joseph was not trusting in the people or circumstances of his life to make his life work; he was trusting in his God. Learning to have faith is not an easy task, but Joseph shows us that it can be done. He believed that even though others may have meant things for evil, God meant them for good. Romans 8:28 says, "And we know that all things work together for good to them that love God, to them who are the called according to his purpose." So keep your eyes open, because He will do the same for you. Proverbs 16:9 says, "A man's mind plans his way, but the Lord directs his steps and establishes them."

I have found meaning and purpose because I have embraced a relationship with Jesus. My life's work is infused with this purpose: to know Him (Jesus) and to make Him known. I believe that true grit is found in a personal relationship with Jesus. What He calls us to in our life is what He will faithfully accomplish. Read Philippians 2:13, "It is God who works in you both to WILL and to DO for His good," and 1 Thessalonians 5:24, "He who calls you is faithful, who will do it." He can be trusted!

PHILANTHROPY

ELLEN POTTS

HUMANITARIAN, WIFE, MOTHER, CHOIR
SINGER, BOARD PRESIDENT OF THE ALABAMA
ASSOCIATION OF HABITAT AFFILIATE

*What counts in life is not the mere fact that we have lived. It
is what difference we have made in the lives of others that
will determine the significance of the life we lead.*
—NELSON MANDELA

I had an imperfect but wonderful childhood. I was very fortunate to grow up in a loving two-parent family with brothers who were six and ten years older than me. My birth was planned, but I was planned several years earlier than I actually showed up. My brothers could pick on me, but no one else could. My parents and grandparents gave me enough love and affirmation that I believed I could accomplish anything I set my mind to. However, my parents' "loving discipline" and my brothers telling me to "suck it up" anytime I started whining or causing drama kept me from getting too high a sense of my own self-worth.

I am fortunate to have had so many mentors growing up. My voice teacher and her husband—my church choir director—Helen and Bob Bargetzi, certainly were musical mentors when I was an adolescent. My youth pastor, Rev. Rick Lemberg, was a mentor in the faith, as were many of my Sunday school teachers, friends' parents, and neighbors. Our college choir director, Hugh Thomas, and his wife, Barbara, probably taught me more about life than music, though I've learned a great profusion of music from both.

I dreamed of the normal things—romance, love, home, family—but I also wanted to be a stockbroker. I majored in finance, but in October of my senior year of college, the market crashed, and I never went back to it. I remember I applied for a job as a health care manager one time when I was

fresh out of college. I probably didn't have the skill set for the job, and I got the interview through a friend. A very elderly gentleman interviewed me, and at the end of the session, he said, "Well, I would hire you, but I just don't think a woman could do this job." I didn't sue him, although I certainly could have. He was a very elderly gentleman who came from a very different time. Besides, I had gotten the interview through a friend and didn't want to damage that relationship. I managed a medical practice for several years after that, with some physicians who were known for being a pretty difficult bunch. However, they never treated me with anything less than respect. I think it's because they realized I wouldn't take anything less than that.

I am fortunate to have a husband who loves me and is very supportive. He was in medical school at the same time I was in graduate school. He was in school full time, and I worked full time in the day and went to school at night. I had about thirty minutes between the time I would get home from work and the time I had to be at school. He would have dinner ready for me on those nights and most other nights, since he got home before I did. He's always been supportive. There are times over the years when he's been the strong one in the relationship, and there are times when I've been the strong one. He's never been patronizing or a chauvinist. He is a wonderful daddy of girls, because he instilled in them that they deserve to be treated with respect.

I was grateful to be able to stay home with our daughters when they were little, and I wouldn't take anything in the world for that time. Our younger daughter was very sick as a baby. Being postpartum, I was not my best self— as my mother told my sister-in-law, I was a basket case. I remember sitting at Maria's bedside and taking the "boldly approach the throne of grace" a little more seriously than perhaps the Lord intended. Danny was the strong one during that time, but my weakness helped build my relationship with God. Maria was healed quite miraculously, but we were told there was a very strong chance that she would have long-term brain damage. She just graduated from college summa cum laude and will begin work on her Ph.D. in the fall. God is good. Even if he had not healed her, he would still be good.

My parents taught me about what it looks like to live a life of service, but they never talked about it. They just led by example.

My dad, George Woodward, taught me how to manage people. He was in charge of a missile system at Redstone Arsenal. After he retired, I worked

in his old office and heard so many people talk about how much they loved working for my daddy and why. The same thing happened when he died and people came through the line at visitation. It made me realize that I needed to step up my game as a manager in the way I advocate for and support my employees.

Sexism is real. I have experienced it from time to time. There are times when people will try to bully you or whatever, and they expect to be able to do that because you are a woman. The thing I have found most helpful, in my career especially but in life in general, is to look at it like a chess game. I confess that I know very little about chess, but the one thing I know is that you have to think several moves ahead of your opponent. When I'm being bullied or someone is trying to undermine me, I try to get out of the emotions of the moment and think long term. In a few key events when I've been in those types of situations, I've been able to play the long game. Both times, it took me a couple of years, but at the end of the day, I was the one still there standing strong, and the bullies were gone. I could have left those positions in either case, but I really wanted to stay where I was both times.

I think that when I first became executive director at Habitat for Humanity of Tuscaloosa, many people didn't think a woman could do the job, since it's basically a nonprofit construction company. Several people have apologized to me over the years for the assumptions they had early on. Being tightly entangled in the job, I have gained a great deal of perspective. Habitat Tuscaloosa primarily serves the working poor. I see single mothers working two and three jobs to support their children. I see people taken advantage of because they don't have the education I was provided. I see people who live in homes that don't have functional plumbing, that have wiring that is a fire hazard, that have collapsing roofs and floors, that are located in neighborhoods where shootings and drug deals are common. Many of our homeowners lost everything in the April 27, 2011, tornado. One of them even lost everything in Hurricane Katrina and lost everything *again* in the tornado. I go home to my house in my safe neighborhood. My roof doesn't leak. My plumbing works. I can pay my mortgage and power bill. Every day, I feel so incredibly fortunate to have the blessings I've been given and to serve the people our organization serves: people of integrity, faith, and resilience. They are really the people—and especially the women—of true grit.

My advice to women seeking the grit to shape their lives is don't expect anything to be handed to you. You're not entitled to anything, and everything should not be taken so personally. Treat everyone—from the queen to the janitor—with the same kindness and respect. Work harder than anyone else. Don't expect anyone to do a job you aren't willing to do yourself. Take out your drama with the trash. Realize that displays of negative emotional reactivity are your enemy in most cases. I'm not saying that you can't use them to your advantage once in a while, but even then, it needs to be in a very controlled, strategic fashion, as you play this chess game that is your career. Most importantly, trust God. Through all the good times and the bad times, trust God. God is faithful. God will get you through anything in life.

I have the privilege of working with some of the most amazing people—employees, homeowners, board, and volunteers. I can't believe they would pay me to do this job. I've always heard that if you love what you do, you never work a day in your life. I think that's the truth. I love what I do so much that I don't really feel like I've given up anything. Of course I have, but it doesn't seem like a loss, because I have gained so much. To be truthful, I think God gave me the exact experiences and the exact group of people I needed to be successful in this time with this organization. God could have chosen anyone, but I am fortunate He chose me and equipped me for the calling. I have such a fabulous staff that it makes my job easy.

I think my family loves what I do. At times it intrudes on our lives, but they are okay with that. I also think it has broadened their horizons, as it has my own, to see beyond our own very privileged existence.

To me true grit means resilience. I have been knocked down a good number of times and have always gotten back up!

LEIGH ANNE TUOHY

DAUGHTER, WIFE, MOTHER, PHILANTHROPIST, AND ADOPTION ADVOCATE

For God so loved the world, that he gave his only Son, that whoever believes in him should not perish but have eternal life.
—JOHN 3:16

I was born and raised in Memphis, Tennessee, and for as long as I can remember, my parents instilled in me a love of the Lord and a passion for helping others. Growing up, my maternal grandmother, Virginia Collins Cummings, a woman of strong faith, lived with us. My first memories of her were her morning and evening quiet times. Her dedication to her faith was what inspired and encouraged me in my walk with God.

I attended Briarcrest Christian School, where I was a cheerleader. After graduation, I attended Ole Miss, where I continued my cheering activities. And it was through cheerleading that I met my husband, Sean Touhy. There was a big away game, and all the basketball players and cheerleaders were on the same plane. Our seats were next to each other, and we ended up talking the entire flight. He told me a lot about his girlfriend back home. By the time we arrived at our destination, played the game, and landed back in Oxford, Mississippi, we had decided to go and have lunch so that we could finish our conversation. After three or four days of talking, I told Sean that he needed to be calling that girlfriend of his and say, "bye." In our junior year at Ole Miss, I told him we were going to get married. We graduated on May 5, 1982, and we got married on June 12. This June, we'll celebrate our fortieth anniversary.

Our faith is what we have built our marriage on and subsequently what we have raised our family with. When your life becomes a movie, *The Blind Side,* people will interpret your life in many ways. But for us, we were just living our lives on faith in God. Sean and I never intended to have a movie

made about our lives; we just fell in love with Michael Oher. The way it felt to us was that he came to stay on a Monday. Monday became Tuesday, Tuesday became a week, a week became a month, and all of a sudden you have a dear young man you can't imagine your day without. We were grateful to have Michael in our lives. We don't think any of this was by chance or accident. He should not have been there, and we should not have been there, but we were meant to be in each other's lives. We believe that this is the story God intended to tell through us, and we try to be good stewards of that message by following Christ and clinging to his word. Actress Sandra Bullock and actor/singer Tim McGraw did such an incredible job of portraying the authenticity of our passion for family in the film. A lifelong friendship was made in the process. I think we were all good influences on each other. They helped us give a bigger voice to underprivileged children.

There are so many people out there who have done more than we did. People who have adopted eight or ten kids. Parents who have taken in hundreds of foster kids. The movie should have been about them, because what they have done is far more interesting than what Sean and I did. We are in the fourth quarter, Sean and I, and we wake up every morning asking ourselves *How can we see this out? What do we want to do from this time until the good Lord is ready to call us home?* And this crazy journey that God has taken us on, we know that we want to impact as many lives as possible. When I lay my head down on the pillow at night, I ask myself, "How have I shown the love of Christ to others today?" I believe that is done through the little things. Something simple like holding the door for someone or stopping to catch up with a friend in the grocery store. I want people to realize it is not a daunting task to make a difference in someone's life. You don't have to run a charity to honor God and love others.

It was these little everyday actions that inspired Sean and me to found the Making It Happen Foundation. Sean had been doing color commentary for the Memphis Grizzlies for sixteen years; he had recognition before the movie came out. So in 2009 we founded it with the mission to share our commitment to faith, family, and others, while opening doors to promote awareness, provide hope, and improve the standard of living and quality of life for all the children fighting to survive in the invisible cracks of our society. Sean and I honestly believe that to whom much is given much is

required. Giving back has been important to us from the beginning. Then with the events of the movie, *The Blind Side,* we just had an opportunity to do things on a bigger scale.

Our commitment to helping youth in the foster care system has only grown over the years. Children who age out of the foster care system are at high risk of making the wrong choices, choices that can lead them down the wrong path. Three out of five young women who age out are trafficked. The number of young men who age out and are incarcerated is astronomical. If we could find loving homes for the kids in the foster care system, it would end the need for foster care and help eliminate drug and sex trafficking along with incarceration. Our focus at the Making It Happen Foundation is providing opportunities for these children who too often slip through the cracks.

The Making It Happen Foundation has different programs that help kids at different ages and stages of life. We support students at the Base Camp Coding Academy by taking a day to shop for work and interview clothes. For younger kids, we host a Valentine's Kindness Store. Kids earn Kindness Cash by doing random acts of kindness in the month before February 14, and then they cash in their "dollars" for treats as a gift for a loved one or themselves. I am so grateful to be able to help provide children with things they both need and want through these fun and enriching activities.

One of my favorite little things that I do is every Friday I post a photo of a child on my Instagram @LeighAnneTouhy. I call it Forever Family Friday. Each child that I post is ready to be adopted. All we need is someone to say yes. For one of the children I posted, we had twenty-four inquiries about adopting. Even just hitting the like button helps. The more people see these kids, the better chance we have of them being adopted into the perfect home.

Being a mother is at the heart of my life. It is what has ignited my passion for children in the foster care system. My loving husband Sean and I know the impact a loving and supportive family can have in a child's life. I could not be prouder of my children, SJ Touhy, Michael Oher, Collins Touhy Smith, and my bonus son Cannon Smith. I am so blessed to have each of them. No matter how old your children are, you never stop being a mother. I never stop cheering them on or advising them. That includes steering Collins away from questionable lipstick decisions. To all the

mothers out there: don't let yourself get bogged down in all the little things. Remember to slow down; enjoy and cherish your children at every stage. A loved child is a happy child. Think about our Heavenly Father's love for us. Without true grit, I would not have the strength to follow my passion to help children in the margins. I am ever grateful for being able to be in a position to help schools and families in low-income areas improve their quality of life.

MARY JEAN EISENHOWER

GRANDDAUGHTER TO THE PRESIDENT, MOTHER, AND PHILANTHROPIST

Don't sweat the small stuff.
—UNKNOWN

I was very coddled and protected growing up. If I had a problem in school with someone I admired, I would tell my mom I couldn't wait to be a grown-up, when everybody got along. Of course, it doesn't work that way. I learned some pretty brutal lessons in young adulthood that showed me the world wasn't perfect...my early "shock factor." My dad, John Sheldon Eisenhower, is the son of Dwight Eisenhower, the thirty-fourth president of the United States. My mom, Barbara Jean Thompson, was a military brat who met my dad in Austria right after the war. They were married thirty-four years.

Daddy grew up an only child. His older brother passed away from scarlet fever while my grandmother, Mamie Eisenhower, was carrying my father. My mom was one of four children, which seemed to make up for daddy's lack of siblings. I am the youngest of four, which is a life lesson all by itself.

My grandfather was a knee-slapping grandfather...a regular family man. I found that trait so endearing. I didn't realize he was globally special until I entered the school and people started treating me strangely. I knew he lived in a fancy house and he came home from the office. I just didn't connect the Oval Office with the presidency at the time. To the credit of my parents and grandparents, our lives were as normal as possible, but it was still surreal. Friends would ask me if I had a huge allowance as I was growing up. I told them my allowance came in the form of an after-school job! So there was normalcy, but I was also sheltered. I would often wonder who my "Commander-in-Chief and President" grandfather trusted. When my father

graduated from West Point on D-Day, he went to England to be my grandfather's aide throughout the war. So the answer was: you trust your family.

Growing up, I wanted to be like June Cleaver. I wanted a white picket fence and I wanted to clean the oven in my pearls! In reality, my mentor was my grandmother, Mamie. She was a steel magnolia, a grit. No question about it. A woman with a backbone doesn't forget how to be a woman: she knows how to be hard, but she realizes she's soft. Every woman needs to emulate a man's strength and still keep her softness and femininity. Other people mistake kindness for weakness. My grandmother, like a steel magnolia, showed kindness but was not the least bit weak.

After my grandparents retired to Gettysburg, we saw them every day, because our property abutted their farm. We were a close-knit family. Not many people were as close to their grandparents as I was. My mother stayed busy raising four children, but my grandparents always had time for me. This is often true with grandparents, especially when parents have a large family. My grandmother always had a minute to talk. After my grandfather passed away, I would see her on weekends, because Gettysburg was only about an hour and fifteen minutes away from my house in D.C. By that time, my sisters and brothers were all married, and I was the only unmarried one. I am so blessed to have been able to spend that time with her.

When I was about to be married, she shared her checkbooks from the twenties to show how she budgeted during the Depression. I couldn't believe she still had them. She taught me etiquette and manners and "just how to be." She said it was "tacky to wear your diamonds before noon," so I don't wear my cubic zirconiums before noon! The whole June Cleaver thing didn't work out for me. I had a couple of not-so-wonderful marriages, but I have a fabulous son, so no complaints. I ended up an involuntary career girl—certainly a different plan than I had envisioned. I worked with my current ex-husband at an engineering firm. I managed the money, and he was the engineer. Working seventy hours a week, we raised his children and my son, who had a touch of dyslexia. While I cooked dinner, I helped my son with his homework. I went to school twice, once for him, as support, and once for myself. It was wearisome. When I came into contact with People to People, it was almost an epiphany—totally unexpected. I met Sergei Khrushchev, the son of one

of my grandfather's greatest adversaries, former Soviet Premier Nikita Khrushchev, at a People to People function. I had been invited to speak and was surprised they put the two of us together on the program. Sergei often speaks to American audiences to share his memories of the "other" side of the Cold War. As it turned out, he was one of the nicest people I had ever met.

Then, I saw it: the whole People to People thing. The organization's stated purpose is to encourage international understanding and friendships through educational, cultural, and humanitarian activities. It was a very real concept, and it worked. From that moment forward, I wanted nothing more than to go to work for People to People. I accepted an offer from the organization and moved to Kansas City. My marriage was falling apart at the time, and this decision gave my life purpose. It was such a pleasant surprise. The puzzle started to make sense, and I landed in the shoes I was supposed to wear.

After this experience, I wouldn't know how to live any other way. I have been lucky to have the opportunity to make even a tiny impact on people's lives. Our organization works to bring peace around the world, and we are involved in several humanitarian endeavors. People to People stations its employees in different countries, where they work to make a difference. For example, we provide supply bags with toothbrushes and other essential supplies for the underserved. The people we work with honestly cannot afford these everyday items. Scores of underserved youth help us with our mission, thereby helping other underserved children.

A most bittersweet moment of courage happened for me in Jordan during the triple bombings in November of 2005. It was 11/9 instead of 9/11, which some believe was on purpose. Directly behind our hotel during a wedding ceremony, a bomb exploded. It was a nightmare...very graphic. Going to the bombing site and relating to what those victims must have gone through took me the longest time to get over. Interestingly for me, though, I learned what it takes to make peace. The Jordanian priest left his parish to sit with the Americans the next day to ease our fears. The royal family called to make sure we had what we needed and to reassure us that we would be fine. Jordan, of course, was closed. We were confined to the hotel at least for the first day for our own safety, so that the dust would settle. As

Americans in a foreign country faced with something of this magnitude, we didn't know if we were the next statistic or not.

That whole experience taught me that peace and comfort do come into the world. People need to understand that fortunately, the really scary things do fail. What we don't hear, and maybe this is why they call it faith, are the beautiful things about the world—the priest who left his parish to sit with the Americans or the young men and women who risk their lives for others. It's not their battle, but they go fight it. These things are not printed in the newspaper. You have to trust and have faith that they exist and go find them for yourself.

One of my biggest life lessons is "don't sweat the small stuff." I am a childhood polio survivor. I was one of the 2 percent who caught it from the vaccine. It was a mild case, leaving my left side with half the strength of my right side. I had special exercises for gym class up until the ninth grade. The teacher stayed after school every night to help bring me up to the level of the other kids. I found my way in that formal gym class in school, and I haven't missed a beat, although I will say that I have had some pretty achy bones over the years. I had a surgical correction in 2005 that helped, but the week before the surgery, I had been feeling miserable. I was in Sri Lanka, right after the tsunami, to assess the situation on how to best use the money we had received for the victims. I started to hurt badly while I was there, but then I saw an amputee from a landmine. I thought to myself, *Never mind my pain.* Don't sweat the small stuff.

Another defining moment happened for me at a school in Sri Lanka. The people knew nothing about me except that I was western and my name was Mary. We arrived to make a donation and see what life was like for the kids. The school matron whispered to me that every child I was going to meet that day had parents who were killed in the civil war. Their ages ranged from one to twelve. A group of kindergarteners was waiting for me. As I came in, they clapped their hands and fell into the cross-legged position on the floor, singing "Mary Had a Little Lamb." I recognized the song, sat down cross-legged with them, and started singing along in English. Those are the little things that last a lifetime and will perhaps allow me to leave my legacy as a friend who loved. It took me a long time to accept the world as it is. If I had to live my life over, I would try to hear the "whispers." Sometimes, it's

right there and you have no idea. John Lennon said, "Life usually happens when you're out planning something else." I love his lyrics: "Let there be peace on earth and let it begin with me." That is realistic…it's not just an idealistic song. It doesn't matter what the vehicle is for peace. It could be entertainment or cultural exchange. It doesn't matter if we speak the same language. It doesn't matter that we dress differently. It doesn't matter that my god differs from your god, especially in today's world. We are not an island, and people need to realize that—not only realize it but savor and cherish it.

Although others may mistake kindness for weakness, if you are a steel magnolia, you are kind and you are not the least bit weak. You are a woman of true grit!

SHIRLEY MULLALLY

DAUGHTER, SISTER, WIFE, MOTHER, MANAGER, AND PHILANTHROPIST

If I have seen further, it is by standing on the shoulders of giants.
—SIR ISAAC NEWTON

To me, it is important to have genuine actions that always show your real essence to everyone you meet in life. Thanks to those who have come before me and shared their wisdom with me, I believe in myself and have faith in my convictions. All I need to do is follow my heart, and I'm confident I will do the right thing. Sometimes, each of us needs to reach down and find a bit of courage to get through challenges.

I have been fortunate to have strong women role models in my life. They taught me to keep an open mind, to be wise enough to listen when someone is giving me good advice, and to learn from these women of character. They shared with me their own experiences, teaching me wonderful lifelong lessons. They supported me through each stage of my young years, instilling in me values such as honesty and self-respect. I learned the value of having confidence in my abilities and the benefits of hard work. Retaining those lessons helped me to become the woman I am today.

As a child, I remember always being aware of everything around me. Everything I saw, heard, and experienced became an intricate series of examples of the lessons my mother and grandmother taught me. This created a deep foundation of internalized information within me. Thankfully, I respected my parents and my maternal grandparents and acted on their guidance. No child can retain every single one of those life lessons, but I remember listening intently, asking questions, and then storing them all safely in the back of my mind.

I stood on the shoulders of my parents. As a family, we enjoyed watching the TV show *Make Room for Daddy* starring Danny Thomas, who would

make a plea of encouragement to his viewers to raise funds for St. Jude Children's Research Hospital, which was working to help save children with cancer. My very young heart was touched and committed forever to help make a difference. As Mr. Thomas said, "No child should die in the dawn of their life." This was my start with this wonderful cause.

I spent a lot of time with my grandmother after my grandfather passed away. My grandmother was a woman who was driven to follow her dream of a better life. At the young age of seventeen, she packed a few clothes and necessities into a carry-on bag and left her family in Europe forever. She embarked on a weeklong voyage to reach the United States of America. Talk about true grit—she never saw any of her European family again! She only communicated with them through letters that were transported by boats that took months to get back and forth across the sea. When both of my daughters celebrated their seventeenth birthday, I remarked how my grandmother had such courage to start such a journey at their age. What an amazing young woman. Do you see how I was inspired by her tenacity and resolution?

Believe me, she knew about overcoming! My time with her developed me into the woman I am today. She taught me how difficult life was during the Great Depression and World War II. She spoke about how those dark days affected everyone in the world, but hard times forced everyone to be creative during such an extraordinarily challenging environment. She was so encouraged by how people helped each other through these days when it seemed impossible to survive.

Of course, I had, close at hand, two fine examples of the goodness she was talking about. The kindnesses and good intentions my grandmother spoke about were demonstrated repeatedly by both of my parents. Their attitude was never "woe is me," or "it's hopeless, so let's give up." Their first idea was always to figure out how to make the best of a bad situation—to have a positive attitude but then immediately try to be uplifting of those around them, supporting others as well as each other.

My mother, Jane Trapp, was also a wonderful role model. She always remained strong in her faith and character. Confidence was important too. She believed in her ability and worked to make any task appear to be easy to accomplish, even when it wasn't. These traits made her not only a wonderful

wife and affectionate mother, but also a smart businesswoman. She worked alongside my kind, funny, supportive, loving, and hardworking father, Augie Trapp, in their restaurant business. They worked together like teammates based on my father's experience playing AAA baseball in the 1920s as property of Chicago White Sox. Their first business together was influenced by that sports theme. My mother also managed her own gift shop and an interior design company, and she served as the landlord for several rental properties they owned. This was a very exceptional feat for a woman in the late 1940s and early 1950s. As busy as my parents were, they found time to support the community girls' and boys' athletic clubs. Together, they also chaired the American Cancer Crusade in the 1950s. She was an extraordinary mom who always attended to the needs of my two siblings and me, while keeping our home neat, clean, and exquisitely designed. She made things fun for us, even if things were difficult for her in her day-to-day life.

She was a woman ahead of her time, doing all these things even before we had the term *multitasking* in our vocabulary. Her attitude was contagious. She made us feel as if everything was going to be all right simply because we all could make it that way. "You can do anything you put your mind to," she would tell us. That's only one example of how she instilled confidence in us. She made us aware that we needed to be grateful for our gifts of food, shelter, and the love and companionship of our family. She taught us to be kind and to guide others to respond in a good and positive way. She taught us the necessity of showing respect to others and taking responsibility for ourselves and our actions. She taught us to pray. She did all this not just by her words but also by her sustained example. I am grateful that these life lessons are still a big part of who I am.

Earlier, I referred to a special memory involving comedian and actor Danny Thomas, who made a passionate plea on his TV show to his viewing audience. He asked for volunteers to go door to door in their local neighborhoods to collect contributions to help him realize his dream of building St. Jude Children's Research Hospital in Memphis, Tennessee. His heart ached for these young patients suffering from cancer. At that time, such a diagnosis was dire, offering little hope of survival for children.

I was nine years old when I saw that on-screen appeal from Danny Thomas. Those few minutes of television changed my life. For the first time,

I began to believe that maybe I could do something positive on a bigger scale. My actions could bring awareness to the tiny patients who were bravely fighting for their lives and their relatives and friends who fought right alongside them. With the permission of my supportive parents, I joined "Danny's Army," collecting donations door to door. All I was doing was following what my family had already taught me. I was trying to make a difference for a wonderful cause!

There is an important point here. Never underestimate the power of the lessons your children are learning from you right now. Those can be both good and bad lessons. Children of all ages watch their parents. If your words aren't consistent with your actions, children might be confused, and they can lose trust in you. Those seeds of trust and distrust are planted very early on. Positive impressions stay within the child, making it more likely that he or she will become an upstanding adult—one that accomplishes good things, spreads kindness, and creates a better world. As my grandmother shared with me, the brain is the miracle organ gifted to a human being to hopefully allow him or her to make the right decisions. However, if guided in the wrong direction, it can lead to evil too.

I have had my share of challenges throughout my life. One of the biggest came when I became a young mother. My oldest daughter, Christy, was born one month premature. We were blessed that she was healthy, and I was able to bring her home with me from the hospital. We learned then what an incredible miracle it was that I had even conceived this beautiful life. I was diagnosed with a unicornuate uterus, a rare disorder in which only half the uterus is formed. Did I have any hope of having a second child? The doctor's answer was positive. "Your body did it once," he told me. "Your body can do it again." Five years later, our second daughter, Sarah, was born. Our precious second baby was *two* months premature. This time it was so hard. We had to leave her in the neonatal unit when I was discharged from the maternity ward. True grit was needed! Dig in, Mom!

With each infant, I felt guilty for bringing these loved lives into the world facing such an uphill climb so early in their lives. I was so very thankful for them, but now, I had to leave Sarah at the hospital without being there to nurture and protect her. I had a cesarean section, which has a six-week healing time. I wanted to bring the "liquid gold," my breast milk, to the

hospital for her. I could visit her daily in the neonatal unit, but I couldn't hold her or touch her since she was in the incubator. I would see her and sing to her and tell her how much I loved her, but leaving her there every day was the most difficult thing I ever had to do.

After a month, she reached her release weight of four pounds, and we could now bring our beautiful baby girl home. I, along with her other care-takers in the household, my husband and mother, received instructions on infant CPR. We learned how to connect her infant monitor and the imme-diate procedure to follow if the alarm sounded, indicating the baby was not breathing. Because she only weighed four pounds, we had to learn to administer medications every few hours. My medical knowledge certainly expanded.

I thanked God every day for these beautiful people in my life: this newborn baby; my husband; my mother, who moved in with us to help during our preemie's uncertain beginning; and my five-year-old daughter, who also brought us boundless happiness every day. Each, in his or her way, supported me and assisted me through this uncertain time. My true grit was supported by such powerful encouragement.

In challenging times, we lean on our faith, family, and many other people who are willing to be there for support. The neonatal nurse, who came to our house once a month to make sure I was secure in my medical knowledge, was my counselor. I asked so many questions, cried so many tears, and leaned on her more than I ever expected to lean on anyone during the eighteen months Sarah was on the infant monitor. *How do I get through this?* I thought. I didn't know what the future held for this fragile little girl. I was admittedly frightened by the huge responsibility I had for this precious life. Even today, I still treasure the wise words of that nurse, who had come into my life to give me such strong encouragement during difficult times: "Take one step at a time," she told me. "One day, one hour, one minute, and sometimes even one second at a time."

She was right. I now know that angels are present everywhere. I still hear her encouraging words. Together, we lift each other up. Together, we show kindness. Understand how important it is that we attentively pamper each special precious life that is in our care. We go through so many trying times, and together we can be the angels on earth that are needed to make it

through another challenging day. I am writing this during the COVID-19 crisis, a pandemic our world has never seen before. I have been sharing her words "one day at a time" with my youngest daughter, who flourished—growing up with energy and well-being and now has a healthy baby of her own. My husband and I had to dig deep for true grit, as we didn't see our grandson, Landon, or his mom and dad, for ten months because of the pandemic. Everyone in the world has known the struggle of quarantine. Now, in 2022, we have been blessed with our second grandson, Carson, and Dan and I are enjoying retirement with a second home near our grandchildren in California.

I am so fortunate that I found the most wonderful man to marry. He is my love, my one and only Dan. He is simply the best. He has the utmost respect for each person he encounters in this world. He lives his life by the Golden Rule, vowing to always "Treat people the way you want to be treated." I have endless examples of how he has been willing to offer a helping hand to those in need. He is such a constant in my life.

In our hearts, Dan and I, together, share a dedication to helping the fantastic work being accomplished at the wonderful St. Jude Children's Research Hospital, built by Danny Thomas here in Memphis, Tennessee. It seems mystical that my true grit was first inspired as a nine-year-old living in Chicago going door to door asking for donations to help Mr. Thomas build this fabulous hospital, and now that hospital is a reality located a short drive from our home. Dan and I are dedicated to St. Jude and all that they accomplish. Together, we began a fundraiser called "Mullally Party with a Purpose." This event was held from 2009 through 2019 in our home, during the annual FedEx St. Jude Classic & Invitational World Golf Championship. Because our home backs up to the eighteenth green of the Tournament Players Club Southwind Golf Course, our guests could watch the professional golfers compete, with the admission fee being their donation to the hospital.

We are so ecstatically proud that this party, with our matching gifts, has contributed more than 1.2 million dollars to help St. Jude Children's Research Hospital achieve their miraculous research. In 1962, the survival rate for children diagnosed with cancer was only 4 percent. Today, the survival rate is at 96 percent. Those children needing treatment can live and

achieve their dreams. We are so appreciative of all our hundreds of wonderful guests who gave so generously. Together, we continue to show support for all the patients and their families. There is no way to put a dollar value on how those donations may have helped St. Jude's patients and families find their true grit when they needed it the most.

In 2015, Dan and I were chosen as "St. Jude Volunteer of the Year." We felt so honored. At that dinner, with our two daughters attending, we were inspired by the stories of the other recipients from across the United States accepting their individual awards. It was a beautiful and emotional ceremony.

In 2017, I was honored to be one of ten "St. Jude Women of Distinction." At that luncheon, I was blessed to meet Edie Hand, who was one of the speakers. I was inspired by her theme of the Genuine Pearl Girls Society, which is based on the scientific phenomenon that an irritation enters a mollusk shell, starting the process that develops that irritation into a beautiful pearl. This is so much like all of us who have a thing of beauty created from the very item that tried to destroy us in our daily life struggles. Remaining brave and standing with confidence helps us find incredible strength within.

I have often pulled from my internal true grit during physical challenges, including bulging discs, a torn meniscus, and even surviving a heart attack at the tender age of forty-six years old. We all must be courageous and go to the depths of our inner strength when we are forced to deal with that irritation, that parasite, that opposition, that challenge: the grief of losing a parent, a child, a loved one, a friend, or even a favorite pet. Our true grit is challenged when we face tragedy or loss, or we witness someone close to us facing their adversities. The spirit of our soul is what makes us who we are. That spirit does not age but the essence that is developed from our birth can be improved with positivity throughout our life. Together, we can concentrate on creating one idea a day to resolve conflict for ourselves or others in our life. In my young years, I had a friend who called me Shirl, the Pearl of a Girl. I would laugh and move on; only now do I know what a gift that title is.

I can verify that I have needed true grit at crucial times and have a pretty good idea of just what it is. To me, it is the determination to make things better when the going gets tough. The task may even appear to be impossible. It is finding the strength to persevere when times appear to be the most

difficult. Remaining positive when it seems there is nothing obvious to be positive about. It is seeing the light at the end of the tunnel as bright goodness and not a freight train bearing down on you. True grit is never giving up.

TERRE THOMAS

If you always do what interests you, at least one person is pleased.
—KATHARINE HEPBURN

Danny Thomas knelt in a Detroit church in front of a statue of St. Jude Thaddeus, the patron saint of hopeless causes. He prayed for a sign. Should he stay in show business or change direction? Mom wanted him to do something secure, like work in the produce business or a grocery store, because working as a comedian was so sporadic and unpredictable. Again, he prayed to St. Jude Thaddeus, "Help me find my way in life, and I'll build you a shrine." He didn't have anything and wasn't sure what the shrine would be. He might be able to create a side altar or maybe even build a little clinic for children. One by one, he was shown signs that encouraged him to continue pursuing his dream of being an entertainer. Many people make hollow vows…not Daddy! As his success grew, so did his passion for this project. Of course, at the time, he had no idea it would be such a monumental undertaking. Yet he never lost sight of it, and it became a passion for all of us in the family.

As fate would have it, the hospital became the greatest pediatric cancer research hospital in the world. Music was always such an important part of my life; maybe it was inherent because my parents met as singers on the radio in Detroit. I was not interested in a full-time career in music and life on the road. Who's to say I would have had what it takes to make it anyway? I wanted to have children more than anything, and luckily, I didn't have to choose between music and family. If I did, children would have won, hands down…no doubt about it! It was never a contest! My passion for children was a sure thing, and I was not going to give that up. If you have music in your heart and soul, you can sing anywhere, even driving the carpool. You don't need an audience. I shared the gift of music with my children and taught them my little acronym, GML—God, Music, and Laughter—which

can get you through anything in life. When St. Jude Children's Research Hospital opened in 1962 in Memphis, Tennessee, Daddy said, "Now I know why I was born." We were all so touched by his passion for this amazing facility and what it could accomplish. In a sense, we feel like we were born to carry on our dad's legacy. He never pushed it at us or dropped it on us, but it was one of the greatest gifts you could inherit...and clearly the right thing to do. Dad came to believe that his entire career was just a vehicle to take him to the place where he could do something lasting to help children. It was a God-given career that made it possible for doctors to do what they could to save children's lives. Dad was Lebanese and Mom was Italian/Sicilian, so there was always activity and music in the house...noise and joviality, personalities vying for airspace at our dinner table. When you *got the floor*, you kept it as long as possible.

Dad was the most influential person in my life. Marlo and Tony feel the same way. He was just like he was on his TV show, *Make Room for Daddy*. Although he could be loud as a lion, he was always gentle as a lamb. He was family-minded. He came from a large family: nine boys and one girl. You can imagine what a saint my grandmother was! He always had time for us and came to everything we were involved in. Mom was always such fun to be with—she had more energy than all of us. When we went to a restaurant, they would often play "Danny Boy" or "Rose Marie, I Love You." Mom would tell jokes to the Italian waiters in Italian. They would encourage her to play the piano and sing. Dad would proudly sit there with an unlit cigar in his mouth. Mom *was* the proverbial wind beneath Dad's wings. He asked Jim Weatherly to write a song about Mom. He wrote "You're the Best Thing That Ever Happened to Me." Ray Price and Gladys Knight both sang it. They each had great success with the song—a great tribute to Mom.

It was hard when Mom got dementia about six years after Daddy went to heaven. Although she had a nurse, I was always there. She had taken care of me, and I was going to do the same for her. It's the hardest thing to see someone who was so vibrant lose herself. Failing health is so hard to accept. I, too, had run-ins with Mother Nature. It started right after the birth of my second child, with the discovery of a little blue knot right below my right knee. I didn't think much of it at first. I had it for years and assumed it was a bruise from playing on the floor with my daughter or kneeling at church

or hitting it on a cabinet. When it started growing, I had it checked out. No one thought it was anything. You have to be your own doctor much of the time, and I felt something wasn't right. Finally, a great surgeon told me it was a blue nevus tumor, a second-degree melanoma. He said if the cancer had spread at all, I could die in about a month. I said, "I'm not going to die. I just had my son ten months ago, and I have a three-and-a-half-year-old daughter at home. I'm going to raise them." The surgery to remove it was successful. The tumor had remarkably stayed intact after all those years. I truly believed I had been given a second lease on life. About thirty years later, doctors found a growth on one of my ovaries. They advised me to have surgery to remove the growth, even though they felt certain it was benign. My decision to have the surgery was confirmed when, just days before the operation, my daughter told me she was expecting my first grandchild. I wanted to have the surgery and get it over with; I felt a peace that everything would be fine. The surgery was a complete success—the growth was benign.

Years later, out of nowhere, an innocent cough led my brilliant doctor to suggest a cat scan. The results confirmed that I had another cancer. This time it was a small tumor in the lung. We found it early, and I didn't have to have chemo and radiation. My parents must have been nagging God! It's funny how we can obsess endlessly over the small things but learn quickly to accept the big things. We need to look to a purpose bigger than ourselves and work every day for that purpose. For me, I have my children and my grandchildren, and I have St. Jude Children's Research Hospital. They keep me going… and going…and going. My faith and the book of Proverbs have helped me through the toughest times of my life. Proverbs 3:5 says, "Trust the Lord with all your heart and lean not on your own understanding." There is no way we can understand why tough times come. What I do know is we can count on God's presence and guidance—that's a big source of my strength.

I learned about giving and making an impact on my community from my dad. He wanted to help as many people as he could. He showed me how important each individual is to any cause, and that was empowering to me. Thinking of his hospital, he would say that it is the small donor that runs it. It's like an adage I once heard, "Drop by drop makes the lake." The research at St. Jude affects the world. Daddy used to say, "The entire pediatric community of the world looks to St. Jude, in Memphis, Tennessee, for

the answers in childhood cancers and catastrophic diseases." I can hear him say that like it was yesterday. I would say to any young woman today who is trying to make her way—beginning her journey—simply be your own person and be the best at whatever you are going to be. Don't lean on a man, or anyone, too hard. Don't depend on another person to be your only source of happiness or to make you feel complete. Believe in yourself and *be* yourself… and you will make it. And, don't forget…GML.

My children were my biggest goal, and they are my greatest achievement. I was *successful* in raising two responsible young people who are now out in the world, affecting others. They are so talented, and I'm so proud of them. They both have careers in show business, where they have learned that getting to your goal is like walking in quicksand. They understand that show business is not always a choice, but more of a calling, and if you are in it for vanity, you won't last. Like their grandfather, their achievement and their grounded approach to their work is what they pass on to others.

True grit means withstanding…holding on when the tide comes in and tries to drag you down. It's about understanding and remembering your true purpose, especially when the waves are crashing all around you. I have come to learn that there will always be something to knock you down; true grit is about not letting it break your spirit.

EDIE HAND

*E*die Hand is a businesswoman, speaker, media personality, filmmaker, international author, and mom. She has authored or coauthored over twenty-five books. The Edie Hand Foundation's brand *Women of True Grit* encourages women to share their stories and passion from the trials they face to their triumphs. Edie has partnered with Sinclair Broadcasting of Birmingham, Alabama, to share Women of True Grit Vignettes in 2022.

Edie, along with FedEx, is leveraging this brand for a special project that will inspire people from all walks of life. She is excited to be working with extraordinary women globally through FedEx and sharing stories that have led these women into powerful leadership roles.

Edie Hand's *Women of True Grit* has developed a series of thirty-minute documentary-style programs. Additionally in development are podcasts, radio interviews, and streaming. Monthly, *Reel Lumiere,* a national digital publication by the Nashville Women in Film and Television, features an article from Edie Hand's *Women of True Grit* series.

This initial airing was in November 2021 and a second airing was in March 2022 on Alabama Public Television and beyond. A second episode highlighting NASA *Women of True Grit* airs in November 2022. Other media for *Women of True Grit* include vignettes on ABC/TV33/40 on Sinclair Broadcasting Network and digital marketing on the Talk of Alabama website. Explore more information at www.womenoftruegrit.org.

A new addition to the *Women of True Grit* brand is the Pearl Coaches, who are contributing their expertise, guidance, and advice through GRIT. ihubapp.org. Edie encourages you to join the GRIT Sisterhood.

Edie has starred in national commercials, appeared on daytime television soaps, hosted national TV programs, and developed several radio shows and vignettes across the country. She was the CEO of a full-service ad company, Hand N Hand Advertising, in Birmingham and Daphne, Alabama, for over thirty years. In recent years, she has partnered with her Hollywood actor/businessman son, Linc Hand, to form Hand N Hand Entertainment to continue her writing for film, television, radio, and podcasts.

Edie also founded the Edie Hand Foundation over fifteen years ago, in memory of her three young Blackburn brothers, to help pay life forward with acts of kindness to others with broken hearts. Edie is a cancer survivor (numerous times over) and understands living with chronic illness, but she always finds the grit to keep moving onward and upward. She learned how to turn hard things into beautiful situations.

Edie learned first-hand about paying life forward through charities in one's community through her family. She also comes from a wonderful family heritage of songwriting, acting, and music, from the Hood-Hacker-Presley family. Her legendary cousin was Elvis Presley.

Edie Hand (formerly Edith Blackburn Hand) is an alumnus of the University of North Alabama. She and her friend George Lindsey founded scholarships there for students pursuing a career in theater or communications. Edie lives near Birmingham, Alabama, but her heart is in Hollywood, California, with her only son, actor Linc Hand, and his wife, singer Victoria Renée Hand.

EdieHand
sharing the art of living

POPULAR SPEAKING TOPICS

Topic 1

EDIE HAND'S

WOMEN
OF TRUE GRIT™

Your attitude toward situations every day can make all the difference. Edie shares some of her personal, inspirational, and humorous stories that show the benefits of building your string of pearls, which are guides to healing one's brokenness. The String is your life, and the Pearls represent your unique necklace. Edie's stories will define what each of the Pearl colors represents to better help you reflect on your passions, understand the importance of resilience, and navigate into your own transitions. Faith is a powerful element of the presentation, so components may include scripture (depending on the venue) to let you know you are not alone in building your pearls of life. You will leave knowing you have the grit to do hard things. Edie's story is your story.

2. Grit-A-Tude
Pushing through life's challenges is made easier when good mentors enter your life. They guide you through your mistakes and can often work magic in pointing out opportunities and goals that help advance your agenda. Along the way, you'll encounter the power of resilience as you navigate life through loss, ride to success, and understand how to find one's grace to balance the belief in oneself. The presentation focuses on a few key elements:
- Perspective
- Pushing through Fears
- Power to Believe

3. The Art of Storytelling

We all love a good story, and everyone has a personal story to share. The keys to successful storytelling are these elements:

- Passion: a strong connection to the subject matter in the story
- Perseverance: it's that drive to share the powerful elements of the story and not give up until the audience feels that determination
- Positive Projection: an opportunity to showcase one's confidence in their project. This can be done by demonstrating a focus on the desires, dreams, and fears of the characters for the audience.

Sessions can have a workshop format based on the dynamics of the audience. Storytelling helps paint pictures through various mediums, including television, magazines, social media, theater, and art.

Customized workshops and other speaking topics are available. Please inquire. Contact Edie Hand at ediemaehand@gmail.com or Mark Dubis at mdubis@gmx.com

No one tells a story better than Edie Hand. Her genuine approach to this art is magnetic and compelling. I highly endorse her as a speaker and facilitator.

—Dr. Devin Stephenson, President/CEO
Northwest Florida State College

Learn more about Edie Hand on these websites:

https://ediehand.com/ • https://hhentertainment.biz/ •
https://www.womenoftruegrit.org/
Join the Women of True Grit at https://grit.ihubapp.org/

**Supporting Resources for marketing,
website development, & publishing**

Mark Dubis, Marketing & Website Production -
https://dubisgroup.com

Karolyn Hart, CEO of InspireHUB
https://inspirehub.com khart@inspirehub.com

Scott Spiewak, Publisher & Publicity Specialist
https://www.franklingreenpublishing.com/

Visit EdieHand.com to view more of Edie's books like
The Genuine Elvis and others,
or check out Amazon or your local bookstore.

PEARLS ON. SWORDS UP.

These women warriors of true grit know how to slay the demons that blocked their paths and to journey on as they find their destiny through "pearls of hope" and new tools for life found in these shared stories—YOU will undoubtedly see pieces of your own story among this sisterhood of life experiences.

REMEMBER: YOU TOO CAN TURN HARD THINGS INTO BEAUTIFUL SITUATIONS!

Printed in the USA
CPSIA information can be obtained
at www.ICGtesting.com
LVHW021950100923
757717LV00007B/9